MUSEUMS

Key Texts in the Anthropology of Visual and Material Culture

Editor: Marcus Banks

Key Texts in the Anthropology of Visual and Material Culture is an innovative series of accessible texts designed for students. Each volume concisely introduces and analyses core topics in the study of visual anthropology and material culture from a distinctively anthropological perspective.

Titles in this series include:

Cinema: A Visual Anthropology

Museums: A Visual Anthropology

MUSEUMS

A Visual Anthropology

Mary Bouquet

London • New York

English edition
First published in 2012 by
Berg
Editorial offices:
50 Bedford Square, London WC1B 3DP, UK
175 Fifth Avenue, New York, NY 10010, USA

Berg is an imprint of Bloomsbury Publishing Plc.

Library of Congress Cataloguing-in-Publication Data

A catalogue record for this book is available from the Library of Congress.

British Library Cataloguing-in-Publication Data

A catalogue record for this book is available from the British Library.

ISBN 978 1 84520 811 0 (Cloth)
978 1 84520 812 7 (Paper)
e-ISBN 978 0 85785 211 3 (institution)
978 0 85785 212 0 (individual)

Typeset by Apex CoVantage, LLC, WI, USA.

www.bergpublishers.com

For Henk

CONTENTS

LIST OF ILLUSTRATIONS

Cover illustration: El Lissitzky (1890, Potsjinok–1941, Schodnia), *New Man* (2009), 3D model after designs and a print by El Lissitzky from 1923, constructed by Henry Milner, collection Van Abbemuseum, Eindhoven.

ACKNOWLEDGEMENTS

First, thanks go to Marcus Banks for inviting me to write this volume for his series and for his encouragement throughout. My debt to Maarten Prak for his unwavering support for this project—even when, at times, he must have wondered whether it was ever going to end—is great. His initial help in getting the project off the ground and sustained enthusiasm throughout the writing process were indispensable. I gratefully acknowledge the Netherlands Scientific Organisation (NWO) grant that enabled me to free up nine precious months for thinking and writing in 2008. Teaching museum studies as part of a liberal arts and sciences bachelor programme in the Netherlands is a privileged position from which to contemplate the development and meaning of museums and cultural heritage. University College Utrecht is a challenging and stimulating professional environment; many colleagues actively supported this venture, and I thank them all for their generous understanding. I will mention a few by name: Rob van der Vaart, whose supportive interest in museums and heritage has been crucial to completing this book, and Aafke Komter and Orlanda Lie, who encouraged my efforts to write over the past years and whose trust and confidence I value. Working with colleagues Gert-Jan Vroege, Hendrik Henrichs, Tijana Zakula and Nana Leigh has been inspiring. Several cohorts of students have contributed to the development of the book in different ways: their critical enthusiasm for this area of studies—and their creativity in going further in it—is endlessly rewarding. I would particularly like to mention the CHIP Alumni Advisory Group: Laura Kraak, Lana Askari, Boris Cornelissen and Valerie Gersen. Many museum experts and professionals have shared their thoughts on changes in museum practice: these include Jan Willem de Lorm and Tim Zeedijk; Georges Petitjean; Marijke Naber; Theo Tegelaers and Nathalie Zonnenberg; Jan Vaessen and Ad de Jong; and David van Duuren and Susan Legêne. Their insight into museum practice is an enduring source of inspiration.

Photographs play an important part in this book and involve their own pathways onto its pages. My sincere thanks go to the many people who have helped in various ways to give this book its visual dimension: photographer Bert Nienhuis, Amsterdam; the directors of Teylers Foundation, and Martijn Zegel of Teylers Museum, Haarlem; Charlotte Huismann of Ateliers Jean Nouvel, Paris; and Cathy Wright,

Philip Grover and Chris Morton at the Pitt Rivers Museum, Oxford. Nuno Porto, in Coimbra, reminded me of the complex biographies of photographs, such as the one of the Dundo Museum, which he generously made available. Sharon Macdonald, Michael O'Hanlon and Tamar Katriel generously allowed me to reproduce photographs from their respective fieldwork. Grateful thanks to Jorge Freitas Branco, Manuela Cantinho and Carlos Ladeira, in Lisbon, for their timely help; and to Director Nuno Ferrand de Almeida and Curator Maria José Cunha of the Natural History Museum of the University of Oporto, for granting permission to reproduce the photograph of the Yimar headmask. Thanks are also due to Gregory August Raml and Alexander Ebrahimi-Navissi of the American Museum of Natural History for their assistance; to John van Geffen, of Tresoar; and to Jesper Kurt-Nielsen of the Etnografisk Samling, Copenhagen. I am very grateful to the Jewish Museum Berlin, and to Dr. Gerhard Stahr (head of the division of legal affairs), Michael Dorrmann and Christiane Rütz, in particular. I thank Asja Kaspers and Robert Knodt of Fotografische Sammlung, Museum Folkwang, Essen; and Annette Otterbach, Deutsches Dokumentationszentrum für Kunstgeschichte, Bildarchiv Foto Marburg for their assistance. I would like to express my gratitude to the carvers of the replica G'psgolox Pole, Henry Robertson, Patricia Robertson, Derek Wilson (now deceased) and Barry Wilson for granting permission to reproduce the photograph of their gift to the Etnografiska Museum, Stockholm. I thank Magnus Johansson and Etnografiska Museum, Stockholm; and Bill McLennan, curator, Pacific Northwest at MOA, Vancouver, for their help with this request. Simon Starling graciously allowed me to reproduce a photograph taken during his Drop Sculpture project at the Rijksmuseum (2008), and I thank Maja McLaughlin for facilitating this. The cover photograph, taken at the Van Abbemuseum in 2009, helped to shape my understanding of current museum dynamics; I thank Chantal Kleinmeulman of the Van Abbemuseum.

Parts of chapters have benefited from discussion in several venues, and I am grateful to Nicky Levell and Anthony Shelton in Vancouver; Helen Rees Leahy, Sharon Macdonald and Tony Bennett in Manchester; Ann Rigney and Chiara de Cesari in Utrecht; Saphinaz-Amal Naguib and Britta Brenna in Oslo; and the European Science Foundation 'Contact Zones Revisited' Conference in Linköping, and Jennifer Morgan in particular. Conversations that have taken place in various contexts with Jorge Freitas Branco, Nuno Porto, Nelia Dias, Mike O'Hanlon, Nick Thomas, Annie Coombes and Howard Morphy have inspired and sustained me.

This has been a slow book, and Berg commissioning editor, Anna Wright, has shown great patience and been truly supportive as delivery finally approached. Since then, Assistant Editor Sophie Hodgson at Berg oversaw image permissions with energy and tenacity. Tiffany Misko of Apex CoVantage guided the copyediting and

subsequent preproduction processes. It was a privilege to work with such professionals. Of course, I bear full responsibility for any remaining errors.

Visiting museums and heritage sites isn't everybody's cup of tea, and it was good to be reminded to look outside the walls of the museum these past few years. So thank you, H.J.M.R. de Haan in Delft, for your critical *tegengas* and eye for what eludes the museum. And thank you, H. J. de Haan in Wageningen, for joining my forays to look at this, or to photograph that, and for your irreplaceable help in seeing this book through to the end—on 11 September 2011. Remembering that day, ten years ago, and its aftermath, should be a spur to expand the basis of museums and cultural heritage—as one of the spaces where the mutual recognition and understanding of values can take place.

Wageningen, 11 September 2011

INTRODUCTION

The photograph on the cover of this book introduces a number of contemporary museum dynamics. The viewer is looking at an artwork on display at the Van Abbe Museum, Eindhoven, the Netherlands—part of the temporary exhibition 'Lissitzky +'.[1] The figure materializes a Proun of the *New Man* by the Russian artist El Lissitzky (1890–1941). A Proun is a design that is halfway between art and architecture. The New Man was a character in Malevich's Futurist opera, *Victory over the Sun*, which was performed in St. Petersburg (1913) and Vitebsk (1923). The opera inspired Lissitzky to make design sketches for electromechanical versions of the characters—including the New Man. The Van Abbe Museum's *New Man* is twice framed: by the museum window and by the view of the outside world that it encloses. We see the sky, with its sunlit clouds, and a puff of smoke issuing from the top of the gleaming white museum building in the foreground, and the security camera mounted on an upper corner of that same building, which houses a stylish public restaurant. Artworks alternating or combined with views outside, upmarket public facilities and security cameras are standard ingredients of many museums today. The Van Abbe Museum integrates the new, large-scale complex by architect Abel Cahen (2009) with the renovated 1936 building by architect Alexander Kropholler. All these aspects express different kinds of values essential to museums as public cultural institutions today: the value of creativity and innovation, in making collections new and accessible for contemporary publics; the value of renovation, bringing historical buildings into the present and combining them with new architecture; the value of having a visible connection between the world outside and the cultural and economic values of the collections and premises within; and the security measures taken to protect these valuables. The renown of museums today depends on their ability to manage and articulate their collections and identities through a range of media.

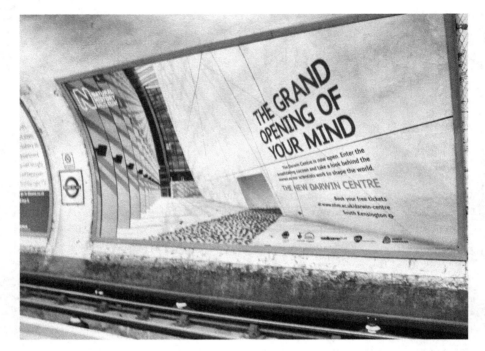

Figure i.1 Advertisement for the Natural History Museum on the London Underground, October 2009. (Photo: M.R. Bouquet)

FRAMING THE MUSEUM

This book is written for those venturing into the large and complex field of museum studies for the first time. It provides readers with an overview of some of the key areas of the field today, introducing them to the historical development of public museums from late-eighteenth-century Europe to their current diffusion worldwide. The book can be seen as creating a pathway through some of the most important developments in the literature and in museum practices, providing a framework for understanding and further exploration. Each chapter addresses a distinctive area of scholarship and museum realities, giving a fresh focus and perspective. Together, the chapters articulate historical developments, theoretical approaches and case material. Exercises at the end of each chapter encourage readers to experiment with the approaches and concepts discussed, using empirical cases at their disposal.

This broad approach, connecting theory with empirical case material, has been shaped by teaching museum studies in a liberal arts and sciences setting in Europe,

at the undergraduate level. The public museum has deep historical roots in Europe, where its value as a scholarly and didactic resource has gained increasing recognition since the 1980s. Museums often surprise students—whether they have a background in the humanities, the social sciences or the sciences—and intrigue them as they learn to see how these institutions occupy a crucial position in public culture. While many disciplinary fields are involved in museum studies, I argue that anthropology has a particular contribution to make. Participant observation, which is at the heart of ethnographic methodology, recognizes the centrality of visually based knowledge gained through long-term field research. Engagement with professional museum activities concerning collections, research, exhibitions and the public is a starting point for research and reflection. It is also a way of understanding the intersection between worlds of professional expertise and the general public. Visual and material dimensions of social life have become central to anthropological theories of culture in recent years. Studies of consumption have made once humble objects of everyday life become central actors in the negotiation of purpose, value and meaning that constitutes culture (Miller 1987) and have shown how meaning and distinction are produced through the world of goods (Douglas and Isherwood 1978). Studies of museums question how the displays of objects transform them into cultural valuables, illuminating the social and political processes taking place behind the scenes (Macdonald 2002). In these ways, anthropologists have been unpicking the taken-for-granted status of museums as authoritative leisure-time destinations, while simultaneously acknowledging the mobility and versatility of this institution worldwide (Stanley 2007). These are some of the ways that museums have become sites of anthropological research into public culture.

The focus of each chapter has been shaped by major scholarly contributions to museum studies: these include the historical ways in which collections mediate between visible and invisible worlds (Pomian 1990), the ways in which new orders of visibility attended the birth of the public museum and their connections to governance and citizenship (Bennett 1995). Another influential conceptualization of the museum is as a post-Enlightenment secular ritual site (Duncan 1995): a place where the nation can be imagined (cf. B. Anderson 1983) and narrated using collection pieces through architectural space. The physical movement of visitors through this scenario is what lends significance to each encounter with an artwork. Museums have also been seen as contact zones where people who were formerly spatially and politically separated through colonialism are brought together through historical collections in new and unpredictable ways (Clifford 1997). The contact zone was a forerunner of the relational museum project which created new knowledge about the collections and the networks they connect (Gosden and Larson 2007). Actor-network theory, whereby human and non-human actors exercise degrees of

agency in different social fields, has proven an inspiring way of understanding certain exhibition-making processes (Macdonald and Basu 2007) and, perhaps, the power of display in more general terms (Staniszewski 1998). These and many other studies drawn on in this book help us to understand the historical development and dynamics of collections, museums, exhibitions and the public.

My approach is equally formed by anthropological approaches to the study of culture: participant observation is the basis of modern ethnography and has been extended in distinctive ways through visual media such as film and photography (Banks 2001). The role of these media in creating anthropological knowledge that goes beyond the written word has been an important subject of theoretical reflection (Grimshaw 2001). The incorporation of material culture into the field of visual anthropology, as proposed by Banks and Morphy (1997), raises equally central questions about how museum displays shape culture. Museums as media produce more than coherent messages; they sometimes create magical, excessive effects (Henning 2006). Museum ethnographies pay particular attention to the visual and material qualities of objects and their effects in specific contexts of practice. Visual anthropological analyses of photographs and photographic practices draw attention to what falls beyond the frame, the material qualities of the image as an object and the way such materials are used in social life. There are parallels between this approach and the attention to the historical donations, exchanges, loans, uses and returns of museum objects and images, meshed into networks of human actors in multiple locations, in the museum context. Developments in museum studies and visual anthropology have formed the position taken in this book. I draw on a wide range of case studies through which to discuss issues, debates and interesting points.

CRITICAL MUSEUM STUDIES

Museums today are open, outward-looking institutions: they take pride in their spectacular architecture, state-of-the-art exhibitions, public-friendly facilities, collection research and social consciences. They project themselves through their websites, public advertisements and other media, thus positioning themselves in the world and for their potential audience(s). This highly visible public presence is both fascinating and problematic. Museum studies arose out of that fascination combined with a more critical desire to understand the historical development, dynamics and significance of this cultural institution in our world. How did museums achieve their current high profile? What kinds of dilemmas do they face? What kind of future lies ahead?

Museum studies developed as an area of multidisciplinary reflection on this institution and its key role in modernity. Scholars from many different

backgrounds—including historians, art historians, anthropologists and sociologists—became interested in the underlying dynamics of this area of public culture. Many academic disciplines had shifted from being based in the museum during the nineteenth century to being based in the university in the twentieth century. Although museums remained connected in significant ways to scholarly institutions, they tended to be seen as places connected with the *history* of different disciplines, and no longer places where cutting-edge research was taking place. This, however, changed as studies of museum and collection history, exhibitions and the public began to be published, drawing attention to critical, overarching questions about power, authority, governance and citizenship. Museum studies also developed out of museum practice itself: those practically engaged with collections, conservation, exhibitions, education and public communication had a professional stake in exchanging ideas and discussing good practice—especially through national and international museum associations. These exchanges also provided the foundations for reflection on common issues concerning (for example) collection management and use, as well as education. Museum studies can thus be seen as arising, at least initially, partly from the common language needed to analyse and discuss shared concerns among professionals. Training museum professionals—curators, educators and communicators—also requires a general understanding of the institution in order to contextualize particular tasks. The interaction between scholars located in both settings has contributed to the development of the field.

Critical museum studies (sometimes called 'new museum studies' or 'new museology') developed in the 1980s, coinciding with a steep rise in the number of museums and heritage sites and capturing the interest of scholars from many different backgrounds, as well as museum professionals themselves (see, for example, Vergo 1989). How was this new preoccupation with the past, and its increasing commercialization, to be explained? How was the state involved, and what role did museums—and control over collections—play in the reproduction of broader power relations and inequalities? Contestation and debate about exhibitions and heritage sites brought out deeply rooted disagreements among various groups about representational practices as well as moral issues concerning the ownership of cultural property. At the same time, discussion (and practice) focused on possible new roles museums could play in postcolonial and multicultural societies. Preoccupations about the accessibility of museums, about the knowledge and cultural competence required to feel at home there, converged with a more general questioning of established authority. Making collections interesting and accessible for the general public came to be seen as more than the exercise of curatorial authority: democratizing the museum was discussed in terms of empowering people—making them want to explore and find out about the collections in ways that built on their own knowledge. Science centres were at the fore in developing more

interactive forms of knowledge. Art museums have also experimented with ways of lowering their thresholds and reaching new audiences. The new public focus on the part of museums also rested on the commercial need to break even.

Ethnographic museums occupy a crucial position in the new museum studies— reflecting their position in the museum world. Studies of historical collections and the renewal of relations with the source communities from which those collections originated have helped to transform the significance of these once rather neglected institutions. The repatriation of human remains, sacred objects and photographic images has been intrinsic to this process of (re)discovery. Other (parts of) ethnographic collections have been reintegrated into national museums in the name of universal heritage. Contemporary artists play a vital role in bringing historical collections of all kinds into the present in new ways.

A VISUAL ANTHROPOLOGY

Many have remarked on the paradox of the visual in Europe and America (e.g. Banks and Morphy 1997; Grimshaw 2001; Pinney 2002a). As we are overwhelmed by images, including the thousands we ourselves routinely make, the casual way we approach them corresponds with a neglect of visual culture by mainstream anthropology for much of the twentieth century (e.g. Taylor 1998). In a similar vein, although our lives are inundated by mass-produced goods, they occupied a humble position in the study of culture (Miller 1987). Museums, by contrast, select what they choose to collect, preserve and display: they elevate collection pieces by making them visually or otherwise interesting. In spite of this difference, museum displays encouraged their own blind spots for the distinctiveness of this particular form of visual and material culture. The ethnographic potential of museums as fieldwork sites was, as part of the implicit background of middle-class academics, long obscured. However, the global expansion of museums and heritage sites towards the end of the twentieth century eventually gave them a place in ethnographic accounts. The development of anthropology at home had a similar effect: museums became visible as ethnographers saw their significance in terms of local identity and the desire to preserve local history.

The theoretical turnaround that took place during the 1980s was profound; visual culture, material culture and museums had been neglected in many areas of mainstream anthropology between 1920 and 1970. Although some anthropologists continued to collect objects for their institutional home museum and took photographs and recorded videos as part of their ethnographic data collection, these were rarely the main focus. This was to change in the 1980s when scholars began to deconstruct ethnographic texts in a critical effort to address issues of representation in the postcolonial context (Clifford and Marcus 1986; Clifford 1988). This linguistic turn was

followed by an attempt to grant images and objects priority, known as the pictorial turn (Pinney 2002a: 82). The development of discourses in all three areas brought with it an increasing amount of traffic between them: Banks and Morphy, for example, argued for including 'material products of culture and recordings of visible cultures within the same discourse' (1997: 17). Refocusing on the place of objects, images and museums was to change our understanding of colonial and postcolonial culture. Anthropological research is not limited to the study of ethnographic museums: ethnographers have written accounts of collection-making, exhibition-making and audiences in a variety of different museum settings (e.g. Macdonald 1998).

Learning to look at the external as well as the internal narratives of the photographic image brought to the fore the significance of the material form(s) framing its social life (e.g. Banks 2001). This analytical way of looking, which has been sharpened by comparative theoretical approaches to photography in anthropology, has impacted on ways of seeing the museum (Edwards and Hart 2004). Analysis of the significance of the various frames—architecture, installation, narrative—around what is displayed has underlined the importance of what remains invisible, and the ongoing processes of negotiation between them.

Scholarly work on the technologies and practices associated with photography has taught us to see things differently: whether looking through the lens, examining the frozen images we produce or using those same pictures for social purposes—there is general acknowledgement of the importance of their material form. Museums are closely connected with photographic practices: their displays focus our attention and lead our feet through the spaces where they organize objects, images and atmospheres in concentrated forms. They provide us with somewhere else to go, something to interact with, look at and talk about—rather like William Whyte's (1988) idea of triangulation. But museums go further than public art in Whyte's small urban spaces: they simultaneously remove us from and then reconnect us with the outside world. They perform similar operations with the collections that are in the process of being transmitted from generation to generation: while they separate and preserve these materials, they continually work at bringing them into the present and into our presence in consciously crafted ways. These ongoing, intergenerational processes transect the museum as a form of public culture.

These processes are present in the cover photograph—even if I was unaware of that at the time of making the photograph. This latent content surfaced through objectification and the new ways of looking it can engender. This excess or surfeit present in the photograph, discussed by Pinney and Peterson (2003), finds an echo in the museum. Beneath the surface of what is on display and the attempts at controlling meaning, there is a kind of volatility to museum collections and meanings—similar to that encoded by the photographic image. That leads to

surprises and discoveries that run counter to the anxieties of control associated with the 'exhibitionary complex', whereby nineteenth-century governments tried to foster new kinds of citizenship—opening up formerly hidden treasures and making them intelligible by ordering objects, spaces and visitors (Bennett 1995). These unintended effects of the museum—an 'other side' to its modernity (Henning 2006)—also indicate the cumulative and sometimes unknown dimensions of this collective form of public property which have recently been opened to investigation (e.g. Gosden and Larson 2007).

As visual anthropology has expanded its scope from an earlier—almost exclusive—association with ethnographic film and photography, it has come to include, via the materialities of these media, a range of visual and material culture: from art, landscape, technology, architecture and consumption to heritage—and, hence, museums and their particular ways of materializing culture. The transformations wrought by museums on the objects, images, texts and people brought within their frame raise questions about agency and structure, process and change, which make this institution so central to global cultural dynamics (cf. Sansi 2007). Through its windows we look at and interact with things that are valued through the distinctive ways they are brought into the present. And we look again at the world, with their presence in mind.

AIMS AND OVERVIEW

Taking a cue from the highly visible contemporary institution, the first chapter explores the emergence of the public museum and early forms of visual culture associated with it—using the case of Teylers Museum. Since this Enlightenment museum also exists in the present, a contrast is established between current forms of visibility, such as websites, and the distinctive experiential qualities of the museum's historical site and its donor. One argument is that since we access and experience even the earliest public museum by means of virtual and actual sites, we need to take both into account. A second argument is that the museum site itself is subject to an ongoing negotiation of the boundary between its front- and backstage areas. What were the distinctive qualities of visual culture in the first public museums (in the eighteenth century), and what is the role of new media in presenting such historical museums today? What is the museum effect that is created through the website, and how does this relate to what is encountered on a site visit?

The rise of national museums and their specific visibility in terms of architecture, as well as highly visible masterpieces, is the subject of the second chapter—using the cases of the Louvre and the Rijksmuseum. How were national museums constituted,

and how are they reinventing themselves as national monuments and as tourist destinations? One thread of the story is that such institutions made the nation visible and tangible in unprecedented ways during the nineteenth century. The second thread is that national museums today are extending and reinventing themselves—both by establishing branch museums bearing their name elsewhere and by undergoing major renovations that transform their buildings, exhibitions and public facilities at home. The creation of visible national culture remains one of the central tasks of such museums and stretches them both internally (the Rijksmuseum's mega-renovation) and externally (the Louvre Abu Dhabi).

Ethnographic collections occupy a central place in this book. How did ethnographic museums come into existence in the nineteenth century, and what was their role in creating visible difference among metropolitan and colonized populations? The third chapter examines how ethnographic collections and museums came to occupy a distinctive position within the exhibitionary complex, and how earlier collections were incorporated into and displayed in new public ethnographic museums according to various museological and classificatory principles. New ethnographic materials were collected in great quantities during the colonial period, delighting the general public at world exhibitions and augmenting the collections of the ethnographic museums that were sometimes established in their wake. Ethnographic museums have undergone and are undergoing transformation in the aftermath of colonialism. Cases from Europe (Leiden, Copenhagen and the Pitt Rivers Museum, Oxford) and Africa (the Dundo Museum, Angola) are discussed.

The fourth chapter shifts the focus from ethnographic museums to ethnographic approaches which have been used to study museums across the spectrum since the mid-1980s. How have anthropologists studied collecting, exhibition-making and guided tours for the public in museums of all kinds? What insights does participant observation offer on these activities? The chapter examines how anthropologists go about studying the social processes of collecting (Highland New Guinea and the Museum of Mankind, London), exhibition-making (Science Museum, London) and guided tours (settler museums, Israel). What kind of knowledge and insight are gained through participant observation—the cornerstone of ethnographic fieldwork? What are the visual and material effects of objects as they are transformed through display, and why is that significant? The work of three anthropologists provides new understandings of the social relations of collections and exhibitions.

How have practices of displaying objects changed through time? The fifth chapter looks at the historical dynamics of display practices as a significant part of public culture. What changes have taken place in professional practices of object display since the nineteenth century? How do museums generate new areas of visual interest? Changing ideas about how to display ethnographic collections—as scientific

specimens or as art—anticipate and reflect one of the major twentieth-century de-
bates on the relationship between what was called 'primitive' art and modern art.
Another significant development has been the expansion of what is deemed fit to be
seen by the public: previously hidden museum activities or subjects are being put on
display. The concepts of objectification, modernism and renovation are used to ana-
lyse the underlying processes of cultural production. European, American, Australian
and Brazilian cases are discussed.

Museums were once thought of as sites for ever-increasing collections: objects
were acquired and at most reshuffled to another institution. Why are certain mu-
seum objects being returned to the descendants of their original owners? What are
the challenges and the opportunities of repatriation for museums? The idea that
museum collection pieces might have more rightful owners to whom they should be
returned became a significant trend after the Second World War, with decoloniza-
tion and reassertion of the value of indigenous and minority cultures. Negotiation
processes around collection items that have been reclaimed by their legal or moral
owners have given museums the opportunity to rethink their position and respon-
sibilities. Chapter 6 examines the repatriation of human remains of identifiable per-
sons, distinguishing these from the more problematic condition of unidentifiable
remains. The processes (indeed, the very possibility) of museums returning cultural
property, such as sacred objects, to indigenous (or first) peoples have brought about
a new constellation of relations. Claims of various sorts on museums by First Peoples
are transforming institutional practices—such as the keeping, access and occasional
use of collection items—as well as calling into question former assumptions about
displaying objects. Photographic collections dating from colonial times are also in-
volved in what is termed 'visual repatriation': reconnecting the descendants of people
who were often the anonymous subjects of colonial photographic practices with
historical images facilitates local appropriations and uses.

These new, collaborative developments in the use and relational purpose of his-
torical collections are of central importance for the practice of contemporary anthro-
pology. The visual and material dimensions of museum buildings, collections and
exhibitions are, as Culture writ large, subject to constant processes of redefinition
and renegotiation. An anthropological approach to museums is of necessity a visual
anthropology: it starts out by taking seriously the prominence given to visual and
material culture by this public institution, and it explores the social and cultural
processes underlying its production, consumption and contestation.

1 MUSEUMS IN THE TWENTY-FIRST CENTURY

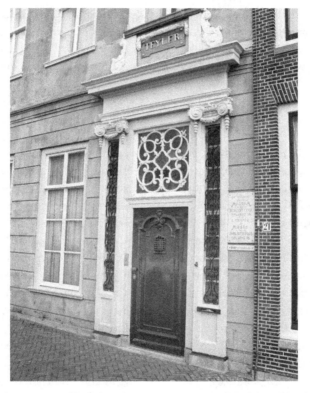

Figure 1.1 The front door to Teyler's eighteenth-century dwelling house, Haarlem, the Netherlands, with the sign directing visitors to the museum and library entrance around the corner. (Photo: M.R. Bouquet)

As I was standing upstairs on the balcony of the magnificent eighteenth-century Oval Room of Teylers Museum in Haarlem, looking down at the specially made scientific instruments, specimens and models together with Pieter Teyler's portrait, the scene was suddenly interrupted. A metal trolley issued from the wooden doors marked 'No Entry' ('Verboden Toegang'), and, for a second, there was a glimpse into the carpeted space beyond. The trolley was soon whisked away and the doors closed firmly after it—leaving behind only a faint savoury whiff soon lost in the unruffled air (Fieldnotes, 2008). Such moments crystallize the fascination of museums as they negotiate the boundaries between the public spaces they inherit or create and the invisible areas behind the scenes where the production and reproduction of the institution take place. The appearance and disappearance of the modern trolley in the heart of an eighteenth-century space was something like Roland Barthes's notion of the photographic punctum: it was a moment that somehow crystallized the contemporary institution.

INTRODUCTION

What sort of institution is the museum today, and how does it deal with its past, both its institutional past and that of its collections? Although museums appear to be historical, they are one of the key institutions of modernity. Museums have been transformed, over the past 250 years, from their beginnings as revolutionary new public spaces, often housed in purpose-built buildings, where formerly private (or restricted-access) collections were made accessible to the public. These collections expanded in the name of that public, and museums have undergone subsequent transformations into their present complex forms. Grasping what we see in museums requires a sense of how they deal with that past in the present. The transfer of treasures from the private to the public domain has been described as 'one of the most potent acts of the Enlightenment' (Sloan 2003: 13), referring to the foundation of the British Museum in 1753. The opening up of the Louvre Palace in 1793 was one of the first acts of the French revolutionary government (Duncan 1995). This key moment of change is also part of the history of much smaller-scale institutions, such as Teylers Museum, which opened in 1784.

This chapter introduces several aspects of visual culture that are significant in museums today. The relationship between museum websites and the museums they present is one of these: what is at stake for historical institutions when they move into virtual reality? Teylers, the oldest public museum in the Netherlands, creates a new version of itself through its website. More than two centuries ago, an equally decisive shift took place when formerly private or restricted-access collections moved into (or were specially assembled for) public museums. The creation of this new kind of space together with its furniture of display required very substantial economic resources for its realization.

The vision and the will that established such public cultural property depended for its future on the way it was taken up by subsequent generations. The sharing of knowledge through collection, demonstration and display also came to incorporate a commemorative dimension—making the donor visible. The extension of museum space into the virtual realm complements other areas and activities that museums bring into public visibility. The ongoing negotiation of the boundary between visible and invisible areas of museum premises and collections also shapes their public identities. These key issues are broached in this first chapter through the case of Teylers Museum, Haarlem.

SITES AND WEBSITES: TEYLERS MUSEUM

Teylers Museum bears the name of the wealthy (and childless) Haarlem textile merchant Pieter Teyler van Hulst (1702–1778). Teyler drew up his will in 1756, leaving his estate in the hands of a foundation with instructions to further religion, encourage the arts and sciences and promote public welfare. This was to be done by means of two societies—the Theological and Second Societies—the first devoted to the discussion of religious topics and the second to the natural sciences, poetry, history, drawing and numismatics. Money was also set aside for expanding the almshouses, Teylers Hofje, which had been built on a site nearby. The societies were to meet in Teyler's house each week and could make use of his library and collections; essay competitions were also to be held (Levere 1973). After Teyler's death, the foundation's directors interpreted the will in their own way: it was decided to found a public museum, the building of which began in 1779. When Martinus van Marum was appointed director of the museum, he successfully established a leading cabinet of natural philosophy, which was used for public lectures and demonstrations, as well as for conducting his own research into electricity and the chemistry of combustion. He ordered an impressive collection of specially made scientific instruments and apparatus, including the spectacular great electricity machine (purchased in 1791) and Leyden battery jars for storing electricity. The world's biggest and most powerful electrostatic generator brought fame to both Teylers Museum and Van Marum. Van Marum's excellent connections in the French scientific world helped to shield the museum from ransacking during the Napoleonic occupation of the Netherlands.

Teylers Museum corresponds with what Krzysztof Pomian terms an 'evergetic' museum: a city benefactor's collection turned over to public use (Pomian 1990: 264). The museum gradually expanded from its eighteenth-century core, the Oval Room, designed by architect Leendert Viervant (completed in 1784; also called the Book and Art Room, or Boek en Konst-Zael), with the Prints and Drawings Room added in 1824 and the first Paintings Gallery in 1838. The Fossil and Instrument Rooms were

added in 1878, and a second Paintings Gallery in 1893. Teylers added a new wing in 1996, and the Multimedia Centre and shop in 2002. The museum website is its most significant virtual extension, redone in 2009, adding to the museum's visual and material complexity. We first look at how the website presents the museum and then consider how that virtual representation compares with 'being there'. A visual analysis of why and how Teyler is present in the museum leads to a discussion of the complex exchanges involved in donation, representation and commemoration. Despite its reputation as some kind of time capsule, Teylers Museum exemplifies the actualization process with which all museums engage: the constant updating of, and additions to, the buildings, the collections and the other facilities. The tension between some apparently static ('historical') features and continually changing contextualization creates a contemporary 'museum effect': creating new objects of visual interest (Alpers 1991: 25). Part of that effect is created by the off-site, virtual representation of the museum.

WWW.TEYLERSMUSEUM.NL

Contemplate a visit to any museum today, and chances are that you will first visit its website.[1] The website can be accessed in advance of a real visit, or retrospectively, or it can be consulted without ever setting foot in the place. Museums, as public institutions that depend on visitor numbers to legitimize their existence, actively use their websites to advertise themselves as attractive, modern destinations. The aesthetic form of the website is a clear attempt by the museum to configure its simultaneous historicity and modernity as compelling characteristics: it is a work of art in its own right (cf. Miller 2001: 148).

The Teylers Museum website underwent radical re-imaging around 2009; it now shows 'moving-slice' views as 'banners' for its main divisions: 'Home' (balcony-level view of the Oval Room), 'Museum' (Instrument Room with the great electricity machine), 'Visit' (houses reflected in the canal waters), 'Collections' (Paintings Gallery I), 'Exhibitions' (Michelangelo), 'Education' (teenagers at computers in the Multimedia Centre), 'Activities' (children being shown one of the rare books in the Library), 'Shop' (brightly coloured, polished minerals) and 'Contact' (a young man with his ear to one of the parabolic focal point mirrors in the Oval Room). The information provided in Dutch is far more extensive than what is available in English. One of the 'trap'-like features of the website is a free audio tour of the museum, which can be downloaded via another website, http://www.artcast.nl, and brought to the museum by the visitor.[2] Information provided in this way, without accompanying *images*, may be experienced as a kind of visual deprivation or as a positive spur to visit the museum—depending on how you look at it.

The portal to the previous website was less alluring: a stylishly blurry black-and-white image of the upper part of the nineteenth-century façade, with a greenish tint

and yellow lettering. The right-hand heading on that site was 'Summary': an English-language illustrated guide to the museum, in which short texts combined with some thirty photographs led the viewer from the monumental façade, via a portrait of Teyler, to the inner core of the eighteenth-century museum—the Oval Room, and then to the Fossil Rooms I and II, the Instrument Room, the Paintings Galleries I and II, the Coin and Medal Room, the Library, the new Exhibition Gallery and the cafeteria, shop, educational pavilion and digital reading table. The summary presented many different facets of the museum, from historical architectural high points (Viervant's Oval Room) to famous collection items, such as Cuthbertson's great electricity machine and Rembrandt's pen-and-ink drawing *Return of the Prodigal Son.* The new extension facilities are also included in the 'Summary'—the Exhibition Gallery (for temporary exhibitions), Book Cabinet, Pavilion for Educational Projects and cafe designed by architect Hubert Jan Henket. As the author notes, 'These important additions mean that the old museum can be restored to its full glory: a uniquely authentic presentation of varied collections in monumental buildings of eighteenth and nineteenth-century date'.[3]

The preservation of historical collections and monumental buildings depends on, and indeed goes hand in hand with, technologically advanced modernity at various levels. One compelling way of being modern is through the selection, organization, conservation, investigation and demonstration of the past by means of collection pieces, and by their actualization for contemporary audiences—the public. The website is an exercise in selecting and summarizing, in (audio)visual and textual styling, creating a new artefact based on existing or newly commissioned materials. The redone website allows the museum to present its historical otherness as a sophisticated treasure house, with an extensive, well-organized and stylish mine of information. In contrast with the previous website, which looked very advanced but had a rather difficult presentational form, Teylers Museum's current website looks simple and welcoming.

The website epitomizes current ideas about information, accessibility and customer service in public institutions; it also permits the museum to preserve its unfamiliar material form. The Instrument Room illustrates this point: the website has the space to present the instrument collection in clear ways, using different approaches to capture the (potential) visitor's attention. A short film has the doors swing open to reveal curious pieces of scientific apparatus like stars in a thrilling drama.[4] Our eyes are directed to the turning wheel of the great electricity machine, following its brass rods to the Leyden battery jars, then panning over the naturally lit surroundings of tall instrument cases. The camera then zooms in on two of the many acoustic instruments: Herman von Helmholtz's resonator bank (1865) and Rudolf Koenig's sound analyser (1880). While our eyes are obviously being directed to these two remarkable-looking brass objects, the point that there are dozens of equally fascinating treasures in this room is well made. Clicking on one of the thumbnail images

of some fifty instruments produces an individual description and an enlarged three-dimensional image which can be rotated by the viewer.

Teylers Museum's website provides one succinct answer to the question of what museums produce or constitute in the contemporary world. Knowledge (or at least information) about Teylers can be transmitted in an organized form via the website, publications, photography and film. *Experiencing* Teylers—the building, its form and dimensions, the quality of its light, the materiality of collection objects, the ways these are integrated into cases, the disposition of collections in various rooms, the visitor's perceptions and experiences of those spaces when moving through them and engaging with their contents—cannot be transmitted virtually.[5] Interacting with Teylers, in the sense of walking through it, looking, listening, smelling, talking to staff or companions, climbing the stairs, drinking a cup of coffee in the new cafeteria, using the restrooms or purchasing a polished stone from the shop, is

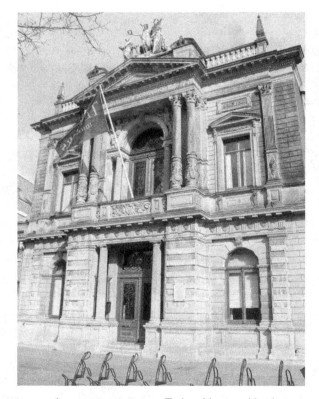

Figure 1.2 The nineteenth-century entrance to Teylers Museum, Haarlem.
(Photo: M.R. Bouquet)

beyond the computer interface. Yet *both* these forms and their respective possibilities for engagement constitute museums today.

How can we approach the current museum configuration? One way of exploring these distinctive but complementary dimensions is by first visiting the website, reading about and looking at the museum in this specific visual and material form, and then visiting the museum as a physical location and listing the differences.[6] Next we need to specify what a site visit adds to visiting the website.

First, the journey to the museum situates it in its local context in a way no website can. Arrival by public transport, for example, means walking from the railway station through the city of Haarlem to the museum, located on the far side of the Market Square. The museum is on the Spaarne canal, beyond the Great Church on the Market Square, and Teyler's almshouses (*hofje*) are a short walk away in the opposite direction.[7] The late-nineteenth-century neoclassical façade, built to commemorate the 100th anniversary of Teylers (1878), has Victory personified on top of the building, crowning the figures of Science (left, with book) and Art (right, with palette); below them are the trumpets of Fame. It is easy to miss the original entrance to the newly opened museum, which was the much more modest front door to Teyler's dwelling: the doorway blends in with the other houses in the street (see Figure 1.1). The bombastic façade belongs to a different museum age.

There is a sense of entering another world when one pushes open the heavy doors and crosses the threshold of the nineteenth-century building. The reception desk, located in the rotunda hall, is bathed in light filtering down from above; the axis of the building veers slightly to the left, from the hall into the Fossil and Instrument Rooms. All museum architecture, contemporary and historical, contextualizes both the collection and the visitor's experience of moving through it. Immersion in what might be termed the aura of the place plays a large role in the museum experience. The website visitor, by contrast, lands with the moving-slice image of the Oval Room: at the heart of the eighteenth-century museum.

The untidiness of arriving in the real museum contrasts with the seamless landing in the virtual Oval Room. This untidiness is an inevitable result, as we shall see, of the way the building has evolved. The golden orbs of the great electricity machine, shining in the depths of the museum, catch the eye and draw it in. In practice, however, some visits begin in the well-stocked and brightly lit shop, next to the chic restrooms. This is not the official order of the *Compact Guide to Teylers Museum*, which follows the order of the rooms: from Fossil Rooms I and II, to the Instrument Room, via two cabinets, to the Oval Room; and from there to the Prints and Drawings Room, Coin and Medal Room and the two galleries of paintings. Even an informed decision to head straight for the Oval Room may be diverted by curious things encountered

on the way there: Eisenblüte crystals in a bell jar or the Luminescence Room. In whichever sequence the museum is visited, it always exceeds an orderly excursion to an Enlightenment world, where art and science neatly combine, filtered through the disciplinary knowledge of nineteenth-century science that encapsulates it.

It is in the eighteenth-century heart of the museum that the division between publicly accessible visible areas and inaccessible invisible ones becomes apparent. The Oval Room was designed by architect Viervant to house the entire collection: the physics instruments in wall cases and the minerals and fossils in the central display cabinet; portfolios with art on paper were stored in cupboards beneath. The upper gallery was reserved for part of the Library. The portrait of Teyler hangs between a staircase marked 'Library: entry by appointment' (leading to the Library upstairs) and a door that leads to Teyler's dwelling house (marked 'No Entry'). The dwelling thus falls entirely beyond the public domain of the museum.[8] Although Teyler's dwelling is usually closed to the public, in 2006 (the 250th anniversary of the making of Teyler's will) it was opened to guided public groups.

Teyler's portrait is flanked by two pyramid-shaped display cabinets, dating from 1803, which were designed by Johan Gottfried Fremming in 1802 to house polished and unpolished stones (Janse 2011: 38). The portrait hangs, somewhat celestially, above a model of Mont Blanc encased in glass. Practices of isolating, protecting and enhancing the appearance of the object are shared across various institutions, including museums, and contribute to generalizing practices of visual and material culture (see Chapter 5). The ways of displaying specimens relate to the display of goods for sale.[9] As one moves from the eighteenth-century Oval Room to the rooms added later, there are clearly different historical styles of display: from encyclopaedic to disciplinary to thematic.

Finally, Teylers Museum resonates with the eighteenth-century Enlightenment ideal of the public museum, which the Encyclopaedists associated with the Library in Alexandria, intended to contribute in a general way to public welfare. The presence of a portrait of the benefactor in a museum that was constructed after his death produces some paradoxical effects for the contemporary visitor. Naming the museum after Teyler suggests it was his creation. However, it was built after his death, and most of the collection was acquired posthumously by the directors of the foundation established by his will.

This preliminary viewing of a website and a museum shows the complex, multilayered character of the institution: partly open to the public, partly inaccessible. While websites render certain facets of museums accessible, other dimensions evade virtual reality: the irreducible sense of being there and the untidiness of that experience. The sense of entering another world and the variety of paths that can be taken through it are also distinct from the routes and tours organized by the museum.

People's paths through the museum may resemble website use at the abstract level of choice yet differ through the embodied component of that experience. The encounter with objects in the museum includes their frames (or showcases) as well as the ensembles in which they are displayed, which are frequently cropped away in images and on websites. Also missing from a virtual visit are the other visitors and the staff members encountered during a real visit. The distinction between public and private zones within museums, which connect with visible and invisible areas and activities, is likewise absent from the virtual representation. The presence of the founder or donor of a museum on a website is quite different to that on-site: Teyler's portrait in the Oval Room marks the boundary where the public museum grew out of his private house.

Many questions arise from this preliminary exploration. What kind of a visual system is this first public museum? How is the benefactor's presence felt in the museum today? What does the enduring presence of a name, or a portrait, associated with a public institution mean today? What does a visually informed analysis of Teyler's portrait, installed between the two pyramidal showcases in the Oval Room, reveal about the transition from individually owned, private collections to institutionally organized, public museums?

FROM PRIVATE COLLECTION TO PUBLIC MUSEUM

The opening of Teylers Museum (in 1784) may be understood as one of a broader range of such developments. Philosopher and historian Krzysztof Pomian (1990) distinguishes four patterns in the formation of public museums: the traditional sanctuary, the revolutionary museum, the evergetic museum and the commercial museum. The traditional sanctuary, with its storeroom, treasure house, relics and emblems of power, was found in churches during the medieval period. The treasure of St. Marks, Venice, was displayed five times annually, as well as being opened for visiting dignitaries. The revolutionary museum was founded by decree and absorbed works from diverse sources; the classic example is the Louvre, which opened in 1793. The evergetic pattern refers to 'private collections left to their founders' home towns, to the state or else to an educational or religious institution, so that the public may have access to them' (Pomian 1990: 264). Pomian discusses sixteenth-century (and later) Venetian examples, as well as the Ashmolean Museum, Oxford, founded in the second half of the seventeenth century. Teylers Museum, which owes its existence to a city benefactor, follows the evergetic model. The evergetic pattern may be distinguished from the fourth, commercial model, exemplified in the founding of the British Museum through the purchase of Sir Hans Sloane's collection.

Pomian notes that there are always gifts to every type of museum and that there are many overlaps between the various models. The typology does, however, permit us to relate museum history to general history. The benefaction and power demonstrated through the making of wills are connected with the development of citizenship. Pomian asserts that the greater the involvement of individuals in the affairs of state, the greater their propensity to place their possessions at the disposal of the community (1990: 267).

When Teyler drew up his will in 1756, there was already a famous precedent in the will of Sir Hans Sloane, the British physician and collector, dating from 1749. Sloane wanted to keep his collection together in the interests of expanding knowledge of the works of nature. Sloane's collection was offered to the nation on his death in 1753 for the sum of £20,000, although it was valued at £100,000. A national lottery was organized and the proceeds used to purchase the collection as well as Montagu House to house it and several other collections. Kim Sloan refers to the museum that opened in 1759 as a 'virtual encyclopaedia of the eighteenth-century state of knowledge of the world' and a 'portal on the Enlightenment' (2003: 14). Sloane was a prominent member of the Royal Society, presenting and publishing papers and discussing new ideas. Although Sloane's primary interest was in botany, his acquisition of ethnographic artefacts alongside botanical specimens was typical of Enlightenment collecting and the encyclopaedic orientation of knowledge. Together with fellow Royal Society member, explorer and scholar Sir Joseph Banks, Sloane made an important contribution to both trade in and knowledge about other cultures: 2,000 of the objects in Sloane's collection that formed the basis of the British Museum were ethnographica—then classified as 'misceallanies' (King 2003: 234).

The ambitions of the wealthy and childless textile manufacturer Teyler were more locally focused and more evergetic when compared with Sloane. In leaving his fortune to a foundation and two societies, Teyler envisioned his collections (consisting of his library, drawings, coins and natural history specimens) as study material for members of the respective societies, meeting in his house and taking part in essay competitions. As a committed Baptist, Teyler also made provision for the poor and needy of Haarlem. On Teyler's death in 1778, the executors (directors) of his will and members of the two societies decided to establish a museum rather than a strictly scientific institution with study collections (Sliggers 2006: 17). Levere argues that the directors interpreted Teyler's will in their own interests insofar as the collection initially entailed an elaboration of the scientific instruments at the expense of the art collection (1973: 41). Work on the building started in 1779 and continued despite political unrest and tensions in Holland: the late 1770s saw the closing down of factories in Haarlem, civil poverty and conflict between the House of Orange and self-styled Patriots.

Before 1800 there was only one other public collection in the Netherlands, also in Haarlem: the Naturalia Cabinet of the Dutch Academy of Sciences (Naturaliënkabinet der Hollandsche Maatschappij der Wetenschappen), which was founded in 1759 and opened in 1772. Martinus van Marum (1750–1837) was involved with both institutions in the capacities of director, keeper or curator for more than half a century. Van Marum was elected to replace one of the directors of Teyler's Foundation and used his influence to steer a course for natural philosophy (Levere 1973: 41). Van Marum's encyclopaedic knowledge enabled him to establish paleontological, mineralogical and natural historical collections whilst conducting path-breaking empirical research in several fields of physics and chemistry at Teylers Museum. His knowledge of botany was also considerable. Van Marum's fame extended overseas, resulting in membership of learned associations as well as a network of international colleagues with whom he corresponded. He was influential in scientific practice from about 1780 to 1830 (Sliggers 2002: 8).

Only when the Oval Room was nearing completion did the design of display and storage cases bring the directors to the question of the collection. Van Marum's plan was to acquire large, costly scientific equipment for the collection that was beyond the means of private individuals. He successfully made the case that collecting models of useful machines and acquiring demonstration apparatus was entirely in line with the founder's wishes. The guiding principle was that once the collections were large enough, they should be used for public lectures in experimental natural philosophy. Considering that the natural sciences formed only a small part of the Theological and Second Societies, Van Marum's demands were quite excessive. He wanted to set up 'a scientific centre of unprecedented scope, a cabinet of natural philosophy which could be used as a teaching and research resource and a cradle of national technology' (Levere 1973: 42). The directors conceded to Van Marum's wishes.

The first acquisition was the great electricity machine, completed by Cuthbertson in 1784, which indeed contributed to the fame of both Van Marum and Teylers Museum. By building a machine bigger than any previous one, it was argued, new discoveries could be made in the realm of experimental physics. These new discoveries would, however, require additional measuring instruments: for chemical research using electricity, studying the effects of electricity on magnetism, and using electrical discharges for physiological investigations.

Julia Noordegraaf begins her book *Strategies of Display* with the argument that Teylers Museum instantiates an important transition in visual culture around 1800 (2004: 10). She discusses the adaptation in 1802 of the upper surface of the large central piece of furniture in the Oval Room, from its initial use for demonstrating scientific instruments and consulting prints and drawings to the installation of glass display cases for fossils, minerals and ores. According to Noordegraaf, '[t]he

emergence of the modern museum in the early nineteenth-century should be understood as part of a new visual regime in which the arrangement and display of objects functioned as a novel way of acquiring and disseminating knowledge' (ibid.). The connection she makes between the new forms of display that were introduced with the advent of arcades and department stores, which did away with the salesperson as an intermediary, has interesting implications with regard to visual culture in museums. One of these is that the display of fossils, ores and minerals on top of the former storage and demonstration table would also transform curatorial mediation of knowledge. While the adaptations to the central showcase certainly transform its former demonstration and consultation function, other changes were also taking place in the Oval Room which provide additional insight on visual culture.

The pyramidal cases appear in Wybrand Hendriks's painting (1800–1820), to be placed on the opposite side of the Oval Room from their current position, and there does not seem to be a portrait there. Two centuries later, these showcases flank the portrait of Teyler, installed on the boundary between the Foundation House and the posthumously built museum, exactly in the middle of the common wall between the two. This portrait of Teyler by H. J. Scholten is a partial copy of the painting by Hendriks, itself a copy of a—now missing—painting of Teyler by Frans Decker dating from 1787. Hendriks's painting of Teyler hangs in the Foundation House (in the Kleine Herenkamer) and is therefore invisible to the public. The monument to Teyler, designed by Viervant and Hendriks and made by Cornelius Asselberghs in 1795, located on the staircase leading to the Library, can be seen only upon ascending or descending the stairs. Since this staircase is not open to the public, most visitors miss the monument. So this specially made portrait has also become central to the Oval Room in a rather different way to Viervant's demonstration/display table. Teyler's portrait introduces a human presence to a room otherwise dominated by the equipment and specimens of the philosophical cabinet. It occupies a strategic place in the room: as if Teyler were looking out from his dwelling house across the contents of the Oval Room in the direction of the first extensions to the museum in 1820s and 1830s. He looks, in fact, into the Numismatic Cabinet—which houses part of his own collection.

EVERGETIC AND DONOR MUSEUMS

The visual representation of the donor—as *part of* the collection and institution created in his name—belongs to a much older tradition of memorializing great men and ancestors in painted or sculptural portraits. The early British Museum held three collections of painted, sculpted and engraved portraits commemorating

great men as well as its own personnel. Sir Hans Sloane's collection was intended to represent both universal history through portraits of philosophers, scientists, collectors and patrons and the local 'family history' of the British Museum itself (Dawson 2003: 27). Sloane's daughters presented the British Museum with a terracotta bust of their father in 1756, which was prominently displayed in Montagu House when the museum opened to the public in 1757. (The painting collection was later separated from the British Museum to form the National Gallery and National Portrait Gallery in the second half of the nineteenth century. In a similar move, the natural history collections left the British Museum for South Kensington at the same time.)

Art historian Carol Duncan (1995) analyses a number of donor memorial museums in the United States and Britain. Men and women with fortunes assemble collections, in later life, which stand as memorials to themselves; the American cases mainly concern turn-of-the-century tycoons. Donor memorials, according to Duncan, are comparable to state and municipal museums in the way they frame looking at art in terms of a ritual scenario. Duncan argues that although collections may vary—they may be encyclopaedic or specialized, historicist or modern—when they are attached to a former residence, visiting them is often structured as a ritual enactment of a visit to an idealized donor. Residence in a palace or mansion was supposed to consolidate an aristocratic identity for a wealthy person. Purchasing and hanging Great Masters in such a mansion was a means of associating oneself with nobility. At some point, collectors have to decide whether to give their collection to existing museums, as a donor wing, or to keep it separate as a distinctive individual donor memorial. Elite culture of the late nineteenth and early twentieth century honoured the Good Citizen: turning one's treasured possessions over to the community reflected those esteemed qualities of citizenship. At the same time, this move was also a way of ensuring immortality: one's name would live on as the collection and help to repair a public image where this had been damaged whilst amassing a fortune. Keeping collections from being absorbed connects with a notion of the collection as a surrogate self. Andrew Mellon, whose collection forms the core of the National Gallery in Washington, explicitly associated collecting art with the desire to connect his life with 'something eternal' (Duncan 1995: 83).

Duncan also discusses how the architecture of donor memorials often recalls tombs or mausolea, sepulchres and religious structures. She explains how, during the eighteenth and nineteenth centuries, Goethe and Hazlitt began to interpret art galleries as sacralized spaces for communing with artistic spirits of the past. The designation of the art collection as a personal or family memorial is, Duncan argues, peculiar to modern times. In ancient times, burial treasures were intended for the deceased in the next world. Now, burial treasures are gathered for the eyes of the living

(cf. Pomian 1990). With the increasing importance of family identity, there was, by the end of the eighteenth century, an emerging wish to remember the dead, and a need on the part of the dying to be remembered. New burial places, such as cemeteries and mausolea, were developed which, although secular, were nonetheless ritual sites. Within this secular trend, the art gallery became a logical place to remember the dead, even an acceptable alternative to conventional burial places: '[i]n a universe where death was being secularized and art was being sacralised, what better place to seek immortality . . . a space set aside from mundane concerns for the contemplation of timeless values?' (Duncan 1995: 84).

The mausoleum at Dulwich Picture Gallery was completed in 1817 by the architect Sir John Soane (1753–1837). Sarcophagi containing the remains of the donors—art dealer Noel Desenfans (1745–1807), his wife and their adopted son and heir, Sir Francis Bourgeois—are installed in the small rotunda and mausoleum in the centre of the gallery. Dim lighting, coloured glass and a liminal atmosphere for both tombs and paintings were thought to induce a state of poetic reverie suitable for commingling with the ancestral shades and for contemplating eternity. Soane's own house, in Lincoln's Inn Fields, London, also combined pictures, sepulchral objects and relics of past cultures, which were deemed to induce meditation on the passage of time and the cycle of life and death (Duncan 1995: 87). The warren-like space of Soane's house was donated to the nation by an Act of Parliament of 1833, whereby the collections were kept intact in a private house memorialized in situ as a museum (see Elsner 1994).

Later American donor memorials include the Frick Collection of Henry Frick (1849–1919), the coke millionaire and strike-breaker, who saw his New York mansion as his 'monument'. This auto-monument comprised European masterpieces incorporated into a modern, domestic setting. The presence of the 'lordly donor' can be felt throughout (Duncan 1995: 76–77). The Henry Huntingdon Library and Art Gallery, San Marino, commemorate the railroad giant Huntingdon (1850–1927) in a similar fashion. The art collection is supplemented by gardens, which evoke a lighter donor presence than the Frick Collection—with the possible exception of the portrait gallery of eighteenth-century 'British ancestors'. The Huntingdon mausoleum (1929), in the form of a circular temple in the gardens, is located at a discreet distance from the art collection.

The steel widow and heiress Isabella Stewart Gardner (1840–1924) had a Renaissance palace rebuilt in Boston. The theatrical and romantic assemblage, housed in a Venetian-style court, opened in 1902. Fenway Court became a public institution after her death, with furnishings and flower arrangements as specified in her will. These material practices allow the donor to continue imposing her will and her presence beyond the grave.

J. P. Getty (1892–1976), the oil tycoon, never saw his museum in California but supervised it from London: housed in a brand-new Roman villa in Los Angeles, the museum combines archaeology and the film industry with his art collection. The combination of a classical collection with fantasy antiquity and a modern museum creates a highly liminal space, reminiscent of an old Hollywood movie (Duncan 1995: 80). The notion that visitors perform a kind of script when they visit museums is not difficult to grasp in a stagey museum of this kind. Although many professional improvements were made to the museum after the donor's death, Getty is buried on-site.

The Robert Lehman Wing at the Metropolitan Museum of Art is housed in a glass pyramid structure dating from the 1970s. A subterranean construction with the pyramid above seems to contradict the possibility of real living space. The wing houses dimly lit period rooms, where time and life are suspended, so that Duncan compares a visit to the Robert Lehman Wing with a visit to the underworld (1995: 91).

The J. P. Morgan Pierpont Morgan Library in New York City (1902) contains three rooms that were furnished and used by Morgan himself: the entrance hall, the original library and Morgan's study. The personal objects and artworks on display are shown as objects once owned by Morgan (rather than art), so that the memory of Morgan is strongly present, resembling a Renaissance prince, able to command the world's treasure and also to monopolize its spiritual benefits (Duncan 1995: 95).

Although the National Gallery of Art in Washington, DC, does not have the donor's name attached, it owes its existence to Andrew Mellon (1855–1937). Mellon chose the architect, approved the design and selected the marble used for the building (Duncan 1995: 97). His presence in this 'dignified and solemn place' is therefore an implicit one. Mellon exemplifies the ideal citizen, having served as a high state official under three presidents. The impersonal authority exuded by the National Gallery, located as it is on the American national and ceremonial site of the Mall, conceals the fact that it could be built by a single man, who was able to 'dictate, pay for, and carry out the creation of so potent a symbol of the nation's spiritual and material wealth' (ibid: 101).

TEYLER'S PORTRAIT

Unlike most of the later nineteenth- and twentieth-century American and European donor memorials analysed by Duncan, Teylers Museum was the posthumous creation of the foundation Teyler endowed. His memorialization in that museum does, however, fit within the ritual scenario Duncan has elaborated for museums, drawing on anthropological theory as well as art history to do so. Through the transposition

of an image of the deceased benefactor into the midst of the collection made possible by his wealth, Teyler is made present. The portrayed looks at us from the invisible worlds of the past, from his former dwelling and also somehow from the two other portraits made of him, one invisible and the other lost.

Duncan has argued that museums are settings for rituals: marked off by their monumental architecture and set apart from their surroundings (sometimes by their entrance, sometimes by a garden or park), art museums are culturally designated and reserved for a special quality of attention, contemplation and learning. Removed from the day-to-day business of mundane life, the visitor enters a liminal or twilight zone, comparable to classic ritual structure where initiates encounter sacred arte-facts and erudite knowledge. They undergo a transformative experience of renewal by following the script or scenario laid out for them, contemplating artworks and communing with the artists and, in the case of donor museums, being exposed to the beneficial surroundings created by these good citizens. Duncan emphasizes the museum visit as a ritual of citizenship: a way of absorbing the cherished values—as well as the class distinctions—of the ruling elite, and perhaps learning one's place in the process.

There is much value in Duncan's approach to the museum as a ritual site, despite the limitations of her ideal visitor in terms of active engagement in and deviation from any script the museum might devise. Extending Duncan's ideas beyond the Western art gallery, we have argued that science museums, natural parks and other kinds of museums (such as a mission museum in Namibia) can also be fruitfully analysed as sites of ritual processes (Bouquet and Porto 2005). We suggested that contemporary museum visits might be considered liminoid (Turner 1977), in a way comparable to cinema or theatre visits, rather than classically liminal, and that such visits are mediated by a range of techniques comparable to Alfred Gell's (1992) 'tech-nology of enchantment'.

If we apply these insights to Teylers, does the presence of the benefactor's por-trait in the Oval Room make this, too, into a donor museum? Pomian has written about the exchanges between visible and invisible worlds, made through collec-tions, in terms of *semiophores*. When an object is removed from its original context of use and recontextualized as part of a collection, it acquires a new meaning; it becomes a semiophore, an object without use but endowed with meaning. The great electricity machine was made especially for Teylers Museum; removed from the Oval Room, fragmented and disconnected, it reminds us of a time when it was cutting-edge science. Teyler's portrait represents a person, painted in his time, but apparently able to see—his museum, his collection and the visitors—as he never could during his lifetime. 'Neither usefulness nor meaning can exist without an observer, as they merely characterise the links which groups and individuals have,

through objects, with their visible and invisible environment' (Pomian 1990: 30). Pomian explains that the formal features of an object enable it to either be useful or else bear meaning. While use and meaning may coexist, 'they imply two different and mutually exclusive types of behaviour. In the first case it is the hand which establishes the visible relationship between this object and other, visible, objects, which it hits, touches, rubs or cuts. In the second case it is the gaze, given a linguistic extension, either tacit or explicit, which establishes an invisible relationship between the object and the invisible element . . . [T]he semiophore reveals its meaning when it goes on display'. Pomian contends that a semiophore fulfils its ultimate purpose when it becomes part of a collection; that meaning and usefulness are mutually exclusive, as the more an object is charged with meaning, the less useful it is (ibid.).

The relationship between this portrait of the donor and his posthumous collection is a complex one since, through it, Teyler can 'see' the collection that bears his name, while the public can behold Teyler captured at his writing desk but simultaneously enjoying the view of 'his' collection and museum, which he never saw during his lifetime. At the same time, we see him as part of his collection: the interpretation of his will by others seems to be *his* will as he looks complacently from his frame.

The incorporation of Teyler's portrait in the Oval Room *alongside* the new ways of arranging and displaying objects thus involves more than the dissemination and acquisition of knowledge. In addition to the connection made by Noordegraaf between museum displays and the display of goods in shops and shop windows, the memorial function of the museum is an intrinsic part of its modernity. In the case of Teyler, this modernity is expressed in the way his image is quite literally brought forward and installed in the present. As the only portrait in an Oval Room that is otherwise filled with scientific apparatus that is as curiously decorative as it is evidently obsolete, Teyler's presence is both unavoidable and unsettling for the contemporary public. And this encounter with Teyler's modest shrine is the stronger for all that has gone before it: for having been drawn into the museum from its nineteenth-century entrance by the glimmer of the great electricity machine, through rooms filled with fossils and antiquated instruments.

This example from Teylers Museum shows how an ethnographic eye for context can be put to work in the visual analysis of museums, just as with any other site. Ethnographic analysis means attending to the context of the museum's setting, the sense of being there, routes through the museum, issues of visibility and invisibility, boundaries between private and public, and the complex interactions between personhood and possessions, to which Teyler's portrait led. It also implies being open to explore further whenever the opportunity arises.

VISITING TEYLER'S FOUNDATION HOUSE

Figure 1.3 A trolley emerges from the Foundation House into the Oval Room, May 2008. (Photo: M.R. Bouquet)

There was a rare opportunity, in 2006, to go behind Teyler's portrait and enter the invisible, inaccessible part of the museum: Teyler's former dwelling, now the Foundation House. The 250th anniversary of Teyler's will, drawn up in 1756, was an occasion for allowing the public to visit the adjoining Foundation House in small groups, accompanied by a guide. Assembling in front of the doorway to the left of Teyler's portrait, being welcomed by the guide, having the ('no entry') door opened and being led across the threshold into the large meeting room gave the visit a strongly ritualized character. This visit to what is now the Foundation House was, on this occasion, also a visit to the normally invisible world of Teyler's former house. The guided tour made clear the superimposition of the Foundation House on the founder's former dwelling, merging the two in a way that made Teyler doubly present, compressing his existences as dweller and as founder into a single space-time continuum.

To enter the Large Gentlemen's Room (Grote Herenkamer) from the Oval Room is to step back in the building's history. Yet this room is still in use for meetings by the directors and the two societies. So it is also present in a vital sense. A door from this room gives access to the inner courtyard. Another door opens into the long corridor that runs the length of the house, connecting the museum at the back to the front door of Teyler's house on the Damstraat. The corridor runs from the Large Gentlemen's Room along one side of the inner courtyard, on the other side of which is the Small Gentlemen's Room (Kleine Herenkamer), where a meal appeared to be in progress (at a roped-off table): the guide explained that red-letter biscuits are specially baked each year on Teyler's birthday, according to a secret recipe, at a local baker's; there was fruit, cheese and fortified wine on the table, which was laid with silver and china belonging to Teyler. Visitors caught glimpses of themselves in the hazy eighteenth-century mirror hanging above the mantelpiece. Here the societies

Figure 1.4 The directors of Teyler's Foundation, May 2006, in front of Wybrand Hendriks's group portrait of the directors of Teyler's Foundation in 1789. (Photo: Bert Nienhuis © Bert Nienhuis)

met and continue to meet and dine together in a kind of eternal ritual communion. The lighted candles in the group photograph of the directors in 2006, seated before the group portrait of the directors in 1789, capture this sense of corporate continuity. Two other rooms were open to the public: the kitchen and a room where the porcelain was kept. Retracing our steps back along the corridor, there was a strong sense of walking back to the present, with an entirely new perspective on the museum. This view of the museum corresponds with Teyler's 'view' from his portrait in the Oval Room. He looks out over 'his' collection as if from a window in the back wall of his former house. Leaving the eighteenth-century Oval Room, after visiting the Foundation House, and retracing one's steps through the nineteenth-century instrument and fossil rooms, to the entrance hall, was also taking leave of Teyler's presence.

The rare opportunity to enter Teyler's residence, combined with the special temporary exhibition 'Teyler's Fortune' ('De miljoenen van Teyler'), transformed any visit to the museum during the period in 2006 when this option was available into an explicit visit to the donor. If, as the website announces it may, this intermittent option of visiting the dwelling house becomes a permanent feature of the museum, then this will be an extension of the memorial function of the museum. This instance shows the ongoing redefinition of domains of the museum: private–public, individual–collective and visible–invisible.

CONCLUSION

The transition from private collections to public museums in the late eighteenth century was a complex process. Although the evergetic museum model suggests an individual donor, as in Teyler's case, it was the interpretation of Teyler's will by the foundation he endowed that led to the creation of a public museum added onto Teyler's private dwelling, and it was Van Marum's emphasis on collecting scientific instruments that gave the museum its distinctive character. The human network spanning the centuries in fact completes the collection. We cannot understand this collection without taking into account the foundation which, from behind the scenes, holds responsibility and makes decisions in Teyler's name. More generally, those behind the scenes of any museum formulate its policies, manage its collections and shape its various public services. Any contemporary museum's mission statement has to be able to provide a coherent account of its origins and architectural and collection histories in terms that make sense for the contemporary public.[10] This translation of the past into the present is the crux of the museum's modernity. As we have seen, a museum's website can play a crucial role in this process, shaping an attractive and accessible image, stimulating curiosity and providing a rich resource base.

The museum effect today extends, through the website, beyond the walls of the museum in ways that exceed photographic reproductions in publications (Malraux 1965). Websites are an integral part of many museums' technologies of enchantment: they allow us to see virtually what we cannot always see on-site. Even so, the experience of being on-site often exceeds the website in various ways, part of that excess residing in the multisensory untidiness of experience. Museum reality does, of course, comprise the website, but not the other way around. Pieter Teyler as evoked as the far-sighted benefactor on the website is a two-dimensional figure when compared with his presence in the Oval Room, looking out from his dwelling house into the public institution constructed in his name. The gradually shifting definitions on the part of the museum about what the public may properly *see*, where they may *tread* and with which *perspectives* they may leave the premises reflect the dynamism of this cultural institution.[11]

KEY CONCEPTS

Private collection
Public museum
Website vs. on-site
Museum effect

Evergetic museum
Donor museum
Visibility vs. invisibility

EXERCISES

The visual and material exploration of museums initiated in this chapter suggests a number of guidelines for analysing museums today. Select a museum which is named after someone (like Teylers Museum), which you have not visited before.

1. Assuming that it has a website, explore the museum website in advance of a visit: analyse the use of visual images (which key images are used, and how?). If images accompany the main headings of the site, analyse their qualities: do they show architectural features, the collection, the public, the shop or restaurant or what). Analyse the mission statement: what feature(s) of the museum is (are) emphasized? Why is the museum named after this person? How do they deal with their history? How do they bridge (or see themselves as bridging) the gap between that history and the contemporary public? What is the range and depth of information provided? Write down four points about the museum (this may be the architecture, collection, facilities) that the website makes you want to look at on-site.

2. Explore the museum on-site: arriving at the museum, what do you notice about the setting? How does this compare with the museum's virtual presentation of itself? What do you notice about going into the museum: the architecture, reception, security, cloakrooms, atmosphere? What kind of guidance does the museum offer: compact guides (paper), audio tours, labelling? Is the person after whom the museum is named 'present' in the museum? If so, how? Locate the features you selected from the website. As you make your way to these features, note the distractions and diversions en route. What catches your eye, or your imagination, on-site—and why? Which surprises do you encounter?
3. To what extent did the experience of being there correspond with or diverge from your expectations based on the website? Specify the overlaps and the divergences. How could you explain the discrepancies?

FURTHER READING

Alpers, S. (1991), 'The Museum as a Way of Seeing', in I. Karp and S. D. Lavine (eds), *Exhibiting Cultures. The Poetics and Politics of Museum Display*, Washington, DC: Smithsonian Institution Press, pp. 25–32.
Duncan, C. (1995), *Civilizing Rituals. Inside Public Art Museums*, London and New York: Routledge.
Pomian, K. (1990), *Collectors and Curiosities. Paris and Venice, 1500–1800*, Cambridge: Polity.
Sloan, K. with Burnett, A. (eds) (2003), *Enlightenment: Discovering the World in the Eighteenth-century*, Washington, DC: Smithsonian Books/British Museum.

2 STRETCHING THE NATIONAL MUSEUM

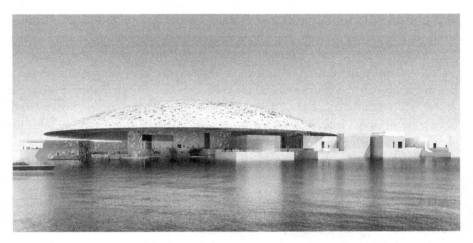

Figure 2.1 Jean Nouvel's rendering of the exterior for the Louvre Abu Dhabi. Reproduced with permission of Ateliers Jean Nouvel, Paris © Ateliers Jean Nouvel, Paris.

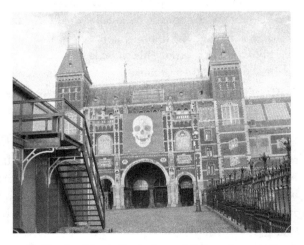

Figure 2.2 Banner with Damien Hirst's *For the Love of God* on the main façade of the Rijksmuseum, Amsterdam, late 2008. (Photo: M.R. Bouquet)

INTRODUCTION

Museums contributed to nation-building during the nineteenth century, the 'century of history', in particularly visible and tangible ways (Bazin 1967: 7). National museums and collections underwent an important reconfiguration in the twentieth century as newly independent nations hastened to present their international credentials in this form, and older nations began to rearrange their collections and their connections within the postcolonial world order. This chapter considers how national museums materialized the nation through their collections and buildings, and why that configuration is being stretched today in various directions—whether through overseas *dépendances*, such as the 'Desert Louvre' in Abu Dhabi, or through drastic internal renovation involving years of closure and an interim programme, such as the Rijksmuseum, Amsterdam. The nineteenth-century model of the national museum seems increasingly deficient in the face of collection mobility (travelling exhibits and loans), spectacular architecture (including those *dépendances*), contemporary artistic interventions in old collections and massive public mobility (international tourism). These dynamics suggest that the national museum today, as part of 'heritage', has been stretched beyond recognition, both internally and externally. This stretching is examined through two interconnected cases: the Louvre (Paris) and the Rijksmuseum (Amsterdam), past and present.

National collections differ significantly from evergetic or donor collections although they do share certain characteristics, as discussed in the previous chapter. Specific collections, together with the museums in which they were housed and the citizens (or 'public') they served, came to be identified with particular nation states in an international context. Smaller museums identified with a single founder, such as Pieter Teyler, are clearly the creations of nationally based social networks spanning the generations. Teyler is memorialized in a museum built after his death, through a largely posthumously formed collection; his name is kept alive by being attached to the museum, and his presence is summoned up through his centrally located portrait (see Chapter 1 and the Afterword). A nation state, in contrast to the memory of a singular, deceased person, refers to an abstract collectivity: a governmental and administrative polity with a large population whose social relations are no longer based on kinship but instead on contract. Nation states compensate for this relative anonymity through institutions that actively cultivate means to enable the population to imagine themselves as belonging to a community. Places of memory and monuments, along with museums, create objects and images of public culture: moulding language, territory and common history into concrete forms of official culture (cf. B. Anderson 1983).

A national collection provides tangible historical, artistic and scientific points of reference (Pomian 1990: 43), facilitating and promoting certain narratives, such as those about origins and heroes, while stifling others. Territorial expansion overseas was an integral part of nineteenth-century state ambitions and had a profound impact on museums and collections and the way other populations were envisaged. National museums housed their collections in rededicated or purpose-built buildings and displayed them in ways aimed at making them intelligible to the public (Duncan 1995). All this was done in the name of a population too large to know one another on a personal basis. The new museum buildings and the collections brought together in them helped to fashion a public realm, where people could be 'knowingly in each other's present' by sharing 'each other's past' (Fabian 1983: 92). This material and visual mediation of relations is common to both national and evergetic museums: the difference is one of scale.

The nineteenth-century emphasis on building collections and opening national museums shifted, in the second half of the twentieth century, for various reasons.[1] Collections had become so large that only a small proportion could be exhibited. The travelling exhibition became one of the ways for collection items to circulate, in addition to the practice of loaning works to museums elsewhere in the world for their own home-produced exhibitions. Although the monumental museum buildings of previous centuries had undergone successive modifications over the years, they were increasingly seen as being ill-equipped to display their collection and to receive the contemporary public—especially since they had become international tourist destinations. This new public was not self-regulating, nor could they be expected to identify with the treasures on display as members of an imagined national community. Hence, the visible and material transformations of displays, architecture and public provision in national museums constitute sensitive registers of the reformulation of public culture. The chapter examines how national patrimony was initially constructed and how it has been transformed in museological terms. How are national collections, buildings and the public activated today, and with what effect?

The controversy surrounding the Abu Dhabi outpost of the multisited Louvre today shows the model of the universal survey museum being pressed into service for quite novel purposes. Meanwhile, the interim strategies developed by the Rijksmuseum, Amsterdam, during its closure for renovation from 2003 on tried in some ways to get back to Cuypers's building of 1885, while maintaining a miniature exhibition of its masterpieces of Dutch art and history, as well as a contemporary art programme. These projects and controversies bear witness to the national museums' contribution to an internationally recognized form of visual and material culture, which includes websites, shops and *dépendances*—as well as the original sites (themselves now transformed).

National museums emerged in the late eighteenth century and are one of the characteristic institutions of modern, democratic nation states. The modern nation state, which arose concomitantly, was both an unfamiliar form of political and social organization and a rather abstract entity for many people. The often imposing architecture of these new institutions, which made them into urban landmarks in many capital cities, helped to create a visible, tangible presence and cultural identity for the nation state.

National museums could take various forms: one model was to transform an existing building, such as the former royal Louvre Palace and its collection; another model was to contract a purpose-built building, such as the Rijksmuseum, Amsterdam. Whether through the revolutionary transformation of an existing royal palace or the construction of an entirely new building, national museums were supposed to materialize the nation and contain its specific collection of treasures, recalling past origins and glory as a connecting link with the contemporary public. National museums received funding from the government, which gave it a direct stake in the institution. The advantage of such monuments for centralized governments, responsible for regulating large-scale populations and maintaining territorial boundaries, lay in the visible, publicly accessible nature of the institution. With the rights and duties of citizenship defined by law, rather than by the bonds of kinship, national museums were intended to foster a sense of pride and identification. This new form of social space and collective property personalized the nation by making its people visible to one another in the presence of a collection and in a building identified with common ancestors.

We look at Krzysztof Pomian's (1990) historical approach to collections as semiophores and consider how the Louvre, with its universal survey approach, and the Rijksmuseum, with its Dutch art and history focus and architectural specificity, made their nations visible. Tony Bennett's (1995) theorization of nineteenth-century museums as part of a larger exhibitionary complex already indicated an international dimension to the national focus. This insight is reinforced by Benedict Anderson's (1983) view that museums were one of the ways that imperial states imagined the territories beyond their own frontiers: bringing the world back home became a way of demonstrating the state's competence. This dynamic helps to explain how the public art museum achieved, in Carol Duncan's (1995) view, the status of a secular ritual site: the place where citizens could visit the national treasures laid out for them in a meaningful sequence.

Against this background, we examine come contemporary forms of internationalization: are the overseas *dépendances*, transmedial recursivity and mega-renovations a continuation of museums' original internationalism, or are there fundamental differences? The Louvre and the Rijksmuseum again provide case

material through which to explore the range of contemporary national museums' public culture.

COLLECTIONS: THE VISIBLE AND THE INVISIBLE

Public access to hitherto private collections was among the ambitions of the expanding middle classes in the eighteenth and nineteenth centuries. Pomian's approach to collections and his concept of semiophore provide a way of understanding the significance of collections for nation states and the new social classes. Pomian attributes to the collection a special mediating role between the visible and invisible realms, by means of the displayed object, or *semiophore*.

The collection is 'a set of natural or artificial objects, kept temporarily or permanently out of the economic circuit, afforded special protection in enclosed spaces adapted specifically for that purpose and put on display' (Pomian 1990: 9). This act of removal from economic circulation and from normal use entails special treatment for such objects. Despite their removal from the economic circuit, such objects do nevertheless possess an exchange value. In reviewing the kinds of objects that have formed collections—funeral objects, offerings, gifts, booty, relics and sacred objects, royal treasures—Pomian focuses on how, historically, they mediated relationships between the living and the dead, between man and god and between sovereign and subjects. He argues that these objects were made for another audience, invisible to mortals in this world; they were the intermediaries in exchanges needed with these superior and powerful beings (ancestors, gods) to ensure protection and fertility in the visible world. 'These offerings could continue to function as intermediaries for this world and the next, the sacred and the secular, while at the same time constituting, at the very heart of the secular world, symbols of the distant, the hidden, the absent. In other words, they acted as go-betweens between those who gazed upon them and the invisible from whence they came' (ibid: 22).

Pomian argues that the invisible realm owes its existence to language: only through discourse could objects' significance be elucidated. The semiophore is an object that is absolutely useless yet endowed with meaning, as it represents the invisible. As he points out, 'Neither usefulness nor meaning can exist without an observer, as they merely characterize the links which groups and individuals have, through objects, with their visible and invisible environment' (1990: 30). A semiophore has a purpose only as part of a collection and reveals its meaning only when put on display—and when people look at it.

The four main categories of semiophore distinguished by Pomian are antiquities, curios, artworks and scientific instruments. Collections in Europe go back to the

second half of the fourteenth century, when new attitudes began to develop towards the past, towards unknown regions of the earth and towards nature. The rediscovery and re-evaluation of antiquities, together with the rediscovery of lost texts from antiquity, were associated with the rise of a new social group: the Humanists. As objects of study during the sixteenth and seventeenth centuries, these fragments of the past enjoyed a higher status than the curios that were added to collections in this period. Curios represented invisible, exotic lands and were much sought-after by scholars; however, their value, in terms of knowledge and understanding of the world, was recognized only later. A third category of semiophore was pictures and works of art. Art that was in harmony with nature provided a route to eternity since it endured. Artists were for this reason of fundamental importance to princes, since they offered a means of extending their life, glory and fame into eternity. Finally, scientific instruments became a means of pushing back the frontiers of nature, enabling man to describe what he could see through the language of mathematics, as well as to arrive at conclusions about what he could not see. Scientists came to constitute another influential social group.

The monetary value of semiophores increased as the wealthy acquired them to bolster their social status, prestige and power. Such things became inaccessible to people lower down in the social hierarchy. Auctions helped to shift demand for different kinds of object. When pictures and antiquities became too pricey, people bought medals, prints, curios and natural history specimens. By the seventeenth and eighteenth centuries, large sections of the population had been cut off from flourishing private collections.

Economic growth and the availability of education to a wider range of people led to demands for access to collections on the part of aspirant middle classes. Meaningful objects that were visible to all members of the nation provided a basis for consensus among the otherwise divided population. The significance of these specially located objects was to celebrate every aspect of the nation's past,

> each and every one of its social, geographical and professional groups which it believes has contributed to the general prosperity, and all the great men born on its soil and who have left lasting works in every domain imaginable. Even objects from other societies and from nature render the nation which has collected them more illustrious, since this action shows that it has recognized, via its artists, scholars, explorers, even its generals, their value and has been able to make sacrifices in order to acquire them. (Pomian 1990: 43)

In addition to celebrating the past, display is future-oriented: the collection projects forward and works as a means of communication between the generations. Pomian compares the placing of objects in a museum for future generations to the displaying

of objects for the gods in the past. Since a museum is a repository for everything connected with the nation's history, access for all is crucial. In transit between the past and the future, this newly visible world is intelligible only through discourse.

THE LOUVRE, PARIS, SINCE 1793

The rise of the nation state, with its territorial delimitation, coincided with the rise of the universal survey museum. The French royal treasures had been largely inaccessible to those outside the monarch's circle, although this did change somewhat during the eighteenth century: limited public access and reorganization according to national schools of painting were already under way before the Revolution of 1789. Dominique Poulot refers to the 'imaginary Louvre' as part of the administrative preoccupations of Louis XVI's court: the proposal to transform the royal collections into a public museum came from the apparatus of power and the established elite (1991: 188). However, insofar as the royal collection was seen as referring to the nation, it was as the king's domain. Demands by the *philosophes* for access to the collection were made on the grounds that sharing in this wealth would benefit the people. A notice above the entrance to the Apollo Gallery states that the Louvre Museum was founded by a decree passed in the National Assembly on 16 September 1792, and opened to the public on 10 August 1793. In the Apollo Gallery, the crowns of the former kings of France were displayed, duly transformed into semiophores of the historicized monarchy, for public inspection. The people could now enter the former palace as 'the public', with an inviolable right of access to view the treasures. Neutralized as part of the collection, the former regalia are transformed into collective property, belonging to and at the same time making visible the nation.

The first public art museums of the late eighteenth century were organized as universal survey museums: they presented a wide spectrum of art history in former royal palaces such as the Louvre or specially designed public buildings. These new public museums rearranged their art collections according to national schools of painting and art historical periods; they put pictures into simple frames and provided clear labels and guides to the collection—as did the Viennese Royal Collection, transferred to the Belvedere in 1776 (Duncan and Wallach 2004: 57). The Belvedere was to be 'a repository where the history of art is made visible' (ibid.). Works of art came to represent moments in art history and to exemplify categories within the new art historical classification. Most private collections, by contrast, were arranged according to the 'gentlemanly hang', which required of the viewer a connoisseur's knowledge to be able to recognize what was seen unaided. This kind of connoisseurship, combined with judgement and taste, was seen as the mark of aristocratic breeding: elite, international and exclusive.

The discipline of art history began in the public art museum as one of the measures designed to create an intelligible experience of the collection, inspired by the democratic and rational ideals of the Enlightenment. The buildings that housed these reordered collections were transformed into a new kind of public ceremonial space. Although the Louvre needed some adaptation, the building was well suited to its new purpose of receiving both foreign visitors and the French public. Citizens could now visit the Louvre and enjoy and understand the works of art that had been invisible to them for so long. The universal survey of art, by including everything deemed part of the history of civilization, presented a vision of shared culture, aimed at uniting citizens on an equal footing. The definition of what is included in this universal culture has changed through time—as the inclusion of masterpieces from Africa, Asia, Oceania and the Americas in the Louvre Pavillon des Sessions, starting in 2000, shows (Kerchache 2001).

The Louvre Palace embodies the state (as seen in the text above the Apollo Gallery entrance), which, as keeper and guardian of its highest cultural values, presents these to citizens from home and abroad in a clearly organized and accessible form. The much later additions of the I. M. Pei Pyramid (1989) and underground carousel have transformed access to the three wings of this vast museum. If one assumes that most visitors' goal is a glimpse of the *Mona Lisa*, then the route leading to this high point contextualizes it—although it says nothing about routes through the other two wings of the Louvre. The trajectory through the Denon Wing goes from Coptic and Roman Egypt to pre-classical Greece (lower ground floor); to Greek, Etruscan and Roman antiquities on the ground floor; to the rededicated Apollo Gallery and Italian High Renaissance paintings on the first floor, with the *Mona Lisa* as the high point, culminating in French painting. Duncan argues that this survey of Western art history, starting from ancient Egypt, proceeding to classical Greece and Rome, then to the High Renaissance, and ending with French art, confirmed French artistic achievement as the pinnacle of civilization. The foreign visitor would be able to grasp the logic and admire the quality of the art, without belonging to the nation. Acknowledgement of the cultural achievements of France might provide the foreign visitors with a standard by which to judge the cultural achievements of their own nations. National museums were thus competing to impress not only their own citizens but also foreign visitors. Duncan and Wallach see the Louvre as the prototypical public art museum, which stands as a monument to the bourgeois state emerging in an age of revolution. Other European states followed, or were led by France, during the nineteenth century, with the Louvre serving as a model for national galleries elsewhere: the Rijksmuseum, Amsterdam, is a case in point.[2]

ARCHITECTURE INTENDED AS A NATIONAL SYMBOL: THE RIJKSMUSEUM, AMSTERDAM

How did the Louvre serve as a model for other national museums? In the first place, by conquest: French occupation of the Netherlands in 1795, followed by the Constitution of 1798, led to the founding of the Batavian Republic—a unified state with a central government, to replace the earlier federation of seven states. Two state cultural institutions, the National Library and National Art Gallery (Nationale Konst-Galerij), were both established in 1798. The National Art Gallery was first housed in the administrative capital, The Hague, at the *stadhouders'* palace, Huis ten Bosch.[3] Huis ten Bosch was opened to the public in 1800, with a collection of 192 paintings. It was decided that the National Art Gallery should display art treasures from the *stadhouders'* collections, which were placed under government protection. Since many of the best pieces in these collections had already been plundered and shipped off to the Louvre in 1796, establishing a national gallery was also a preventive measure. The model for the new Dutch state institution was the chronological ordering of the statues of French kings and fragments at the Louvre and the Museum des Monuments français (Bergvelt 1998; Ham 2000).

Although French-inspired, the national museum had a number of distinctly local traits. The first of these is the move of the National Gallery from The Hague to the capital, Amsterdam, in 1808. Second, about half of the Dutch art collection comprised historical artefacts. Third, the Amsterdam city collection had a profound influence on the national collection. While the former *stadhouders'* collection became state property, the Amsterdam city paintings remained the property of the city. Fourth, while it was felt that a national museum *ought* to have an international collection, this ideal was not practicable in the Netherlands. Finally, the explicit connection between the national collection and Dutch identity was made only much later in the century. In sum, the Dutch national collection was characterized by its educational nature, its historical quality and a lack of resources that stemmed from the pre-1795 relationship between art and the government (Bergvelt 1998: 53). Art historian Ellinoor Bergvelt underlines that art demonstrated *urban* power in the Netherlands before 1795, rather than princely or state power. This urban, civic quality of pre-nineteenth-century Dutch collections had a decisive impact on the national collection.

When King Louis Napoleon established the Royal Museum in the Dam Palace in 1807, *he* may well have intended it as a symbol of the king's power (Ham 2000: 45). However, when the Netherlands regained independence in 1813, the museum celebrated Dutch sovereignty. In 1815, 127 paintings and some 10,000 other national

historical objects were repatriated to the Netherlands from the Louvre—about two-thirds of what had been plundered from The Hague in 1795 (ibid: 63). This early repatriation gave recognition to the principle of national heritage and property, thereby contributing to the long-term development of national consciousness—even though an explicit link between national identity and the Rijksmuseum was made much later in the nineteenth century with the construction of Cuypers's large new museum building.[4]

For much of the nineteenth century, the Dutch national collection remained scattered over several locations in three cities: The Hague, Amsterdam and Haarlem.[5] Government policy towards the arts and science changed only in the 1870s when, for the first time in its history, the Netherlands had a cultural policy. Senior civil servant Victor de Stuers succeeded in placing museums on the political agenda and successfully made the case for art to be considered as government business, to be financed by government.[6] He proposed that taking care of historical objects was a matter of national importance, arguing that history creates and maintains the ties that bind people together as nations. Art was seen as a way of illustrating national identity in history, using portraits of important men and images of political or military events (Bergvelt 1998: 197).

De Stuers's efforts resulted in parliamentary recognition that museum provision in the Netherlands was lagging behind the rest of Europe—where new museum buildings were being constructed in every self-respecting state. Culture had become part of a modern complex of ideas about civilization, including education in the broadest sense (Bergvelt 1998: 192). The healthy Dutch economy after 1870 made it possible to push through plans for a new Rijksmuseum, where earlier attempts had failed. These favourable economic circumstances were due in part to the Dutch East Indies. Architect Pierre Cuypers won the competition for the new national museum with a design that combined several architectural styles.[7] Cuypers's building was as much influenced by Renaissance as by Gothic architecture: the Aduard chapel is said to resemble a sixteenth-century Loire castle, while the Gallery of Honour has been compared to the Roman basilica of Maxenius. The building was supposed to monumentalize the values of art and culture, supported by government. The medieval references were supposed to give the building a much broader character than simply 'Catholic'. There was also a crafts component to the Rijksmuseum, since it was thought that this would promote better craftsmanship among artisans and workers. The emphasis on the past and the restoration of monuments was entirely consistent with the development of historical consciousness in the nineteenth century.

The Rijksmuseum was a conglomerate of museums with multiple uses: it comprised art, history, education, training in crafts and taste in general. It was thought that the combination of history and art would encourage national sentiments and

hence the creation of Dutch identity. The Netherlands differed from countries with a long-standing relationship between the king and his art collection, making it far more difficult to establish a purely art-based national museum—such as the Louvre, the Berlin Altes Museum and the London National Gallery (Bergvelt 1998: 231). The combination of art and history, in Cuypers's imposing red-brick building, with its lofty towers, made the Rijksmuseum *look* very different from its counterparts elsewhere. Furthermore, important parts of the collection—Rembrandt's *Jewish Bride*, the *Mill at Wijk bij Duurstede*, Vermeer's *Reading Woman*—belonged to the city of Amsterdam.[8] Cuypers's Rijksmuseum is designed around Rembrandt's *Nightwatch*, which—normally—hangs at the end of the Gallery of Honour on the second floor. The masterpiece status of the *Nightwatch* reinforces the local brilliance ('the Golden Age') in which the other Amsterdam paintings bathe.

The Amsterdam city council contributed its collection, land and money to the new museum, which was supposed to look typically Dutch, not international: its exterior was not to resemble a palace or temple, but to point to a past that went further than just the seventeenth century (Ham 2000: 149). In fact, there is a telling resemblance between the museum and Amsterdam Central Station—also designed by Cuypers. Because of the Amsterdam stake in the museum, Cuypers was obliged to incorporate a passageway right through the middle of the building so that people were not obliged to make a detour. The passage effectively divides the building in two. Building work began in 1876, and Cuypers's new Rijksmuseum opened in 1885: the painting galleries upstairs were ready for the opening; the Netherlands Museum for History and Art, downstairs, opened two years later. The two inner courtyards were covered with glass during the 1890s, so that they could be used as exhibition space.

Historian Gijs van der Ham (2000) explains that the decoration of the building, both inside and outside (Cuypers was assisted in this by art historian Alberdingk Thijm), was supposed to show that the new museum was not just a place for art objects, but an expression of the community from which the art came forth. The whole structure is heavy with symbols, the most prominent of which, on the front façade, are universal: the Victory at the top is a remnant of the 1863 plan for the museum to commemorate the founding of the independent kingdom of the Netherlands in 1813. Level with the edge of the roof are the figures of Work and Inspiration (values required for great art and a harmonious community), and halfway up the façade were Art and History (foundations of the museum and world order). Dutch symbolism and references to artistic life decorate the entire building outside and inside: this includes the arms of Amsterdam, The Hague and eighteen other Dutch cities; the classicist relief above the entrance to the underpassage shows famous Dutch artists, some medieval, paying homage to the Dutch Maid. Even Pallas Athene, as

patroness of the arts, casts a protective eye over the Dutch Maid. Above the windows there are portraits of some eighty-two artists, more than half of whom are painters, with Rembrandt and Van der Helst occupying the places of honour in the middle of the main façade. The decorative programme devotes relatively little attention to the seventeenth century—the Golden Age of Dutch art—and rather a lot to royal and Church patronage of the arts. The typical bourgeois character of Dutch seventeenth-century art is scarcely visible in the decorations, and there is little direct attention to Dutch history. This welter of decoration on the exterior is barely distinguishable from a distance, showing how well Cuypers integrated it into the building.

Although the museum was meant as a national symbol, few Dutch people could decipher the many meanings of the building when it opened in 1885. The vision of the national past and national art to which this building spoke was an idealization of the past with which the public had little affinity—if they understood it at all. It can be seen as an attempt to evoke invisible worlds (the past, art, the nation) that were above the heads (and hearts) of contemporary society. The Netherlands was not a harmonious society where everyone knew his or her place. The 'pillarizing' of society and the rise of the working class, in particular, made the building look immediately 'old-fashioned'. Angry letters were published in the press; people were furious and nonplussed at the symbolic values expressed in the building. Most people valued the Rijksmuseum for its contents, the paintings and the bourgeois values they encapsulated, which were scarcely to be seen in the building itself (Ham 2000: 151).

Perhaps it was the sheer size of Cuypers's building, the largest in the Netherlands in 1885, and its imposing physical structure, which drew half a million visitors between 14 July (when it opened) and 30 September 1885. Bergvelt refers to a 'Centre Pompidou Effect' regarding the numbers who flocked to see this building (1998: 240). The physicality of the huge building, thus, rather than its iconographic programme, provided the nation with a new form of public space. The route through the building, the information provided and the souvenirs on sale were what made its contents intelligible to visitors. The image of the Dutch Golden Age in art that came to be so closely identified with the building and, through it perhaps, with the invisible Dutch nation was a distinctive local version of a global trend.

THE EXHIBITIONARY COMPLEX

Museums such as the Louvre and the Rijksmuseum thus made their respective nations and cultural possessions visible, through their architectural programmes as well as their collections and exhibitions. Museums became one of the institutions financed by the state, aimed at educating citizens and offering them improving forms

of enjoyment as well as providing a focus for national consciousness. Museums and public libraries were intended, particularly in nineteenth-century Britain, to offer a rational alternative to the pub (Conlin 2006). Museums featured in 1830s discussions in Britain about how to deal with civil unrest among the radicalized working population. Self-improvement, by enabling people to understand the collections made available in public space, came to be seen as a promising option for achieving social regulation. Displaying art treasures and objects relating to national history in newly opened public spaces, accessible to all, and in sequences that made objects intelligible (for example as part of history), was to have an empowering effect on the viewer. As the visitor walked through the galleries of the museum, looking was an active process: following narratives of progress (evolutionary or historical), the visitor absorbed the underlying message through their own locomotion as they moved from simpler to more complex forms (Bennett 1995).

As already discussed, museums became locations where culture and history were used to give specific content of the nation. The universal survey museum often embodied the nation state in its architecture and inventoried the nation in its collections, while at the same time situating the nation state in the universal order of things (Prösler 1996: 34). Museums thereby expressed the distinctiveness of a nation from all others. Collection formation during the nineteenth century demonstrated the ability of the state to assemble and organize materials from the world and from its own territory.

On the other hand, longings for independence on the part of a nation such as Norway, for example, which had been part of a union with Sweden for most of the nineteenth century, could also be given expression through its university collections (Bouquet 1996). The process of identifying a common culture was, of course, also a process of selection and exclusion. *Nations* in the nineteenth century referred to states composed of heterogeneous ethnic groups having a common identity imposed on them (Kaplan 1994). Martin Prösler uses the term *theatrum nationis* to refer to institutions such as museums in the context of the state. The notion of the museum as a theatre of the nation aptly captures the staging of the collection in often monumental buildings, suggesting the casting of objects (through their installation), made to perform for an audience (the public or citizens).

Museums performed this work together with a range of other institutions, conceptualized by Tony Bennett (1995: 59) as the exhibitionary complex. Bennett situates the birth of the public museum in a wider social and political framework. The shift to providing general and intelligible access to collections offered those from the lowest social echelons the experience of being the subjects rather than the objects of knowledge (ibid: 63). The purpose of this knowledge was that people would know and regulate themselves, thus rendering obsolete earlier forms of public punishment and

correction. By knowing themselves 'from the side of power', the argument goes, they would internalize and become compliant with the social order as defined by those in power. Bennett connects and distinguishes the museum, as part of the exhibitionary complex, from the institutions of punishment analysed by Michel Foucault as part of the 'carceral archipelago'. While earlier spectacles of punishment were removed from public view to behind the closed doors of prisons, formerly private collections gained unprecedented visibility when reinvented as public museums, whose aims included self-improvement and self-regulation. Implicit in these criss-crossing institutional trajectories is the newly defined citizen of the newly emergent nation state.

The visibility and accessibility of collections was backed up by placing collection items in a narrative, distributed through the space available. Thus visitors would follow an evolutionary sequence, for example by walking from the simplest to the most complex examples of the sequence. Some have argued that art museums occupied an exceptional position in these developments; others contest this. Bennett's (1995: 59) view is that the position of the art museum was closely related to a wider range of institutions: 'history and natural history museums, dioramas and panoramas, national and later international exhibitions, arcades and department stores'. These various locations served to connect the specialized knowledge developing in the new academic disciplines of history, biology, art history and anthropology, which took as their discursive fields the past, evolution, aesthetics and humankind. A further crucial development was in the technologies of vision: nineteenth-century museum architecture developed new ways of rendering both objects and people visible, making good use of materials such as glass and steel to create new forms of transparency, as well as opening up new vistas on the crowd as an orderly assembly.

Historicized museum displays, such as the *galleria progressiva*, accompanied the exploration of ever deeper pasts. Such displays were particularly fitting for nation states, which were increasingly interested in preserving and immortalizing their own formation as part of the 'nationing' of their populations (Bennett 1995: 76). Museums constituted a key space for the imagined community of the nation state, not only by displaying material evidence of its deep historical origins, but also by demonstrating its dominion over other populations. This superiority could be shown through booty seized as, for example, by the Dutch fleet in a surprise attack on the port of Chatham in June 1667, returning home with the *Royal Charles* flagship in tow—the counter decoration of which is among the masterpieces of the Rijksmuseum. It could also be shown through the things removed from distant populations, subjugated or colonized by the nation state.[9] The effect of these extraneous objects on local viewers was to create a sense of unity, effacing class divisions and composing a 'we' in opposition to the 'other'.

This visual and spatial welding of different schools of painting has been interpreted as another way of consolidating national identity through the collection. French painting in the Denon Wing of the Louvre appears to emerge from its Italian

and classical forerunners. If the nation state started out as an abstract entity, theoretically belonging to the people after the fall of the old regime, then the collections were an effective means of rendering the state concrete, visible and eminently historical.

Great exhibitions were yet another crucial dimension of the nineteenth-century exhibitionary complex, complementing museums in various ways. Such exhibitions displayed machinery and industrial processes, commodities and art objects, in a narrative of progress. Exhibits were divided into different national courts, where nations and subject peoples were represented as occupying the higher and lower stages of civilization, defined by their respective manufacturing processes. Nation, empire and race were the criteria used for arranging the displays. The creation of colonial cities or villages at such exhibitions further reinforced the 'we' that national museums sought to make concrete. Such exhibitions were also places where international networks took shape, encouraging new transnational forms of exchange and perception (Bennett 2006: 43). When such exhibitions closed, many of their displayed objects were transferred to museums.

Just such an international network can be glimpsed in the formation of the Ethnographic Collection of the University Museum in Christiania (later Oslo), Norway, in the mid-nineteenth century. The Norwegian case is especially interesting in terms of nation-building since throughout the nineteenth century Norway was seeking independence from the union with Sweden that dated from 1814. The University Museum became a focus for nationalist sentiment, a place where the local elite could build up a collection by making use of international connections. Director of the Ethnographic Collection Ludwig Daa's main contact in the international museum world was the English ethnologist Robert Latham, with whom he became friends during Latham's visit to Christiania in the 1830s. When Latham was charged with establishing an ethnographic museum in the wake of the 1851 Great Exhibition, he contacted Daa in order to obtain Sami (then called Lappish) objects for the collection. In return for the Sami objects supplied, Latham offered Daa objects from various parts of the world—including Borneo—to enrich the Christiania collection. Daa mobilized funds to purchase Sami objects by means of a commission, which obtained a government grant in 1853, made on condition that the university would receive one example of each. Among the items that entered the Oslo University Ethnographic Collection in this way were three plaster casts of the heads of Sami detained after the 1852 Easter Uprising in Kautokeino, made by the Italian plaster sculptor Guidotti. When the Oslo University Ethnographic Collection opened to the public in 1857, as part of the university museum, the collection comprised 197 objects, including seven plaster cast figures of 'Lapps', ten British Guyana face masks and some fine Dayak armour from Borneo (Bouquet 1996: 111–14). The museum engaged in many other exchanges, for example with the Smithsonian Institution in Washington, DC, and the Musée du Trocadéro in Paris.

The public museum was already part of far-reaching networks from its inception in the late eighteenth century (see Chapter 1). What is specific to its development during the nineteenth century is the way the institution fits into the governmental logic

of culture as 'a historically distinctive, and complexly articulated, set of means for transforming people through their own self-activity', according to Bennett. Culture is used to designate both 'the shared traditions, values, and relationships, the *unconscious* cognitive and social reflexes, which members of a community share and collectively embody', and 'the self-*conscious* intellectual and artistic efforts of individuals to express, enrich and distinguish themselves, as well as the works such efforts produce and the institutions that foster them' (Bennett 2006: 52). A current example of how these two dimensions interact can be seen when contemporary artists 'comment on' historical collections through their interventions. Damien Hirst's 2008 *Cornucopia* intervention placed 200 spin-painted plastic skulls in the King's Library of the British Museum, subtly disturbing the reconstruction.

IMAGINED COMMUNITIES

Museums are one of the means by which the 'imagined communities' of nation states are created and sustained, according to Anderson (1983). Nineteenth-century colonial state administrations mapped, conducted censuses and established museums as ways of conceptualizing the territory, the population and the past beyond their own state boundaries. The census achieved this by categorizing people and attributing identities to them based, for example, on racial or religious characteristics. The map modelled colonial territories, by emphasizing boundaries and demonstrating the antiquity of certain well-defined territorial states. The museum, and more particularly the 'museumizing imagination', played a central role in colonial and postcolonial power relations. The gradual awakening of interest in ancient civilizations and monuments among colonial rulers during the nineteenth century may be compared with Renaissance interest in antiquity. Excavation and preservation of archaeological sites (such as Borobudur on Java), as well as the collections made for metropolitan institutions, emphasized the colonial state's role as the keeper of civilization—abroad as well as at home. Anderson argues that the 'unjungling' of lost civilizations in overseas territories, the ability to display collections made overseas in museums at home, and the reproduction and circulation of images and information via printed media all contributed to a sense of national identity in the nineteenth century. Excavating, collecting, classifying and displaying other populations thus became a means of objectifying the 'other', thereby reinforcing a sense of shared identity as members of the imagined community of the nation state.

This sense of shared national identity, enhanced through contrasts made with colonized peoples, did much to disguise the inequalities inherent in the nation state as a form of political organization. Taking control of others' possessions seems to have

been considered an almost natural characteristic of 'higher' civilizations: collections were made on the assumption that colonization would bring about inevitable change. Museums provided a place for keeping what were seen as the salvaged specimens of traditional (i.e. pre-contact) culture. National schools of painting and fine art were distinguished from the 'primitive' arts of colonized peoples, who were thus excluded from Western art history. The position occupied by Western art and the discipline of art history in national museums worked, in combination with ethnographic and other collections and disciplines, to define national identity during the nineteenth century.

THE MUSEUM AS A RITUAL SITE

Art historian Carol Duncan approaches art collections by analysing their broader context. Drawing on anthropological theories of ritual (by Mary Douglas, Edmund Leach and Victor Turner), Duncan analyses public art museums as ritual sites. She starts by questioning the post-Enlightenment dichotomy between religious and secular life, arguing that museums and similar sites publicly represent beliefs about the order of the world, its past and present and the individual's place in it. She demonstrates how museums, far from being secular, rational places, embody beliefs, forms of magic, symbolic sacrifice, miraculous transformations and prodigious changes of consciousness. Museums filled the void left in a disenchanted world (as Weber refers to the world after the process of secularization), providing monumental ceremonial spaces for public rituals: corridors for processions, halls for gatherings and inner sanctuaries to house semiophores.

Public art museums came to be seen as one of the institutions needed to qualify as a virtuous state (Duncan 1995: 21). Duncan argues that the development of civilization is identified with that of Western art history, culminating, as exemplified at the Louvre, in the Italian High Renaissance and French painting. The embedding of collection objects within the physical setting of the national museum is central to constituting the museum as a ritual site. Physically moving the visitor through the former royal palace, with its ceremonial staircases, long corridors and reception galleries, filled with the breathtaking collection that is organized as an ascending walk through art history to the *Mona Lisa*, materially impresses the visitor with a sense of pride at belonging to a nation capable of opening this museum by decree of the legislative assembly.

Duncan's model can also be applied to the Rijksmuseum, Amsterdam, where Cuypers's Gallery of Honour on the second floor culminates in Rembrandt's *Nightwatch*—not after a universal survey, but rather a national one. Urban bourgeois values of citizenship are prominent in the seventeenth-century northern Dutch

painting collection which became the national collection during the nineteenth century: interiors, portraits and group portraits were well represented in the Amsterdam city collection, as well as landscapes, historical scenes and genre paintings. The physical size of the *Nightwatch* group portrait of a civic militia, as well as the theatrical arrangement of the group members, contributed to the painting's installation as the masterpiece of masterpieces in the 1880s. The international renown of Dutch Golden Age painting in general, and the *Nightwatch* in particular, provided another set of reasons for its ceremonial installation as the high point of any foreign visitor's pilgrimage to the Rijksmuseum.

INTERNATIONALIZATION

There is an important distinction between the evident importance of international networks, competition and prestige for national museums during the nineteenth century and contemporary forms of internationalization (or globalization). Current internationalization ranges from overseas *dépendances* to travelling blockbuster exhibitions. It also includes the starchitects who leave their mark on the international circuit of museums, whether by designing dazzling new buildings or through ingenious renovations or additions to existing ones, and the star curators who circulate among prestigious institutions, briefly illuminating them before moving on. It includes millions of tourists for whom museums are important destinations, and also organizations, such as the International Council of Museums (ICOM), which seek to promote professional discussion, cooperation and policy at global level. Why do national museums persist in our internationally oriented world, and in which ways are they reinventing themselves? The visual/material dimensions of museums and their transformations can be seen in architecture, design, websites and uses of contemporary art, all of which aim to render collections visible and accessible to the public.

Plans by the Louvre to establish *dépendances* elsewhere in the world (such as Abu Dhabi) generated heated debate in France in the early years of this century. Consternation appears to hinge on domestic anxieties which in turn provide insight into the contested nature of the national museum. The invocation of universal values by proponents of the Abu Dhabi project is a reminder of the powerful universal survey model on which the Louvre was refashioned as a public institution after 1793. The debate about the propriety or otherwise of circulating *patrimoine* may be approached through the notion of heritage as inalienable possessions, and the Abu Dhabi venture as an instance of 'giving while keeping' (Weiner 1992). As international tourist destinations, museum facilities are under pressure to cater for increasing numbers of visitors; mega-renovation projects aimed to equip museums to cope with the scale

of their contemporary public are a further dimension of internationalization which also raises local issues. Renovation of the Rijksmuseum, Amsterdam, involves both closure and a range of interim activities designed to fill the gap. The Louvre and the Rijksmuseum show the current stretching of national museums—both overseas and at home—and bring to the fore issues of visibility and accessibility. The closure of the main buildings of major national museums for renovation provides an occasion for rethinking the building, the collections, restoration processes and the public. Redistribution of parts of the collection beyond home base unsettles the former combination of setting–building–collection–experience and raises questions about what is in a name: what is the Louvre, the British Museum or the Rijksmuseum today? How does that differ from the period when national museums were being established? What do these changes reflect in terms of citizenship, possessions, national and other kinds of identity, imagined communities, 'having a culture', 'having a history' and 'having a—collective—memory'? Why are these issues important not just for domestic audiences but also for international ones? How do the two interact?

How, and into what, is the national museum metamorphosing? The next section considers several forms of internationalization of museums together with their repercussions at the national level: in France, *dépendances* overseas provoke debate about *patrimoine* (heritage) and the public; in the Netherlands, mega-renovations at home trigger their own interim activities and a major operation in sharing the collection during a lengthy period of closure. These projects involve varying modes and degrees of visibility which have different kinds of impacts on the national museum. The interventions of contemporary artists, 'star' curators, novelists and film-makers provide fresh takes on old museums and their collections, capturing the public imagination in new ways.

THE DESERT LOUVRE CONTROVERSY

Reference to the universal mission of the planned 'Louvre des Sables', or 'Desert Louvre', in Abu Dhabi is a striking feature of the discussions that appear on the *Tribune de l'Art* website.[10] The agreement between the French and the United Arab Emirates governments, made on 6 March 2007, announced the creation of an entirely new museum built on the universal survey model; it will include art from all eras and regions, including Islamic art. This museum will carry the name of the Louvre to Abu Dhabi and, with it, the spirit of the universal survey mission of the first public art museums in Europe. The agreement makes reference to the inalienable character of French patrimony (meaning that it cannot be sold) and at the same time to the intangible principles that this patrimony embodies—presumably those of *liberté*, *égalité* and *fraternité* among citizens, established by the French Revolution. The text expresses

a combination of pride with an awareness of the responsibilities that these treasured possessions bring with them. This responsibility is defined as a kind of escalating cultural pledge: keeping alive the most authentic *patrimoine* of French culture and the French nation is also about keeping European and indeed universal culture alive; as well as ensuring a meeting with contemporary art. Apart from loans of works to the Louvre des Sables, French expertise will be used to found an agency that will assist in building up the museum's own collection. The agreement shows how stately responsibilities readily incorporate international as well as domestic dimensions.

The 'magnificent project' will include a building by Jean Nouvel (architect of the Institut du Monde Arabe, as well as the Musée du Quai Branly in Paris), a flying saucer-like construction that is partly inspired by Arab architecture. The figures which are included in the agreement are impressive: some 24,000 square metres, divided into 6,000 square metres of permanent galleries and 2,000 square metres of temporary exhibition space, along with space for the reception area and cultural and educational services; as well as the guarantee of some 200 works of art loaned for periods of two years. As the document points out, the Louvre's universal mission *already* entails the annual departure of some 1,400 works of art from France to take part in exhibitions abroad. Since only 5–10 per cent of the national collection is currently visible to the public, there is no risk of there being a shortage of works for exhibitions at home. There is, however, an unspecified number of works of art that will never leave French territory. Furthermore, great museums such as the Louvre, Musée Quai d'Orsay, Musée Picasso and others would never jeopardize the physical condition of their artworks by reckless sharing, so the argument goes.

The distinction between the small percentage of visible collection and largely invisible holdings is a key argument in this debate: the obligation to make public collections visible and accessible is keenly felt by museums today. The argument that the Louvre des Sables will, under strictly controlled conditions, serve a new international public is a compelling one. The counterargument is that serving a public consisting of the wealthy, golf-playing inhabitants of the luxury Saadiyat Island development can scarcely be construed as an act of sharing (Launet 2007). The further admission that certain possessions are considered too closely bound up with national reputation and glory to be allowed to leave national territory raises interesting questions. Which items would never be allowed to leave, and why not, when it is clear that masterpieces and other artworks are regularly loaned? The reluctance to lend certain works of art to foreign institutions combined with a general sense of the obligation to do so is reminiscent of the conflicting emotions and attendant schemes enfolding the famous *kula* institution in the south-west Pacific. The circulation of treasured armshells and necklaces among *kula* partners is the condition for the fame and reputation of those who own as well as those who manage to secure one of these treasured possessions (Malinowski 1922). A great

deal of energy and skill also goes into ensuring that a treasured possession will eventually 'return' to its rightful owners—even if this only takes place in the next generation (Weiner 1992). There is a sense in which renowned national collection items may also be seen as inalienable possessions of the nation—although with differences: the lenders are institutions, and the loan periods are much shorter.

When state institutions such as museums entrust others with cherished objects from the national collection, this helps to create allies and opens up channels of diplomacy and commerce among nation states, just as the circulation of Trobriand *vayg'ua* valuables animates *kula* partnerships and coexists with trading among islanders of the region. Museum loans are hemmed in by stringently defined conditions and substantial insurance policies; objects may be accompanied by a member of the lending museum's staff, to supervise unpacking, display and repacking; such objects have to be returned by a specified date. Loaning collection pieces in this way adds to their renown, to the glory of their owner and to the temporary glory of the borrower, as part of some major temporary exhibition. Despite awareness of the obligation to loan, museums may be reluctant to do so although that reluctance is tempered by the knowledge that sooner or later they themselves will need to put in a request to borrow an object from another institution. These practices may be compared with Weiner's 'giving while keeping' (Weiner 1992). The existence of de facto loan practice, combined with a further distinction between works which may be loaned and those that would never (or only very exceptionally) be loaned, leads to the question of whether there are other reasons besides conservation considerations for refusing to allow certain works beyond state territory.

The debate about the planned Louvre des Sables revolves around scepticism about the globalization of heritage and about French *éclat* (brilliance) in diffusing universal culture and knowledge by means of such constructions. There is clearly concern about the circulation of national artworks for commercial and diplomatic purposes, and cynicism about the purportedly enlightened cultural policy of sharing objects considered part of world heritage with the public of Saadiyat Island (see www.saadiyat.ae). How can the claim be made to be sharing French *patrimoine* with world citizens, if these turn out to be Saadiyat's spoiled inhabitants? If there were a serious public function to the project, would it not involve the larger population of migrant workers who sustain the Island of Happiness? By scrutinizing the public who will 'share' French cultural heritage abroad, critics question the principle of equality invoked by the French government as an argument for their Abu Dhabi venture. If the cultural symbols of the imagined community of the nation are to be more widely shared, then 'With whom?' is a relevant question.

Another feature of the Louvre controversy are the rumours circulating in the international press, of which the BBC World News and the Dutch *NRC Handelsblad*

cited here are merely two examples. International reporting on the official contents of press releases, as well as opposition to the plan, includes rumour and gossip, which all redound to the fame and reputation of national museums and collections. Some reported the initiative in terms of foreign policy, interpreting it as a way of counter-balancing American domination in the Middle East (Moerland 2007). Unconfirmed sources asserted that the partnership means that Abu Dhabi will pay €500–700 million for a French museum concept, developed by the Museums Directorate of the Ministry of Culture. Another interesting piece of gossip (from a 'leaked source') has it that Abu Dhabi acquired the right to use the name 'Louvre' for twenty years (ibid.). The fact that thirty-four French museums together with the Louvre will contribute to the Abu Dhabi 'Louvre' was also mulled over in the international press. If the original Louvre was once firmly anchored in a 'nation building', the name no longer seems to be tied to that site. The French commitment was reported to involve four temporary exhibits in the first ten years, the loan of some 300 works for a ten-year period and a new French agency sponsored by Abu Dhabi to help the emirate build up its own collection. The competitive cultural economy spurs national governments and their museums to enter into their own partnerships: the Louvre director felt his museum could not be 'left behind' in his perception of this 'fact of life'. The Louvre des Sables is lined up with Abu Dhabi Guggenheim (by Frank Gehry), the Maritime Museum (by Tadao Ando) and the Performing Arts Centre (by Zaha Hadid): part of a complex designed to attract mass, upmarket tourism.

The Louvre des Sables plans met with anything but unanimous enthusiasm in France. Former museum directors published an open letter in December 2006 headed 'Museums Are Not for Sale', in which they rejected the diplomatically and commercially inspired plans, accusing the ministry of 'selling out' (see website *Tribune de l'Art*). They refer to the commercial and media usage of masterpieces of national heritage as a 'moral outrage', asserting that the 'Louvre is not Disneyland; it is not eternally reproducible'. Furthermore, they reject the notion of art as an 'export product with which to promote the national image'. Instead, as Patrick Ramade, director of the Musée des Beaux Arts, Caen, put it, '[A] collection of cultural property constitutes the nation' (ibid.). Loans should be permitted only according to strictly defined goals, specifying the public for whom they are destined, and the desired returns, in cultural rather than monetary terms. Concern that the Abu Dhabi Louvre will be little more than a tourist attraction also reflects French uneasiness about globalization. Didier Rykner, founder of the *Tribune de l'Art* and initiator of the petition against the Louvre des Sables, believes that cultural heritage is increasingly seen by internationally active museums as a 'reservoir of art works that travel freely about the world' (Rykner 2007).[11] Disgruntled museum directors today thus acknowledge the Disneyfication of cultural heritage to be a fact, with the fiction of its cultural uniqueness as the main selling point.

The export of the Louvre name and reputation, of its 'universal' claims, of collection items (from a variety of French museums, as noted), of French museum expertise—and the discussion this has precipitated—capture succinctly the reconfiguration of 'the nation' on the contemporary international museum scene. In addition to the Abu Dhabi project, the Louvre is involved in negotiations with more international partners, such as the High Museum, Atlanta. Other French museums have entered into similar partnerships: the Centre Pompidou, with an annex in Shanghai, and the Musée Rodin, with a *dépendance* in Bahia, Brazil. All such expansions have significant repercussions at home, not least in terms of public debate and the sense of national identity involved: where does citizenship begin and end today? Instead of the nation state as an imagined community, there is nowadays an imagined international community allied through exchanges of works of art, loans that include names such as the Louvre and museum and architectural expertise worth millions. This new international 'community' effectively excludes large swathes of the international migrant worker population, at home and abroad, from enjoying the benefits of this shared heritage.[12]

TRANSMEDIAL RECURSIVITY: THE *DA VINCI CODE* THEMATIC TOUR

Corinne Kratz and Ivan Karp (2006: 12) observe that museums face both inwards to local constituencies and outwards to wider audiences; through relations to other museums and sites, these institutions have ways of mobilizing an international—perhaps global—sense of local identities, histories and concerns. In this respect, they suggest, museums are no longer just a place or institution but a 'portable social technology'. While 'the Louvre' can assume a mobile form with regard to its *dépendances* overseas, a Parisian site/place/collection may occupy the public imagination through other media, such as novels and films, with effects on the Louvre itself.

Apart from decoding the *Mona Lisa* and *The Last Supper*, novelist Dan Brown uses the Louvre as the setting for a murder in a detective plot. Brown's evocation of the Louvre engages 'reality effects': forensic ideas of traces, background noise and irrelevant detail,[13] to make the reader feel as if he or she is watching the action unfold. The film made as a result of the novel's bestselling success shot its opening and closing footage in the Louvre galleries. Until November 2007, the Louvre offered a *Da Vinci Code* thematic tour along the route of the plot, reining in the novelist's flights of fantasy with good-natured art historical authority. These three media shifts (from fiction to film to tour) make various plots in different media converge on the same site. The attention given to the site helps to transform it.

Ann Rigney, in her work on the cultural construction of memory, refers to the transmedial recursivity of certain *lieux de mémoire*, connecting them to Anderson's imagined communities:

> Unlike material monuments, texts and images circulate and, in the process, they connect up people who, although they themselves never meet face-to-face, may nevertheless, thanks to the stories and the media that carry them, come to share memories as members of 'imagined communities' (Anderson 1991[1983]). Moreover, there is evidence to suggest that particular stories in the form of novels or films enjoy such a high profile because of their aesthetic properties and manner of distribution that they play a role as catalysts in the emergence of topics in public remembrance. (Rigney 2005: 20)

In the case of the Louvre, the *Da Vinci Code* in its novel, film and site-tour forms appears to *reinforce* both the material monument and its existence in the public imagination, engaging in a new form of dialogue with these off-site agents, making active use of them to look anew at the building and the collection. This *Da Vinci Code* effect resembles what Alfred Gell referred to as 'cognitive stickiness' (cited in Küchler 2002: 10): a powerful attraction that is thus fed by more than the architecture, the collection, the site and the museological arrangements. These high-profile properties, rather, provide the novelist with a setting for hatching his plot. Brown's reality effects make use of every detail, from the spectacular Pyramid entrance to the elevator to the floor and even the lavatory. The Louvre as a physical location in Paris gains extra volume through such bestselling fiction followed by a box-office success—as the *Da Vinci Code* tour indicates. This wandering of the historical museum among the media, sometimes associated with authority, sometimes with the miraculous and occult, reinforces its simultaneously ultra-modern and magical qualities in the social imagination. So, in addition to providing ultra-new visions of the social, through spectacular architecture, museums may increase in their volume as places where mystery, drama or simply daydreams echo across the media that give shape and form to the social imagination.

Given the assiduity with which visitors photograph themselves on-site, the importance of being there, of including the self in the picture on-site at the museum, seems to have increased. So while the Louvre establishes itself in the desert, the attraction of its Parisian site seems to be reinforced through other media. International visitors incorporate into their own secular rituals of museum-visiting the photographic rituals that dominate large areas of everyday life outside the museum. Therefore, the visual technology of photography appears to be a crucial feature of the portable social technology to which Kratz and Karp (2006: 4) refer. Photography is a means by which people place themselves in the museum, incorporating the museum into their own narratives and recording that moment as part of their personal archive.

MEGA-RENOVATION: THE RIJKSMUSEUM, AMSTERDAM

Kratz and Karp (2006: 12) refer to 'dramatic blockbuster-like reinstallations of permanent exhibitions'—including the Louvre, the Met, the National Museums of Kenya, the Field Museum, the Smithsonian Museum of Natural History (1999) and the British Museum (2001)—as another trend in the globalizing and internationalizing direction museums have taken in the past decade. Kratz and Karp are interested in the frictions and conflicting interests that arise on the interface between the old and the new, and the public culture this produces. As the Abu Dhabi controversy shows, there is a distinctly (inter)national basis to this trend. Examining a mega-renovation and what that entails for the Rijksmuseum, Amsterdam, develops that insight. It shows how a major museum navigates a course between its international image on the cultural-tourism circuit (strongly shaped by seventeenth-century Dutch art), the desire/need to innovate (to remain competitive with international peers, such as the Louvre and the British Museum) and its proclaimed responsibility to the local public, as a high-profile government-financed institution, at a time of political uncertainty about national identity.

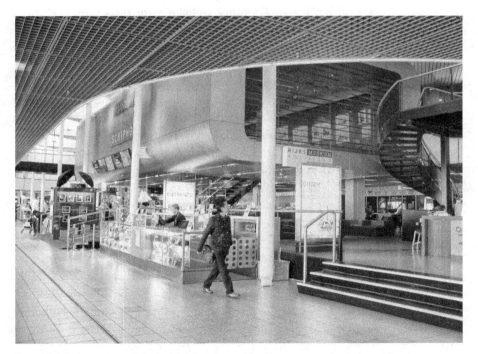

Figure 2.3 Rijksmuseum Schiphol Amsterdam—'the first museum in the world to have an annexe in an airport and ... the first airport to have a museum in its terminal' ('Rijksmuseum Schiphol', http://www.rijksmuseum.nl/tentoonstellingen/schiphol, accessed 9 April 2012). (Photo: M.R. Bouquet)

The programme devised for the period of closure included an abbreviated 'Masterpieces' exhibition in the Philips Wing, which remained open while the Rijksmuseum was under renovation. Satellite museums were established, either by loaning collection items to other museums or, as in the case of the Rijksmuseum Amsterdam Schiphol, by establishing an innovative satellite museum aimed at giving air travellers in transit a taste of Dutch art. In addition, there was a contemporary arts programme (with a budget of 1 per cent of the renovation costs), interventions by international artists including film-maker Peter Greenaway (*Nightwatching*) and Damien Hirst (*For the Love of God*) and hard-hat tours through the decommissioned building (see Chapter 5). Greenaway's and Hirst's interventions were set in the interim 'Masterpieces' exhibition in the Philips Wing. Bringing together historical objects and some paintings (downstairs), and mainly seventeenth-century Dutch paintings and some objects (upstairs), the interim museum served as a testing ground for that combination of art and history to which the New Rijksmuseum is committed.

Greenaway's multimedia installation was part of the Holland Festival (2006) and dramatized Rembrandt's *Nightwatch* painting by focusing on those portrayed and allowing them to tell their stories as part of a murder plot (see Greenaway 2006). After viewing Greenaway's filming of his plots on multiple screens, in an antechamber, visitors could proceed to the *Nightwatch* room and view this great painting from a specially constructed tribune, with lighting and sound effects. Greenaway later brought out a film, *Nightwatching*, although this never captured the public imagination in the way the filmed *Da Vinci Code* did. Hirst's 2008 intervention included both the installation of a diamond-studded skull in a darkened room and the artist's selection of seventeenth-century Dutch paintings (from the Rijksmuseum's collection in storage) arranged in the adjacent room. The contemporary art programme had artists reflect on the building, the collection and such typical museum practices as restoration. The programme included Germaine Kruip's light installation, *Rehearsal*, which illuminated Cuypers's emptied building from the inside during the winter of 2005–2006. Bikvanderpol's *Fly Me to the Moon* was a meditation on the social life of a piece of moonrock donated to the national collection by former Dutch premier Willem Drees's family after his death (Bikvanderpol 2006). Although *NG-1991-4-25* was subsequently unmasked as a piece of fossilized wood, this only augments its heritage interest. Simon Starling's high-tech triplication of another collection item—Artus Quellinus's damaged clay model for the figure of Atlas on the Amsterdam Town Hall—was followed by the deliberate breaking of the three replicas, from plinths of different heights in the atrium of the Rijksmuseum's Ateliergebouw (Bouquet 2008; Zonnenberg 2008). The three restored models are now on permanent display in the Ateliergebouw atrium.

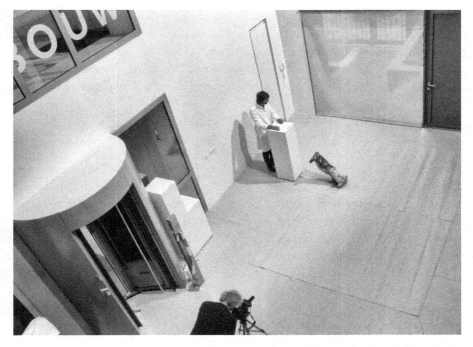

Figure 2.4 Simon Starling dropping one of the three replicas of Artus Quellinus's *Atlas* sketch in the atrium of the Rijksmuseum's Ateliergebouw, 18 April 2008. (Photo: M.R. Bouquet)

Major renovation and refurbishment at home contribute to the international profile of national museums. As a state project, the new Rijksmuseum received a large government financial commitment (€100 million) in 1999. The Ministries of Education and the Environment have been actively engaged as partners with the Rijksmuseum in the project. The museum bears a clear responsibility not just for keeping and displaying the nation's cultural heritage but also for bringing it into the present by making it accessible to its publics. To cater for large numbers of foreign tourists, as well as the Dutch public, it was decided that the museum needed proper facilities to receive them, as well as a redesign of the display of its unique collections of art and history. Renovation was defined in terms of 'going further with' Cuypers's building and decorative programme, and at the same time modernizing it with the latest technical systems. Although Cuypers's combination of decoration, colour and architecture was thoroughly researched, this did not mean 'going back to Cuypers' in any literal sense. The decorations were restored where this was deemed compatible with current design ideas. Elsewhere, decorations were uncovered and studied and then, as it were, put once more to rest. The Sevillian architects Cruz y Ortiz, whose design for the New Rijksmuseum won the competition, aimed to create a welcoming public space by

'going further with Cuypers': by better integrating the building into its immediate surroundings (the garden) and by opening up and connecting the two former inner courtyards beneath the central passageway to create a light and spacious reception area. The interior design of the New Rijksmuseum, by the French architect Wilmotte, aims to integrate the art and history collections while respecting Cuypers's building.

CONCLUSION

The transformation of the nineteenth-century national museum was an inevitable economic and cultural development. These museums are currently characterized by apparently diverging tendencies: on the one hand, by the establishment of overseas *dépendances*, or satellites closer to home; and on the other, by mega-renovation/expansion of the original site. In both cases, collection visibility and public access have high priority so that these dynamics are complementary rather than divergent. The international public, which has become the de facto majority audience, has played a major role in stretching the museum in new directions both on- and off-site. Some of these developments were already incipient in the nineteenth century: De Stuers's Rijksmuseum was a conglomerate of museums, and international visitors were already taken into account in the construction of this 'national symbol'. The satellites and *dépendances* of today are conspicuous exercises in collection use at strategic nodes on the international stage.

The loan of some national possessions helps to offset the (relative) immobility of certain masterpieces which museums are reluctant to lend. Meanwhile, national museums also provide a space of projection for the public imagination, which finds expression in literature and film and may reconverge in the museum as a thematic tour. Mega-renovation of national museums can open up a space for reflection on various aspects of this public institution.

KEY CONCEPTS

Semiophore	Museum as a ritual site
Collection	*Dépendance*
Universal survey museum	Mega-renovation
Theatrum nationis	Inalienable possessions
Exhibitionary complex	Giving while keeping
Imagined communities	Transmedial recursivity

EXERCISES

1. Visit any national museum, locate what you consider to be its masterpiece(s), and explain why.
2. Analyse the route from the entrance to the key masterpiece. Does this route constitute a narrative?
3. Are there important national works that are not in the national museum? If so, where are they, and why?
4. Which public(s) does this museum serve?
5. Which strategies does the national museum employ to actualize its collection?

FURTHER READING

Belk, R. (2006), 'Collectors and Collecting', in C. Tilley, W. Keane, S. Küchler, M. Rowlands and P. Spyer (eds), *Handbook of Material Culture*, London: Sage, pp. 534–45.

Boswell, D. and Evans, J. (eds) (2004 [1999]), *Representing the Nation: A Reader. Histories, Heritage and Museums*, London and New York: Open University/Routledge.

Duncan, C. (1995), *Civilizing Rituals. Inside Public Art Museums*, London and New York: Routledge.

Duncan, C. and Wallach, A. (2004 [1980]), 'The Universal Survey Museum', in Bettina Messias Carbonell (ed), *Museum Studies. An Anthology of Contexts*, Oxford: Blackwell, pp. 51–70.

Sloan, K. (2003), '"Aimed at Universality and Belonging to the Nation": The Enlightenment and the British Museum', in K. Sloan with A. Burnett (eds), *Enlightenment: Discovering the World in the Eighteenth Century*, Washington, DC: Smithsonian Books, pp. 12–25.

3 A HISTORY OF ETHNOGRAPHIC MUSEUMS

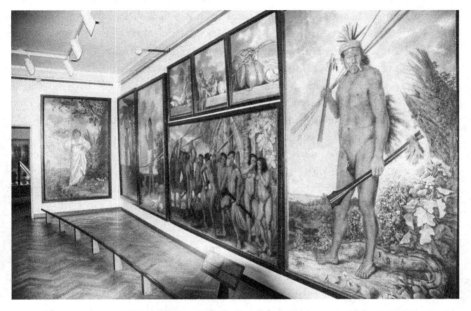

Figure 3.1 A number of Albert Eckhout's ethnographic portraits in the 'Peoples of the Earth' exhibition at the Danish National Museum, Copenhagen. From left to right: *mameluca*, Brazilian man, dancing Tapuyas, still lifes, Tapuya man, 1641–1643. Presented to Frederik III of Denmark by Johan Maurits in 1654. (Photo: H. J. de Haan)

INTRODUCTION

'An ethnographic museum', wrote Philip Franz Siebold in a letter to King Willem I of the Netherlands in 1837, 'is a scientifically arranged collection of objects from different lands—mainly outside Europe—which both in their own right and in relation to other objects, further acquaint us with the people to whom they belong. Placing before our eyes their religion, manners and customs, the museum provides us with a clear idea of the state of their arts and sciences, their rural economy, handicrafts, industry and trade' (1937: 63).

This simple statement was, in 1837, little short of a manifesto: Siebold was publicly enlisting the king's support for establishing a public ethnographic museum in the Netherlands.[1] Some of the reasons why Siebold felt that the Netherlands should have such an institution were quite specific to national circumstances; others, however, were of a more general nature. Ethnographic museums, along with other sorts of specialized public museums, were in the process of being invented during the nineteenth century. This chapter discusses some of the main processes involved in that invention, with concrete illustrations concerning various institutions. The aim is to provide insight on the specific characteristics of nineteenth-century public ethnographic museums, including the sources from which their collections were drawn, the nineteenth-century exhibitionary complex of which they were part and the geographical and typological classificatory systems and exhibitionary techniques they used in addressing various publics. This configuration reflects, by the very nature of the objects, institutions and people involved, a complex tangle of national and international interests. Diverse examples, rather than an in-depth chronological treatment of one or two institutions, are used to explore these developments. Siebold's manifesto offers various points of reference to grasp the nuances given by some of these institutions to the issues involved. Although the public ethnographic museum is an essentially nineteenth-century creation, brief excursions backwards into the seventeenth and eighteenth centuries as well as forwards into the twentieth century are sometimes needed to glimpse the beginning or the end of a process.

ETHNOGRAPHIE—AN ENLIGHTENMENT TERM

The term *ethnographie* entered Enlightenment scientific discourse during the second half of the eighteenth century. Scholars in German-speaking countries and in Russia first came up with the neo-Greek terms *ethnographia* and *ethnographie*, which were used as synonyms for the German *Völkerkunde*—literally, the science of peoples (Vermeulen 1996). Diverse scientific developments reflected a new concern with the universal study of humankind: the French *philosophes* were mainly interested in the comparative study of moral systems (the 'spirit' of laws and nations); primitive peoples played an important role in the theories of the Scottish Enlightenment moral philosophers, who tried to show how human society developed. German Enlightenment thinkers also studied universal history, and *Völkerkunde* became a new area of study. *Völkerkunde* (ethnography and ethnology) became, from the 1770s onwards, a discipline related to history, geography, natural history, anthropology, linguistics and statistics. The subject enjoyed great popularity due in no small part to eighteenth-century expeditions to the Pacific and elsewhere, as well as to the romanticization of noble savages (Sloan 2003).

THE ETHNOGRAPHIC MUSEUM: A PUBLIC INSTITUTION

This late-eighteenth-century interest in the universal study of humankind found further expression in the early-nineteenth-century establishment of ethnographic museums and ethnological societies. There was, however, more to this invention of public ethnographic museums than the ferment of intellectual ideas. Strange objects from faraway places had long exercised a fascination of a more popular kind over the European imagination. Nonetheless, it was only in the nineteenth century that collections comprising these objects were opened to the general public for explicitly educational and recreational purposes. A number of general tendencies were involved in that innovation, as well as local differences in interpreting and realizing a public ethnographic museum in several European national contexts. Siebold's treatise captures the novelty of nineteenth-century developments: the orderly presentation of these mainly extra-European collections was for 'us', for an audience that later in the nineteenth century came to be synonymous with *the public*. This audience comprised both public servants and *citizens* of the nation state, who, in being educated about the state of the arts and sciences, agriculture, handicrafts and trade of peoples of the wider world, were at the same time gaining a new perspective on their own place in that world and in relation to others. Around 1900, the modernist avant-garde recognized the compelling aesthetics of collection pieces from outside the Western art historical canon (Clifford 1988; Myers 2006).

Collections including non-Western objects (such as weapons, ornaments and clothing) had been in existence for as many centuries as European powers had been exploring, trading with and conquering peoples in Asia, the Americas, Africa and Australia. What distinguished nineteenth-century ethnographic collections from their precursors was the creation of specialized *public* institutions for their accommodation: they were not only open to the public but also financially supported by government as being something positive for the people. As public institutions, the explicit aim was to display the peoples of the world in such a way as to make difference both visible and intelligible. As will become apparent, there were various views on how this public task might best be accomplished: while some exhibitions were geographically organized and functionally arranged within regions (the Ethnographic Department of the Danish National Museum, Copenhagen), others opted for typological displays (Pitt Rivers Museum, Oxford), while yet others adopted picturesque panoplies (Musée du Trocadéro, Paris), which might be combined with a classical art museum aesthetic (National Museum of Ethnology, Leiden). These modes of display were related to contemporary scientific theories, notably Darwinian evolutionism, and more general ideas about progress and social evolution. The idea that there was a progression was widespread. Small wonder, then, that Siebold's letter quoted earlier

betrays the urgency of establishing an ethnographic museum in the Netherlands: he enumerates so many sound reasons for having this institution that by 1837 it seemed almost backward to be without one.

Where and how did these new public institutions obtain their collections, and what sorts of things did they comprise? Some were 'inherited' from earlier private collections; others were acquired as part of particular national (and often imperial) activities by nineteenth-century nation states. The everyday things that were collected and the manner in which they were obtained tended to bolster popular ideas about the superiority of the collecting peoples over those being collected from; among the collecting nations themselves there was a rivalry suggesting that social evolutionary ideas left their mark at a symbolic level that was played out at world exhibitions and in public museums. Possession of a fine and varied ethnographic collection expressed the power of the acquiring nation to command these objects from the farthest corners of the globe, whether by virtue of their own empires or via the complex networks that existed between their respective museums. As world exhibitions shifted venue, the hosting nation had the opportunity quite literally to display not only elements of its own ethnographic collections amongst the displays of technological progress but also those of other (visiting) nations (Bloembergen 2002).

In looking into the circumstances surrounding their invention as well as local differences between the public ethnographic museums that developed in the nineteenth century, each part of the chapter deals with one of the issues mentioned in the preceding by referring to concrete examples. We look first at the prehistory and transformation of ethnographica through what is claimed to be the oldest public ethnographic museum in the world: the Ethnographic Department of the Danish National Museum, which first opened in 1825 (see the following). Then, we look at ways in which the new public ethnographic museums of the nineteenth century acquired ethnographica, including gifts, purchases, exchanges between institutions and scientific expeditions, producing novel public involvement in the collection. The nineteenth-century exhibitionary complex situates the ethnographic museum within broader sociopolitical developments such as world exhibitions (for example the 1851 Great Exhibition in London), in which ethnographica played a particular role vis-à-vis the products of industry and progress—and were used to found or augment museum collections in the exhibitions' aftermath. The distinctive reasons for having ethnographic museums in the Netherlands, Denmark and Britain are briefly considered.

Notions of change and progress connected with scientific theories were embodied in the systematic classificatory systems underpinning nineteenth-century public ethnographic museums. Siebold's systematic classification is discussed, as well as the typological organization of the Pitt Rivers Museum, Oxford. Finally, we consider

aesthetic aspects of ethnographic museum buildings, ways of exhibiting ethnographica ('art' vs. 'picturesque') and ceremonial uses of ethnographic museums in three European museums and one African museum.

THE FIRST PUBLIC ETHNOGRAPHIC MUSEUM IN COPENHAGEN

The recasting of certain elements of already-existing collections combined with active, systematic pursuit of new accessions was one important dimension of the new public ethnographic museum. The Royal Danish Ethnographic Museum opened to the public in 1849; the ethnographic *collection* had already opened to the public in 1825, as part of the *Kunstmuseet*, which makes it worth looking in more detail at what happened between these two dates. The Danish case also exemplifies the migration of a collection from a seventeenth- and eighteenth-century royal *Kunstkammer* into one of several specialized museums for the general public in the nineteenth century (Dam-Mikkelsen and Lundbæk 1980; T. Thomsen 1937). A number of ethnographic items still in the Danish National Museum today can be traced back to the seventeenth-century royal collection, indeed even back to Dutch private collections. It is instructive to see (more generally) how the contents of the original *Kunstkammer* were classified and arranged in the seventeenth, eighteenth and nineteenth centuries, as scholars have been able to determine using inventories dating from 1689, 1737 and 1825. During the nineteenth century, the general public was involved in building up the new national museum both as collection donors and as audience.

The final stages of work on the new Danish ethnographic museum began in 1837—the same year Siebold was addressing the Dutch king. When Christian Jürgensen Thomsen was appointed head of the *Kunstmuseet* in 1839, he took charge of a remnant of the old Royal Art Museum (*Kunstkammer*) founded by Frederik III in 1650, and from it selected items for the new ethnographic museum. This *Kunstmuseet* nucleus of several hundred objects reflected both the inclusiveness of the category *kunst* (art) as well as the breadth of Danish exploration and contacts worldwide. For example Frederik III sent expeditions to Greenland in 1652, 1653 and 1654 'to exploit whatever the land had been blessed with by God' (cited by Dam-Mikkelsen and Lundbæk 1980: 4); among the items brought back were hunting implements as well as a picture of four Greenlanders painted in 1654.

Similarly, North and South American objects, such as tobacco pipes, feathered ornaments and weapons, as well as twenty-six life-size paintings of Brazilians, Indians and Africans by Albert Eckhout, presented to Frederik III by Johan Maurits of Nassau in 1654, were also included in the *Kunstkammer* as ethnographic rarities.

Nigerian ivory carvings, Angolan basketry and textiles, weapons and ornaments were also part of the collection that devolved to the nineteenth-century *Kunstmuseet* (art museum); likewise, arms and military equipment, textiles, footwear and ceramics from the Ottoman Empire.

Collections were in Frederik III's time the province of kings, aristocrats, prosperous citizens and scholars, who travelled specially to visit the famous European cabinets of curiosities. Frederik travelled to both France and the Netherlands in 1628–1630 and became Prince Bishop of Bremen from 1634 to 1644, which would have given him ample opportunity to visit collections and to start acquiring his own. The Danish physician Ole Worm was especially inspired by visiting in 1611 the *Kunstkammer* at Kassel, one of the richest and most renowned collections of objects of art and nature of the German Renaissance. Kassel was a high-ranking destination for scholars on the European circuit of such cabinets, which also included the first great universal collection of the Enkhuizen physician Bernardus Paludanus (which indeed Worm also visited). The passion for collecting ethnographic objects would certainly have been encouraged by those seen in other people's collections in the course of such a tour, as well as providing the necessary contacts for Worm to start his own in Copenhagen. Around 1650, ethnographic material in museums such as Worm's was mainly classified under *artificialia*—objects being grouped according to the substance from which they were made. Worm's ethnographica included an Iroquois pipe bowl, a basket from Angola, an ivory figure and a geomantic compass from China and a Turkish bow and quiver (Dam-Mikkelsen and Lundbæk 1980: xxxiii). After his death, Worm's museum was incorporated in Frederik III's *Kunstkammer*.

By about 1653, Frederik III's collection had taken over eight rooms of the royal palace. The oldest inventory of the *Kunstkammer* indicates that these rooms were organized according to certain principles: the first room was for 'natural objects' and the second for 'art objects'; the third was called the 'gun room'; the fourth was a 'picture room'; the fifth a 'mathematical cabinet'; the sixth an 'East Indian cabinet'; the seventh a 'medal cabinet'; and the eighth a 'model cabinet'. Beyond the old division between naturalia and artificialia, there were now further spatial and classificatory distinctions concerning weapons, pictures, medals and models. The East Indian cabinet is particularly striking with regard to the historical development of the ethnographic collection: the name suggests that the majority of the collection came from the East. However, it appears that objects from all over the world were collected here. By the early 1660s, the king's library and *Kunstkammer* had become so full that it was necessary to move them from the palace to new premises, which were ready by the early 1670s. In this new building, called the *Kunstkammer* building, different sorts of collections were distributed over the three floors: the arsenal occupied the ground floor, the library was on the first floor and the *Kunstkammer* on

the second. A ground plan from 1737 shows how two spiral staircases, one on each side of the building, gave access to the *Kunstkammer*.

Ethnographica were distributed over several of these rooms: the new Indian Cabinet comprised mainly objects from China and the East Indies, but also some from elsewhere; the Artificial Cabinet contained various sorts of objects of human manufacture: paintings, sculptures and objects of silver and other metals, of bone and wood, of amber and wax, of straw and paper, of glass and other substances—some of which originated from outside Europe. The Cabinet of Natural Objects included rare as well monstrous things from land and sea, earth and air, as well as a few objects of human manufacture made of materials such as bone, skin or feathers. The principles of classification were much the same as those used when the collection was still at the palace in the seventeenth century.

The *Kunstkammer* not only absorbed three other museums, including Worm's, but also started to reassign items during the eighteenth and early nineteenth centuries: astronomical instruments were dispatched to the observatory, while coins and medals went to the royal numismatic collection at Rosenburg. These steps were taken by successive *Kunstkammer* keepers, most of whom seem to have been unable to keep up with the work of inventory. By the beginning of the nineteenth century it was decided to reorganize the collection according to new scientific ideas—and to try to avoid further deterioration. The foundation of distinct academic disciplines, each with its own museum, was one of the scientific developments that contributed to this process: the newly developing science of humankind—ethnology or anthropology—was closely associated with the emergence in this period of ethnographica as a subdivision in its own right.[2]

Recommendations included a proper description of all items (for security purposes), more space, correct storage conditions, a new inventory, proper classification, what was seen as 'tasteful arrangement' and the 'elimination of irrelevant material' (Dam-Mikkelsen and Lundbæk 1980: xxiii). Many items from the Model Cabinet ended up at an auction held in 1811 to dispose of unwanted things. Seven expert committees were charged with the task of classifying the different groups of objects into which the new 'art museum' (*Kunstmuseet*) collection was to be divided: (a) paintings, (b) Nordic antiquities, (c) classical antiquity, (d) modern genuine polished stones and precious objects, (e) ethnographica and (f) carved and turned pieces. The important point is that natural and scientific objects were assigned to other collections. The category of Nordic antiquities indicates the new preoccupation with the origins of the settlement of Scandinavia, which was connected with the rise of nationalism, for example in Norway. The Art Museum (*Kunstmuseet*) was thus distinguished from the Curiosity Cabinet (*Kunstkammer*) as the place for manmade or -fashioned objects from all over the world, ranging from ethnographica to

antiquities (from the ancient world and also Scandinavia), precious stones and an incipient arts and crafts collection.

Each piece was classified into an appropriate department and labelled accordingly; objects that did not fit into one of the 'art object' categories were moved elsewhere. One of the objects originally in Worm's cabinet, 'the lower jaw of a horse, so joined to an oak branch that no traces of its insertion remain', was sent to the new Museum of Natural History in 1824, which became the Zoological Museum in 1862 (Wolff Purcell and Gould 1986). A Javanese spearhead, an Angolan basket and a Chinese geomantic compass from Worm's collection, on the other hand, were sent to the *Kunstmuseet* (Art Museum). So, too, were the twenty-six paintings by Albert Eckhout which had been part of the 'Indian Cabinet' in the *Kunstkammer*.

When the *Kunstmuseet* opened in 1825 (after transferring to new premises in 1823), the ethnographic commissioners had still not completed their task—reflecting the dilemmas of classification they faced. Once the space of the *Kunstmuseet* had been divided up, the objects were rearranged according to their labels, so as to bring together objects belonging to the same category at this particular juncture. After this distribution the objects were numbered and described. By 1827 the ethnographic commissioners had come up with a system that disaggregated objects earlier classified as 'East Indian' into geographically more specific areas: ethnographic objects were thus divided between (a) Japan; (b) China; (c) India East of the Ganges; (d) India West of the Ganges; (e) Persia; (f) Arabia; (g) Africa; (h) America; (i) Australia and the Pacific; (k) Russian, Finnish and Tartar objects; (l) Lapland, Finland, Greenland, Iceland; (m) Turkey; and (n) Miscellaneous objects (Dam-Mikkelsen and Lundbæk 1980: xxiii). Objects assigned to a geographical region were then organized according to function: (a) religious objects, (b) arms, and (c) tools, implements, art objects and ornaments. The origins of this collection reflect long-standing trading and other connections such as those among collectors, as mentioned earlier.

THE PUBLIC STAKE IN THE NINETEENTH-CENTURY ETHNOGRAPHIC MUSEUM

After C. J. Thomsen's appointment in 1839, he made a selection of materials from the *Kunstmuseet* for the new ethnographic museum; however, the main impetus for the collection came from another source. Denmark still had colonial possessions in West Africa, India, the Nicobar Islands and the West Indies—as well as Greenland. Thomsen's view was that, as a maritime state with colonial possessions, Denmark was a 'natural place' for such an institution (cited in T. Thomsen 1937: 309). The situation was in fact no more favourable or natural in Copenhagen than in several other European nations. Similar arguments were used in different places

to achieve the same goal, emphasizing the competitive nationalist edge to the ethnographic museum as an institution. If Thomsen began by securing systematic collections from the Danish colonies, his plan was to include *all* non-European peoples in the museum. He aimed to assemble representative series of objects that would provide knowledge of humankind under the various conditions of climate, race and religion prevailing in the world. Despite the limited means available to him, Thomsen succeeded in mobilizing colonial officials, merchant captains and Danish businessmen throughout the world as enthusiastic donors to the collections. Indeed, only a year after opening in 1841, the museum had to move due to overcrowding, reopening in 1849 as the Royal Ethnographic Museum in the Prince's Palace, where it occupied forty-four rooms on three floors. The collection continued to grow and, in 1892, was to combine with other public collections that had meanwhile also moved to the Prince's Palace to become departments of the National Museum.

The voyage round the world of the Danish corvette *Galathea* (1845–1847) gave C. J. Thomsen another opportunity to acquire objects from the places visited: pre-Columbian earthen vessels from Peru, Hawaiian feather-work and Indian temple bronzes from Tranquebar were among the additions to the collection from this source (T. Thomsen 1937: 310–311). Towards the end of the nineteenth century, the Danish missionary Eduard Löventhal managed to obtain many stone sculptures from ruined temples in Mysore together with a large folk collection from southern India. Plantation owners, merchants, diplomats and bankers were among those who were drawn into the museum circle. Exchange of what were referred to as 'duplicate' objects (*doubletten*, in the sense of closely resembling one another) was another way in which museums built up their collections during the nineteenth century; Copenhagen and Washington swapped such objects in 1868. A huge number of scientific expeditions took place in the nineteenth century, building on an already well-established eighteenth-century practice and one that was to continue into the twentieth century. These expeditions collected on a much grander scale, documenting and archiving the natural history and ethnography of remote places more precisely—often at the behest of colonial administrations. These expeditions provided yet another supply channel for the museum.[3]

The prestige attached to donating such gifts to the Royal Ethnographic Collection was an incentive for those citizens able to respond to Thomsen's requests. The fact that the *royal* collection became the *national* museum during the second half of the nineteenth century suggests that nationalization of this royal property transformed it into an important unifying symbol for the Danish nation state. These donors, first to the Royal Ethnographic Collection and later to the National Museum, had prestigious stakes in the ethnographic museum. As with other public museums, the

ethnographic museum allowed visitors from the new proletarian classes to experience being on the side of the powerful (Bennett 1995). Where kings, aristocrats, scholars and educated, well-heeled citizens were, in earlier centuries, both the owners and the (more restricted) audience for such collections (including botanical and zoological gardens and anatomical theatres), museums were now opened up to the people. The opening of the Louvre Palace to French citizens (1793), discussed in Chapter 2, established an important precedent and significantly altered the power relations embodied in collections. In Britain and Germany, this referred specifically to working-class access. In Denmark, too, the general public, which included working men, soldiers and children, flocked to the museum to enjoy C. J. Thomsen's personal guided tours through the exhibitions (T. Thomsen 1937). However, T. Thomsen (ibid.: 310) notes that 'the aloof, superior scholars of the day made fun of this public', demonstrating that class divisions were by no means collapsed through the mere opening of previously restricted collections. The peculiar significance of the ethnographic museum (and also of world exhibitions) lay in creating the spectacle of others arrested at some putatively earlier stage of development, thereby diverting attention away from internal class divisions and serving symbolically to unite the museum's national audience (Coombes 1988). Looking at the varyingly 'wild', 'savage' or anyway 'exotic' peoples signified by the collections gave the viewers a feeling of belonging to a superior level of civilization (for example in terms of technology but also of manners and customs), not least by the simple fact of *being able to* gaze on them in this way (cf. Saunders 2005).

ETHNOGRAPHICA AND THE NINETEENTH-CENTURY EXHIBITIONARY COMPLEX

ENTERTAINING AND EDUCATING THE PUBLIC

One of Siebold's arguments to King Willem I was that an ethnographic museum provided both amusement and education for the general public. In addition to satisfying public curiosity, he argued, such museums were instructive, diffusing almost imperceptibly knowledge that would take much longer and be much more laborious to glean from literary sources (Siebold 1937). Museums, galleries and exhibitions were of great significance as educational and civilizing agencies during the consolidation of the nineteenth-century nation state and have been analysed in these terms as part of the exhibitionary complex, as discussed in Chapter 2 (Bennett 1995). World or industrial exhibitions were part of the exhibitionary complex. One of the key features of these exhibitions was the display of advanced technologies and products in

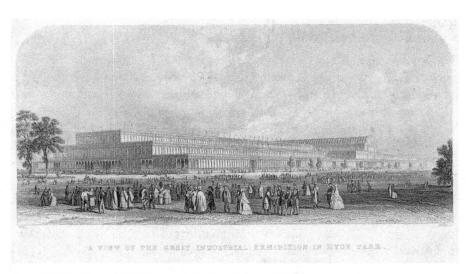

Figure 3.2 The Great Exhibition in Hyde Park, London, 1851 (private collection).

the same exhibition space as ethnographic objects (such as figures, weapons, implements and clothing), which established a new distinction: between citizens of the (progressive, civilized) nation and 'others' who inhabited the far-flung territories of the empire (ibid.: 67). New architectural forms also contributed to the visibility of both exhibitions and visitors, so that the latter kept one another under observation, thereby encouraging emulation of bourgeois manners and conduct by the newly admitted masses (cf. Coombes 1988: 61). The Crystal Palace in London is a prime example of this sort of architecture. In addition to the display of ethnographic objects as such, native villages were often reconstructed in the exhibition grounds, thereby extending into the industrial age a practice of exhibiting people that went back several centuries.

The public assembled outside the Crystal Palace for the 1851 Great Exhibition appeared to include people dressed in Indian attire, in addition to the soldiers and bourgeois visitors, who are prominently present. Hence the popularity of nineteenth-century ethnographica went beyond collections of artefacts: ethnographic 'types' (which included European rural dwellers as well as colonial subjects) were also on display—whether as figures in exhibitions, as performers in a spectacle (the native village) or indeed as part of the public, looking and being looked at. Ordinary citizens could thus *see* otherness in an apparent contrast with their own national population and its supposed progress.

TRAINING PUBLIC SERVANTS

Many ethnographic museums took shape in the wake of the great industrial or universal exhibitions of the nineteenth century: for example, although ethnographic objects had been part of the British Museum's collection since its foundation in 1753, the ethnographic department was established only after the Great Exhibition of 1851 in London.[4] This connection was less direct in the Netherlands: Siebold's collection became a royal museum in 1838, while the Colonial Museum in Haarlem opened in 1871—preceding the Colonial Exhibition in Amsterdam (1883) by more than a decade. The decision to found the Colonial Institute and to move the museum from Haarlem to the monumental premises that opened in Amsterdam in 1926 did, however, gain momentum—and collection—through the Amsterdam Colonial Exhibition. The founding of the Royal Museum for Central Africa at Tervuren, Belgium, after the great Colonial Exhibition of 1897, provided another incentive for going ahead with the massive project in Amsterdam. The competition between nation states to show off their (colonial) possessions demonstrates the international as well as local dimensions of the exhibitionary complex.

Imperial powers vied with one another for prestige through these competitive displays, where the 'primitive' was used as a backdrop against which national progress could be gauged. Such exhibitions may also be seen as laboratories of museology, combining a framework for celebrating, indeed glorifying, colonialism with a 'visual apprenticeship' for the working-class public who had been recently admitted to museums (Dias 1991: 95). Yet there were significant differences, and in some respects ethnographic museums could never hope to emulate the spectacular popularity of world exhibitions. This had to do with the tensions between scientific knowledge versus popular education and enjoyment (already noted in the context of Copenhagen) and with the pedagogical role that was ascribed to such museums for public servants, especially evident in Siebold's treatise.

Siebold insisted on the value of the ethnographic museum as a source of knowledge for missionaries, administrators, officers, traders and seamen in preparing for their tours of duty. These public servants could acquaint themselves with the peoples they would be in contact with, in the comfort of their own country. Siebold could make this argument from personal experience since he himself had been in the service of the Dutch authorities in Decima, where he assembled his Japanese collection. Simply by looking at the objects on display, he explained, one could gain a clear idea of the level of civilization, the arts and sciences there and the people whom they hoped to convert, rule, trade with or otherwise manage, in an engaging and intelligent way. The exhibit would be so arranged that anyone seriously wishing for

instruction could, within the space of a few days, gain a clear image of the civilization, morals and customs of the inhabitants of an unknown land.

Another reason adduced by Siebold for getting to know the inhabitants of foreign lands at home was that of taking an enlightened and noble interest in one's fellow man; learning to see human qualities beneath strange appearances was deemed a mark of civilization. Learning to appreciate non-Europeans at home would promote better understanding when in their countries than several centuries of hearsay by supposedly civilized Europeans. Respect for other peoples' religious beliefs gained through an ethnographic understanding would, according to Siebold, further the missionaries' own goals. Appreciation of the raw materials and manufacturing processes involved in remarkable objects of trade was likely to stimulate the spirit of enterprise. Economists, craftsmen, manufacturers and architects would all find useful and worthy knowledge in the rural economy, tools, models, machines, buildings and ships made by people who had already formed a state for thousands of years. This reminder about the earlier stages of civilization was coupled with the observation that appreciation of the classical arts and sciences would be placed in proper perspective by showing examples of non-European literature, painting and other fine art in the ethnographic museum. It was thought that there was a scale of civilization: from the most primitive (usually Papuan or Aboriginal) to the most civilized (Chinese and Japanese) non-Western peoples.

This approach, emphasizing the usefulness of the ethnographic museum in preparing Dutch missionaries, traders, colonial administrators and seafarers for their work abroad, denotes one historically specific emphasis, in one European country. It was Siebold's way of making a case for bringing together into one national ethnographic museum the ethnographica from three different Dutch collections: the king's own Cabinet of Curiosities, the Overmeer Fisscher collection (also mainly Japanese) and Siebold's own mainly Japanese collection (see Effert 2003). His argument about the practical use of an ethnographic museum as a way of preparing public servants, traders and seafarers to better perform their tasks far from home referred to Dutch trading circumstances. Before 1854 no foreigners, apart from the Dutch, were admitted to Japan. The national significance of colonial interests in the East and West Indies during the nineteenth century would certainly have been accentuated by the 'loss' of Belgium in 1830. Belgian efforts to acquire colonial possessions in the latter part of the nineteenth century and King Leopold's project to build the Royal Museum for Central Africa at Tervuren would have been a further (competitive) spur.

The reasons for proposing a Dutch ethnographic museum were similar but not identical to those in other European countries. The university ethnographic museum that opened in Oslo, Norway, in 1857 became a rallying point for nationalism and the desire for independence from the Swedish-Norwegian union. Although Norway

had no colonies of its own (indeed, it was arguably a Swedish colony at the time), Norwegians travelled the world as sea captains and traders and in the service of other colonial states. Possession of a public ethnographic museum gave Norwegian nationalist longings a tangible focus, placing it on an equal footing with (for example) Copenhagen. The fact that the ethnographic collection was one of the university's scientific collections did not detract from its wider public—national—function. Indeed, the university setting (dating back to 1811 when Norway was still part of the Danish-Norwegian kingdom) if anything strengthened its nationalist appeal since successive directors made a point of opening the doors not only to wealthy benefactors but also to working people, for whom special evening guided tours were arranged (Bouquet 1996).

While Denmark was on the verge of dispensing with its colonies and trading posts by the mid-nineteenth century, Portugal was still bent on establishing a 'third empire' in the early twentieth century. The absence of a national ethnographic collection in Portugal during the Third Portuguese Empire was compensated by the development of the Dundo Museum in the Diamang concessionary area of north-eastern Angola from the 1930s onwards (Porto 2000). The case of the Dundo Museum prompts one further remark concerning the nineteenth-century exhibitionary complex: the founding of museums in the metropolitan countries of Europe was sometimes preceded by their foundation in colonial territories elsewhere in the world. The first museums (which included natural history as well as local cultures) were established in the white settler colonies of Charleston, in 1773, and Sydney, in 1821. Rio de Janeiro gained a museum in 1815, as did Cape Town in 1825. Museums in Batavia (1778) and Lucknow (1796/1814) were followed only fifty years later by museums in Latin America, Africa and Asia (Prösler 1996: 24). It is therefore important to note that although the worldwide multiplication of museums really took off after 1870, the museum was becoming a key institution for the formation of ideas about 'the world' as well as the identity of individuals and social groups across the world long before that time (ibid.: 26).

The concept of the sovereign 'nation' and the nation state as a particular form of social association went together with the emergence of a specific kind of human being: the individual conceived as a citizen, with loyalties, obligations and responsibilities to fellow citizens within the (nation) state which took precedence over kin groups. The fact that some of these museums *preceded* their European counterparts is perhaps less surprising when the museum is interpreted as an instrument for imagining communities, as Anderson (1983) has put it (see Chapter 2). The early museums made it possible for settlers to imagine the unfamiliar lands in which they had arrived, enabling them to construct a microcosm which they could order and control. Siebold's argument about the value of an ethnographic museum *at home*, in the

nineteenth-century public context, was also concerned with enabling those who had never travelled there to imagine the peoples whom their fellow countrymen were conquering, administrating, converting and educating.

CLASSIFICATION: GEOGRAPHICAL, MATERIAL, FUNCTIONAL AND TYPOLOGICAL WAYS OF ORDERING ETHNOGRAPHIC COLLECTIONS

Public museums had to show things in an intelligible way in order to convey information to the people who now had access to them. This section deals with two important ways of organizing ethnographic materials in the nineteenth century: Siebold's treatise from 1837 provides insight on the motives for a geographically based classification, while the Pitt Rivers Museum in Oxford exemplifies the typological approach. The Leiden collection was divided into three parts, yet most visitors were more impressed by the quantity and unfamiliar nature of the objects than by Siebold's systematic classification (Effert 2003: 139–140). The written version of Siebold's classification, available to visitors in both Dutch and French, was clearer than the arrangement of the 'Japanese museum' itself.

SIEBOLD'S SYSTEMATIC CLASSIFICATION (LEIDEN, 1837)

To realize the double public agenda of a museum both for the general public and for public servants, Siebold's proposal to the king included some basic principles for assembling, classifying and arranging ethnographic objects in an instructive way. The fact that this systematic arrangement was written in French, while the rest of the request to the king was in Dutch, is significant. It meant that the scheme was internationally accessible to, for example, Christian Jürgensen Thomsen at the Ethnographic Museum in Copenhagen and Edme-François Jomard at the Musée du Trocadéro in Paris, with both of whom he was in contact. In seeking to systematize the new public ethnographic collections, curators consulted one another and exchanged and adapted ideas. While the eighteenth-century inventory of the Copenhagen *Kunstkammer* shows that geography and function were the criteria used to order collections, the nineteenth-century addition of public educational goals to ethnographic museums invested both of these criteria with new meaning. Walking through and looking at this carefully constructed narrative had a deliberate purpose (cf. Bennett 1995).

The emphasis on materials and level of sophistication achieved in using them was associated, in this system of classification, with the general condition of the people

Siebold thought that classificatory activities should be limited initially to those objects relating to 'our East Indies, our West Indies possessions, China, Japan (with other lands added)'. These were the principal areas from which most objects in the collections known to him came. Taking Japan (thus a geographical unit) as an illustration, Siebold systematically ordered the collection into three main divisions: scientific objects, objects of national manufacture and a model collection. There is an interesting contrast between Siebold's (1830s) and the Copenhagen (1827) approaches to geographical classification: in Copenhagen the category 'East Indian' was disaggregated, while in Leiden 'Japan' stands as a model that can be applied to other regions. Siebold's further subdivisions were also rather different to those specified in Copenhagen (religious, military, industry and art). The first major class (scientific objects) was subdivided into three sections: printed books, manuscripts and woodcuts; drawings and pictures; and coins, medals and some archaeological objects. The second and largest class (objects of national manufacture) was arranged to show the state of the arts and crafts, in addition to the various tools in relation to manners and customs. Its first subdivision included raw materials (animal, vegetable and mineral) serving various manufacturing purposes, food and medication. Worked materials consisting mainly of simple substances formed a second category: skin, hair, feathers; silk; cord; straw, bark, reed; paper; papier-mâché; wood; sculpted works, ivory, bone, horn, scales; gold leaf; varnished and inlaid work; pottery, earthenware, bricks; porcelain and glass; stone; metal—gold, silver; copper, brass, iron and steel (vessels). Worked materials consisting of several substances, classified according to their use, constituted a third division: clothing; religious objects; arms; musical instruments; mathematical, surgical or measuring instruments; and games. As clearly stated, this vast array of 'objects of national manufacture' was classified from simple raw materials to complex compound artefacts, in order to show the condition or level of civilization of a people (or 'nation').

The third major class comprised the model collection: machines and instruments pertaining to domestic architecture (houses and buildings), hydraulic architecture (mills, bridges, dikes and sluices), naval architecture, vehicles and fire stations. Other subsections covered household equipment and tools, agricultural and fishing equipment, and machines and technical instruments. This inclusion of models in Siebold's scheme contrasts with the exclusion of this category of objects from the *Kunstmuseet* ethnographic collection in Copenhagen in 1827 (see earlier discussion).

concerned. If a geographically based systematic classification of the sciences, arts and crafts and technologies of a given 'nation' made sense for a *national* ethnographic museum, there was an underlying ranking of nations in terms of their achieved levels of civilization. The typological system that most clearly expressed such social evolutionary notions was, however, found in university or municipal (ethnographic) museums in Britain.

PITT RIVERS'S TYPOLOGICAL SERIES (BETHNAL GREEN—OXFORD—FARNHAM)

Lieutenant General Augustus Pitt Rivers (1827–1900) first became interested in the development of material aspects of culture during his military career while investigating the use and improvement of the newly introduced army rifle (Van

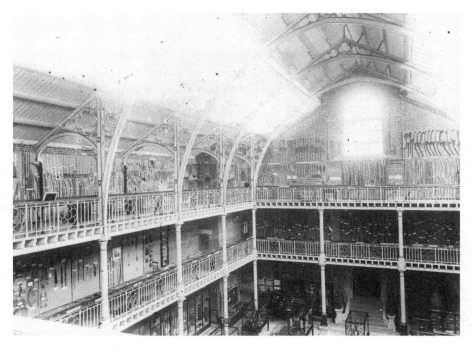

Figure 3.3 Interior of the Pitt Rivers Museum, taken from the Upper Gallery looking west towards the entrance from the University Museum. Shows the museum with its original glazed roof around 1890. © Pitt Rivers Museum, University of Oxford. 1998.267.94.1.

Keuren 1984). From analysing changes and modifications to the rifle, he developed a wider interest in the evolution of material culture: he collected weapons, navigational technology, art objects and ornaments, pottery, tools, religious equipment and clothing.

Pitt Rivers's interest in evolutionary processes derived from several different sources. He was inspired by Herbert Spencer's theories concerning natural selection and the survival of the fittest applied to the state, seen as a social organism evolving from 'primitive simplicity' to increasing complexity and differentiation. These ideas were closely related at source to those of Charles Darwin. The main difference between the two theorists lay in the application of their theories: Darwin's were applied to the natural world (including humankind) and Spencer's to the social and political organization of humankind. Pitt Rivers's excavations of prehistoric sites in Dorset and Acton were comparable to the work of leading prehistorians, which had uncovered the remote antiquity of humankind in Europe.[5] The deep historical time depths opened up by excavation made it possible to demonstrate the gradual evolution from

simple to increasingly refined artefacts. Social evolutionary theory and prehistoric archaeology combined with Pitt Rivers's earlier interest in firearms to find expression in sequences of types (or typologies) that demonstrated technological evolution. The main idea of selection and display was to show how one form led to another. Since the chronology of most prehistoric artefacts and primitive arts was uncertain, typological arrangement was held to be the most satisfactory interpretation.

Until 1874, Pitt Rivers's collection was private and kept in his London home. After he came into an inheritance in 1880, the collection expanded still further. This growth was a major reason for loaning the collection to the Bethnal Green Museum and, in 1883, giving it to Oxford University (14,000 objects). Before the gift to Oxford, the collection had been offered to the South Kensington Museum and the British Museum. Although Pitt Rivers reasoned that his offer would be an asset to the geographically organized collections of the British Museum, the trustees declined: they wanted neither the typological organization of the collection nor the collector's desire to keep control over it.

Pitt Rivers regretted that his collection would not go on exhibition to the large London audiences. However, despite the smaller public at Oxford there were advantages in becoming an adjunct to the University Science Museum at such an old and prestigious British university. While at Bethnal Green the ethnological collection was intended as an educational instrument for a popular metropolitan audience; at Oxford it was meant as a university teaching and research aid. At Bethnal Green the emphasis was on the evolution of weaponry; at Oxford it shifted to domestic and material arts, although weapons were still included. There had been series at Bethnal Green on the evolution of weaving and the origin of clothing, but other series were added in Oxford, with more objects—including prehistoric weapons and implements.

Pitt Rivers's typological series were used to order and display his collection in several different museums. Apart from Bethnal Green and Oxford, he later established a local museum in Dorset at Farnham. Here the potential audience was rural and much smaller, and the emphasis was on the evolution of peasant life in material culture. This local history museum showed agricultural implements and peasant handicrafts together with historical 'antecedents' from other parts of the world. There were series of pottery, peasant costumes, personal ornaments, agricultural tools and household implements—as well as finds from the excavations on Cranbourne Chase. Further attractions included free entry to Pitt Rivers's estate, low-priced refreshment, a private band and a recreation ground.

The late nineteenth century was a period of economic decline which led to unrest and political agitation in Britain. Pitt Rivers was a conservative who believed in gradual and moderate social change without major disruptions.

Scientific knowledge of natural laws and the gradualism of evolutionary change were embodied in the typological arrangement of the museum, but they also resonated with Pitt Rivers's broader political stance: if the 'masses' could learn their place in the social hierarchy, gradual change would inevitably follow in the course of time.[6]

Pitt Rivers's gift of his collection to Oxford University was accompanied by the endowment of a lectureship in anthropology, to which Edward Tylor was appointed. Tylor's *Primitive Culture* (1871) marked a turning point in the development of academic anthropology, which ultimately contributed to reorienting British anthropology *away from* material culture (Chapman 1985: 37). Tylor used the idea of evolution to study the development of society (as the science of *culture* in terms of—largely intangible—social institutions) rather than the development of *material* aspects of culture. This development was to endow the term *ethnography* with an entirely new sense in twentieth-century social and cultural anthropology, so that Pitt Rivers's typological series came to epitomize conjectural history and the Pitt Rivers Museum to resemble a cabinet of curiosities to the social anthropology of the early and mid-twentieth century. It should be added that Oxford is one of the universities where there has been a dramatic reconvergence between academic and museum anthropologies since the turn of the twenty-first century, as has occurred in many other places.

AESTHETIC AND EXPERIENTIAL CONSIDERATIONS INVOLVED IN EXHIBITING ETHNOGRAPHICA

Acquiring collections, classifying them and putting them on display for various kinds of publics involved elaborating grammars and techniques of display, for the public ethnographic museum was more than a collection and involved more than scientific knowledge alone. As a social artefact and a political institution, the aesthetic and experiential dimensions of the public museum were the definitive ingredients: the message(s) that unschooled people picked up as they walked through such an exhibition went beyond the scientific intentions of the makers.

THE CLASSICAL AND THE PICTURESQUE AT THE NATIONAL MUSEUM OF ETHNOLOGY IN LEIDEN

As with Oxford, the ethnographic museum in Leiden developed from the initiative of a private collector; unlike Oxford, however, Leiden was destined to become a *national* museum of ethnography rather than a *university* museum. Nonetheless, the

university played a considerable role in keeping the collection in Leiden and in the appointment of scientific staff and later lecturers. The lack of proper accommodation for the museum was also a major difference with Oxford, where the problem of space was to some extent solved by the typological arrangement that worked almost as a kind of exhibitionary shorthand: large quantities of slightly varying artefacts were so ordered as to demonstrate gradual change in form; geographical grouping and contextualization were unnecessary. Exhibiting different parts of the collection in domestic-scale accommodations in Leiden deprived this national ethnographic collection of the kind of setting that transformed art (and other kinds of) museums into secular ritual sites (see Chapter 2).

Despite the king's support for Siebold's proposal, the problems of accommodating and displaying the collection to the public were less easily resolved. Siebold's ambitions for a museum of ethnography that would constitute a 'national memorial' had to wait. It would take a century before the various collections that were purchased, donated, exchanged or specifically collected for Leiden could be housed with the necessary dignity under one roof. Although the collection was certainly visible before 1937, Siebold's litany of complaints indicates that the lack of suitable accommodation (that is one conforming to international standards) *was* a big issue in Leiden. The various regional collections were spread over several addresses in the town. This dismal accommodation scarcely corresponded with modern ideas about museum architecture, such as that found in Cologne, Stuttgart and Hamburg. However, Leiden defended its right to and its academic need for an ethnographic museum. The threat of being absorbed by Amsterdam, when plans were taking shape for the transferral of the Colonial Museum in Haarlem to magnificent new premises in the capital, may have given the necessary impetus for solving the accommodation problem. Despite an initial lack of enthusiasm for moving into the old Academic Hospital building in Leiden, there was eventually agreement, with the museum opening to the public in July 1937.

The new museum was geographically arranged, with Indonesia, the Pacific and Australia on the ground floor and Japan, continental Asia, Africa and America upstairs. Director Rassers writes of the sobriety with which the building had been converted and the exhibitions installed and of the care taken in exhibiting the 'works of art' (*Overzicht* 1937: 61), as he now referred to the objects. He specifically refers to the importance of proper ordering and enough space when designing an ethnographic exhibition for general public education. Siebold's ideas about being able to take in the characteristics of a people at a glance were translated into exhibitions showing characteristic objects (such as the Javanese gamelan) but also making extensive use of panoplies and of vitrines combined with figures (either singly or in groups).

The relative importance of Indonesia is clear from its prominent place in the building, the space devoted to it and the two genres of exhibition styles used for the

historical and ethnographic collections respectively. This emphasis reflects the great significance of Indonesia as a Dutch colonial possession, with long-standing trading, military, administrative and missionary contacts dating back several centuries. Hindu-Javanese 'art' occupied a hall and a sculpture gallery. These historical objects, attributed to an earlier, 'higher' civilization, stand as well-spaced, single pieces on plinths or as clusters in small cases, emphasizing the unique aesthetic qualities of each item. This classical way of displaying the art of a vanished civilization (reminiscent of Greek and Roman sculpture galleries) contrasts with the display of ethnographica collected from colonized peoples. The (free-standing) Dayak warrior group in the Borneo hall, located on the other side of the entrance hall from the Hindu-Javanese hall, was a striking example of this. The slightly asymmetrical composition of the Dayak group (one figure standing with a spear, the other sitting), flanked by high showcases (containing masks on the left and assorted objects on the right), was elaborated by three paddles hung vertically on the wall on each side of the centrepiece, between the figures and the showcases, and three round shields hung overhead to complete the scene.

The use of life-size figures to bring the ethnographic materials to life often produced a decorative language of display: ethnographic artefacts form miniature décors around figures, literally framing them in so picturesque and distinctive a fashion as to create visible ethnic groups. Such figures, representing ethnic types engaged in characteristic activities often connected with the original artefacts on display, were found throughout the ethnographic collection. Some figures were themselves in glass cases: the Samoan woman crouching to pound barkcloth in the Pacific section appeared, disconcertingly, to be caged. The educational aim of the figure, surrounded by cases containing barkcloth specimens, was to elucidate the process of manufacture. However, the aesthetic effect of reconstructing and freezing a moment in the process, using a crouching figure in a glass case, is to place the craft and the people associated with it in a time warp—beyond any incursive influences from the world outside.[7] Although this did not—yet—imply a reduction in the amount of material being collected and added to ethnographic collections, it did mean that an increasing proportion of the collection was assigned to the depot rather than the exhibition floor.

THE ARCHITECTURE OF COLONIAL ENTERPRISE: FROM HAARLEM TO AMSTERDAM

Whereas the National Museum of Ethnology at Leiden placed the emphasis on art, ancient history and foreign civilizations, the Colonial Museum in Haarlem was a museum of colonial products, which included not only the 'raw materials' used for Dutch manufacturing industry but also the handicrafts donated by members of the Dutch

colonial elite who had spent time overseas. The Haarlem museum was to become the first *colonial* museum in the world, and it was transferred to the largest building in Amsterdam in 1926.

The Colonial Museum, Haarlem, began in Frederik Willem van Eeden's private house in 1859. As secretary for the Society for the Advancement of Handicrafts he knew of many private collections, comprising all kinds of things from the colonies, in danger of deterioration. Van Eeden's ambition was to bring these collections together under one roof for scientific research and public education. There was considerable public interest, offers and gifts for the collection, so that by 1865 the government provided the museum with accommodation in the Pavilion Welgelegen (Van Duuren 1990).

The main focus of the Colonial Museum was on colonial products: nine of the twelve rooms were devoted to minerals, crops and their uses, while only three displayed indigenous handicrafts and creations. By 1908 the museum comprised sections with models of Indian houses and vehicles, weapons and musical instruments, Indonesian handicrafts and art, a wood-herbarium, plant products, minerals, zoological artefacts, fibres, waxes, gums, ethereal oils, quinine and opium, fruits and foods, and so on. The second floor was for research and study: there was the Map Room (with a large collection of maps, engravings, photos, watercolours of plants, negatives, illustrations and lantern slides), the Pharmaceutical Room (with medicines, herbs, seeds and fruits from all over the tropical world, together with a complete Chinese apothecary) and the Herbarium (with countless dried plants in portfolios).

In addition to the collection in Pavilion Welgelegen there were travelling school collections, which circulated with the aim of kindling public interest in the Dutch Indies from an early age. The ethnographic collections continued to grow both through private donations and via colonial exhibitions (Amsterdam, 1883) and other sorts of exhibitions. Military campaigns, scientific expeditions and administrators' personal efforts all contributed to the growth of the museum (Van Duuren 1990). When the new Colonial Museum opened in Amsterdam in 1926, the ethnographic collection numbered over 30,000 pieces. There were now three departments: Tropical Products, Tropical Hygiene and Ethnology. The Tropical Products museum was called the Trade Museum, although it later reverted to being the Museum of Tropical Products—as in Haarlem. The ethnological collection, mainly drawn from the East Indies, aimed to give a picture of peoples' lives in the colonies.

Apart from the collection itself, the building into which it moved served to frame it in a distinctive way. This massive monument to the colonial period was designed by the architect Johannes Jacobus van Nieukerken and sponsored by powerful colonial interests; it became the largest building in Amsterdam when it opened in 1926, after fifteen years' construction work. Decorative friezes on the outside of the building symbolize the meeting of East and West; there is a marble entrance hall where

the institute's founders and benefactors are immortalized, as well as thematic murals along staircases and corridors, and details referring to stories (such as the *kantjil*, the clever deer) worked into the pillars of halls. The ceremonial function of the building was exemplified in 1938 when it became one of the venues where Queen Wilhelmina celebrated her fortieth jubilee. The Colonial Institute marked the occasion with an exhibition tracing the development of Dutch overseas territories during those forty years. The exhibition included a group of colonial subjects standing in a semicircle around the sovereign's empty throne. The Queen never visited the East Indies; she did, however, perform ceremonial duties at the museum—such as opening it.

German occupation of the Netherlands in 1940 coincided with Japanese occupation of the Dutch East Indies, and the liberation of the Netherlands was closely followed by the Indonesian declaration of independence. Although this declaration was not initially accepted by the Dutch government, the official transfer of sovereignty took place in 1949. The former Colonial Institute in Amsterdam, which had optimistically adopted the name Indonesian Institute after the Japanese capitulation, became the Royal Tropical Institute in 1950. The Colonial Museum followed suit: what had been fleetingly renamed the Indonesian Museum in 1945 became the Royal Tropical Museum (Tropenmuseum) in 1950. The goals remained collecting and expanding knowledge, but these now extended to the entire tropical world. The colonial history of the institution (including architectural features, such as the museum entrance) was suppressed as far as possible (see Legêne 1999; Legêne and Postel-Coster 2000).

ETHNOGRAPHICA AND ART AT TERVUREN

How did the Dutch Colonial Museum in Amsterdam compare with the Belgian Royal Museum for Central Africa in Tervuren, which opened in 1909? One significant difference concerned the artistic content of the materials brought to Belgium at the turn of the century, as Wendy Morris (2001; see later on) has pointed out. The Belgian Congo Museum opened to the public in 1898 in the former royal residence and park at Tervuren, just outside Brussels. Animals, plants and ethnographica were specially imported to engage the interest and win the support of the Belgian public for the Congo Free State. Small colonial exhibitions held between 1885 and 1894 enjoyed only limited success in stirring public interest for the Congo. King Leopold therefore decided to use the occasion of the 1897 Universal Exposition in Brussels-Tervuren to organize a larger colonial exhibition at Tervuren, which had been a royal residence and park since the thirteenth century. The museum opened in the aftermath—in the 'Palais des Colonies' (Audenaerde 1994).

Such was the influx of collections that a new, larger building was soon needed. Architect Charles Girault was commissioned in 1902, and the neoclassical building

was completed in 1909 and opened by King Albert I in 1910. When Leopold II died in 1909, the Congo Free State became the Belgian Congo, and that change and the opening of the museum made it impossible for Belgians to ignore their colonial possessions. The Museum of the Belgian Congo became a popular afternoon outing for the inhabitants of Brussels. Despite the new building, the shortage of space remained an ongoing problem.

As in the Netherlands, military personnel and missionaries were significant sources of ethnographica for the museum. Objects were confiscated as trophies by Belgian officers during military campaigns and entered the museum either directly or via private collections—such as the one donated by General Storms's widow (Wastiau 2000). Missionary work frequently entailed either destruction or confiscation of indigenous ritual objects. These might be kept in missionary collections in the colony or back home; objects were also sold or given to private collectors or to museums such as Tervuren. The staff at Tervuren also drew on missionary knowledge to document the traditional uses and geographical distribution of objects in their collections.

The Congo collections initially served a propaganda purpose in the Tervuren museum. The artistic styles were carefully inventoried and classified on the assumption that they corresponded with ethnic groups where they had been found. The collections were ordered along the lines of a natural history museum: objects were used to illustrate points about African culture (such as the place of the dead in the world of the living), not for their intrinsic qualities (cf. Vogel 1991: 199). Tervuren was not intended as an art museum (Wastiau 2000: 41)—as, for example, Leiden was to be; its concern was with science.

Whatever the original intention, art was entangled with science at Tervuren in many different ways from the beginning (cf. Morris 2001). First, the huge quantity of ethnographica shipped to Belgium from the colony became caught up in the art trade. Brussels became an important centre for the African art market during the twentieth century. Morris argues that the arrival of these African artworks in Belgium around the end of the nineteenth century also prompted its own European response. Leopold II in fact promoted the revival of chryselephantine (ivory and precious metals) sculpture by facilitating the import of tons of ivory tusks and tropical wood for the artists and furniture makers who worked on the interior of the new museum. These Belgian sculptures and art nouveau cabinets were juxtaposed with African sculptures in the gallery of honour at the 1897 Colonial Exhibition at Tervuren, in a similar fashion to the circle of gilded classical allegorical sculptures (by Arsène Matton) in the museum's rotunda entrance hall, above the circle of plaster figures representing Africans by Herbert Ward (see Morris 2001; Saunders 2005).

In the context of this neoclassical building with its sculptural and other decorations and its various colonial collections, ethnography was from the beginning a sort of foil: decontextualized, anonymous and recontextualized as 'artefacts' rather

than works of art, the Congo collections underlined for the Belgian visitor colonial potential and mastery. While the museum effect is indeed common to all such institutions, the colonial nature of this museum accentuated the specific message about relative power and status among the parties involved. Only a tiny fraction of the African artistic production that arrived in Europe appealed to the avant-garde. However, the museum itself played a significant role in elevating certain objects within its collections to the status of masterpiece (cf. Clifford 1988: 224). A trend towards aestheticizing exhibitions at Tervuren from the 1940s onwards, as well as travelling exhibitions and their accompanying publications that served to promote the renown of certain pieces, contributed to this elevation. The transformation of certain items at Tervuren from ethnographic curiosity ('fetish') to 'art object' to 'masterpiece' was a process with effects that extended far beyond the museum's own collections.

AN ETHNOGRAPHIC MUSEUM IN THE HEART OF BLACK AFRICA

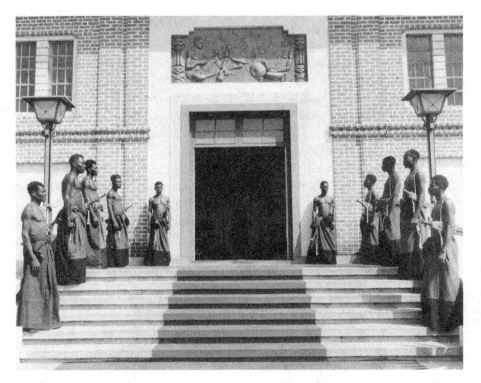

Figure 3.4 Indigenous guard of honour at the main entrance to the Dundo Museum, Angola, awaiting the Portuguese president's arrival, 1954. Source: *Annual Report*, 1954. © Universidade de Coimbra.

One of the places these effects were felt was at the Dundo Museum in north-east Angola, where the local Cokwé population was effectively musealized in situ in the course of the—late—Portuguese colonial thrust into sub-Saharan Africa in the early twentieth century. Masterpieces of Cokwé art were created at the Dundo Museum in north-east Angola during the Third Portuguese Empire (cf. Porto 2000). The Dundo Museum, established in the late 1930s, was a crucially important institution in the activities of Diamang, the Diamond Company of Angola (1917–1975). The museum's goal of 'preserving native culture' was formulated in the realization that the company's mining activities were in fact destroying that culture. The museum collected, identified and classified ethnographic as well as geological, prehistoric, zoological and historical specimens. Moving in an anticlockwise direction through the exhibition rooms, starting from the (Indigenous) entrance hall with a throne, the visitor would traverse domestic objects, hunting and fishing, local industry/crafts, the (European) history gallery (with oil paintings and an alternative entrance), religion, then geology and prehistory, African fauna, a room with photographic murals (of chiefs), and, finally, art (mainly Cokwé sculpture). At one level, this was an essentially *local* museum; classification of the geological and natural environment (associated with knowledge of the physical conditions of diamond mining), and of the local population (who provided the labour required for open-cast mining), followed a combination of natural history and ethnographic (functional) principles in line with those developed in nineteenth-century Europe. Other kinds of—folkloric—activities took place in the Native Village (next to the museum), which, in addition to the 'throne room' in the museum itself, played a significant ceremonial function in the life of this organization. Important foreign visitors were received in the museum and entertained in the village; so, too, were important Portuguese and local dignitaries (*sobas*).

The scientific work based in the museum helped to legitimate the company's extremely lucrative diamond-mining activities and divert attention from the persistence of the Third Portuguese Empire, which continued beyond the point where other European powers had been ousted or had handed over power in their respective colonies (1970s). The Dundo Museum compared favourably with the activities of other colonial powers: establishing regional and national museums in Africa was presented as a way of combating the pillage of huge amounts of cultural heritage. As far as the local public was concerned, the museum played a significant role in the social lives of labourers working in the mines and their kin living outside the company area. The museum became a ceremonial centre for them, too: it was a place where they became both performers and spectators of their own culture, surrounded by the carefully ordered and preserved memorial to it.

The museum had a wide-ranging network of international contacts and produced a series of high-quality scientific publications, such as the English-language *Dundo Museum Annual Reports*. One of the most important contacts was the Royal Museum

for Central Africa, Tervuren, which became the scientific metropolis for the Dundo Museum. Scientific research (1956–1961) conducted by M. L. Bastin (a member of the staff at Tervuren) helped to establish 'Tschokwe Art' as part of the international Arte Negra scene (cf. Porto 2000: 438). Critics of the Portuguese colonial regime were invited to consider the positive work of the Diamang company in creating an ethnographic museum in the heart of black Africa, 'to conserve as faithfully as possible the indigenous traditions of the collective soul' (cited in Porto 2000: 423).

With war and Angolan independence, the Dundo Museum entered a new phase in its existence. Cokwé art has been claimed, in the context of the new Angolan state, as part of national heritage. Cokwé works of art, like their Congo counterparts, fetch high prices on the international art market. This factor politicizes the issue of ownership that subtends discussions of national versus regional identities said to be objectified in the artworks.

CONCLUSION

The public ethnographic museum is an essentially nineteenth-century institution. It was the public's stake in the museum that imbued the category *ethnographica* with specific meaning in the nineteenth century. While seventeenth- and eighteenth-century collections certainly *included* 'Indian' and other objects that would later be termed 'ethnographic', the novelty of the nineteenth-century specialist ethnographic *museum* lay in the specific aims of educating and entertaining the public by creating a spectacle of others. Several processes were involved in the invention of this new institution. Some of these processes relied on scientific knowledge: new systems of classification (such as those developed in Copenhagen, Leiden and Oxford) were, as we have seen, often developed in the process of trying to arrange already-existing collections for various—new—publics: the working-class visitors in Copenhagen and Tervuren, the colonial administrators in Leiden and local people in Farnham and also in colonial north-east Angola of the twentieth century. These systematic developments took place within the broader social and political contexts of nineteenth-century nation states. If socio-economic class divided the citizenry of those industrializing powers, then their imperial possessions held out a sort of compensation.

Even if the principal visitors of museums remained upper-class citizens, scientists and artists, the fact that Pitt Rivers and his contemporaries as much as refer to industrial workers and agricultural labourers—in short, 'the masses'—reflects the scale of the sociological transformation taking place in and around public museums. Such people now counted as both potential and real audiences for the ethnographic museum. Looking at and learning about other (and in the first instance that meant colonized) peoples of the world, made visible and intelligible through the arrangements

of objects in the ethnographic museum, created a new sense of identity ('we'), if not unity, among the audience. This feeling of unity was tied up with the act of looking at other, strange peoples, situated at supposedly different levels of civilization and progress. Since the objects on display in European ethnographic museums (such as the Danish National Museum in Copenhagen, the National Museum of Ethnology in Leiden, the Pitt Rivers Museum in Oxford, the Colonial Museum in Haarlem and later in Amsterdam and the Royal Museum for Central Africa in Tervuren) came, in the first instance, from the colonies of the nation state concerned (the situation in Paris, Berlin and London was comparable), the public was effectively looking at the populations of their empires. Many of the objects they gazed on were given by (former) expatriate citizens, who also had a stake in the museum. Government support for public museums actively encouraged these various forms of participation. National (class) unity was experienced in the particular way of looking at and walking through ethnographic museums. The ethnographic museum was part of a wider nineteenth-century exhibitionary complex which included the industrial and world exhibitions where ethnographica, together with native villages and performances, served to accentuate industrial and technological progress—and to entertain.

The fact that ethnographic museums have persisted into the twentieth and twenty-first centuries does not detract from the conclusion that these are essentially nineteenth-century institutions. Indeed, efforts to 'modernize' them and to make relevant what are mostly nineteenth-century collections have proven extremely difficult when cast in terms of educating the public about other peoples of the world. This is because the basis for the nineteenth-century dichotomy between those who counted as 'the public' and those who counted as 'other peoples' collapsed after decolonization. Late-twentieth-century politics of identity make it difficult to present ethnographic collections in terms other than world history or world art, elucidating historical relationships among peoples (collectors and collected from) and examining the transformation of ethnographica into art.[8]

Seen from the perspective of contemporary citizens of Angola, *their* ethnographic museum has become an issue of national cultural heritage in the postcolonial period. The fact that some of the objects that were once seen as ethnographica, used to enable European publics to picture the populations inhabiting their empires, have subsequently been designated as works of art of universal value has profound consequences for the future of ethnographic museums worldwide. As self-appointed keepers of world heritage, ethnographic museums face a daunting task in the contemporary world. Designated as universal works of art, certain objects may well serve as ambassadors for new nation states, or at least their powerful elites. The removal of these objects from their original contexts, the whole process of their recontextualization as semiophores in Pomian's (1990) terms and the commoditization of some of them as works of art means that every move they make is a political one—as, of

course, it always has been in the context of the nineteenth-century public ethnographic museum (see Chapter 6).

Ethnographic museums today wrestle with options ranging from repatriation of certain collection elements (National Museum of Denmark, Copenhagen to Greenland), through ostentatious inclusion of former ethnographic objects now designated as universal works of art in national art museums (Pavillon des Sessions, Musée du Louvre, Paris) and interventions by contemporary artists (at the Pitt Rivers Museum, Oxford), to—partial—historical contextualization (Tropenmuseum, Amsterdam). These options are conditioned by local circumstances, which include the national museum landscape within which each institution operates, receives its funding and draws the lion's share of its public. While many ethnographic museums dabble with experimentation, most still contend with their nineteenth-century origins and the definitions that went with them. Ethnographic museums are obviously as much about 'us' as Siebold thought they were about 'them', and above all the dynamic relations between us all.

KEY CONCEPTS

Curiosity cabinet (*Kunstkammer*)
Ethnographie
Systematic classification:
 —geographical
 —typological

Display aesthetics:
 —panoply
 —picturesque
 —classical
Colonial museum
Ethnography vs. art
'Primitive art' market
Contemporary artists

EXERCISES

1. Visit any self-proclaimed ethnographic museum. Write down three reasons why the museum defines itself as such.
2. Are the collection items on display mainly historical or contemporary? How do you explain this?
3. How would you characterize the exhibitions (permanent and temporary): are they educational, entertaining or aesthetic (or a mixture)?
4. How are different identities presented by the museum in different parts of its exhibitions (group identities, individual identities, changing identities)?
5. Does the museum feature its own history as part of the story it is telling? If so, how does it do this?

FURTHER READING

Clifford, J. (1988), *The Predicament of Culture. Twentieth-century Ethnography, Literature, and Art*, Cambridge, Mass.: Harvard University Press, chapters 9 and 10.

Kirschenblatt-Gimblett, B. (1991), 'Objects of Ethnography', in I. Karp and S. D. Lavine (eds), *Exhibiting Cultures. The Poetics and Politics of Museum Display*, Washington, DC: Smithsonian Institution Press, pp. 386–443.

Lidchi, H. (1997), 'The Poetics and Politics of Exhibiting Other Cultures', in S. Hall (ed), *Representation. Cultural Representations and Signifying Practices*, London: Sage/Open University, pp. 151–222.

Thomas, N. (1991), *Entangled Objects: Exchange, Material Culture, and Colonialism in the Pacific*, Cambridge, Mass.: Harvard University Press.

4 THE ETHNOGRAPHY OF MUSEUMS

> I can still almost viscerally feel the excitement that I first felt on being able to go from the front-stage of the Museum displays through doors, often hidden at the back of galleries, into what initially seemed to be a maze of footfall-echoey staircases and doors to mysterious offices. I liked having my own key to be able to use these doors, and being able to move, unchallenged by security warders who manned the boundary from visitor space to curator space.
>
> (Macdonald 2002: 10)

INTRODUCTION

Going behind the scenes of a public museum opens up new perspectives on collections and their life-support systems, as well as the staff who tend them and who are usually invisible in the front area of the institution, and communities who are often beyond the casual observer's field of vision. What does an ethnographic approach add to interdisciplinary scholarship in the field of museum studies?[1] This chapter examines a number of characteristic museum activities—collecting, exhibition-making and public guided tours—drawing on studies by anthropologists. It considers how the making of a collection involves the agency of the collected-from as well as the collecting institution. It looks at the way professional identities are implicated in designing and realizing a new exhibition through both the objects and the knowledge that are included. And it explores the role particular collection items play in guided-tour narratives and how they become modified in the process of transmission between guides.

The chapter begins with a brief review of the ethnographic method and its historical relation to the ethnographic museum in the history of anthropology. Nowadays, ethnographic approaches are more widely used to examine the micro-dynamics of collection, representation, and public mediation practices in museums. Michael O'Hanlon's ethnography is an account of making a collection in

Highland New Guinea for the British Museum, in 1986 and 1990 (O'Hanlon 1993). Venturing behind the scenes at the Science Museum, London, Sharon Macdonald's (2002) ethnography of exhibition-making in the late 1980s analyses the everyday processes involved—from the concept to the opening and beyond. Guided tours are seen as performances of the past in which objects play crucial roles in Tamar Katriel's (1997) study of Israeli settlement museums in the late 1980s. The case studies show how ethnographers begin their studies and how they conduct them in the longer term in the museum context. They also raise questions about the role of visual and material culture in the knowledge produced *about* museums—as well as *by* them. This connects with an important distinction between 'observing' and 'really seeing', where the latter refers to the qualitative depth of understanding.

ETHNOGRAPHIC FIELDWORK

Ethnographic research is a way of exploring social relations and cultural meanings in all their complexity at a particular time and in a particular place or places. This microlevel, contextualizing approach often involves the ethnographer gaining access to a different society and learning to see and to understand it from the inside; to gain an indigenous point of view (cf. Malinowski 1922). Visual methods, such as participant observation, are at the core of ethnographic research and are used in combination with conversations and interviews, working with key cultural consultants. Intensive methods such as taking genealogies, conducting in-depth interviews and collecting life histories all dovetail with ongoing visual methods. Problem-oriented, longitudinal and team research still depends on being there and witnessing what is happening over time (Kottak 2004: 324). This holistic approach to understanding social life depends on goodwill and trust, which requires a relatively extended period of time in the field: at least a year, with return visits anticipated in the long term. Ethnography involves learning the local language in order to be able to grasp culturally important categories, ways of speaking and knowing, which are fundamental to understanding the world view. It involves developing practical linguistic and cultural competence by participating in everyday life, taking field notes and keeping an ethnographic diary. More recently, anthropologists have emphasized the role of photography, film and other recordings for conditioning interactions in the field, as well as forming a basis for later analyses, and for textual and audiovisual representation (e.g. Pink 2006: 296). Others have pointed out that while ethnographic text has always made use of visual representations in the form of photographs, drawings and diagrams, the methodological and theoretical implications were long

neglected (see Edwards 1992; Banks 2001; Grimshaw 2001). As already noted in Chapter 1, new media—such as museum websites and linked Internet sources—are increasingly important to ethnographers.

The general aim of ethnographic analysis is to explain actions and ideas that might at first sight appear inexplicable and to grasp the texture of a particular lifeworld. While the ethnographer's initial observations are framed by theoretical questions derived from other studies, the direction ethnographic work follows is largely determined by what happens. This unknown and unpredictable quality of ethnography is one of its distinctive features—and one in which the practice of photography is implicated. Marcus Banks tells how at a feast, early in his fieldwork in India, he was directed by friends to photograph the feast donor in a particular way. This resulted in images of social facts that he knew, because he had been told them, but 'by being directed to capture them on film I was made aware not only of their strength and value but of the power of photography to legitimate them' (Banks 2001: 47). The awareness that came about through the collaborative making of a photographic image resembles O'Hanlon's observation about 'really seeing' through the process of collecting (cf. O'Hanlon 1993: 63). Furthermore, the complexity of a particular lifeworld is often more vividly conveyed through visual forms, such as film, photography and material culture, than would be possible through ethnographic text alone. In practice, photographs, films, material culture and books often involve powerful combinations of words and images in specific material settings. Alertness to the interactions of these media, both during ethnographic fieldwork and in the work of representation that follows it, brings to the fore new dimensions of the social world.

While it could be argued that participant observation has always been visually based, the place of the visual, and indeed the material, in explicit methodology and theory was subordinate to that of writing and abstraction for much of the twentieth century (Grimshaw 2001). Nonetheless, the explicit use of visual approaches to ethnographic inquiry increased, and visual anthropology developed into a distinctive area of mainstream anthropology from the 1970s onwards. Renewed ethnographic and theoretical interest in material culture from the 1980s onwards (see Miller 1987), following a long period of neglect, shared in what has been called the visual turn in anthropology (Pinney 2002b). Empirical studies of a wide range of material culture and related activities—from shopping to heritage—gave a new impulse to the study of social relations and new meaning to the concept of culture (see Buchli 2002; Tilley et al. 2006). An anthropology of museums fits into these broader developments in visual anthropology and material culture studies, drawing inspiration from approaches to the social life of things (Appadurai 1986), the entanglement of objects (Thomas 1991) and the explicit link made between the visual and the material in social systems (Banks and Morphy 1997).

ETHNOGRAPHIC MUSEUMS AND THE ETHNOGRAPHY OF MUSEUMS

Historically, the relationship between academic anthropology and museums was assumed to lie in ethnographic collections. Anthropology was born in the ethnographic museum during the nineteenth century, with the university-based academic discipline casting off its collections to become what was seen as a fully fledged social and cultural study defined by empirical fieldwork methodology, during the early twentieth century (Stocking 1996). Fieldwork became, within this frame of reference, the hallmark of modern, academic anthropology (Van Keuren 1989: 26), with museum anthropology slipping into the sidelines to reach an unprecedented level of professional obscurity by the middle of the twentieth century, or the mid-1960s in France (Ames 1992; Bouquet 2001). The resulting divide between the study of social and material life was radical in some places, producing a knowledge gap between historical collections and the scholars who might have been expected to work on them.

This interpretation of history was already under revision by the 1990s. The rekindling of critical interest in collections extended to museums and exhibitions (e.g. Karp and Lavine 1991) and is clearly connected with broader developments in visual anthropology and material culture studies indicated in the previous section. Researching the social lives of the objects and images in collections was one of the routes that led anthropologists back into museums.

Unravelling a Collection

My own first encounter with a small ethnographic collection from Melanesia at the National Museum of Ethnology in Lisbon, in the mid-1980s, brought home the problems of how to interpret such materials at the time (Bouquet and Freitas Branco 1988). The assorted masks, weapons, drums, utensils, clothing, adornments, *malanggan* and other carvings, and an overmodelled Sepik skull in a plastic bag, were arranged on a sheet on the storage-area floor. The collection had been brought to Lisbon from the University of Oporto for restoration. The plan was to exhibit the restored pieces in Lisbon, before returning them to Oporto. The dilemma facing the museum was whether to make an exhibition of 'primitive art' (echoing the famous 1984 '"Primitivism" in Twentieth Century Art' exhibition at the Museum of Modern Art (MoMA) in New York), or whether to display the objects as representing Melanesian cultures in a regional ethnographic fashion and, if so, how to make them intelligible to the Portuguese public. Since there was no colonial connection with the area concerned, no knowledge, however vague, could be assumed. The National Museum of Ethnology was only sporadically open to the public at that time, since it was a research institution mainly devoted to collecting and documenting collections of Portuguese agricultural implements and popular culture, as well as some colonial collections.

An initial visual analysis of the—apparently undocumented—collection revealed several sets of labels and numbers, which provided clues for piecing together the complicated route by which this collection had arrived in Portugal. This story, we decided, was integral to the collection and had to be told both in the exhibition at the museum and in its accompanying publication. Only by explaining its compound historical nature did the fragmentary snippets of disconnected ethnographic contextualization make sense.

The Melanesian collection arrived at the University of Oporto in 1926, as part of an exchange with museums in Berlin. Several small sample collections were put together in Berlin, drawing on their extensive reserves, to recover an Assyrian archaeological collection, excavated by Andrae from Basra in 1903, from the Lisbon port authorities. The ship carrying this archaeological cargo had been impounded by the Portuguese in 1916, when Portugal entered the First World War as an ally of Britain. The Melanesian collection was composed of items from many different German colonial expeditions to mainland New Guinea

Figure 4.1 Photograph of the Yimar headmask from the Oporto collection.

© Carlos Ladeira, Portugal (1988); Museu de História Natural da Universidade do Porto.

and island Melanesia in the late nineteenth century. After lengthy negotiations between German and Portuguese scholars, an exchange was agreed between the institutions: this included the Melanesian collection being sent to the University of Oporto and the Assyrian archaeological collection continuing its journey to Berlin.

We used German expedition reports from that time to unravel the complicated stories of the collection and to give an idea of the circumstances under which the collections were made. The reports included photographs of specific artefacts. It was a photograph of one of these artefacts, a Yimar woven basketry mask, published in an article by Von Luschan in 1911, which provided the first clue to deciphering the complicated histories of the objects in the collection.

The need to historicize ethnographic collections became a generalized perception by the mid-1980s. George Stocking's edited volume *Objects and Others* (1985), James Clifford's *Predicament of Culture* (1988) and Sally Price's *Primitive Art in Civilized Places* (1989) all addressed ways in which the historical nature of ethnographic collections was suppressed in the processes of de- and recontextualization

accompanying their movement into ethnographic museums as specimens—or into modern art museums as primitive art.

One of the milestones of subsequent scholarship, Nicholas Thomas's *Entangled Objects: Exchange, Material Culture and Colonialism in the Pacific* (1991), systematically analysed the entangled histories of objects that passed between populations involved in various kinds of colonial encounters. This line of research has been extended in various ways by reinterpreting collecting activities as part of the early ethnographic project (O'Hanlon and Welsch 2000) and exploring colonial power relations as a crucial dimension of this material (Gosden and Knowles 2001). This renewed engagement with historical ethnographic collections later involved new forms of dialogue—and fieldwork—with contemporary source communities. This last term denotes contemporary communities who now identify historical collections that were made from their ancestors in terms of their cultural property and heritage. The collections made from communities such as the Torres Strait Islanders by the Cambridge Torres Strait Expedition of 1896 are a case in point. Re-establishing links between the Cambridge Museum of Archaeology and Anthropology and the Islanders brought about a new kind of dialogue between both parties (Herle and Rouse 1998). Among First Nations of Canada, the USA, Australia and New Zealand, this process has been under way for much longer than in Europe due to the nature of settler colonialism (Morphy 2006). This has been a widespread development across a broad range of ethnographic museums and is connected with repatriation claims and the development of indigenous museums worldwide (see Chapter 6).

THE ETHNOGRAPHY OF MUSEUMS: POINTS OF DEPARTURE

At about the same time that scholars began to study the histories of ethnographic collections, there was a move by some anthropologists *beyond* the ethnographic museum, to re-examine museum processes ethnographically. These studies involved major areas of museum work, as we shall see: collections and collecting (O'Hanlon 1993), exhibition-making (Macdonald 2002) and guided tours for the public (Katriel 1997). While not exhaustive, these three classic ethnographies demonstrate the scope and diversity of this approach to museums across a variety of sites. They also engage with important areas of theory: agency and exchange, brokerage, actor-network theory, the question of authorship, cultural production and consumption, and semiotics and narrative. Methodologically, these ethnographies adopt various starting points, which entail different forms of engagement with the institution as a fieldwork site.

MAKING A COLLECTION

Museums contain collections drawn from outside their walls and recontextualized within them. The ethnography of a collection is therefore intrinsically multisited.[2] An illuminating way of understanding what goes into a collection is making one, or following the making of either a personal or an institutional collection. Michael O'Hanlon's account of collecting contemporary Highland Papua New Guinea material culture for the Ethnography Department of the British Museum, then located at the Museum of Mankind in Burlington Gardens in London,[3] demonstrates how ethnographic fieldwork can be conducted *through* the making of a collection. Collecting in this case was done on two three-month return visits to the same population with whom O'Hanlon had undertaken earlier conventional ethnographic fieldwork for a longer period.

EXHIBITION-MAKING

A second approach is to follow the process of making an exhibition, which might be either semi-permanent or temporary. Sharon Macdonald's ethnography conducted behind the scenes at the Science Museum in London followed the daily negotiations and decision-making of the project team that created 'Food for Thought: The Sainsbury Gallery' at the Science Museum in 1989. The research was conceived as a way of investigating how the public understanding of science might be conditioned by the three-dimensional demands of a museum exhibition. By focusing on the process of *producing* such a cultural artefact, Macdonald aimed to go beyond 'reading off' meanings from a finished exhibition, dwelling instead on the complexities of authorship under the specific conditions of late 1980s British enterprise culture.[4]

GUIDED TOURS

A third way is to analyse the *use* made of the museum as an intercultural arena between staff and visitors: guided tours are one way of doing this. Tamar Katriel followed guided tours for the public through settler museum exhibitions, observing the encounter between guides and visitors as a storytelling performance.[5] Her analysis of how the guides negotiate a local version of the Israeli master narrative of Zionist pioneering elucidates the complex interactions between words and things; how some meanings are articulated and others excluded, and how guides and visitors deal with these exclusions.

Ethnography can thus be engaged for looking into and contextualizing museum activities, both on- and offstage, on- and off-site. The ethnographer looks, with

varying degrees of engagement in the process under way, at constructions of the past, the present and the future; at plans and visions and what actually happens; and at the negotiations taking place. What happens in the process of making a collection? How is it shaped, and what agency does it contain (and not contain)? What happens to an exhibition, from its conceptualization to its opening and aftermath? And what does *not* happen? What happens on a guided tour? How is it that some stories are articulated and others suppressed? And how does this fit into the meta-narratives of a given society at a particular time?

All three studies deal with the agency of objects and people: what is included in a collection, what is left out and the expectations concerning ongoing relations through the collection. This non-human agency also comes out in the intractability of certain collection items and other objects in displays: some are too heavy, too big or too badly behaved for the gallery space. The visual and material qualities of objects impinge on storytelling in ways that guides cannot always control: ploughs, tractors and pioneer tents that are meant to tell one story may end up creating ambivalences that cannot be controlled by words. Looking in more detail at each of the three ethnographies gives insight into the texture and the specificity of ethnographic scholarship. The first case is located between the Museum of Mankind in London and the hamlet of Topkalap.

PARADISE: AN ETHNOGRAPHY OF COLLECTION-MAKING

O'Hanlon's ethnography of making a collection in Highland New Guinea rests, as already noted, on previously conducted anthropological fieldwork in the north-west Wahgi area of the Western Highlands of Papua New Guinea, among the Komblo tribe (Kekanen clan) in Topkalap hamlet on the Kar River, between 1979 and 1981. His return to the field for two three-month collecting visits (in 1986 and 1990) raised a number of very interesting questions. Although O'Hanlon was somewhat apprehensive about returning to the community he knew well with financial resources to make a collection for the Museum of Mankind (as the Ethnographic Department of the British Museum then was called), he discovered that his new role was culturally more intelligible than his previous one as a student fieldworker.[6]

Collecting was recognizable behaviour, comparable to that of an in-law, owing the payments due to 'source people'—maternal kin in a patrilineal system. As he points out, '[i]n a society where much of politics revolves around accumulating objects and presenting them to other groups' (O'Hanlon 1993: 12), collecting might mean something other than the removal of cultural property emphasized by critical studies

of collecting during the 1980s. The collected objects might, for example, be seen as envoys in a continuing relationship, rather than hostages.

The historical background against which his collection was made includes the discovery of the densely populated Central Highlands of Papua New Guinea in 1933 by Australian gold prospectors (see Connolly and Anderson 1987). A crash course in modernity followed, with cash-cropping (coffee) transforming subsistence production and generational relations, bringing in both cash and material goods from the world system. Then there were the effects of the Pacific war, followed by Australian administration, missionary activity and independence in 1975. Tensions about coffee, land and income were behind an upsurge in violence after the coffee boom of the 1970s.

This violence was clearly part of the social context of collecting, including broker-age by the ethnographer's sponsor, Kinden. During his initial fieldwork, O'Hanlon and his wife, Linda, lived in a house built by Kinden and were necessarily under his protection at a time of escalating violence in the Highlands. The purpose-built house for his collecting visits reminded O'Hanlon of the garden of that earlier house, which Kinden had tabooed to prevent resources from flowing out of it. The so-cial distribution of wealth became even more of an issue now that O'Hanlon had resources for collecting. Kinden had very clear ideas about the order in which people could offer things for sale, which reflected local social structure: first, people from the local community, then gradually expanding outwards through subclans and other Komblo clans, and finally to other Wahgi. Although there was some flexibility in this ordering, it was broadly adhered to, with Kinden acting as master of ceremonies in the transactions (O'Hanlon 1993: 60).

O'Hanlon wanted to collect a full repertoire of portable Wahgi mater-ial culture—personal adornment, clothing, netbags, household goods and weaponry—to fill one of the gaps in the Museum of Mankind's Oceania collection. One of his aims was to counter the exoticizing stereotypes still attaching to New Guinean people in Europe in the 1990s. Among the principal items represented in the collection were netbags and shields. The colourful netbags woven from imported acrylic yarns are used for everything—women carry babies in them, and men use them as receptacles for war and love magic. The bags have named designs, such as 'Christmas', 'Forestry', 'One Ace' and 'Diamond', and are looped from a single thread; they are ubiquitous objects—often exchanged as gifts be-tween women (cf. Küchler 1999).

While shields had been scarce during O'Hanlon's first fieldwork, the upsurge in fighting in the 1980s meant that men started to make them again. This was not a specialist task. New designs appeared, using oil paints instead of traditional pig-ments and including such details as the date and scale of the conflict and the bearer's

name. Other written inscriptions included 'Now buddy slays buddy', 'Wahgi fish'; on a shield, 'Six to Six' (a wider Papua New Guinean idiom—originally referring to an all-night party) refers to the ability to fight all day long. Using the shield to advertise South Pacific beer makes sense in so far as clansmen drink together and fight together. Other emblems used on shields include the bird of paradise (O'Hanlon 1993: 67–68). As the collection grew, the O'Hanlon house started to resemble a museum, prompting visitors to give short performances or demonstrations of the objects' uses. The shields exercised a magnetic attraction over the men, whose vigorous demonstrations occasionally worried the collector. People's reaction to the making of the collection expressed their historical experience. Artefacts associated with forbidden practices, such as warfare and ritual, meant a rediscovery of lost or suppressed elements of local culture.

Once people had grasped O'Hanlon's wishes with regard to the collection they became actively involved in its contents and representativeness. They looked into the possibility of obtaining discontinued items, which in turn meant that O'Hanlon felt obliged to commission their making. Artificial though this was, in a way, it brought out all the rules associated with certain items that would normally have remained implicit, in the form of jokes—for example in the making of ceremonial *geru* boards (O'Hanlon 1963: 62). O'Hanlon notes that technical and social details of making and using certain artefacts, although observed during earlier fieldwork, were only really seen in the context of collecting (ibid.: 63).

The negotiation of prices for the objects offered to him underlined that these were not simply purchases but rather moral transactions for the sellers. 'It's up to you', they would say when asked about the price. Since group membership had been extended to O'Hanlon through his sponsor, careful calculation of prices was considered inappropriate. Redefining these transactions as an uncalculated exchange between kin in this way had implications for how the collection was seen by local people: contributors felt they had a stake in it. When it came to leave-taking, the collection was actually compared by one man to a bride. In local terms, a bride leaves her natal kin to go and live with her husband's clanspeople. There was even a ceremony of beautification for the collection. O'Hanlon's payments, from this perspective, constitute bridewealth, which is only the first payment made to the bride's kin. A bride's brothers can also expect payments for the children she bears—as their source people. The comparison underlines O'Hanlon's continuing indebtedness to those who had helped him. The frontispiece photograph of the ethnography shows Zacharias and Wik calculating the distribution of pork at O'Hanlon's leaving party: visual documentation of where *local* collecting interest really lies: 'in learning, evaluating, and secreting accounts of past indebtedness and betrayal' (1993: 63).

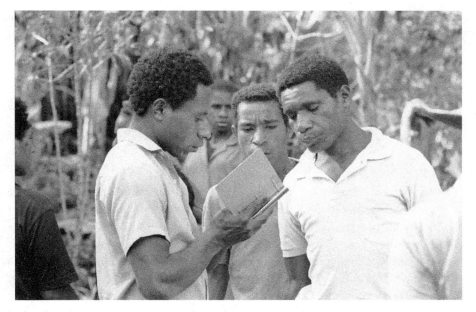

Figure 4.2 Zacharias and Wik calculating the distribution of pork at O'Hanlon's leaving party. Photo: Michael O'Hanlon. Reproduced by kind permission of Michael O'Hanlon.

The opportunities for making a collection such as the Komblo-O'Hanlon one are rare, and accounts of the process still rarer. While there are certainly excellent analyses of historical or contemporary collectors and collection processes (e.g. Balk 2006; Elsner and Cardinal 1994), they differ from a hands-on account of making a collection such as O'Hanlon's. He also provides a brief ethnography of the context of the 'Paradise' exhibition at the Museum of Mankind in London where, due to local circumstances, it was installed in the set of a previous Palestinian exhibition. Although this part of the ethnography is much less developed than the former (the exhibition had not yet been made when the book went to press), it makes interesting reading alongside Clifford's (1995) detailed analysis of the exhibition and Lidchi's (1997) 'reading off' of the finalized exhibition.

The ethnography of the collecting *process* provides insight into the social, cultural and material dynamics involved, from the inside, thereby adding a unique perspective to interdisciplinary scholarship on collections. The agency of those collected from, as well as that of the collector, and the role of cultural brokers in shaping the collection are among the principal findings of this research.[7] It is interesting to note that a similar approach to agency in collections can be found in art historical

scholarship.[8] Moving now to the *use* made of collections, particularly in the form of exhibitions, let us turn to Macdonald's ethnographic account of making a semi-permanent exhibition at the Science Museum, London, in the late 1980s.

'FOOD FOR THOUGHT': AN ETHNOGRAPHY OF EXHIBITION-MAKING AT THE SCIENCE MUSEUM, LONDON

Sharon Macdonald began her fieldwork at the Science Museum on the day entrance charges were introduced: 3 October 1988. Her aim was to study the construction of science in museum exhibitions, exploring agendas and assumptions involved in creating science for the public. The research was part of an Economic and Social Research Council (ESRC) programme designed to investigate understandings of science in diverse public settings. Following the makers and consumers of a science exhibition was a means of studying the processes of translating expert scientific knowledge into public knowledge for the layperson. The aim was to identify the constraints involved in representing and understanding science in the shape of a three-dimensional exhibition, scheduled to remain in place for ten years.

Research started out from a communication model, with science taken from the world of science and translated into something for the public to respond to. Participant observation in the actual process of making an exhibition on food and science revealed a much more multifaceted and untidy process that neither began nor ended with science. Following those involved and trying to understand their concerns, their ways of seeing and doing, was 'a principal and in many ways traditional aim of this ethnography' (Macdonald 2002: 7). Human actors are recognized as an important dimension of social research on science and technology. Actor-network theory proposes that not only humans but also non-humans may be actors and exercise agency: they have the power to do or act on behalf of others. Paying attention to objects and technologies in this way gave Macdonald a means of defamiliarizing what might otherwise have been an all-too-familiar setting—and a classic problem for anthropology at home. For Macdonald as a middle-class British person, the museum was an implicit part of her background and therefore difficult to 'see' in the ethnographic sense discussed by O'Hanlon (see earlier). Her starting point was 'Food for Thought: The Sainsbury Gallery', and her main focus the project group (known as 'the Team' or 'the Foodies') assigned to its making.

By observing the daily activities and negotiations that go into producing an exhibition over a period of more than a year, she hoped that the demands and constraints would become explicit—as they did. This process of becoming explicit—visible—was

also a feature of O'Hanlon's ethnography of collecting. So, although time- and place-specific, the ethnography casts features and ambivalences of museum ambitions and practice into relief in a way that has more general relevance. She compares this time-place specificity with Victor Turner's social dramas, arguing that this is a place worth speaking from 'in order to speak of and to broader political-cultural concerns' (Macdonald 2002: 6).

The ethnography shows how agency and authorship are contested and negotiated among the various groups and individuals involved (during the encoding process), in ways that have consequences for the cultural product and its interpretation. Macdonald explores the authorial puzzle of its production and is particularly curious about the sense of alienation and estrangement felt by the Team when the exhibit was opened. Visitors' responses to the exhibit are subjected to similar critical examination in the follow-up ethnography carried out once the gallery had opened. She looks into the reasons *why* visitors say and do what they say and do in the gallery, rather than simply recording and celebrating it—as much visitor research tends to do.

The Science Museum was founded in the nineteenth century as part of the South Kensington Albertopolis complex, along with the Natural History Museum and the Victoria and Albert Museum. If it had been a bulwark of nineteenth-century museological science, the Science Museum was in the throes of a cultural revolution in the late 1980s' enterprise culture.[9] This revolution entailed a major shift of emphasis within museums from a collections focus to a visitor focus. Management felt that everything would have to be new and different, and this would mean a reorganization of museum structure itself. The newly installed Division of Public Services at the Science Museum, for example, was responsible for everything from mounting exhibitions to providing educational services, as well as managing restaurants and lavatories—whereas previously exhibition-making had been a curatorial prerogative.

It is interesting to note that *vision* was one of the ideals the museum was striving for under the aegis of its new and dynamic director, Dr Neil Cossons. The 'Food for Thought' gallery was a part of the New Gallery Plan for the museum as a whole. The Science Museum had evolved gradually since the nineteenth century and was divided into discrete subjects, relating to the collection of artefacts that had accumulated over time: for example 'Glass', 'Optics', 'Aeronautics' and 'Electricity and Magnetism'. Collections were grouped into larger categories, such as 'Transport', which included 'Land Transport' and 'Aeronautics', the former being further subdivided into 'road' and 'rail'. This taxonomic subdividing was typical for nineteenth-century museological or analytical science (John Pickstone, cited by Macdonald 2002). Museological science refers to a division into domains, and further subdivision to reveal a deeper level of structure or process. Science Museum categories were sometimes everyday (as with 'Transport') and sometimes scientific/disciplinary (as with 'Earth Sciences').

The larger taxonomy was not mapped onto the museum layout, the structuring of which followed discrete disciplinary domains. There was some juxtapositioning—such as 'Photography' next to 'Optics'.

Organizational identity and staff expertise revolved around the collections. 'Object feel' within these collection-driven domains (comparable to an art historian's 'good eye') was a means of reinforcing disciplinary boundaries and excluding others. There was a widespread view that objects were sacrosanct once part of collections. Curators were the advocates of collections, with their ability to get things displayed part of a battle for territory in an overcrowded museum. As a result, presentation was atomized, with professional territorialization and lack of an overall plan. Subjects evolved into spaces as a result of particular curators' effort. Sponsorship (such by gas and electricity companies) had also left its marks on the exhibits. Sainsbury's sponsorship of the food exhibition is a continuation of earlier sponsorship practices. Scares about science during the 1980s, including nuclear fuel (Atomic Energy Authority), the chemical industry and food safety, gave the Public Relations Department of the museum pause for thought. The New Gallery Plan aimed to change the piecemeal character of the Science Museum, creating a structure for the entire museum based on 'Knowing', 'Making' and 'Using'.

In the event, the Gallery Plan was found to lack vision upon its completion, resonating perhaps with the demise of master narratives more generally around the end of the 1980s. Seen as a cultural struggle behind the scenes, what emerged from this attempt at rewriting a national museum was a multi-museum, with a more flexible framework responsive to audience diversity and preferences. This flexible approach could also better accommodate the various camps among the staff, channelling their energy into competing with one another for the good of the institution rather than defining what that might be in advance.

Nonetheless, the reorientation towards visitors and away from collections in and of themselves marks a profound change in the institutional landscape at the time.[10] Visitors had to be attracted into museums, and once they got there, they were be provided with 'what they want': Saatchi & Saatchi created a memorable advertisement for the Victoria & Albert Museum (also located in South Kensington)—'Ace caff with quite a nice museum attached'—that perfectly reflects the new 'customer care' approach (Macdonald 2002: 36). And indeed the aims of the Foodies project team of six women staff members responsible for developing the food exhibition reflect the rhetoric of newness and difference, visitor orientation and subversion of the old curatorial hierarchy at the museum. Although well-qualified generalists, none of the Foodies was an expert in the field of nutrition, and part of the set-up involved consultation with a panel of—mainly university-based—scientists. The Team's non-expert, interpretative role was considered an advantage in the context

of reorientation to the public and the perceived need to make science accessible and entertaining to that public.

As a thematic exhibition, 'Food for Thought' also signals a break with collection-based exhibitions: it would draw on various museum collections and loans, as well as creating reconstructions and interactive exhibits. The theme was topical (because of food scares in Britain), consumption-focused (therefore likely to be accessible to the public) and attractive to sponsors (Sainsbury's became the major sponsor). The thematic approach accords with a managerial strategy of severing the natural connection between collections and exhibitions (Macdonald 2002: 112). The approach was to be democratic and fun ('no boring text panels'), with the emphasis on interactive exhibits rather than a didactic approach (associated with an object focus and curatorial authority); collection items would be placed at the disposal of the theme, rather than determining the exhibition. The Foodies wanted to give the visitors choice in the exhibition as, for example, in the route they could take—there were two entrances—and to allow them to experience such food-related sensations as what it feels like to be a frozen pea.

Drawing on the actor-network approach, Macdonald introduces the non-human as well as human actors into her account: these include a malfunctioning sausage machine, the oldest can in the world, exercise bikes and artificial fruits and vegetables. Additional non-human agents that proved significant in the making of 'Food for Thought' were the disruptive bus and Underground strikes of 1989; the chicken-pox virus that afflicted several Team members; and the erratic fax machine, personal computers and the kettle. She admits that it would take 'an enormous and quite unreadable book to give an account of all the players involved in making this exhibition' (2002: 180), and she therefore limited herself to the human players from the local perspective who were accorded principal agency. It is interesting to consider whether, had Macdonald been writing a publication to accompany the exhibition, these non-human actors might have occupied a much more central position—as they do in O'Hanlon's account of his collection.

The ethnography covers various phases in the exhibition-making process: the feasibility study and the exhilarating research phase when each member of the Team added what they liked to their part of the exhibition—rather like collectors. At this stage, the Scientific Advisory Panel vetted the concept and made some suggestions. The scientists refused to adopt the critical role the Team had hoped they would in relation to the public. Although the professors disagreed among themselves, they did agree on separating the nutrition section from food, and from areas of the exhibition dealing with food production. This advice, which was accepted, was to have consequences for the exhibition.

The next step was the retreat when the Team withdrew with the two designers to figure out how the exhibition would be organized in terms of space, aesthetics,

collection and interior design (the where, why, what and how of the process). This involved further cuts, as well as the integration of some of the conceptual separations made by the advisory panel into the design. Faced with the designers' views on 'visitor flow', avoiding 'bottle-necks' and 'confusing spaces', the Team now had to accommodate the professional organization of space. Cuts had to be made: 'sugar' and the 'psychology of shopping' were among them. They also indulged in a fair amount of self-censorship regarding the sponsors: anything contentious or likely to antagonize the sponsors (such as salmonella in eggs) was removed from the plan. Later they regretted this, when the finished product was reviewed as being just what the food companies would like.

Finally, the director himself called for a rethink some ten months before the exhibition was due to open: the messages had to be made clearer. The rigorous conceptual rethink set in motion by the director's call resulted in messages such as 'Science and Technology have brought us greater choice'. The pressure of managing professional identities, of heeding all the good advice proffered, as well as the pressure to get the job done on time, combined with the decision-making and negotiating process briefly sketched in the preceding, resulted in a cultural product that fell short of the ambitions and dreams with which the Team began. The ethnography thus unravels some of the mysteries of authorship, as well as documenting the emptiness of consumer choice if the knowledge required to make such choices is withheld.

Macdonald's photographs provide visual documentation of the development of the gallery. In her role as ethnographer, she was given odd jobs by the Team. She followed them, conducted interviews and attended meetings at the Science Museum. But she did not intervene, nor did she have an official role (except perhaps that of 'reporter') in the project. There are intriguing differences between O'Hanlon's account of collecting and Macdonald's of the exhibition-making process. Macdonald sees her role as observer ending symbolically when she dropped and smashed her camera at the end of the long opening day. She extricated herself—not without difficulty—and moved on to the next phase of her work, which involved conducting visitor research.

Conducting ethnography among the real visitors to the exhibition after its opening brought out some interesting discrepancies with the phantoms which had populated its making phase. If the virtual visitors who haunted discussions in the production phase of the exhibition were anticipated as wanting a busy, fun exhibit, the real visitors inevitably made their own readings and connections in the exhibition they encountered. Many interpreted the exhibition as being authored by Sainsbury's. Others expected to find controversial issues concerning food safety and production methods dealt with. The lengthy texts that were added in an attempt to convey the message

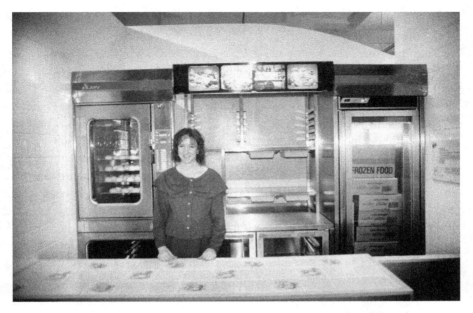

Figure 4.3 Sharon Macdonald in the in-store bakery on the opening day of 'Food for Thought' at the Science Museum, London. Reproduced by kind permission of Sharon Macdonald.

clearly were not well received. The Team often thought of messages as being verbal and explicit, while they gave subtler three-dimensional matters far less attention. Reviewers and visitors tended to look at the gallery rather than reading the text panels.

Visitors certainly enjoyed the interactive dimension of what was offered. Macdonald suggests, however, that fun and pleasure became conflated with democracy (or consumer sovereignty) throughout the process of production. Ironically, some visitors became disoriented by the lack of narrative and were unable to see the scientific content of the exhibition: it seemed more like common sense to them. Others imposed their own evolutionary reading on the gallery: they thought it was about 'food through the ages', showing how this improved with scientific progress. They also seem to have been lulled into a sense of complacency by the presence of objects such as large pasteurizing machines, which created the impression that food is safe and hygienic thanks to modern technology. Moreover, the exhibition appeared on people's lists of things to do when in the capital, suggesting a predisposition to understand the exhibit in certain ways. Visiting authoritative national institutions such as the Science Museum may involve searching for narratives and expecting to be provided with the right answers (Macdonald 2002: 241).

By bringing a process of exhibition creation and a specific group of people charged with that task under her observational and analytical lens, Macdonald brings the museum into focus as a 'visible site of intersection between science, state, materials, the public and other interest groups' (2002: 94). As an observer, she was not concerned whether the exhibition was good or not, or whether she liked it: it was first and foremost a relevant position to speak from. Here there is a divergence with ethnographers who do engage with the materials of exhibition-making as well as the human actors.[11] Ethnographies written from that position tend to be publications accompanying exhibitions and do not cover the classic ground of conventional ethnography.

The question of whether the visual and material forms of an exhibition express or embody something in addition to verbal or written language re-emerges in the ethnography of guided tours in Israeli settlement museums. In these museums there is a meta-narrative, and visitors are firmly guided through the material displays. A greater contrast with the Science Museum visitors adrift in the 'Food for Thought' gallery is perhaps difficult to imagine. The presence of a meta-narrative therefore brings the agency of objects into focus.

'MAKING THE WALLS SPEAK': AN ETHNOGRAPHY OF GUIDED-TOUR ENCOUNTERS IN TWO ISRAELI SETTLEMENT MUSEUMS

Tamar Katriel's ethnography conducted in two Israeli settler museums explores how stories and objects are interwoven in museum discourse and how this local discourse fits into the master narrative of the Zionist project. Having obtained permission to carry out her study, she became a regular visitor (sometimes together with her students), observing particular encounters between guides and visitors on guided tours; she also conducted interviews with guides off stage. Guided tours centre on the performance of stories about the Zionist pioneering settlement of Israel, improvised around the material display. The tour guide's role in 'making the walls speak' involves enchanting the mundane objects collected by and displayed in these museums. Visitors are invited to get involved with the museum's past, which concerns the national foundational myth.

Initially interested in the semiotics of museum discourse, Katriel later focused on the museum as a public site where meanings are constructed and communicated through visual display and verbal mediation, realizing the need 'to attend to ideological and political dimensions of museum making' (Katriel 1997: 2). Yifat Museum, in the Jezreel Valley, was founded in 1970 in an area that was settled

by Jews in the 1920s. The Old Courtyard Museum at Ein Shemer was founded in 1988 and is built on the site of the kibbutz that started there in 1927. Many heritage museums were established in Israel during the 1970s and 1980s. Katriel's starting point was the stories, with their paradoxical search for cultural roots; from there she went on to examine how museums 'partake of the larger cultural struggle in Israeli society over conceptions of shared history and ways of speaking about the past' (ibid.: 11).

Museum guided tours are seen as performances that make tourist sites sacred. While the tour guide's role is central, the museum setting also defines these encounters. It is the magnificent view of meticulously cultivated Jezreel Valley below that frames the entire visitor experience at Yifat, making the museum spill into the landscape past (biblical and pioneer) and present. Similarly, the beautiful old trees planted by the settlers at the entrance to Ein Shemer help to invest the site with a sense of authentic connection to the past. The Yifat landscape frames the stories about people who used the objects in the past and what they meant to them, as well as the heroic tales of how certain objects were acquired for the museum. This landscape is never far from the surface and re-emerges in the stories of pioneers who drained the swamps and built the place. This framing of storytelling is therefore central to the performance of the past.

The museum combines the 'edifying and imaginative thrust of verbal expositions and narrations' with the 'concreteness, authenticity and authority associated with material display' (Katriel 1997: 22). The objects serve as mnemonic devices, triggering stories grounded either in the (old-timer) guide's own personal experience or in a 'collective fund of museum tales shared by the guides' (ibid.). Objects trigger different kinds of stories, thereby contributing to the visitor's visual and kinetic experience of the museum, which is controlled by the guides as they move along the path. This authoritative approach still leaves room for visitors' own experience and appropriation: for example, child visitors to Yifat have the opportunity to dress up in pioneers' clothing as a prelude to trying on pioneer identity. This occurred at a point in the tour when they had already heard enough stories and seen enough classificatory displays (of agricultural tools and kitchen implements) and mimetic reconstructions of pioneering settings (such as the communal dining room, the babies' nursery and the communal shower) for their play to be directed. In this sense, the guide has institutionalized control over the visitors' encounter with the objects, although the children did on one occasion challenge the relevance of the story to their lives by means of a such a play (ibid.: 142–143).

Pivotal objects, such as the first tractor, the family tent and the communal kitchen, dining room and shower, all evoke a range of meanings associated with early kibbutz life as portrayed in Jewish settlement literature of the 1930s and 1940s. The museum rematerializes this symbolic system, as Katriel puts it, providing narrative

stepping stones for the tour. This visual component of personal and collective re-
membering of early Zionist pioneering life dovetails with the stories. The objects
from the displays that are included by guides in their interpretation often reappear in
the slide shows and video presentations that introduce and conclude visits, thereby
reinforcing them. One such object used to narrate the pioneering way of life is the—
overcrowded—family tent. The family tent becomes a vivid anchor for the primus
stories which concern the community assignment of third persons to the conjugal
dwelling when accommodation was in short supply. The primus (after the stove)
is a joking circumlocution for this third person, who becomes a kind of object in
a domestic relationship under pressure from the demands of communal living ar-
rangements. The primus story is one of a number of such stories that elaborate on the
hardship of early pioneering life and the challenges of achieving a balance between
collective and individual interests. Another area of hardship (for parents) was the col-
lective nursery care provided for babies, to which the caretaker stories give vent.

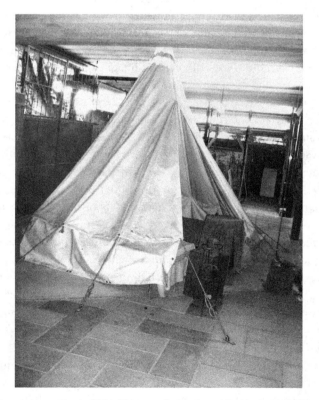

Figure 4.4 A pioneer's tent in the Yifat Museum. Reproduced by kind permission of
Tamar Katriel.

New guides learn the ropes from old-timers: they learn how to use objects, verbal expressions and visual images selectively and appropriately. The intergenerational transfer of stories between guides touches on one of the main concerns for contemporary kibbutzim: that young people are leaving them. This gives the sense of place at Ein Shemer a particular poignancy, which the guides do not avoid. The tour starts with old photos of the pioneers; it takes a look into the parental home of a pioneer with its reminders of the religious Eastern European Jewish families from which the secular pioneers originated. The communal dining room is, in contrast to Yifat, populated by mannequins, each of which allows the guide to tell a story; the stories relate mainly to the hardships of pioneer life. There is a family cabin (and a broom story, somewhat similar to the primus story) and a weapons cache concealed beneath a bed (combined with a story about women's untrustworthiness).

There are interesting distinctions in the respective styles of old-timer guides and their younger colleagues. Visionary old-timers personify the Zionist dream, bear direct witness to it and use an inclusive 'we' to talk about it. The younger generations re-infuse the museum story with contemporary life: some dress up in period attire, playing a role alongside the mannequins in the communal dining room. Some grew up on the kibbutz and therefore have personal stories to tell about that. Many of their stories are borrowed from the old-timers. Their use of the first person distinguishes their references to a shared present. Another key difference is that the younger guides seldom use the verbal signs and visual emblems central to the pioneering tale. Instead, they draw on their own personalized responses to the scenes and meanings of the pioneers' world. In doing so, they personify the outcome of the Zionist dream: the new Zionist person, the native Israeli, reflexively filled with self-doubt and yet paradoxically fully committed to the canon.

There is a multilayered relationship between stories and objects in the settler museum. The Israeli master narrative of pioneering shapes and conditions collecting and exhibiting practices. Museum-making here is about visualizing the story of Zionist settlement. However, contemporary Israeli audiences are diverse, and what was once the national foundation myth is being challenged. Differences in and contestations of the master narrative surface in the interesting ways that Katriel's sensitive account reveals. The ethnic rift between new Israelis (of Middle Eastern or North African origin) and the European Ashkenazi Jews, who were the original pioneers, brings the *lack* of shared experience and assumptions to the fore. Religious Jews who visit the museums also have difficulty in celebrating the secular life of the early settlers.

Another rarely voiced rift is between the pioneers and the survivors of the Holocaust, many of whom arrived in Israel in the 1940s and 1950s, under desperate circumstances (see also Katriel 2001). This distinction emerged during a tour by elderly visitors on a day trip from another kibbutz. The tour guide, who had been

looking forward to this visit, was taken aback by the unusual difficulty she experi-
enced in holding her audience's attention. Indeed, quite a few drifted away from the
group. Katriel recounts how a former teacher of hers, who was part of the group,
clarified these visitors' lack of enthusiasm for the pathos of the pioneering story told
by the old-timer guide. Probing the reasons for this misfired encounter, Katriel dis-
covered an underlying source of malaise. When she suggested a comparison between
settlement and Holocaust museums being established in so many places (Katriel
1997: 113), her former teacher's response was incredulous: 'How can you compare?'
Although the Holocaust story has become foundational in contemporary Israel, its
inevitable cohabitation with the formerly central pioneering ethos is an ambiguous
one. Indeed, the question forced Katriel to re-examine her own position in relation
to the pioneer museum story. In so doing, she came to understand the 'limits of the
museum master narrative . . . its hegemonic nature and exclusionary potential' (ibid.:
115). For Arab visitors, the pioneering stories about the land (also their land), the
tools (once their forefathers' tools) and the settlers' Arab neighbours not only deny
their modernity and equality but also the fact of their displacement from the area.[12]

Through the dramatic enactment of their stories, guides create an imaginary
world for themselves and their audience. The guide's authoritative role as keeper of
pioneering memory and ritual leader of the guided visit means they do most of the
talking. The effort to fix and preserve the pioneering moment through settlement
museum discourse has become increasingly difficult in complex contemporary Israel,
turning such museums into micro-arenas where the politics of nostalgia are played
out. Settlement museum discourse is moreover set against right-wing settlement of
Gaza and the West Bank. In seeking to infuse the future by means of a 'past-oriented
gesture of commemoration', the effort to enhance identification with the museum
story ends by accentuating its 'remoteness from present day circumstances and
most patrons' (ibid.: 149). Katriel's ethnographic analysis tunes into and probes the
ambivalences, paradoxical strains and contradictory themes articulated in ongoing
construction of the museum narrative. By locating pioneer settlement museum dis-
course in the broader Israeli heritage scene, the ethnography shows how these houses
of memory are also houses of forgetting.[13]

CONCLUSION

The accounts of collecting, exhibition-making, museum encounters and perfor-
mances discussed in this chapter indicate what an ethnographic approach adds to
museum studies research. The ethnographers probe the complexities of these fun-
damental domains of the museum, both charting and contextualizing the detail of

everyday activities and placing them within broader frames of reference. The methodological precept of participant observation brings the researcher into the midst of the negotiated realities being analysed. The distinctiveness of ethnographic vision resides in systematically following and engaging with the activities being described and analysed, and articulating the complexities of microlevel analysis with broader cultural issues and debates. What is the significance of each of these three cases in terms of a visual anthropology of museums? I limit myself to two comments here: the first concerns the use of visual documentation in the ethnographies; the second, the place of the visual, vision, visibility and the distinction between observing and really seeing.

As written ethnographies, all three are constructed, to varying degrees, around photographic or drawn images. O'Hanlon's ethnography, *Paradise*, is the most strikingly visual, with fifty-six images (as well as two maps): there are a few historical images by Michael Leahy, dating from the 1930s; studio photographs of objects, by the British Museum; and many field photographs, in black-and-white and colour, taken by O'Hanlon himself. As with most museum publications, the images are high quality, as is the graphic design of the publication. The images are an integral part of the ethnography, documenting the collection and its making in Highland New Guinea, as well as contextualizing it historically and in London.

Photographic documentation—some thirty-seven black-and-white photographs, mainly her own, as well as a few diagrams and other visual representations—also endows Macdonald's ethnography with a significant visual dimension. She uses photographic portraits to introduce the Foodies and the designers, each of whom is portrayed—according to their wishes—in the exhibition context, alongside the written portraits of each. She also documents the development of the exhibition photographically.

Katriel includes ten black-and-white photographs of a selection of key objects and scenes in her third chapter, 'The Tools Tell the Story: Narrative Trajectories in Settlement Museum Tours'. Her discussion of how objects are interwoven with stories in the tour context shows how powerful the visual and material dimensions of the museum are: although the guides' selective use of the displayed objects and images seems to reinforce the pioneer narrative, the awkward questions raised by diverse contemporary visitors destabilize the narrative and show that there are several possible interpretations. Nonetheless, the objects remain while discussion goes on around them.

All these varying forms and uses of the visual, alongside the material, combined with written and verbal discourse, deserve further consideration as part of the visual in anthropology which includes the practical efficacy of both images and objects (Pinney 2002b). O'Hanlon's distinction between observing and really seeing in the context of collecting exemplifies this new visual depth. Active engagement

in collecting, making exhibitions and guiding visitors provides distinctive vantage points from which to write an ethnographic account. As we have seen, the replication of *geru* boards for the collection made explicit all kinds of implicit rules and ideas. The collection, as a collectively (if selectively) authored entity, worked similarly: absorbing the agencies of both its collector and its contributors, as it was packed, shipped and unloaded in London, it materialized, expressed and concretized their social relationships.

The making of an exhibition is an artificial exercise through which implicit ideas and practices are made explicit. Macdonald's position as ethnographer was not combined with that of exhibition-maker: instead, she brought together different strands of museum life and paid attention to a fast-moving process that is difficult for participants to reflect on (Macdonald 2002: 12). She distinguishes between this kind of ethnographic account and in situ accounts—such as those of a collector-ethnographer or an exhibition-making ethnographer. If the ethnographer's cultural product is *both* a text and an active part in the authorship of a collection, an exhibition or the performance of a guided tour, this complicates and diversifies the notion of ethnography as a written document. Both Macdonald's and Katriel's ethnographies make explicit (or visible) activities and meanings that are normally taken for granted (and therefore invisible).

O'Hanlon's double role both in the field and back at the museum involved him in several different ways of conducting ethnography. Embedded participant observation (where the ethnographer participates in the making of a collection, the making of an exhibition or the performance of a guided tour) echoes a major debate in visual anthropology concerning ethnographic film. Lucien Taylor proposes that the ethnographic film constitutes a distinctive visual form of ethnography that challenges the hegemony of written ethnographies (1998: 16). The ethnographies discussed here demonstrate how materially and visually mediated practices of collecting, making exhibitions and performing guided tours impress themselves on written accounts and, through them, alter the ways we perceive and understand museums.

KEY CONCEPTS

Ethnography	Performance
Agency	Pivotal objects
Authorship	Visual memory
Actor-network theory	Storytelling

EXERCISES

1. Try to arrange a visit to a nonpublic area of a museum: this may be a visit to a depot, an archive or a meeting room. Some museums organize occasional tours of such areas (e.g. Artis Zoo, Amsterdam); others include open depots as part of their permanent exhibitions. Write down your experience of moving between the front area and the area behind the scenes. What did you notice about staff and/or collections in this area?

2. Find out which exhibitions are currently planned or are being made or installed at the moment in a given museum. If there are public presentations or discussions of plans, try to attend a meeting or preferably more than one meeting. Notice how the plans are presented and debated. If there are debates and controversies, what are the lines of dissent between the parties involved about?

3. Take an audio tour of an exhibition, then sign up for a special guided tour of the same exhibition. What differences do you notice? What is the meta-narrative within which the exhibition is contextualized? Which objects are pivotal to which stories?

FURTHER READING

Clavir, M. (2002), *Preserving What Is Valued. Museums, Conservation, and First Nations*, Vancouver: University of British Columbia Press.

Handler, R. and Gable, E. (1997), *The New History in an Old Museum. Creating the Past at Colonial Williamsburg*, Durham, NC: Duke University Press.

Katriel, T. (1997), *Performing the Past. A Study of Israeli Settlement Museums*, Mahwah, NJ, and London: Lawrence Erlbaum.

Macdonald, S. (2002), *Behind the Scenes at the Science Museum*, Oxford and New York: Berg.

O'Hanlon, M. (1993), *Paradise. Portraying the New Guinea Highlands*, London: British Museum Press.

Tythacott, L. (2011), *The Lives of Chinese Objects, Buddhism, Imperialism and Display*, Oxford and New York: Berghahn Books.

5 PRACTICES OF OBJECT DISPLAY

[M]useum exhibition techniques continue to impose academic classifications—our 'glass boxes' of interpretation—upon diverse cultures. The sizes and shapes of these boxes have changed with the theoretical fashions within anthropology—ranging from progressive technology exhibits, comparative, cultural displays of family groups, and dioramas or stage sets to demonstrations and performances.

(Ames 1992: 140)

Exhibitions are discrete events which articulate objects, texts, visual representations, reconstructions and sounds to create an intricate and bounded system.

(Lidchi 1997: 168)

Accumulating and displaying valued material things is, arguably, a very widespread human activity not limited to any class or cultural group.

(Clifford 1997: 217)

Practices of keeping may be universal, but practices of display are not so obvious.

(Sansi 2007: 99)

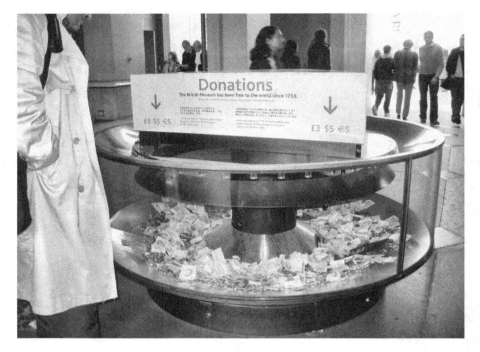

Figure 5.1 Donations on display at the British Museum. (Photo: M.R. Bouquet)

INTRODUCTION

Glass display cases filled with an assortment of the world's coins and banknotes in the entrance hall and freely accessible Great Court of the British Museum are an arresting sight. These display cases create a powerful image of donation by transforming small change into an object of contemplation, and they also include an interactive dimension. The visitor, adding to the heap of currency inside, engages in a small rite of civility in this newly defined public space of the world's oldest museum. Voluntary personal donation becomes a conscious act that visibly augments the common good: it contributes to keeping the unique historical collections and buildings for posterity, making them accessible to everyone now and in the future.[1] Every individual visitor can transform a tiny particle of their economic capital into cultural capital in a gesture that obviates ticket queues and turnstiles. What does this simple device have to do with the displays of world culture for which the museum is famous?

Putting objects on display is a widespread human activity. The social dynamics of what is made visible or invisible are crucial issues for visual anthropology. Studies of the poetics, politics and practices of display explore the construction of meaning

in exhibition space; institutional relations that constrain selection and naturalize certain modes and narratives of display; and the social agency of people and objects cross-cutting and generating new dynamics of display.

Questioning the self-evident nature of the donations case is the starting point for this chapter. It identifies the principal dynamics that shape the poetics, politics and practices of display: objectification, modernism and renovation. Objectification refers here to the power, knowledge and authority involved in de- and recontextualizing selected things, thereby transforming them into objects of attention, meaning and Culture (cf. Sansi 2007). In the past, numismatic collections removed coins from circulation and endowed them with historical value and interest (cf. Pomian 1990; Bennett 1995). The British Museum donations case does something quite different: it objectifies the disorderly appearance of currency in this transparent container as part of an *interactive* exhibit. The viewer can choose to augment the heap, or decide to ignore it. This gives the donations case a relational position in the renovated British Museum Great Court. Foster & Partners created this modern, glass-roofed, public space at the heart of the British Museum, fashioning new pathways that radiate out, cutting through the former linear narrative of empire (Williams 2004). This new set-up was accompanied by the return to the British Museum of the ethnographic collections from the Museum of Mankind, where they were displayed from 1970 to 1997. As the department of Africa, Oceania and the Americas, the ethnographic collections take their place among the world's great cultures at the museum. The Northwest Coast memorial and house poles that were raised anew in the Great Court, in the presence of Haida chiefs (MacGregor 2007), announce that return amid the dazzling white limestone surfaces of the new South Portico façade and the newly streamlined, multipurpose Reading Room at its centre.

Renovation therefore encompasses both objectification and modernization, and goes beyond both. The donation cases objectify currency as part of a bigger, modernizing design. Donation, as a euphemism for the self-management of civic responsibility (cf. Bennett 2006), enters the renovation process in a playful, reflexive way.

Much scholarly attention has been devoted to the critical interpretation of exhibitions.[2] Constructionist approaches focus on the internal creation of meaning through design and display methods, which naturalize and legitimate selected meanings. Exhibition resembles a text which can be read as a signifying system by drawing on semiotic theory (cf. Lidchi 1997). Selection and display can be seen as governed by prevailing relationships of knowledge and power in specific institutional settings through discursive approaches. Practice-based approaches emphasize agency and the processes of negotiation which cross-cut contemporary institutions that are embedded in complex global networks.

Exhibiting objects is one of the primary tasks of museums, making them important players in the field of cultural production (Bourdieu 1993; Lidchi 1997). Exhibitions allow museums to establish and renew their reputations and identities, their value and quality of service, thereby positioning and repositioning themselves in the arena of public culture. The economic value of cultural heritage is a major factor in its expansion and diversification (Kirschenblatt-Gimblett 2006). Exhibition activities are circumscribed by a field of forces that includes trustees, sponsors, staff networks outside the museum, the collection, the public, source communities, critics and the press. There have been shifts in notions about which objects should be displayed, in which institutions, and how they are displayed and how the public engages with them; there have been crises of representation, and new ways forward have been found. Objects once classified and displayed as ethnographic have played a pivotal role in the processes of objectification, modernism and renovation. This chapter is organized in three interconnected parts. While it is easiest to see objectification in the past, the process of course continues. Museums are seen as an integral part of modernity. Modernism reinvented the museum, redefining, among other things, the space and dynamics of exhibition. Renovation is the act of reconnecting the old with the new.

The first part thus examines objectification through a number of display practices that shaped late-nineteenth-century exhibitions: typologically arranged series of objects, life groups and 'rooms'. Debates about the respective values of typologies versus regionally based displays were also debates about modes of interaction between objects and audiences, indicating changes in how these were viewed. Life groups and inhabited rooms that could be entered and walked around in by visitors arose in this context, drawing on popular exhibition practices to animate museum displays and capture audience attention. The second part considers modernist attempts at reformulating the space of exhibition, which involved banishing the overcrowded nineteenth-century museum displays. Some ethnographic artefacts became a source of avant-garde inspiration, initially juxtaposed with, and later incorporated into, modern art—rather than being scientifically classified out of it. Exhibition design became a modernist discipline in its own right—aiming to transform the visitor from passive viewer into active participant in this newly created space. However, this produced curious backwaters that had apparently been left out of the process. The last part, on renovation, refers to the heritage dynamic of renewal applied in the broadest sense to buildings, exhibitions and the social relations of collections. The recovery and revaluation of suppressed or difficult histories, actively using collection pieces or buildings, foregrounds the visible, material presence of the object in newly reflexive ways.

OBJECTIFICATION: TYPOLOGIES

Objectification in the museum context involves the appropriation of cultural property and its reconfiguration within a systematic framework of knowledge. Once objectified in public, visible form, Culture can be discussed, used and manipulated—exactly because it has been transformed (Sansi 2007; Rowlands 2002a; Thomas 1991). Glass cases are a classic device for creating distance between the viewer and the object (cf. Lidchi 1997: 173). All museum collections involve the removal of objects from one context and their recontextualization as part of a collection and/or as part of a display in which new meanings are attributed. The Pitt Rivers Museum,[3] Oxford, founded in 1884, organized its prehistoric and ethnographic objects as types, grouping them in the displays according to their form and function—for example as weapons or hunting equipment. Some of these groups constituted series, showing small variations in form over time from simple to complex, which were supposed to parallel the development of cultural groups. This equation between material culture and culture was based on then current ideas about technological development, thought to culminate in the industrial progress of the Victorian Age. The assumption

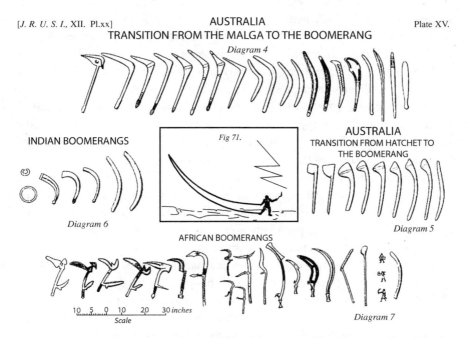

Figure 5.2 Typological series of boomerangs from Australia, India and Africa, published by Pitt Rivers in 'Primitive Warfare Part II', *Journal of the Royal United Services Institute* (Lane Fox [Pitt Rivers] 1868).

was that classification by physical characteristics made the collection more scientific. The viewer's attention was focused on characteristics visible on the surface of the artefact (referred to as the 'internal criteria'), rather than external criteria such as provenance.

Typological displays allowed the viewer to take in technological and artistic traditions from various parts of the world at a glance. The typologies comprise thousands of tiny modifications to different branches of the human arts and industries, and were supposed to show the transition from 'brute creation' to 'civilized' society (Gosden and Larson 2007: 98). Such scientific arrangements were an authoritative source of visual knowledge in the pre-mass media era. Although typological displays might appear static to our eyes, the arrangement worked like a magnet, attracting new objects to fill the infinite gaps in any sequence of types. Hence, from the outset, the Pitt Rivers Museum cases were constantly being rearranged to accommodate new acquisitions. The growth of the collection through these additions was taken to indicate a growth in their scientific value, thereby adding to the museum's increasing importance.

While the scientific discourse of evolution and the political discourse of progress shaped the classification organizing this display, some objects managed to evade the system. Objects from Cook's Second Voyage, the Nagaland exhibit and themed groups such as magic, divination and religion indicate, through their resistance, the limits to the objectifying logic of the typological display: external references in these cases overpower the internal criteria. Some series, such as fire-making equipment and boomerangs, were considered 'very typical', which meant the acquisition of as many styles and versions as possible. The elaboration of these series seems to have come about through an almost organic process of mutual reinforcement, rather than by methodological prescription. The educational aim was to demonstrate broad patterns of cultural diversity, charting the progressive evolution of types through series. The scientific authority of this way of display thus rested on the activities undertaken at the museum itself.

The museum's founder, Lieutenant General Pitt Rivers, and staff members Edward Burnett Tylor and Henry Balfour were primarily concerned with the tangible qualities of the objects. They not only measured, grouped and arranged artefacts but also experimented with them and gave demonstrations in ways unknown to modern museum staff. They knapped flints, used fire-making equipment and even practised boomerang-throwing in a local park as part of what Pitt Rivers called 'eye training'. This visual and haptic training was thought to facilitate classification, thereby bolstering the scientific value of the collections and displays: indeed, the tiny figure at the centre of the typological series is throwing a boomerang (Figure 5.2).

Stone tools were *seen* as primitive: their physical qualities received a great deal of attention, and this prompted efforts to secure more examples. Their presence in

Oxford, in this collection, made them seem primitive and ancient and therefore worthy of study. Stone tools and weapons make up more than half of the collection, suggesting that the objects themselves exercised a strong attraction—stronger than any interest in their makers. Pitt Rivers and Balfour spent much time 'arranging their collections of weapons and tools into scientific series, which led them back from pistols and ploughs to simple stoneflakes and flints. The simplicity of these blades and flakes, positioned at the very beginning of evolutionary series, suggested the origins of human ingenuity' (Gosden and Larson 2007: 101). The boomerang series, as well as the Australian objects placed at the beginning of series, created their own feedback loop: classified and visually confirmed as 'primitive', they contained within themselves the momentum for further elaboration.

The persistence of the museum as an objectification of a nineteenth-century evolutionary view of world cultures presented its late-twentieth-century direction with a professional and public dilemma. What was the value of keeping this historical vision of the world intact (however fascinating its unfamiliarity) when the world had changed so fundamentally? Shouldn't the displays be modernized? The Relational Museum Project (2002–2006) dug beneath the form acquired by the Pitt Rivers Museum as it developed through time to investigate the social relations of its production. Collections research in fact transformed the museum's predicament into a resource for producing new forms of knowledge: statistical analyses of the digitized collection archive revealed its hitherto-unknown dimensions; biographical research into selected figures combined with collection analysis made the networks and dynamics of the collection visible. Making these invisible social processes visible represents a modern approach to museum display through research. This research redirects attention beyond the objectified display at the museum to the archive which, through systematic analysis using computer technologies, yielded an image of the social relations of the collection extending out from the museum along myriad pathways into the world. The new knowledge produced in this way is transmitted to the public via the museum website, thereby rendering the old displays intelligible and historically valuable in new ways. The website has become an extremely important medium for the museum to present its research findings to a broad public worldwide, and to share its collections digitally with source communities (see Chapter 6). The relational significance of the collection thus emerged through scholarly investigation of the process of objectification.[4]

Evolutionary displays were subject to criticism at the time of their production due to changing views about the relationship between scientific knowledge and the general public. Franz Boas contested both the scientific basis of social evolutionary theory and the material form given to it in museums.[5] Boas's ethnographic fieldwork among indigenous peoples of North America convinced him that museums should try to convey the richness of particular life ways rather than integrating artefacts from diverse origins

into universal classificatory schemes (Jacknis 1985: 77). The debate that took place in American museums during the 1880s, between proponents of typological arrangements based on form and function and those in favour of regional exhibits, was also a discussion about how best to serve the public. This discussion paved the way for experiments with life groups, which, in turn, led to a different form of objectification.

LIFE GROUPS

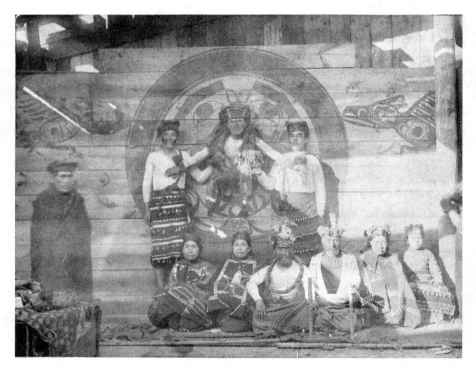

Figure 5.3 Performance of a Hamat'sa, World's Columbian Exposition, Chicago, 1893. (Photo: John Grabill. American Museum of Natural History, Neg. # 338326)

> It seems as if every natural history museum with a major Northwest Coast collection had to have a life-sized depiction of the Kawkwakawa'kw *Hamat'sa* to supplement their towering totem poles and giant war canoes.
>
> (Glass 2006)

On the face of it, life groups seem to repersonalize displays (and hence collections): to render them popular and accessible by staging realistic scenes of daily or ritual

life. Jacknis proposes that 'the life group was anthropology's attempt to create a functional or contextual setting for its specimens', at the same time that habitat groups were introduced in biology, and period rooms in history and art (1985: 82). Already popular in Europe (see later on), the life group was introduced to America at the Chicago World Exposition of 1893. Naturalistic scenes of human cultural activity, involving several human figures together with artefacts, were commissioned by a number of museums in the 1890s.

The life scene stages collected artefacts—often from different sources—as if they were being used by the figures, instead of leaving the visitor to make those connections from the juxtapositioning and labels. So captivating were these scenes that they gave viewers the illusion of looking at something real, rather than historically specific cultural snapshots extracted and reconstructed from the flow of time.[6] Boas wanted to include such groups in the regional, ethnically based displays he advocated to combat the problem of visitors' wandering attention. And indeed the groups were immensely popular with the public. For Boas, the main point of ethnographic collections was to show that civilization was not absolute but relative to the position of the observer. As an employee of the American Museum of Natural History in New York, Boas had of course to contend with the institution's position in the field of cultural production.[7] The New York financial elite comprising the museum's twenty-four trustees were not scientists, and they depended on wealthy patrons who were much more interested in 'donating magnificent collections' than funding the substantial costs of expensive installations.[8] Donation in this context was a matter for wealthy citizens eager to leave their mark on the institution (cf. Duncan 1995). Life groups may have seemed in this context an expensive diversion from the core task of presenting collections.

This realist mode of representation demonstrates, then, an alternative route to objectification: collected objects—such as cedar bark rings and capes—were subjected to the narrative that the life scene depicted. Glass (2006) argues that the circulation of photographs of such life scenes among North American museums produced an iconic image of native peoples. Framed and lit, protected by glass, the scenes show indigenous peoples frozen in the act of performing some typical activity— initiation, weaving or hunting—as if in a photograph.[9] Indeed, Boas himself modelled for the photographs that were taken in the process of producing these realistic scenes (Jacknis 1985: 99; Glass 2006). The complex interplay between photography and modelling, enactment and re-enactment, is quite different from the hands-on experiments that preceded arrangement into typological sequences in Oxford. The life group scenes were intended to arrest the distracted attention of a modern public (cf. Henning 2006) and give context to regionally arranged displays of artefacts. In fact, the very success of the life groups had its own drawbacks: their overpowering

nature could be detrimental to their scientific purpose, and the audience could become sated by their repetition.[10]

THE INHABITED ROOM

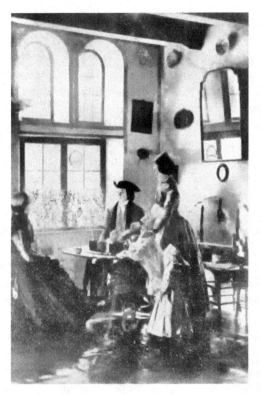

Figure 5.4 The Hindeloopen Room with mannequins. From an album with photographs of the Historical Exhibition, held in Her Majesty's Palace, Leeuwarden, in the summer of 1877. (Photographer: Gerarda Henrietta Matthijssen. Source: Tresoar, T55)

Life groups originated in Europe and were inspired by displays of colonized peoples at nineteenth-century world exhibitions. Around the same time that spatially distant populations were being objectified in typological displays, life groups and dioramas, Romantic, atmospheric evocations of folk culture gained currency in Europe. Farmers' and fishermen's lives were idealized by urban elites, in particular, who saw them as maintaining the traditional values of the nation, which were being destroyed by industrialization and urbanization. Artists who discovered the attractions of painting

outdoors, on location, made rural life and landscapes famous through their paintings.[11] The industrialization of production, urban expansion and new and rapid forms of travel made people look to the disappearing rural folk culture as a source of enduring (national) values.

In Europe, the Hindeloopen *kamer* (room) represents a distinctive variant of the period room: the *inhabited* best room. The three-dimensional reconstruction of the best room of a prosperous household from the town of Hindeloopen on the Frisian Ijsselmeer became an influential display trope initially used at historical and international exhibitions before settling down in museums. The room comprised furniture, a bedstead, silver, Chinese porcelain and Indian fabric and was populated by mannequins dressed in Frisian national costume. Visitors could—literally—go a step further than *looking*: they could enter and experience a past apparently captured in the three-dimensional space of this room.

How did this room come into existence? Earlier philological interest in recording folk songs and folk tales made way for a more general interest in collecting rural material culture by the end of the century: local costumes, handicrafts and farm buildings were all seen as being on the verge of extinction and therefore requiring preservation in museums (De Jong 2001). The Swedish Open Air Museum of Skansen, founded by Artur Hazelius in 1891, was the first public institution in the world devoted to such forms of popular heritage. Other folk museums soon followed elsewhere in Scandinavia.[12]

Glorification of folk culture was a pan-European phenomenon that was harnessed to the—essentially cosmopolitan—project of defining national identity.[13] This entailed collecting folk costume, painted furniture and everyday objects connected with calendrical as well as life-cycle rituals, and celebrating these feasts—revived where necessary (De Jong 2001: 14). The Netherlands Open Air Museum, founded in 1912 and opened in 1916, was the first such institution outside Scandinavia and Finland. An eighteenth-century Hindeloopen interior was an early acquisition by the museum in 1923. Like the Hamat'sa life group in the North American context, the Hindeloopen Room was featured at national and international exhibitions before its incorporation into the Netherlands Open Air Museum.

One important source of inspiration for the Hindeloopen Room was the atmospheric reconstruction of François I's *chambre*, by Alexandre du Sommerard, exhibited complete with sixteenth-century furniture at the Hotel de Cluny in Paris, 1832 (De Jong 2001: 73). Architect Pierre Cuypers was inspired by this *chambre* as he sought to create atmospheric rooms, or *ensembles*, for the Amsterdam Historical Exhibition of 1876 and later for the Rijksmuseum (1885). These *ensembles* consisted of fully furnished rooms, such as kitchens and bedrooms, through which visitors could walk and where they could experience their forefathers' living presence—rather than

just commemorating abstract historical events. The *ensemble* may arguably be seen as an early version of Clifford's (1997) contact zone.[14] These scenes certainly proved very popular with the public.[15]

This, then, was the museological gist behind the first Hindeloopen Room created for the Historical Exhibition at Leeuwarden, Friesland, in 1877. The choice of Hindeloopen was based on sketches of interiors and costumes by the Hindeloopen naive painter Hendrik Lap, commissioned in 1849, some of which were also put on display at the exhibition (Elzinga n.d.). Shown together with ensembles similar to those shown in Amsterdam, the room was distinguished by life-size mannequins dressed in local costume who were displayed taking afternoon tea together. A painted tile backdrop successfully created an effect of visual authenticity (De Jong 2001: 24). Flexible opening hours and modest entry fees increased the popular appeal of the Leeuwarden Historical Exhibition. Reviewers praised the realist illusion and drew comparisons with Cuypers's ensembles shown in Amsterdam the previous year. It was indeed the high point of the Leeuwarden exhibition.

The Hindeloopen Room distilled from these various sources both strengthened Frisian national sentiment (assuring Friesland a special place in the Dutch kingdom) and provided a model that could be replicated elsewhere. Transposed to the international stage, the room came to stand for Dutch national identity. The public entering the Hindeloopen Room in the Dutch Pavilion at the 1878 Paris World Exhibition mingled with figures enacting baptismal preparations. People were struck by the difference between *looking at* Hazelius's many diorama scenes with life-size costumed figures depicting Swedish folklife (also on display in Paris) and *being in* the Hindeloopen Room. Bernhard Olsen of the Danish Folk Museum remarked that the Dutch display of a 'closed peasant room' could transport the visitor into another world, far removed in time and space from the teeming modern exhibition (Sandberg 2003: 200).

There is a long history of representing everyday life through genre painting, particularly among seventeenth-century Dutch masters (Franits 2004; Gombrich 1989: 336). Scenes of everyday life, interiors and domestic settings became popular with the new class of patrons that arose after the Reformation. During the nineteenth century, artists drew attention to the picturesque potential of rural life in their genre scenes (Gombrich 1989: 402–403). Local rooms became typical when translated into museum representations, taking their place among techniques borrowed from panorama, panopticon and theatre to try to keep their audience's attention (Henning 2006: 34). Natural history dioramas necessarily remained behind glass, due to the complex taxidermic preparation and conservation of their specimens. Folk scenes migrated, by contrast, early on from interior immersion to outdoor enactment and, later, into various forms of living history. Hazelius was to turn the effect, initially developed with interior scenes, inside out at Skansen, where he combined

live, costumed tour guides with groups of mannequins outdoors (see also Handler and Gable 1997).

Life groups were a reaction to evolutionary displays and the scientific idea informing them. Inhabited, historical rooms, on the other hand, hark back to a past recreated as a form of solace against the disenchantment of the industrial world. Just as the habitat diorama seems to refer to unspoiled nature (sometimes including indigenous people), and the folk museum to traditional rural life, both are created using modern techniques. Dipping into these controlled and sanitized versions of Nature, the Other and the Past was in this respect a modern attitude.

Not everyone was thrilled by the popular nostalgia and conviviality of these scenes; the backlash came in the early twentieth century (De Jong 2001: 122). The new director of the Rijksmuseum, Amsterdam, took steps to remove historical objects, including folk costumes, upon his appointment in 1896.[16] A new emphasis was placed on the aesthetic and artistic dimensions of objects, which were seen as an intrinsic part of showing art historical connections and developments. The historical collection was dismissively referred to as rubbish—*prullen* (Ham 2000: 203). The costumes made way for a typological presentation of history (De Jong 2001: 340).

Personalization thus had its risks: those represented might not necessarily identify with what was shown, while those in charge grew tired of them. However, just as the Pitt Rivers Museum found a new way of approaching its historical legacy of objectification, so too was the Netherlands Open Air Museum to draw inspiration from the historical repertoire of display devices when it reinvented itself in the 1990s: dioramas, waxworks, panoramas and theatres were used to renew the museum as a public attraction (De Jong 2010: 335). This reinvention included a shift away from being an object-oriented museum to being a story-oriented museum (ibid.: 332). As we have seen, Boas had abandoned life groups (and indeed museum exhibits) as an educational tool for scientific purposes by 1906. Later, in the 1930s, he experimented with film as an ethnographic medium, shooting footage of Kwakwakawa'kw dances and the Hamat'sa (Glass 2006). Experimentation with space and the visitor experience in the Hindeloopen Room anticipate a number of modernist developments—as we shall see.

When Lévi-Strauss visited the Northwest Coast Indian Gallery of the American Museum of Natural History in 1943, he was enchanted by the power of the exhibition for rather different reasons. The next section considers the impact of modernism on museum displays in the 1920s and 1930s—starting out from a counter-case.

MODERNISM

'There is in New York', I wrote in 1943, 'a magic place where the dreams of childhood hold a rendez-vous, where century-old tree trunks sing and speak,

where indefinable objects watch out for the visitor, with the anxious stare of human faces, where animals of superhuman gentleness join their little paws like hands in prayer for the privilege of building the palace of the beaver for the chosen one, of guiding him to the realm of seals, or of teaching him, with a mystic kiss, the language of the frog or the kingfisher. This place, on which outmoded but singularly effective museographic methods have conferred the additional allurements of the chiaroscuro of caves and the tottering heaps of lost treasures, may be seen daily from ten to five o'clock at the American Museum of Natural History. It is the vast ground-floor gallery devoted to the Indians of the Pacific Northwest Coast, an area extending from Alaska to British Columbia.'

(Lévi-Strauss 1983: 3)

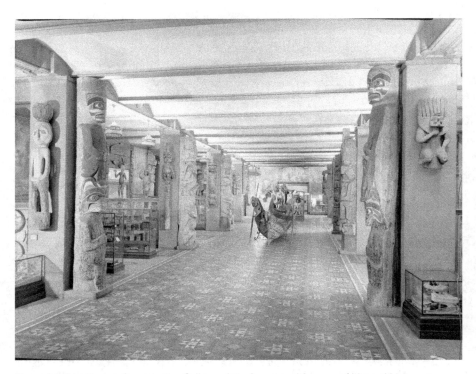

Figure 5.5 Northwest Coast Indian Gallery of the American Museum of Natural History in 1943. American Museum of Natural History, # 318931.

The unintended effects of museum displays—when things exceed their allotted roles—can be seen as the 'other side of modernity' (Henning 2006: 2,100). Lévi-Strauss's remarks about the American Museum of Natural History's Northwest Coast Indian Gallery in 1943 appearing at once outmoded, magical and

singularly effective touch on this same area: the material seems to exceed the institutional narratives and rites of citizenship allotted to it (Duncan 1995). Indeed, the combination of things at the American Museum of Natural History accentuates the bizarreness of the display—echoing the Pitt Rivers Museum effect, albeit in a different way.[17] By grouping things from the same region, the Northwest Coast Indian Gallery condensed variations and distinctions on certain themes—prompting Lévi-Strauss's ethnographically based exploration in *The Way of Masks* (1983).

Like many American museums in the 1930s and 1940s, the American Museum of Natural History had started experimenting with new installation techniques and with exhibitions of art. The first such art exhibition was held in 1939 (Staniszewski 1998: 99). Around the same time, modern art museums—notably the Museum of Modern Art (MoMA), founded in New York in 1929—entered their most experimental phase, exhibiting 'primitive art' and experimenting with ethnographic-style installations. This interchange of display practices across the spectrum of museums reflects the professionalization of exhibition design from the 1920s. This professionalization accompanied an important taxonomic shift that was taking place during the first half of the twentieth century. Selected ethnographic specimens were 'becoming art' (Morphy 2007): identified first as 'primitive art', and later as fine art,[18] they were displayed accordingly (see Clifford 1988: 224). Although this transformation owed much to display techniques, the process was uneven. While many ethnographic museums modernized their collections to represent other cultures, others remained unmodernized, thereby producing the kind of effects that surprised Lévi-Strauss. Although crucial, 'installation design as an aesthetic medium and historical category . . . has been officially and collectively forgotten as a part of modern art history' (Staniszewski 1998: xxi).

The transition of certain ethnographic artefacts into the category of art took place in various ways: recognition of the aesthetic value of African, Oceanian and American objects in ethnographic museums—such as the Trocadéro—was initially as a source of inspiration by avant-garde artists, who started acquiring pieces for their ateliers. Modern art connoisseurs' interest was sparked, and they began to purchase ethnographic objects for their collections.[19] By the 1920s it had become accepted practice among modern art galleries and museums to exhibit 'primitive art' together with modern art works. The Karl Ernst Osthaus Museum in Hagen, which later became the Folkwang Museum in Essen, implemented this practice as early as 1911. When Paul Sachs, one of the founders of the MoMA, described the Folkwang Museum as 'the most beautiful museum in the world' (*Kurzführer* 2010) during a visit there in 1932, this combination was undoubtedly part of that beauty.

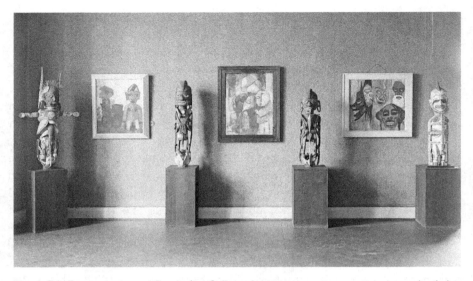

Figure 5.6 Expressionist and Exotic Art Gallery, showing contemporary painting and tribal art exhibited together in 1915 at the Karl Ernst Osthaus Museum in Hagen, later the Folkwang Museum, Essen. Foto Marburg: 625.684.

Apart from combining works from different origins to reinforce one another in terms of modernist explorations of form, colour, perspective and materials, innovative ways of display had the power to transform everyday objects into artworks. Exhibition design had become a favourite arena for experimentation among avant-garde artists, architects and designers by the 1920s. These designers moved away from the salon style of exhibiting artworks on the walls of galleries, based on classical aesthetics and perspective, creating instead transparent, total environments. A sense of expansive space was achieved by using free-standing units, colour, lighting and atmosphere (Staniszewski 1998). The density and symmetry of historical displays (such as the one Lévi-Strauss wrote about) were replaced in some institutions by sparse, asymmetrical and interactive arrangements.[20] A closer look at some of the influential design components indicates how the modernist vision of displaying and interacting with artworks was implemented.

THE L AND T SYSTEM

One of the free-standing units used to create this new space was Frederick Kiesler's L and T system (*Leger*—'lying'—and *Trager*—'bearing'). This system comprised horizontal and vertical adjustable display panels and beams which were both strong and

moveable, enabling works of art to be brought into the time and space of the visitor. The units could be recombined in various ways independent of the gallery walls; they could be partially spotlighted and coloured, further transforming the experience of the space of display. The L and T system was first tried out at the Vienna International Exhibition of New Theatre Techniques (1924), where it was used to display drawings, posters, marionettes, photographs, designs and models of avant-garde theatre. A version of the Vienna show travelled to New York in 1926.

The L and T system was one of the building blocks of Kiesler's theory of correalism, developed in the 1930s, which he saw as 'an exchange of interacting forces . . . the science of its relationships' (cited by Staniszewski 1998: 12). In *The Second Manifesto of Correalism* (1965), Kiesler elaborated further: 'The traditional art object, be it a painting, a sculpture, or a piece of architecture, is no longer seen as an isolated entity but must be considered within the context of its expanding environment. The environment becomes equally important as the object, if not more so, because the object breathes into the surrounding and inhales the realities of the environment no matter what space, close or wide apart, open air or indoor'. Correalism was thus attuned to the relative, culturally specific and interactive construction of meaning in the space of exhibition: or, the poetics.

THE ATMOSPHERE ROOM

Another design icon from this period was Soviet artist El Lissitzky's Abstract Cabinet, made for the 1928 Dresden International Art Exhibition and for the Landesmuseum, Hannover (1927–1928). Lissitzky's aim was to transform the viewer's experience of the exhibited works from passive looking to active engagement, through design. The shimmering effect of the Abstract Cabinet was created through the interaction between a walking subject and the flat vertical strips projecting at right angles from the wall, painted in different tones—black and white—on each side (Milner 2009: 30). There were also sliding display panels allowing the visitor to rearrange the room.[21] Like Kiesler's sysem, the Abstract Cabinet was a dynamic, interactive setting, with moveable units and innovative lighting, detached from the architectural detailing of the surrounding gallery. It was described by MoMA Director Alfred Barr as the 'most famous single room in the history of modern art' (Staniszewski 1998: 16). The Abstract Cabinet was installed next to Moholy-Nagy's Room of Our Time as the last two galleries in a chronological series of atmosphere rooms at the Landesmuseum in Hannover. Director Alexander Dorner dismantled the old salon-like, symmetrical installations and created these atmosphere rooms intended to immerse the viewer in the spirit of each art historical period. These rooms effectively broke open the former art historical chronology, making space for modern art of all kinds (ibid.: 19).

THE FIELD OF VISION

Herbert Bayer's field-of-vision concept articulates the interactive impact of the visitor in gallery space. Bayer was associated with the Bauhaus group, which, under Mies van der Rohe's directorship (from 1930), devoted much effort to developing free plan exhibitions. Using asymmetrical spatial arrangements and incorporating free-standing planes and columns, these exhibitions treated space as a 'flow', actively trying to increase the sense of movement. While designing the architecture and furniture gallery for the German section of the Paris Exposition of Decorative Arts (1930), Bayer sketched his installation concept in diagrammatic form. The concept showed the arrangement of objects and panels in relation to the viewer's field of vision. Panels above and below eye level were tilted at angles to the floor and ceiling. At the Building Workers' Union Exhibition of 1935, the field-of-vision concept was worked out even further to include a 360-degree field of vision. Bayer also made use of devices such as cut-out footprints on the gallery floor to guide visitors to particular exhibits.

Set against the background of such developments, it is small wonder that the American Museum of Natural History's Northwest Coast Indian Gallery struck Lévi-Strauss as outmoded in 1943. The hall seemed untouched by the upheavals in art history, the experiments with exhibition space and the interactive, individualist public presupposed by these changes. Yet it was by no means an exception. Modernist design practices and theories—such as correalism, interactivity and field of vision—helped to reshape exhibition space and visitor expectations more generally. But this was not a uniform process. The institutional reclassification of selected ethnographic objects as art objects that was taking place in museums such as the Folkwang Museum and the MoMA was significant. A number of experimental exhibitions at the MoMA during the 1930s and 1940s indicate the impact of incorporating ethnography into the modern art canon that the MoMA established after 1929. However, they also indicate the limitations of that process.

ETHNOGRAPHY AND MODERNISMS[22]

JUXTAPOSITION, ATMOSPHERE ROOMS, PERFORMANCE, VISTA

During the 1930s and 1940s, MoMA's director, Alfred Barr, engaged a range of strategies, including modernist installations, as part of his efforts to institutionalize modern art. He envisaged various themes and display conventions for 'primitive' and premodernist art, popular culture, film, architecture, design and the modernization of daily life. Artists and architects explored innovative ways of deploying the collection

in gallery space, so as actively to involve the visitor. Barr's multidepartmental plan for the MoMA (1929) expressed commitment to practical, commercial and popular arts, in addition to fine arts; he hoped 'to encourage and develop the study of modern art' as well as the application of such art to manufacture and everyday life (Staniszewski 1998: 74). Barr's earlier visits to Europe and the Soviet Union, as well as his contacts with avant-garde art movements—including De Stijl and the Bauhaus—shaped his network and his ambitions.[23]

The first primitive-art show at the MoMA was 'African Negro Sculpture' in 1935. This was followed in 1936 by 'Cubism and Abstract Art', in which 'primitive' and 'premodern' works were juxtaposed with modernist painting and sculpture, suggesting timeless and universal qualities in the works shown together. An influential exhibition, 'Indian Art in the U.S.', opened at the MoMA in 1941, presenting Native American culture and ethnographic artefacts in unprecedented ways for a modern art museum. The entire building was taken up by the exhibition, which, as part of President Roosevelt's New Deal, aimed to encourage the appreciation of Native American cultures as well as providing marginalized communities with a commercial opportunity to develop their arts and crafts. There were sections titled Prehistoric Art, Living Traditions and Indian Art for Modern Living, as well as a specially carved totem pole made by named Haida artists that was positioned at the entrance.

The curator of this exhibition, René d'Harnoncourt, used various techniques: atmosphere rooms—similar to the former installations at the Landesmuseum, Hannover—were created for the nine groups of tribal cultures represented. The wall colours and exhibition materials were chosen to harmonize with the geographical and cultural contexts of the ways of living represented. Thus, the Northwest Coast Room was darkly lit, with wooden walls, to evoke the interior of a 'huge wooden house of the region' (Staniszewski 1998: 93). The Navajo exhibit had ponchos and blankets draped over cylinders; no mannequins were used, to avoid any hint of natural history habitat groups and specimens. Instead, the rather abstract tableau suggested figures in a landscape in an aesthetic way; artefacts were grouped according to the activity for which they had been made. Objects with a strong aesthetic value were highlighted and displayed on pedestals to represent regional styles. The commercially oriented display on the first floor came very close to modern shop window dressing (cf. Noordegraaf 2004: 168).

The museum also hosted performances and dances by Native Americans in specially designated areas. Visitors could watch sand paintings being created, dancers performing and silversmiths working—at a respectful distance. Navajo sand painters regularly created ritual paintings, over several days, which were then ceremonially destroyed. The various installation techniques used together helped to dissolve the 'unified totalised presentation of these objects as "exhibition"' (Staniszewski 1998: 87;

cf. Vogel 1991). D'Harnoncourt's innovative ways of displaying these objects played an important part in redefining the boundaries of art/artefact.

Another display technique, the vista, was developed for the 1946 'Arts of the South Seas' exhibition. The vista depended on the idea of affinity: this was a way of visually connecting objects without any cultural links. Affinity was an important concept in Robert Goldwater's (1938) book *Primitivism in Modern Art*. Goldwater proposed affinity as a way of associating cultural objects that looked similar but were entirely unrelated in indigenous function and meaning, to try to account for Western assimilation of these objects, once separated from their original context. One way of showing such affinities was through atmospheric galleries that gave vistas on other sections of the exhibition—views from one gallery into another. In 'Arts of the South Seas' one could look from the Solomon Island Galleries into the Polynesian Gallery, and beyond to the Easter Island section. Overlapping vistas allowed the viewer to connect objects in three different areas sharing the same formal characteristics, functions and materials. Different uses of colour and lighting were combined, in places, with bamboo poles, pebbles or sand covering a low, curved plinth to suggest a riverbed. Moving between the various spaces was supposed to give the visitor a sense of travelling between different cultures.

Both the 'Indian Art' and 'South Seas' exhibits were much more experimental than later practices of installing objects and images in isolating, neutral-coloured interiors, at eye level, to suggest timeless, universalizing aesthetics—and a static, ahistorical viewer. However, these kinds of exhibitions gradually became the norm as modern art became institutionalized.[24]

'"Primitivism" in Twentieth Century Art: Affinity of the Tribal and the Modern' (1984) was a late, and much criticized, attempt at making sense of the affinities between 'primitive' and twentieth-century art. Ethnographic objects were displayed in terms of chance resemblances (not influences) with modern artworks: the affinity between Picasso's *Girl with Mirror* and the Kwakiutl half mask—which were shown together—is based on an optical illusion (Clifford 1988: 193–195). According to Clifford, the modernism celebrated at the 1984 MoMA show affirmed the Western capacity for appropriating otherness, while excluding Third World modernisms. The lack of discussion of this appropriation, of colonialism and of the many living traditions from which these artefacts originated made the 1984 exhibition more conservative than those of 1941 and 1946—when the MoMA's universalizing project made sense in the immediate aftermath of the Second World War.

What were these other modernisms to which Clifford refers?[25] Sansi's (2007) ethnography of the transformation of candomblé religious practices and objects into artistic and heritage status provides insight on Brazilian modernism. The role of museum display in this process is crucial. Police confiscated cult objects associated with

the forbidden candomblé practices of ex-slaves in north-east Brazil. These objects were initially displayed in the late-nineteenth-century scientific institutions of Bahia as illegal instruments of sorcery (ibid.: 84) and as evidence of pathology or racial degeneration (ibid.: 87). However, new elites composed of local and foreign artists and intellectuals helped to transform some of the objects, houses and practices of candomblé into publicly recognized Afro-Brazilian culture.[26] The complex process of national and international recognition was set in motion by the Brazilian modernist movement of the 1920s and 1930s. While eager to connect with literary and artistic movements in Europe, Brazilian avant-garde figures of the 1920s rejected simply importing European models and themes. Instead, they tried to create universal modern art from a Brazilian point of view (ibid.: 125): *Brasilidade*—Brazilianness—was born.

Some candomblé houses were distinguished for their noble African (Yoruba) origins. Although candomblé arose through the interaction between different African cults and Catholicism, and between different populations, aristocratic candomblé houses achieved recognition as centres of Afro-Brazilian culture by rejecting syncretism. By the 1980s, some of the most renowned houses had started their own museums (Sansi 2007: 97). These 'museums of the temple' displayed public cult objects, including clothing, and focused mainly on the senior female ritual specialist, as well as presenting photographs of famous members of the house. The shrines and foundations of the house, however, were kept out of sight.

Although Brazilian modernism started as a revolutionary movement, it became a deeply nationalist one (Sansi 2007: 139). Artists developed strong links with Africa and the United States. The MoMA took an active interest in the modernist movement in Brazil. After a visit to artist Mario Cravo's atelier and his collection of ex-votos in 1953, d'Harnoncourt declared the 'popular art of Bahia' as the 'strongest from Panama to Tierra del Fuego' (cited in ibid.: 134).

One of the characteristics of modernism was the attempted rupture with the established European art tradition, while at the same time drawing inspiration from artistic traditions outside that canon. As elsewhere, museums played a crucial role in the reclassification of ethnographic specimens first as primitive art and later as fine art. As exhibition design became professionalized, this paradigm shift was reinforced by specific practices of display. The backlash against modern art in 1930s Nazi Germany—where it was proclaimed to be degenerate (*entartete Kunst*), modern art museums were closed, and leading directors were dismissed or fled—indicates some of the unanswered problems raised by modernism (cf. Grasskamp 1994). Dealing with the past became unavoidable in the aftermath of the Second World War and decolonization. These crises were followed, in the late twentieth century, by a remarkable expansion of museums and heritage institutions worldwide. The

mobility of museum practices lends the institution to the articulation of identity, power and tradition. The expansion of museums brought with it investment in often spectacular new architecture which served to put collections on the map of international tourist destinations (cf. Kirschenblatt-Gimblett 1998). Blockbuster exhibits, starting in the 1970s, were followed by the 'blockbuster re-installation trend' (Karp et al. 2006: 12).[27]

RENOVATION

> The contrast between the museum as container and the museum as activity is itself exhibited in the debates about different definitions of museums, the object, heritage, and display. Museums, especially, often strive to hold to the classic definition of their purpose as a repository of objects at the same time as they experiment with new technologies of display, from other exhibition settings.
>
> (Kirschenblatt-Gimblett 2006: 43)

The perception that museum displays become stale with the passage of time is not new and results in moves varying from ongoing rearrangement, while retaining the basic structure, to radical revision or reinstallation. New buildings, extensions and major renovations of old ones shape museums' outside face or presence in their surroundings, as well as defining their inner spaces, light fall, shadow and composition.[28] The term 'renovation' is used here to refer to the renewal of the relationship between the old and the new. The notion is derived from architect Jo Coenen's (2010) discussion of continuity and renewal in architecture. Coenen's main point is that although modernism proclaims a breach with existing conceptual frameworks, many iconic modern buildings are inspired by the knowledge of earlier ones (ibid.: 43). Elaborating on Le Corbusier's assertion that architecture is *un jeu savant*, Coenen proposes instead that it is a game with an existing object.[29]

The coexistence of (semi-)permanent and temporary exhibitions is one way of interweaving old and new in museums. This creates new dynamics within the institution and situates it in the field of cultural production: every year there are new temporary exhibitions, which offset the slower pace of change of the semi-permanent. Contemporary artists' interventions create new ways of looking at historical presentations and masterpieces: Damien Hirst's *Cornucopia* intervention—rows of spin-painted plastic skulls in case 163 of the British Museum Enlightenment Gallery/King's Library (2008)—is a good example.[30] A somewhat different approach consists in making accessible areas or activities of the museum itself that were previously out of bounds for the public: open storage, public restoration and guided tours

of decommissioned buildings, and even making curatorial staff part of an interactive display. Are these simply recent attempts to carve out new things for people to look at—so an extension of modernism? Or do they indicate more fundamental changes in the exhibitionary complex (Bennett 1995, 2006)?

VISIBLE STORAGE

Visible storage is a well-established exhibition practice that gives visitors a sense of the density of collections as a material archive. The Museum of Anthropology in Vancouver introduced this concept when it opened its new building in 1976. The aesthetics of storage, with the emphasis on security, classification, preservation, quantity, order and visible difference, are quite distinctive from modern exhibitions where a few 'ideal' specimens are shown.[31] Visible storage is a public performance of the museum as 're-pository' (Kirschenblatt-Gimblett 2006: 43). Storage evokes the museum's potential—a resource or raw material that can be used to power exhibitions (cf. Edwards 2001; Bjerregaard 2009). Visible storage has become a regular museological trope: at the Netherlands Open Air Museum, open depots give an idea of how the museum stores its textiles, toys, kettles and wagons. The idea of storage may also be extended via the website (as the Netherlands Open Air Museum does), where many museums also present the collection. The mutual reinforcement between the exhibition on the ground and that in cyberspace is one of the key developments in object display practices.[32]

The visibility of objects presented in this way may be subject to criticism: the Museum of Anthropology was requested to remove a description of ceremonial practices recorded by early anthropologists from the documentation of visible storage to *reduce* public accessibility (Clavir 2002: 179). The sensitivity of the open depot has to do with First Nations' rediscovery of the ancestral objects that were removed from them at the time of their marginalization. The processes of decolonization, mass migration and civil rights after the Second World War brought about a renewal of interest among First Peoples in cultural property in museums.[33]

PUBLIC RESTORATION

Visible storage was a first step towards bringing—a representation of—what had become 'backstage' (namely the stores) to the fore. Public restoration of paintings provides a more dynamic window. 'I can feel the varnish becoming soluble', says the restorer at Boijmans van Beuningen as she starts work on Dali's *Girl with a Skipping Rope.*[34] Filmed as she traverses Dali's surrealist triptych with her cotton-wool swabs, she—and others—explains that she is not only cleaning and restoring where necessary but enacting the greater aim of bringing the side panels into a

new relation with the central panel. This is a process of discovery: they discover that there is 'something wrong' with the frame. It is an aged painting, with quite a history: they don't want to take away the history, but they do want the painting 'to look better'. This probing of the museum object, which included a reframing, produced an improvement (according to the restorer): 'compositionally, it works much better, and we're actually getting a better interpretation of the painting', she says. Restoration brought 'clarity, brightness, but also more harmony to the painting'. The fact that this work was carried out publicly, with the public able to watch at some distance (but not disturb), and with occasional opportunities to ask questions, adds a further—theatrical—dimension. The public is made party to the museum's role as caretaker of a public collection: this is a form of knowledge that goes deeper than provenance or creation. The restorer's knowledge of the object comes from her expert contact with its materiality as an artwork, which film allows us to follow. Film, then, produces a new museum artefact that extends the time and place of this kind of activity or performance. Archived together with similar works on Boijmans Art Tube, the film tells several stories and makes use of archival footage. The painting is examined both materially and aesthetically: its material condition is diagnosed, its dirt and old varnish layers removed, limited retouching carried out, and different varnish applied to 'bring it into better balance'. These are the central narrative themes represented as unfolding in real time on the gallery floor, in the film.

This is not a return of the museum object: it is an exercise in bringing an historical collection piece into the spotlight by a kind of 'second look' (or different way of looking) at this painting. The qualities of an object (colour, luminosity, shape and size) constituting its appearance are perceived by the eye but also by the other senses involved in the event. The words of the professional restorer, her judgements, her actions upon the painting, the smell of the chemicals and the sound of the instruments being used: all of this, together with the painting, constitutes a new sense in which the artwork is made present. This presence goes beyond aesthetic contemplation, Romantic mystery or modernist interactivity between the artwork and the individualized viewer. The public restoration of the artwork brings it into the present in an unprecedented way: restoration visibly socializes the work, transforming it into a collective endeavour; rendering institutional care visible and personal.

At the same time, the object works like an anchor, securing all the stories and discourses it has generated. This effect, remarked on by Hall when discussing the effect of placing authentic objects (an Ijele mask) in the simulated Disney World Florida, need not refer to hyperreal worlds: it can also work for the clusters of film footage, website information and the general attention given by art critics and others who make up the field of cultural production (Hall 2006; Bourdieu 1993).

We see the object differently: it is brought into our presence as a fully socialized being, and it is simultaneously projected outwards through the images and texts generated by its reappearance in the present. Then, its objecthood reasserts itself by anchoring it into the world—in a new and unique way.[35]

HARD-HAT TOURS

Tours through a decommissioned building undergoing mega-restoration clearly differ from either visible storage or public restoration. What they share is the notion of making the normally invisible visible. The aesthetic of demolition and ruin is accentuated by the limited group size and ritual donning of heavy-duty footwear, fluorescent vests and builders' helms (from which the name 'hard-hat tour' is derived), combined in a unique excursion behind the scenes at the Rijksmuseum, Amsterdam. In the early years of the nearly decade-long closure, the attractions included a visit to the newly excavated inner courts of Cuypers's late-nineteenth-century building— complete with parked bulldozer and pits filled with water. Walking through familiar spaces of the emptied building is an uncanny experience—however professionally guided.

Attention is drawn to the 'discoveries'—fragments of architect Cuypers's original decorative scheme long covered by whitewash—and participants are made party to the dilemmas facing the museum (such as covering murals up again and blocking out windows to create more wall space). All this is being done in the name of the public: in the desire better to serve that public, to provide for the creature comforts of that public and to 'go on with Cuypers' (as distinct from just 'going back to Cuypers'): having recourse to the past for present purposes; cleansing the building of its twentieth-century growths.[36] Demolishing the growths of the two inner courtyards of the Rijksmuseum resembles Sir Norman Foster's approach to the Great Court of the British Museum, where the—once round—Reading Room had grown square through the addition of book stacks. In the case of the Rijksmuseum, light, public provision, transparency and the interests of the local populations (the cyclist and pedestrian thoroughfare in Amsterdam) are all discussed, pointed out and explained on the guided tour. We visit the nooks and crannies of the building—behind the *Nightwatch*—and peer into the special device for raising and lowering the huge painting from its normal place at the end of the Gallery of Honour on the first floor.

Buildings have become museum objects in their own right; not only new buildings, such as Gehry's Guggenheim Bilbao, but also historical ones—especially when they have undergone major renovation by a famous architects' bureau. The museum effect of calling attention to, isolating and aestheticizing but also transforming work in progress into an object of inspection—and of inviting the audience to share in

the work of understanding—thus gives the historical building a new lease of life: as a worked-on object, a valued object. Sharing the dilemmas, the inconvenience, the noise, cold and discomfort of this long-term transformation could not be further removed from the smoothness of the Guggenheim Bilbao audio tour analysed by Fraser (2006). The roughness of the hard-hat tour is precisely its appeal.

SCIENTISTS AT WORK

A much smoother feature of the new Darwin Centre 2 (DC2) cocoon at the Natural History Museum in London, but part of the same renovation impetus, is the incorporation of scientists into the new exhibition. This happens in three ways: first, a number of the museum's scientific staff talk about their passion for their work (spiders, butterflies) on large screens at various points in the cocoon exhibition. Second, there is an invitation to experience the life of a working museum scientist as one views the Preparing Specimens Workspace located on the sixth floor. It is even possible to talk to scientific staff (who may choose to spend part of their day in such a workstation) using the two-way microphone. The conversations are supposed to take place as the staff prepare and conserve specimens collected from around the world. Third, scientists are visible from the cocoon as they carry out vital research (fighting malaria, climate change) in the 'spectacular new Darwin Centre 2'.[37]

In an environment filled with media—including films of staff members performing the role of scientists enthusing over butterflies or mosquitoes—bringing in real scientists is a remarkable museological move. Real scientists with whom one can interact or whom one can simply watch going about their work in an adjacent building serve to anchor this high-tech rendering of natural history in the human world. These human anchors work alongside the historical artefacts from the eighteenth-century Sloane collection which are also on display in DC2 and form the historical heart of the museum.

Bringing the human dimension of a science museum comprising an active research component (220 scientific staff work in the Darwin Centre) to the forefront of display is a remarkable exercise in the public communication of science.[38] The vision is complex: staff members may travel the world (or the streets of London) in the course of their work or be mediated as part of the simulated realm of the cocoon, but their human presence (with or without white lab coats) is at a premium—especially in the multilayered museological environments of the Natural History Museum. This is a new step for the museum that made a name for itself through the creation of interactive displays in the 1970s (Henning 2006; Macdonald 2002). The practice, performance and mediation of science in the three ways already referred to—on screen, as part of interactive workstations via a two-way microphone, and on view

as white-coated scientists going about their work undisturbed in one of the visible workstations of the adjacent DC2—create new objects and modes of display.

The public communication of science at the Natural History Museum involves several depths of focus, which reinforce one another: bringing in the scientists in these different ways also brings out the—otherwise invisible—dimensions of the museum itself: the off-stage, global connections to field sites where the scientists work and from which they collect; the laboratories where they conduct research; and the public interface where they are prepared to explain what they are doing in terms that a layperson or schoolchild can understand.

Giving science a face, a voice and a presence in the museum in these ways adds credibility to (for example) the museum's public position on climate change—which asserts that humans are responsible. The claim is based on knowledge, produced by research, among an identifiable community of scientists. The museum makes scientists and their world visible and articulate in the space of display. This corresponds with the public restoration of an artwork, which, as we have seen, brings the interaction between art specialist and artwork from behind closed doors to the attention of the audience. Public visits to building sites and collection storage areas perform similar operations by redirecting attention to the work of maintenance, care and research and those who undertake it.

CONTACT ZONES

When Clifford proposed approaching museums and exhibitions as contact zones—spaces of colonial encounter (after Mary Louise Pratt)—he was prompted by an encounter in the basement of the Portland Art Museum in 1989 (Clifford 1997: 188). There, a diverse group of museum staff, anthropologists and invited Tlingit elders and translators had gathered to discuss reinstallation of the museum's Rasmussen Northwest Coast Indian collection.

The search for new ways of displaying objects has always been a concern of museum professionals (Clifford 1997: 102)—certainly since the late nineteenth century. Various principles of display, ranging from typological to geographical, from life scenes and dioramas to immersive rooms and living history, have been tried out. As we have seen, 'ethnographic' displays became part of the language of modernism during the 1930s, although they had little to do with the typologies and life groups of ethnographic museums. The freshness of that approach faded over the years as experimentation slowed down and the white cube gained ascendancy in many modern art institutions. It is not difficult to imagine that by 1989 the 'drab' and somewhat 'ethnographic' manner of installation at the Portland Art Museum was seen as needing renovation.

Bringing source community members into the discussion may initially have been seen as a way of improving documentation of historical collections, yet the situation quickly transformed into something that went beyond consultation. As the raven mask, the octopus headdress and the killer whale drum were brought into the presence of those assembled in the Portland basement, they triggered stories, dances and ceremonial behaviour among the Tlingit elders (Clifford 1997: 193). The objects worked as touchstones for storytelling and for performances, and the participants called on the museum to assume its responsibilities vis-à-vis the community. It was a plea for reciprocity, accountability and the stewardship of clan objects rather than just their preservation; a bid to rework the unequal exchanges of the past in a sustained relationship based on a publicly constituted identity in which the museum was a stakeholder.[39]

The renovation of a display thus unleashed a process that drew attention to the social relations underlying the production of culture. Myers elaborates on this point, observing: 'When culture is understood as a signifying practice (materiality), it warrants a theoretical shift from an emphasis on representation to one on cultural production and a methodological attention to the social actors in different complicities' (2006: 506). What is at issue here?

According to Weiner (1992), some culturally significant objects may be lent or circulated but will always refer back to their original owners as their inalienable possessions. Hence, although legal ownership may have been transferred through exchange, there is a notion that the identity of the maker is extended into the object—especially in the case of the artist through the artwork.[40] In this way, a collection is 'enmeshed in social relationships' (Gell 1998: 17), which make it a concentrated bundle of potential energy that is periodically reactivated—for example in temporary exhibitions (Bjerregaard 2009). This is why the reinstallation of historical collections in public displays is never neutral.

Australian Aboriginal people have long used inalienable possessions as part of a process of exchange with Europeans—to gain access to such things as money, tobacco and control over land. The Yolngu Elcho Island Memorial, made by local people in 1957, was a key moment of asserting identity (Morphy 1998: 240). Yolngu took the unprecedented step of exposing carved and sacred painted objects to public view. Showing secret objects was intended to enlighten Europeans and promote a dialogue with them: 'by showing Europeans their most sacred and valuable possessions they hoped to get in return better education, employment, control over access to their lands and more influence over their affairs' (ibid.: 240–241). The revelation was also intended to change interclan relations. This doubling between internal and external audiences is one of the ways in which museological processes and practices go beyond the museum (cf. Kratz and Karp 2006: 2).

The Aboriginal Memorial, a display of 200 hollow-log coffins at the National Gallery of Australia, Canberra, for the bicentennial celebrations of 1988, reminded visitors of the Australian genocide that took place during this period. Museums as state institutions provide a prestigious, high-profile stage on which to make these points. Morphy explains that the selective release of paintings did not involve yielding influence, since their value lay in their ancestral origins, not in secrecy (1998: 242). The artworks perform this didactic task on behalf of their makers: bringing public attention to the value of Aboriginal culture as tangible, visible difference that can be placed on an equal footing with masterpieces from any cultural tradition in the world.

When we recall that Aboriginal objects were once objectified on the left-hand (primitive) side of evolutionary series at the Pitt Rivers Museum, the significance of their recognition as art becomes clear. The reassertion of Aboriginal identity through Aboriginal art, in its various traditions, including new urban avant-garde forms, parallels in some respects the renaissance of Northwest Coast artistic traditions. In both cases, historical collections of both objects and images play a key role in that process.[41] The Tlingit elders in Portland, the Yolngu on Elcho Island and the artists who produced the Aboriginal Memorial were all, in their different ways, making (and making claims to) public culture. In all these cases, a new relational mode developed between institutions as keepers of public property and First Peoples as they identified with that property as their inalienable possessions. Phillips refers to this mode, which developed during the 1990s, as the collaborative paradigm (2003: 157).

The complexity of collaborative exhibition-making is well illustrated in Morphy's account of the making of a Yingapungapu sand sculpture by the Yolngu of Northeastern Arnhemland for the First Australians Gallery at the National Museum of Australia, which opened in Canberra in 2001 (Morphy 2006: 473). The National Ethnographic Collection, which includes Aboriginal and Torres Strait Islander collections, became a core component of the new National Museum of Australia (ibid.: 475). Yolngu are adept at using public institutions such as museums for their own purposes; agreeing to open up the Yingapungapu ceremony for Europeans and for women is part of a long-term effort to educate fellow Australians and persuade them of the value of Aboriginal culture. Such artwork might 'appear apolitical but actually reflected the ongoing campaign to protect rights in law and maintain autonomy' (ibid.: 473). The sand sculpture is part of a mortuary ritual to which Europeans have been granted access in recent times. The sculpture made for the National Museum of Australia therefore fits within this trend of using art forms both to persuade and make the Aboriginal case for civil and land rights and to provide a source of income.

The Yingapungapu exhibition was co-curated by Morphy in consultation with the Yolngu community with whom he has worked for many years. The form taken by

the sand painting was linked to a myth about the travels of three sisters from Groot Eylandt to the mainland, where they established three sites along the coast. The complicated process of curation involved the artists and community, National Museum of Australia staff, the Boston-based design team in charge of the whole project and the Canberra-based consortium of government and business responsible for building and installing the exhibition. The frictions that arose were typical of situations where museological processes are multisited and ramify far beyond museum settings (Kratz and Karp 2006: 2). If museum exhibitions are inevitably a Western expressive format, changing meanings through processes of translation, their communicative power and international reach is, as Phillips has noted, 'irresistible': collaborative exhibitions are distinguished by their efforts to achieve 'more accurate translations' (2003: 166).

Exhibitions such as the 'Torres Strait Centennial' (1998), at the Cambridge University Museum of Archaeology and Anthropology, and 'African Worlds', at the Horniman Museum in London, brought in source communities and local diasporic residents, respectively, in their efforts to renovate historical collections (Herle 1998, 2003; Shelton 2003). In the case of the Cambridge exhibition, this reactivated research in the museum—with museum staff re-establishing relations with contemporary Torres Strait communities and bringing community leaders to Cambridge in the process.[42] Looked at as a process, the exhibition was a framework for bringing people and objects into dynamic relations, whereby the turtleshell masks, feather headdresses, models, photos and texts become vital links between the past and the present. In this new configuration, the historical collection could serve as a source of inspiration for contemporary artists, as well as functioning as a contact zone for the communities involved. The names of owners of particular pieces were included in the exhibition since they are of great importance to the source communities, and this was one of the effects of consultation that was visible in the exhibition (Herle 2003: 196).[43]

CONCLUSION

The British Museum donations case, with which this chapter began, encapsulates the major display dynamics of objectification, modernism and renovation. At one level, the glass case filled with coins shows some continuity with the logic of numismatic collections: the rise of digital transactions makes hard currency seem almost arcane—a good candidate for transformation into an object of inspection. However, the case neither organizes its contents according to a theoretical principle nor personalizes it as part of a popular installation. Instead, its look, position and interactive nature make the case a very modern installation. Articulating the complementary principles of free access and donation, the case stops us in our tracks and demands our attention—for our place in this public space, for our rights and

obligations as global citizens according to the universal claims being made by the institution.

The case is part of a project of institutional renewal, or renovation, which differs from classical modernism by explicitly seeking to work together with an existing object through modification, intervention and transformation of the old to produce a new combination. As part of the furniture of the new space of flows created at the heart of this historical institution, the donation cases help to give pause to the circulation and to offset the court as a place of consumption. If the donation cases perform an interactive task in one way, the renewed presence of historical ethnographic collections raises issues of collaborative display, mutual responsibilities and—on occasion—the return of cultural property. It is to this latter topic that the final chapter turns.

KEY CONCEPTS

Objectification	Interactivity
Typology	Performance
Life group	Vista
Inhabited room	Affinity
Ensemble	Renovation
Modernism	Visible storage
L and T system	Public restoration
Atmosphere room	Hard-hat tours
Field of vision	Scientists at work
Correalism	Contact zones

EXERCISES

1. Write down three ways in which objectification takes place in an exhibition at a museum of your choice.
2. Describe three ways in which modernism has influenced the museum's displays.
3. Are there any plans for renovation—of the buildings and site, the semi-permanent exhibitions or the public facilities—or research into the collections?
4. Examine whether and how the museum is redefining what it considers fit to be seen: for example through public restoration, behind-the-scenes tours or any other initiative.

FURTHER READING

Henning, M. L. (2006), *Museums, Media and Cultural Theory*, Maidenhead: OUP.

Macdonald, S. and Basu, P. (eds) (2007), *Exhibition Experiments*, Oxford: Blackwell.

Noordegraaf, J. (2004), *Strategies of Display. Museum Presentations in Nineteenth- and Twentieth-century Visual Culture*, Rotterdam: Museum Boijmans van Beuningen Rotterdam/NAi Publishers.

Staniszewski, M. A. (1998), *The Power of Display. A History of Exhibition Installations at the Museum of Modern Art*, Cambridge, Mass.: MIT Press

6 OBJECT AND IMAGE REPATRIATION

Figure 6.1 View of part of the exhibition 'Raub und Restitution', showing the installation with Lovis Corinth's portrait of Walther Silberstein, at the Jewish Museum Berlin, 2008. © Jüdisches Museum Berlin. (Photo: Jens Ziehe)

INTRODUCTION

The restitution of artworks looted from their Jewish owners in Nazi Germany to their heirs contributed to a growing awareness of ownership questions involving artworks and museum collections after 1945—particularly in Europe. Lovis Corinth's 1923 portrait of Walther Silberstein, for example, disappeared after Silberstein's widow was deported in 1942. After decades of obscurity, Silberstein's grandson Leo Hepner was able to purchase the painting from a Berlin art dealer in 2003 and present it to

his grandmother on her ninety-ninth birthday—before the background of the work was known (Bertz 2008: 272).

'Repatriation' is an umbrella term which, when applied to museums, connotes the restoring, returning, repairing, replacing and renewing of objects and images as well as the relationships that compose them. Restitution and repatriation issues involving museum collections of various kinds (artworks, ethnographic objects and photographs) reflect changing understandings of how this material is embedded in the social world. Museums of all kinds are deeply implicated in long-term processes of separating material objects from their original owners, thereby transforming personal possessions into the collective property of states, cities or local authorities. Photography belongs to this process, and photographic and filmed images constitute part of the material relationships that are currently under review. Objects were integrated into collections, and given new significance as such, through professionally organized procedures of collection, classification, conservation and representation. These practices effectively erased or otherwise obscured those original relationships inherent in the objects, replacing them with systematic references to other objects within the collection. Repatriation, in its broadest sense, reverses that excision by reconstituting relationships—for example with legally defined heirs or 'source communities'—through a reconsideration of what was lost through the institutionalization of these materials. Reappraisal of the social basis of materiality corresponds with different ways of apprehending collections: these different ways of 'looking at' collections involve not only issues of ownership and restitution but also other ways in which museum objects make sense beyond vision (Feldman 2006).

This chapter examines how the repatriation of images and objects involves reinterpreting museum collections. It looks first at the repatriation debate, then at cases exemplifying repatriation of various kinds: human remains, sacred objects and photographs, which generate new kinds of social relationships.

The 'repatriation debate' of the final decades of the twentieth century refers, on the one hand, to various claims being made on musealized objects by original owners, First Peoples and indigenous communities and, on the other hand, to the institutional resistance expressed (for example) as fears about 'opening the floodgates' (Peers 2004). The debate revolves around matters of ownership, authority, custodianship and justice, with respect to museum collections and cultural heritage (Simpson 1996). Authority over human remains and sacred objects assigned to public institutions such as museums is a major issue. That authority is linked to scientific knowledge and representational practices in museums, the legitimacy of which has been undermined by changing perceptions about the ethics of public displays of formerly colonized peoples, particularly in the postwar period. Taking into account alternative claims, expressed in terms of kinship (or ancestry) and religion, has come to be seen

as a matter of human decency. Yet, as the 'Declaration of the Importance and Value of Universal Museums', drawn up in 2002 by twenty-one museums in Europe and the United States, made clear, there is still concern about the long-term implications of repatriation (International Council of Museums (ICOM) 2004).

REPATRIATION OF HUMAN REMAINS

Fierce debates about the reburial of human remains stored in ethnographic and other museums arose in the 1970s and 1980s. Large quantities of human remains were shipped to European and American museums between 1850 and 1950 as scientists attempted to explain human diversity by measuring and comparing physical differences. From about 1950 onwards, museum policy and practice regarding human remains changed dramatically. Although there were differences in emphasis among the various national authorities, as well as in their timing, the redefinition of ownership, agency and authority over these materials was a shared concern.

Debate about the propriety of keeping human remains in museums started in former settler colonies: the United States, Canada, Australia and New Zealand. Legislative milestones include the Native American Graves Protection and Repatriation Act (NAGPRA) of 1990, to protect grave sites and archaeological and human remains and to inventory and return human remains and sacred objects upon request from recognized descendants or communities.[1] Another important benchmark is the first International Conference on Cultural and Intellectual Property Rights of Indigenous Peoples, held in New Zealand in 1993, which, in producing recommendations to states, nations and international agencies about human remains and cultural objects, both politicized collections and helped to shift the locus of authority from 'experts' to source communities. One crucial example of Maori human remains are the tattooed heads collected by explorers in the nineteenth century, which were redefined by tribal authority as ancestral remains to be treated as human beings rather than objects. Aboriginal and Torres Strait Islander legislation provided for the preservation and protection of areas and objects significant to Aboriginal peoples in Australia and Australian waters, from 1984 onwards, requiring that discoveries of Aboriginal remains would be reported to the Ministry of Aboriginal and Torres Strait Islander Affairs, ensuring that the appropriate Aboriginal community would be consulted. One of the results of the Australian policy was an increase in museums and cultural centres, which are connected to the repatriation of Aboriginal materials from overseas, as well as the politicization of indigenous communities (as in the United States and Canada). A Canadian Joint Task Force of First Peoples and the Canadian Museums Association were set up in the wake of a controversial

exhibition ('The Spirit Sings', 1988), to report on access to and the involvement of First Peoples in museum interpretation, as well as the repatriation of human remains and cultural artefacts. This consultative process involved many different parties: First Peoples and museum staff, academics, archaeologists and members of cultural, educational, political and governmental organizations. The 1992 Task Force Report recommended partnership strategies between museums and First Peoples, emphasizing the importance of cultural artefacts in museums to First Peoples as a source of pride, self-esteem and continuity with traditional cultures and values. This is a recurrent point in the following sections.

These issues were, with a few important exceptions,[2] taken up only later by European museums. One reason for this delay was a greater perceived political and social (as well as geographical) distance between European museums and source communities. Connected with this sense of distance was a reluctance on the part of some European museums to relinquish their collection or, rather, to reconstruct the relationships embedded in them. Revision came about in European museums partly as the developments which had taken place elsewhere filtered through professional museums associations (such as ICOM) and partly through the momentum provided by high-profile repatriation cases which effectively personalized human remains.

PERSONALIZING HUMAN REMAINS

The return of human remains in the form of identifiable individuals by European museums to former colonial states is, arguably, the most dramatic expression of repatriation. The ceremonial transfer of named individuals between state representatives for reburial by communities on their ancestral lands enacts a powerful rehumanization of these museum objects. The transformation of a person into an object (or several objects), and then back again into a person, also powerfully demonstrates that the museum may be a temporary resting place, rather than an eternal one, in the cultural biography of things (cf. Kopytoff 1986). The un-doing of the museum effect, transforming an object of visual interest back into a human subject deserving proper burial, is a profoundly significant act, opening up a new phase in museum history.

The objectification of other human beings was an intrinsic part of colonial relations in the nineteenth century, defined by the unequal relations between colonizing and colonized populations (see Chapter 5). Those associated with the colonial power were often required to collect information as part of their task. Their position in military, administrative and trading networks gave them access to a range of material culture, including body parts and even living human beings, for which there was a market. This demand had to do with science, on the one hand, and popular culture, on the other.

Collecting humans beings or parts took place within the intellectual framework provided by Darwinian evolutionary theory, which was in turn made possible by the discovery of fossilized remains of extinct species and a concomitant expansion of geological time (Rudwick 1976). The visible diversity of human beings was first explained in terms of a gradual diversification of the species from a single origin. This was subsequently contested by a theory proposing several simultaneous processes of human origins, producing several 'races' of man (Theunissen 1989). Race was correlated with material culture and organized hierarchically from those considered closest in evolutionary terms to the ape (savages with simple technology) to those assumed to be most evolved (civilized northern Europeans with industrial technology). The collection of skeletal, particularly cranial, and other body parts for nineteenth-century museums went together with attempts at systematically recording, measuring and classifying skin colour, hair texture and bodily features. Observations and measurements were not only written down but also photographically recorded after 1839. Systems of photographing people frontally and in profile, against a grid, attempted to provide objective evidence of the racial theories that the skeletal remains were supposed to document, and to provide evidence for comparison (Spencer 1992).

Alongside these scientific projects of collection and comparison was the further dimension of popular culture. Anatomically unfamiliar-looking people were exhibited live as exotic specimens in popular shows, or taxidermically or otherwise preserved after death in museums, ostensibly as educational exhibits but more often as popular attractions.

The highly personalized repatriations of the physical remains of Saartje Baartman, El Negro and King Badu Bonsu II are explicit attempts by European governments and museums to make amends for what is now seen as shameful conduct towards colonized peoples during the nineteenth century. Returning an historicized individual to a contemporary community provides a focus, allowing this person to represent the anonymous 'human remains' still kept in museum collections. As a diplomatic act, repatriation expresses a relation of equality between former colonial and more recently independent states. The elapse of history and politicization of such collections can obscure, in some cases, the proper destination for the returned items. Local disagreements may then be cancelled in the name of entire nations or even continents, in the interests of avoiding procrastination that might jeopardize any return being made at all.

The task of dealing with fragmentary collections of anonymous human remains is more challenging. The Tropenmuseum, Amsterdam, prompted by the publicity attending repatriation cases, published its human remains collection and consulted experts about the various options, expressing the hope that claimants will come forward (Van Duuren et al. 2007). Although this collection does contain one

apparently better-documented individual ('Little Indian in Spirits'), 'an early native American foetus from Suriname clothed as a curiosity in a headdress, shoes and jewellery that once belonged to the collection of Amsterdam's Artis Zoo' (ibid.: 8), the anonymous remains were the subject of the Tropenmuseum's special report. Although such a collection has no place in the contemporary Royal Tropical Institute (Koninklijk Instituut voor de Tropen, KIT), that makes the need to dispose of it in an ethical manner all the more urgent—in both scholarly and professional terms. Museum procedures and classificatory systems effectively sundered, with few exceptions, the relational networks by which such materials entered their collections. This obfuscates the process of reconstructing provenance and determining appropriate repatriation destinations. It also underlines the need to reconnect human remains with other collections—both ethnographic and photographic (see later on). It is worth looking more closely at the three personalized cases—Saartje Baartman, El Negro and King Badu Bonsu II—by way of contrast with the fate of anonymous human remains in museum collections.

SAARTJE BAARTMAN

The remains of the South African Khoikhoi woman, Sara Baartman, were repatriated by France to the government of South Africa in 2002, after an eight-year campaign for her return. The 'Hottentot Venus', as she was also known, is a name reflecting the long-standing combination of prurient and scientific interest in Khoikhoi anatomy among naturalists and travellers. Saartje ('little Sara') Baartman believed she would make her fortune when she boarded a ship from the Cape to Liverpool in 1810. In fact, she was brought to London as part of a 'traffic of animals, plants and people for display as objects representing colonial expansion' and a means of making money (Qureshi 2004: 335). Once in London, Saartje Baartman was sold to a showman, who put her on display in Piccadilly, where she could be viewed for two shillings. Abolitionists considered her to be in a condition of slavery and tried to have her sent back to the Cape by means of a court case. Although they failed, the publicity surrounding the case transformed Saartje Baartman into a politicized attraction, which significantly augmented the effect of phenotypical difference (ibid.).

Throughout the nineteenth century, living exhibits of colonized peoples were a popular form of entertainment in Britain. Unsurprisingly, Saartje Baartman is reported as having been resentful of her treatment—as an animal—and resisting all attempts at removing her scanty covering. Saartje Baartman travelled to other cities, before being transported to Paris in 1814. She survived one year, again featuring as a live exhibit, before her demise. She was dissected by Georges Cuvier, who also published a detailed account of her anatomy, classifying her as a 'Boschimanne'—whom

he thought to represent the lowest level of humanity, closest to the ape. Removing every trace of her individuality through the scientific process of classification prepared the way for displaying her as a specimen of comparative anatomy at the Muséum d'Histoire Naturelle from 1827. She was moved to the Musée de l'Homme in 1937, where her skeleton was displayed next to a plaster cast—to popular acclaim. The skeleton was removed from display in 1974, and the body cast two years later, after feminist protest.

Curatorial resistance to her repatriation, on scientific grounds, prevailed for some twenty years after Saartje Baartman's removal from display. Her remains were claimed by the South African government in 1995, and after seven years of political wrangling, she was repatriated and given a local burial at Hankey, 500 miles east of Cape Town. Thousands attended her funeral, which attempted to restore her dignity as a person. Her return and burial as a local woman were important attempts to redress the wrongs done and to reattribute to her individuality after two centuries of reification. The material processes of Saartje Baartman's musealization played a crucial part in her objectification, classification, exoticization and politicization. There may, of course, be new forms of objectification and abstraction to which Saartje Baartman is subjected if she is transformed into a cultural icon. However, since there are comparable repatriation cases involving the renegotiation of different sets of (post) colonial relations, her cultural biography can be contextualized among these other developments.

EL NEGRO

The taxidermically prepared male known as El Negro ('the black man') was classified as a 'Bushman from the Kalahari'. Differences in the ways Saartje Baartman and El Negro, respectively, were musealized are revealing. Whereas Saartje Baartman was trafficked alive, El Negro's remains were exhumed from the grave where he was buried and underwent taxidermic preparation by Jules Verraux in the Cape. He was then transported to Paris, where by 1831 he appears to have been part of the Verraux brothers' commercial taxidermic collection (Parsons 2000). El Negro was purchased by Francesc Darder for exhibition at the universal exposition in Barcelona in 1888 and was bequeathed to the Darder Museum in Banyoles after 1916.

Although initially classified as a 'Bushman', scholars from the University of Botswana argue that El Negro was probably a 'Bechuana' (the spear he held in his right hand and the antelope fur dress in which he was buried indicate this, as do references in contemporary Parisian newspapers). The shield, spear and bird feathers with which he was exhibited in Barcelona in 1888 correspond with those of a Bechuana warrior of the 1830s. El Negro has been identified as probably belonging to one

of the BaTlhaping groups of the most southerly Tswana (or Bechuanas), who lived on the lower Vaal River close to its junction with the Orange River, around 1830. The 1916 classification of 'El Negro' made in the Banyoles catalogue corresponds with the tripartite physical anthropological racial division of mankind into Negro, Caucasian and Mongoloid races, which persisted until the mid-twentieth century.

El Negro's skin was blackened with boot polish, and he was exhibited among natural history specimens, a variety of freaks, and the skeletons and crania of physical anthropology in Banyoles. He was a major local school and tourist attraction until 1997, when he was removed from display to the depots as a result of local political pressure for reburial and an end to the injustice done to him. High-level intervention ultimately led to El Negro's repatriation to Botswana in 2000. The issue of which community would be an appropriate recipient of the remains of El Negro delayed and even threatened to disrupt repatriation: there were local concerns in Botswana as to whether these ancestral remains ought to be buried in Botswana at all. In the end, the issue was resolved, at least temporarily, by arguing that burial in Botswana was 'for the whole of Africa'.

Although the repatriation of seemingly identifiable persons appears to provide a measure of closure for past injustices, this may not be so. The material reality of El Negro's repatriation (a box of bones) failed to live up to expectations (a full corpse), provoking outrage among the population of Botswana (Gewald 2001). The flesh, nails and hair of El Negro had been removed, probably in Madrid, on the way home. To strip off these added parts of El Negro, without consultation, seems to deny his history in Banyoles. This latest unannounced intervention could only add further insult to injury.

BADU BONSU II

The return of the head of King Badu Bonsu II by the Netherlands to Ghana in July 2009 shows an acceleration in the process of repatriating human remains—when compared with the two cases discussed so far.[3] The precedents established by Saartje Baartman and El Negro may have facilitated faster and smoother repatriation for the Ghanaian king's head. The more general debate, research and policy-making regarding repatriation of human remains by museums since 2000 would also have contributed to this. There is a further historical dimension concerning Dutch involvement in the transatlantic trade in and transportation of slaves from the sixteenth to the nineteenth century.

King Badu Bonsu II was executed by Dutch officials in a retaliatory act in 1839. His head was preserved in formaldehyde, transported to the Netherlands for phrenological research and deposited with the anatomical collection of the

University of Leiden around 1840. The head was requested by Ghana in 2008 after its existence was uncovered by the novelist Arthur Japin while he was carrying out research on the collection. According to tribal tradition, the soul of the king would be unable to rest if his body was incomplete on burial. At the ceremony in The Hague marking the transfer of the head, the Dutch foreign minister paid respect to Ghanaian burial traditions and also underlined the excellent relations between Ghana and the Netherlands, enabling frank discussion of their common history in the notorious slave trade. He went on to remark that, far from ignoring this common heritage in the slave trade, the two countries are actively engaged in preserving it as, for example, in the fortress at Elmina. The fortress, which was once an important base for slave traders and the surrounding villages, was restored by the Ghanaian government, supported by the Netherlands. Human remains are thus, from a Dutch diplomatic perspective, part of an established heritage flow between the two countries, itself the outcome of historical trading (and slaving) relations. There are in fact multiple claims on this heritage and support for restoration by both UNESCO and US donor agency funds (cf. Kreamer 2006). The Dutch education minister, for his part, emphasized that the head had no scientific or educational value, therefore making its return for proper burial a rather straightforward decision.

The reunion of Badu Bonsu II's head and body in Ghana provides a third variation on the reconstitution of persons through repatriation. It should be noted that the official transfer of the head in The Hague precluded a situation such as that attending El Negro's return to Botswana. The asserted lack of scientific and educational importance of such remains establishes a distance from the study of race as it was pursued in nineteenth-century phrenology and physical anthropology, shored up by techniques such as anthropometry and anthropological photography. It can, however, be argued that the human remains in museum collections of former colonial powers do have scientific significance—although in a different sense. It is to this other relevance that we now turn.

THE TROPENMUSEUM, AMSTERDAM—HUMAN REMAINS COLLECTION

Unidentifiable human remains are less easy to repatriate than those which can be reconstructed into named individuals. Since most historical collections of human remains are dissociated from current biological research, many have ended up in obscurity. Such was the fate of the Amsterdam Tropenmuseum's physical anthropology collection, which dates from 1915, when it was established as part of the Colonial Institute. The collection, which had been stored at the University of Amsterdam's

Vrolik Museum of Anatomy since 1973, was retrieved by the Tropenmuseum in 2002. While the Vrolik Museum declared that the collection was of 'no scientific value', its retrieval by the Tropenmuseum for historical, political and relational re-contextualization provides insight on the dilemmas associated with this kind of anonymous material.

The Tropenmuseum's decision to retrieve the collection in 2002 was influenced by the global debate then taking place among international organizations, national governments, museum associations, academic forums, committees and specially appointed bodies set up to support requests and demands made by indigenous peoples (Van Duuren et al. 2007: 37). This debate had come about as peoples and groups from whom skeletal material had been collected realized its significance in terms of 'once repressed or lost cultural or group identity' (ibid.). Human remains were only part of what they were trying to reclaim, which included legal and physical possession of ancestral lands and tribal territories, restoration of rights that had been denied and retrieval of cultural heritage, such as sacred objects, that had been removed. The term 'human remains' includes skeletal remains, specimens in alcohol and skin and hair samples; they are also incorporated into many 'ethnographic' objects: from overmodelled, decorated ancestral or enemy skulls to ceremonial objects made from human bone.

Human remains had thus become a matter of major international concern by 2002. The Tropenmuseum, as the institutional successor of the former Colonial Museum after Indonesian independence in 1949, took a proactive approach to its historical legacy in this area—*before* a claim was made on it. The return of the orphaned collection involved a research project to catalogue, establish the provenance and photograph it, in order to be able to reconstruct the relational network within which it was acquired. The permeable boundaries between human remains classified as physical anthropology and ethnographic objects incorporating human remains meant that further research was needed. This research was also required in order to be able to contact national governments, communities and overseas museums in the effort to decide what to do with such materials.

The collection comprises some 1,250 objects (some of which are in fact groups of objects); most of these were human remains, but there were also photographs, plaster casts and scientific instruments; animal remains; and artefacts incorporating human remains. The main origin was Indonesia, and the classification system—whereby the Physical Anthropology Department of the Colonial Institute was assigned everything including human remains—produced an 'absurd anomaly' (Van Duuren et al. 2007: 45). They also found that the collection was based on a 'deluge of gifts' rather than any coherent policy (ibid.: 44).

The research group produced guidelines for handling the collection, which they discussed with invited experts, who were asked to consider the collection in

historical, ethical, legal and biomedical terms. Four categories of material were distinguished: (a) physical anthropological remains, which they proposed to destroy or dispose of; (b) ethnological remains; (c) archaeological remains; and (d) recent historical remains from the Second World War in Dutch New Guinea.

The first category implied cremation or burial, which, as ritual acts, raised ethical problems. Even if representatives of source communities, rather than the Tropenmuseum, were to be asked to pronounce on the matter, such people or authorities would first have to be identified. This would require more research and a re-evaluation of how human remains are connected to other parts of the main Tropenmuseum collection in storage. Contacting source communities was recommended for archaeological materials including human remains and burial goods from Peru, while it was proposed to send excavated remains from pre-Columbian Kwatta in Suriname to Paramaribo, together with its Royal Tropical Institute archival documentation. There would need to be discussion, with all the parties concerned, about the collection's significance in the context of Suriname before the return could be implemented. The fourth category, recent skeletal material (of 'Japanese' soldiers) from Dutch New Guinea, should be returned but might require DNA testing to establish where they were from since many different nationalities fought under the Japanese flag.

Understanding such a collection therefore requires an innovative scientific approach: the authors of the report prefer to see their work as initiatives rather than proposals to be implemented. They emphasize the need to understand the collection as a whole (including photographs, documentation and plaster casts) and to position it within the history of physical anthropology and Western scientific practice more generally (Van Duuren et al. 2007: 53). The expert group, in its turn, advised the Tropenmuseum not to focus exclusively on the remains but to engage with the notion of repatriating authority.

This account of the Tropenmuseum's work echoes, in its search for a more holistic understanding of the collection, one of the central themes of the repatriation of human remains discussed so far: rehumanization and personalization as a means of remaking relationships. The questions of authority, ownership and agency which emerge from the Tropenmuseum's publication of its human remains collection recur in the broader discussions about repatriating cultural property taking place between museums and source communities.

REPATRIATION OF OBJECTS

Sacred, ancestral or ceremonial objects, some of which may include human remains, are also the subject of repatriation claims. The cases discussed here concern Canadian

Northwest Coast artefacts or assemblages dating from the late nineteenth and early twentieth century; they were removed between 1904 and 1927. Repatriation was initiated from the late 1950s and was completed, in the case of the potlatch regalia, at the end of the 1970s and, in that of the G'psgolox Pole, in 2006; for the Yuquot Whalers' Shrine, repatriation is still in progress.[4] Focusing on cases of removal from the same area has the advantage of underlining variation in the modes of appropriation, from scientific collection to confiscation. This regional focus brings to the fore the networks which made this traffic in culture possible: professional anthropologists, embedded in national institutions, and their local assistants, embedded in neighbouring tribal populations. This approach makes clear the contrast between repressive state policy towards indigenous peoples during the earlier period (1880–1930), with its Indian agents (amongst others) who attempted to implement that policy at the local level during the 1920s, and Canadian 'participatory democracy' of the 1950s, when self-government was introduced with local band councils, which encouraged all kinds of cultural performances that strengthened local identity and helped to pave the way for the cultural centres and indigenous museums of the 1970s. The effects of relative geopolitical distance on the unfolding social drama of repatriation (Jacknis 1996) also become clear through this selection of cases, bringing out both intranational and international negotiations. Repatriation issues concerning Native American objects in Canada and the United States have often been mutually influential, if not directly connected.[5]

The collection of sacred objects as well as objects of daily use partly overlaps with the collection of human remains. As already noted, some ethnographic objects incorporate human remains: this is the case with the Whalers' Shrine from British Columbia, now in the American Museum of Natural History in New York, which combined human skulls and carved ancestral figures for secret and sacred whaling rituals (Jonaitis 1999). Sacred objects, such as the Whalers' Shrine, were an integral part of indigenous practice (Clavir 2002: 154). Their collection was part of a scientific project based on the belief that such cultures were about to disappear and that material culture should be preserved as a record of the past.[6] The confiscation of cultural property, such as the Kwakiutl potlatch regalia, was part of governmental suppression of what were considered to be harmful cultural practices (Jacknis 1996; Saunders 1997; Phillips 2005). The competitive acquisition of certain items of material culture, such as memorial (totem) poles, was considered imperative by European museums, making the donation of such poles by national citizens who travelled or worked overseas itself a prestigious act—although one based on the assumption that these were the vestiges of dying, if not dead, cultures.[7]

The flow of material culture into museums at the end of the nineteenth and beginning of the twentieth century had a profound impact on indigenous people's view of

the world and of themselves. It actively contributed to a sense of loss and marginalization as second-class citizens. The retrieval of such objects from museums should be seen in the context of a renaissance of native culture in the second half of the twentieth century, which brought about new relationships between First Nations and museum professionals, some of whom are from source communities, mediated through the collections. The three examples discussed in the following concern Canadian Northwest Coast First Nations and their efforts at the national and international levels to recover cultural property. The cases illuminate repatriation processes extending over various scales: between a national museum and two newly created indigenous museums within the Canadian state; between a source community and a leading American museum; and between a First Nation and a Swedish national museum.

One of the significant changes accompanying the renewal of indigenous culture in Canada is the reinvigoration of collection research. Such research requires both old and new methods.[8] Repatriation demands require both traditional art historical skills of archival research and connoisseurship to identify the style and period, in order to establish provenance. Older anthropological approaches to material culture, including histories of production, use and exchange, also gain new relevance in reconnecting collections and communities. These approaches can be productively combined with the new ways of theorizing material and visual culture in anthropology, art history and cultural studies (Phillips 2005: 85).

Ruth Phillips argues that sharing the findings of collection-based research with the originating communities can in itself be seen as a form of repatriation (2005: 94). Knowledge about collections can be actively augmented by new models of native partnership with museums, as pioneered by the Museum of Anthropology at the University of British Columbia.[9] Such partnerships bring with them innovative ways of accessing, managing and interpreting collections. Reconnecting communities with objects that were collected long ago produces new forms of knowledge for the community: 'When an elder lifts up a moccasin or a mask in a museum storeroom and begins to sing a song or recount a story, we realise the unique potential of museum objects to trigger memories and offer access to aesthetic and cognitive systems that are not, in the first instance, visual, but have to do rather with hearing, touching, smelling or tasting' (ibid.: 97). Such developments in museum practice have given a major impetus to new directions in scholarship: from the cultural biographies of objects to their hybridity, 'entanglement' and agency.

Research conducted by Richard Inglis on the Whalers' Shrine in 1983, at the request of the Mowachaht community, exemplifies a new collaborative scholarship. When, in 1989, Inglis was joined by Northwest Coast scholar Aldona Jonaitis, their joint research on the shrine was approved by the community. This way of

conducting research contrasts with the salvage ethnography of Franz Boas's time is a significant part of the repatriation story.

SACRED OBJECTS

The Yuquot Whalers' Shrine (southern Vancouver Island, British Columbia) was purchased in 1904 by George Hunt, native assistant to the anthropologist Franz Boas of the American Museum of Natural History (AMNH); since 1978 there have been plans and discussions between the museum and the Mowachaht community concerning its repatriation. These plans included both research and exhibition. However, the shrine has never been exhibited as a complete assemblage and is still in storage at the AMNH, where the Mowachaht have access to it and are in dialogue with the museum about it. It would be problematic, in the purely legal terms of NAGPRA, to repatriate the shrine across national borders since it is not urgently required for contemporary rituals.

After receiving photographs and information about the shrine from Hunt, Boas recommended the shrine's purchase by the AMNH in 1904 (Jonaitis 1999: 3). The shrine, comprising some eighty-eight carved ancestral figures, four carved whales and more than twenty human skulls, housed in a shed-like structure, was used for chiefly whaling rituals. Hunt's first visit to the area in 1903 coincided with a period of disruption among the Mowachaht people, who were decimated by epidemics, depopulation and increasing incursion by non-Native settlers into the area. Contact between the Mowachaht and whites dates back at least to Captain Cook, who visited Nootka Island (Friendly Cove) in 1778 in his search for the Northwest Passage (see King 2003: 235–236). This contact continued during the nineteenth century to the point where fur-trading and wage labour replaced whaling. The shrine is thought to have originated in the seventeenth century (Jonaitis 1999: 240), and throughout its existence, it was changed, renewed and gained further figures. These alterations were especially prevalent during the nineteenth century, when at least one chief attempted to reassert his authority, wealth and rank in the face of growing acculturation and social disruption (ibid.: 94).

Hunt purchased the shrine in 1904 from two chiefs who claimed joint ownership rights; he paid $500 and rights to ten Kwakwaka'wakw *hamats'a* (cannibal) songs, and arranged for the shrine's secret removal. The negotiations for and shipment of the shrine in two instalments to New York City were intended to provide the museum with an exceptional exhibit. The figures were to be set up according to Hunt's detailed photographs, with the sides and back of the shrine made realistic with wax tendrils and foliage (Jonaitis 1999: 77). In the event, Boas left the AMNH for a teaching position at New York's Columbia University in 1905, and the shrine went into storage. A model of it was made in 1941 for public exhibition in

the Northwest Coast Indians Hall at the museum (ibid.: 13, figure 4); some of the figures have been exhibited separately in temporary exhibitions. Boas published a description of the shrine in 1930 as part of his Kwakiutl ethnography. However, he largely ignored Hunt's collected narratives, which indicated that Mowachaht culture was not derivative from Kwakwaka'wakw, as Boas assumed, thereby raising awkward questions for his diffusionist framework of interpretation and salvage ethnography approach to material culture (ibid.: 51). Boas's move from the AMNH to Columbia University therefore marks one of the moments of reorientation away from material culture in twentieth-century anthropology, which echoes developments in Europe.

When Mowachaht delegations visited the AMNH in 1989 and 1990 to discuss possible exhibitions of the shrine in New York and Victoria, they did so in a context that had profoundly changed. Although repatriation was not broached directly, it underlay all their conversations (Jonaitis 1999: 42). The emotional re-encounter between community representatives and the shrine in storage in New York was followed by discussion about the propriety of showing such a sacred assemblage to the public. The Mowachaht were, at the time, very preoccupied about the relocation of their community from Yuquot to Gold River. The press immediately picked up on the repatriation dimension of the story since this was a matter of great public interest at the time (ibid.: 44). Hugh Brody's film *The Washing of Tears* (1994), by contrast, focuses more on how Mowachaht reacquaintance with the shrine at the AMNH gave the community a new sense of purpose. The renewal of interest in their own history and traditions, which had been largely expunged from their lives, provided them with new dignity and self-confidence.

The AMNH presented a framed print of one of Hunt's 1904 photographs of the shrine to community representatives in 1990 (Jonaitis 1999: 77, 78, figure 13), marking a transformation of the shrine into a cultural treasure in the new 'spirit of partnership and open dialogue between museums and native peoples' (ibid.: 79). It is the simultaneous extension and recognition of their world, through the shrine, that distinguishes Mowachaht reappropriation of their cultural property. Although NAGPRA legal provisions for repatriation do not apply outside the USA, and the 1992 Canadian Task Force Report is limited to dialogue between Canadian museums and First Peoples, the shrine demonstrates that international dialogue may come about through other channels. The renewal of research, approved by and shared with the community, and the long-term plan of recovering the shrine for a cultural centre in Yuquot all contribute to the process of reincorporating Mowachaht history into the present.

Visual representation of the Yuquot shrine is a key theoretical issue. The secrecy surrounding the shrine meant that it had never been seen by most Mowachaht. Since its removal to the AMNH, it has also been seen by very few people. As Jonaitis

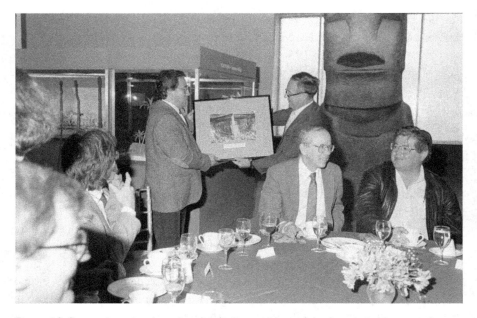

Figure 6.2 George Langdon (standing right), the president of the American Museum of Natural History, presents a framed print of George Hunt's 1904 photograph of the Whalers' Shrine to Mowachaht/Muchalat chiefs and council spokesperson Larry Andrews (left). In the foreground, museum director Bill Moynihan (left) is seated next to Nuu-chah-nulth Tribal Council president George Watt. American Museum of Natural History, #600362-06.

observes, 'The shrine, no longer only an artefact of considerable power to those chiefs who used it for whaling before 1904, now plays a role in an international dialogue between Natives and museums in both New York and Victoria, a dialogue that has entered the even larger world of the media' (1999: 44–45). The shrine's appearance in forms ranging from scientific to popular publications, to exhibits, movies and television programmes, effectively created public understanding of what it is: authors select its main characteristics, present its meaning and draw attention to the points they consider important. This means that '[o]ver the years these representations have wrapped the artefact with layers of meaning that interact with the subject and with each other and, in the process, become as real as—or perhaps even more real than— the original material object' (ibid.: 47). The ability of these representations to touch an enormous number of people indicates their power. Jonaitis argues that it is

> the discourse of repatriation, with its unqualified acceptance of the continuity
> and vitality of contemporary Native people for whom the shrine has meaning,

that offers an alternative. Repatriation is, in part, predicated upon the criticism of past archaeological and ethnographic practices . . . But it also signifies a growing empowerment on the part of Native people. *The Washing of Tears* demonstrates that the shrine and its supernatural potency offer a great source of strength that could enable the Mowachaht to thrive in a difficult age. (ibid.: 48)

CEREMONIAL OBJECTS

The Yuquot shrine was collected nearly twenty years before the confiscation of the Kwakwaka'wakw potlatch regalia. One of the connections between the two events lay in the early-twentieth-century conviction that native culture was either dying (in the case of the shrine) or needed to be stamped out (in the case of the potlatch regalia as part of potlatching).[10]

The Kwakwaka'wakw potlatch regalia were confiscated under the terms of the 1884 Anti Potlatch Law, which aimed to curb the increasingly elaborate potlatch ceremonies that colonial trading had made possible. These 'excessive' potlatches reflected the disruption caused by trading, which enabled young men without genealogical rights to engage in potlatching, thereby gaining prestige and legitimating their social position. The ban on potlatching was part of a more general policy of suppressing native culture, which, it was thought, was bound to disappear once people adapted to modern life. The practice did, however, continue, and in 1921 Dan Cranmer's ostentatious potlatch ended with intervention by the Royal Canadian Mounted Police and the local Indian agent.[11] There were arrests, and the potlatch regalia were confiscated, or surrendered by their owners, as part of an agreement to avoid imprisonment and further persecution. They were paid compensation of $1,495 for a total of 750 objects, some of which were estimated locally as having a value of $35,000. What became the 'Potlatch Collection' was then crated up, and most of it[12] was dispatched to the Ottawa Victoria Museum (later the National Museum of Man), where it became part of Canadian patrimony. It was never unpacked. The confiscation was never forgotten by the Kwakwaka'wakw.

When in 1951 the Anti Potlatch Law was dropped, potlatching resumed with renewed meaning. The first official attempt to reclaim the regalia was made in 1957; during the 1960s there was a renaissance of native arts and widespread recognition of the aesthetic value of the regalia. A new Museum Act made de-accessioning possible, and it was agreed that the National Museum of Man would return the collection to a museum—not to individual owners. There was, however, misunderstanding about where the collection should go (to an existing library-museum at Alert Bay or to a new museum to be built at Cape Mudge), and by 1973 two local groups made

distinctive claims on the regalia, resulting in its division between them (see Saunders 1997: 104). The two museums opened in 1979 and 1980, respectively—each with a potlatch. The contrasting ways of reincorporating and displaying the returned collection underline the complexities of repatriation—as well as the impetus given to establishing indigenous museums and cultural centres.

The U'Mista Cultural Centre (Alert Bay) exhibited the repatriated potlatch regalia at the heart of its display, representing the colonial history of the potlatch and featuring Cranmer's 1921 potlatch (Clifford 1991: 243). James Clifford characterizes the U'Mista display as having both a community and a more cosmopolitan orientation (ibid.: 245). Gloria Cranmer Webster, the first director of the U'Mista centre, emphasized the specificity of repatriation to Alert Bay:

> I guess what was different about our repatriation—you read a lot of stuff about other Native groups demanding the return of their objects because those are needed in their ceremonial rites. The difference for us was we didn't need any of this because people had continued carving masks, people had kept masks and other gear. The demand for the repatriation of the potlatch collection was based on other things—the idea that they belong here, that they were wrongfully placed in museums. (quoted in Clavir 2002: 179)

The regalia displayed in the big-house setting at U'Mista are in more or less the order that they would have appeared in the ceremony. Clifford describes the regalia being exhibited as 'treasures and historical witnesses for the Kwakwaka'wakw', giving the museum a kind of 'majority status within the dispersed but emerging tribal unity formerly called Southern Kwakiutl' (1991: 245). Although assembled in a ritual procession, objects are documented for their part in the 1921 potlatch. The objects' visible presence is strongly connected to the stories that are told about them, which can be understood by both local and wider audiences.

The Kwagiulth Museum, Mudge Bay, by contrast, organized its potlatch regalia according to family ownership. The intended audience is Kwagiulth, and unlike in the U'Mista Cultural Centre, there is no emphasis on the story of the loss and return of the potlatch collection in the exhibition, although there is a publication dealing with the prosecutions resulting from the 1921 potlatch and explaining the circumstances to a wider audience (see Simpson 1996: 157).

The repatriation of the potlatch regalia reflected the differing views—regarding legitimate claims and rights to display—of the descendants of those whose possessions were confiscated, or who were arrested, as a result of the 1921 potlatch. These divergences underline some of the issues associated with repatriation when this is conditional on a community facility. Unlike the Yuquot Whalers' Shrine, which was

shrouded in secrecy and not intended for public display, the potlatch regalia played a visible, public role in legitimating the authority of sponsors at these elaborate ceremonies. The 'collection' of the Whalers' Shrine and the confiscation of the potlatch regalia, and their respective storage in various museums, are therefore distinctive, although related, acts. Their respective repatriation processes underline the dynamics of relationships between the various parties involved, in which indigenous museums and cultural centres play a vital mediating role.

TOTEM POLES

The opening of the Kwagiulth Museum in 1979 was marked by a potlatch and the raising of a totem pole in memory of Chief Billy Assu, one of those who were charged in the wake of the 1921 ceremony. Canadian Northwest Coast totem poles were avidly collected by European museums in the late nineteenth and early twentieth century. This was the fate of the memorial pole raised by the Haisla Chief G'psgolox in 1872 to commemorate his encounter with a spirit after the deaths of his children through an epidemic.[13] Memorial poles are allowed to decay and fall as part of a natural cycle. The renewal of that cycle is ensured through the continuing practice of carving. Carving was one of the activities discouraged among children who were sent off to boarding schools in the twentieth century as a way of promoting their assimilation into majority culture. The pole was cut down by the Indian agent and removed from Kitlope Valley in 1929 and purchased by the Swedish consul, who had it transported back to Stockholm and donated it to the National Museum of Ethnography.[14]

When descendants of G'psgolox discovered the location of the pole (a centrepiece of the Swedish National Museum of Ethnography) in the 1990s, they visited Stockholm several times and claimed it back in 1991. Negotiations commenced, and the Swedish government agreed to repatriation on the condition that the ethnographic museum would receive a replica as part of the deal and that the old pole would be properly housed on its return. Two replicas of the original pole were made by Haisla carvers Henry Robertson, Patricia Robertson, Derek Wilson, and Barry Wilson: one for the Swedish National Museum of Ethnography and one to be raised on the original site in the Kitlope Valley from which the G'psgolox Pole had been taken. After one of the replicas was raised at Mis'kusa, the other was flown to Stockholm and presented to the museum. The original G'psgolox Pole was shipped back to Vancouver in 2006, staying temporarily at the University of British Columbia's Museum of Anthropology en route, before a ceremonial return on 13 June 2006 to the Haisla village of Kitmaat. The G'psgolox Pole was temporarily stored in the City Centre Mall pending completion of a community centre in Kitmaat.

Figure 6.3 The replica G'psgolox Pole presented to the Swedish National Museum of Ethnography as part of the exchange to retrieve the original G'psgolox Pole, 2011. Photo: M.R. Bouquet. Reproduced by kind permission of Henry Robertson, Patricia Robertson, and Barry Wilson.

Memorial poles such as the G'psgolox Pole are intended to commemorate through an organic process of gradual decay (see Clavir 2002: 154). Repairing and restoring such a pole would require a potlatch, which, in turn, presupposes an accumulation of resources. The Haisla replica pole is being allowed to deteriorate; the replica in Stockholm is also, significantly, outdoors. However, as noted, one of the conditions for the return of the 'original' from Stockholm was that it be housed in a protective facility. This involves fund-raising, just as the recovery process did, which brings the community into contact with a wider network of funding agencies, both governmental and nongovernmental.[15] Museums are also being transformed by such processes in ways that were difficult to imagine in many European museums at the beginning of the 1990s. In 2007 the British Museum moved its Haida memorial pole from the obscurity of an inner stairwell to a prominent position in Sir Norman Foster's Great Court, after due consultation and an appropriate ceremony with Haida representatives (MacGregor 2007).

Both film and photography have contributed significantly to the processes of change—as is clear from the cases of the Whalers' Shrine and the G'psgolox Pole: Hunt's early photographs spurred Boas on to collect it, while Brody's *The Washing of Tears* (1994) gave the Whalers' Shrine a public existence and meaning after its removal from Yuquot to the AMNH. The film *Totem: The Return of the G'psgolox Pole* (2003) was deliberately made to publicize the repatriation process (cf. Rozental 2007); *Totem: Return and Renewal* (2009) followed up on the return. The recognition that is articulated through collection pieces involves the recreation of social relations in the postcolonial period. The next section takes a closer look at the meaning and process of visual repatriation.

VISUAL REPATRIATION

If the dynamic potential of collections of historical artefacts only started to become apparent at the beginning of the 1990s, the same applied to collections of historical photographs. While the colonial context was the initial site where such images needed to be placed, as Elizabeth Edwards remarked, '[I]t is not improbable that other, more complex contexts of analysis will emerge (or are indeed already emerging) especially as formerly colonised peoples reassert their power and repossess their own histories' (1992: 12).

Edwards's premonition, expressed in an important work on anthropology and photography from the early 1990s, accurately reflects what became known variously as 'visual repatriation' (Peers and Brown 2003; Fienup-Riordan 2003; Bell 2003; Banks 2007), 'visual homecomings' (Pinney 2003; Morton and Oteyo 2008) or 're-cuperation' (Pinney 2003). Just as the repatriation of human remains overlaps with that of sacred and ceremonial objects, there is often an intertwining of objects and images in visual repatriation.

This section considers some of the ways in which visual repatriation overlaps with and is embedded in other forms of material repatriation.[16] Beyond the public domain of ceremonial exchange and exhibition, there is the private domain of museum stores and archives. Indeed, it was the encounter between the Mowachaht representatives and the Whalers' Shrine in the storerooms of the AMNH that forms one of the most moving sequences in Brody's film *The Washing of Tears*. Such meetings have increased substantially since the 1990s. A consultation session in the basement of the Portland Art Museum in Portland, Oregon, in 1989, between museum staff, anthropologists and experts on Northwest Coast art and a group of Tlingit elders, inspired Clifford's concept of the 'contact zone'.[17] 'When museums are seen as contact zones, their organising structure as a collection becomes an on-going historical, political, moral relationship—a power charged set of exchanges' (Clifford 1997: 190). How does visual repatriation work out in practice in such contact zones?

'GOING THROUGH' ADRIAN JACOBSEN'S YUP'IK COLLECTION AT THE BERLIN ETHNOLOGISCHES MUSEUM

First, new kinds of knowledge are generated, as Ann Fienup-Riordan's (2003) account of 'fieldwork on its head' with Yup'ik elders at the former Berlin Museum für Völkerkunde shows. After she happened on museum staff unpacking Adrian Jacobsen's Yup'ik collection (dating from 1882–1883), while looking for Yup'ik masks for an exhibition in Anchorage, Fienup-Riordan resolved to go back to Berlin and dig deeper into the collection. In 1997 she returned with a seven-member Yup'ik delegation to spend three weeks examining the Yup'ik collection in the museum's storeroom. 'As in the mask exhibit, what we sought was not so much the collection's physical return to Alaska, but the return of the knowledge and stories, the history and the pride that they embodied and that, we hoped, we would be able to bring home' (Fienup-Riordan 2003: 29). Although she does not go into detail, she mentions that she spent her time 'busily photographing masks' on her 1994 visit to Berlin and that she was 'photographer and guide' when she returned in 1997 as part of the Yup'ik delegation (ibid.). These photographs, as well as those taken by the elders themselves, clearly constitute part of the process of visual repatriation in the sense intended by Fienup-Riordan.[18]

She uses the term 'visual repatriation' to connote the knowledge and experience that the objects embodied for the elders through their systematic study of the Jacobsen collection in Berlin. During their three weeks at the Ethnologisches Museum, they had access to look at and handle their ancestral objects. Their work began with blessings and prayers, but as they grew familiar with the collection and with one another, they developed playful ways of examining the 2,000 objects. Their engagement with the collection was more than just looking at it: apart from handling the objects freely, they even recorded their sounds—such as the tinkling of a caribou-tooth belt. They discussed the names of objects and the regional variation in the terms used, told jokes and stories, sang songs, and re-enacted the use of, for example, a bow and arrow. The term 'visual repatriation' might, in some ways, seem too narrow to contain all this. Fienup-Riordan makes a crucial observation on this point: 'I think the elders were not as impressed by what they saw as by what they heard from their hosts and from each other' (2003: 37).

What starts as 'looking at' proceeds through a much broader register of the senses: 'feeling each grip and point, looking down the line of each arrow, opening each tobacco box' (Fienup-Riordan 2003: 33). Going through the motions of chopping with axes, shooting arrows, digging mouse food, shovelling snow, mixing *akutaq* or making fire with a drill bow took them into areas of experience beyond the visual.

One Yup'ik elder collected the requisites for preparing snuff tobacco from different parts of the collection, pretending to cut, pound and strain tobacco and mix it with ash, before sniffing it, sneezing and wiping her eyes (ibid.).

The elders expressed their gratitude both to the collector (for assembling their things) and to the museum for the care and organization of the collection, which means it is there for their own descendants. They were especially grateful to the museum for granting them the time, the space and the privacy to go through the objects together. 'If pictures of the things we saw here were seen by our descendants, it might help to reunite the people. And our descendants might begin to believe in themselves and their culture' (Fienup-Riordan 2003: 37). Looking at the objects once used by their ancestors, one elder said that he began to realize how hard-working and persevering they were, in control of their own lives: self-reliant, responsible craftsmen, with insight. Visual repatriation here meant sharing their work with their communities, partly through the photographs taken. This process is premised on the idea that promoting an understanding of their ancestors' culture helps people to believe in and be proud of their identities. As one elder put it, 'I envision our people gaining more faith in their own identity by seeing the objects or seeing the pictures or reading about them in books' (ibid.: 38). The elders saw themselves as representatives of the Yup'ik nation in Germany, and they viewed their visit, which had brought them halfway around the world, as serious business. Although it must have been very taxing for them to make this long journey and spend three such intense weeks away from home, in this contact zone, they created new relationships through the objects and what they themselves made of them.

The Yup'ik elders' access to their ancestral collection in the backstage area of a major Berlin museum is a powerful route to visual repatriation, facilitated in an exemplary way by the institution. Another route leads from the photographic archive to the field. Joshua Bell's (2003) exploration of the social embeddedness of photographs outside the museum and archive back in the field of their original production illuminates a different phase in the social lives of images.

VISUAL REPATRIATION AND LEARNING TO SEE IN THE PURARI DELTA, PAPUA NEW GUINEA

Bell's visual repatriation involved photographs taken by two early-twentieth-century anthropologists in the coastal Purari Delta area, Gulf Province, Papua New Guinea. The photographs comprised fifty-eight images taken by Alfred Haddon and his daughter while in the area in 1914, from the Museum of Archaeology and

Anthropology at Cambridge University; and seventy-six prints taken by Francis Edgar Williams in 1922, when he was a government anthropologist, from collections held at the National Archives of Papua New Guinea and the National Archives of Australia. The images included snapshots or posed 'scientific reference' images of individuals or groups, photographs of material culture and landscape photographs of villages, government stations and natural features. The Kabu Movement (1946–1949) for economic self-sufficiency, which arose in this area, meant that many traditional practices (such as building longhouses and making ancestral carvings) were abandoned, and the authority of chiefly hierarchy and clan histories eroded. Hence, the photographs, in documenting a period before the Kabu Movement, were seen as visual evidence for contemporary claims to chiefly ancestry—among other things.[19]

The arrival of the photographs was greeted with enthusiasm and emotion: memories were stirred by scenes and objects that had been gone for more than fifty years. Bell noticed how the images worked differently in public and private settings. In public settings, where members of different clans were present, there were personal reminiscences about rituals, songs and the ways in which artefacts were made and used. When alone or with immediate family, people brought in genealogical and personal connections to land or chiefly status and discussed questions of identity more openly. They also brought out heirlooms and placed them alongside photographs, more readily incorporating the images into their personal histories (Bell 2003: 115).

The photographs allowed elders to perform aspects of their identity that had been submerged for years: shell valuables, for example, were located and put on in the course of looking at photographs of these adornments. The photograph of an over-modelled skull was held up and explained. Seeing photographs of longhouses and mother ancestral spirit masks prompted dancing and singing. They re-enacted the pounding of drums remembered from the last longhouse opening. People traced the outlines of figures and objects in the photographs with their fingertips in these more private settings. Sometimes they were overcome with emotion while holding the photographs in their hands. People also spent quite a lot of time in trying to ascertain where photographs were taken, trying to situate them in former patterns of movement and social relations.

There were also dissenting voices: the old ways did not appeal to everyone, and there were expressions of cultural distancing from this past, experienced by some—especially younger men—as a 'foreign country' (quite literally, 'Africa'). Nonetheless, the presence of these images from the past did involve people in discussions that could not otherwise have taken place. Viewing the photographs allowed people to articulate certain material relationships that would otherwise have been impossible. Like a new 'skin', the collections created a space where the dead, spirits and histories

could reside and circulate.[20] These historical photographs were also absorbed into an evolving critique of Malaysian logging in this area, bringing to the surface discussions about chiefly hierarchy, clan history and resource ownership (Bell 2003: 112). The ease with which the photographs could be used in these various ways shows their intrinsically unstable meanings.

Returning photographs is something anthropologists and the institutions they represent can do for host communities: these two collections have been deposited in the archives at Port Moresby. When storage conditions permit, they will be repatriated locally. Photographs, like artefacts, offer a way of revisiting, contesting and publicly discussing the past. '[V]isual repatriation creates spaces wherein the host community, researcher and holding institution can revisit and rework intersecting histories as they are embodied and displayed in by-products' (Bell 2003: 120). Photographs intermediate between anthropological ancestors and fieldworkers and the community and their ancestors, enabling the parties to engage in a dialogue that began long ago. The resulting conversations, much like those in the Berlin storerooms, 'open up' these objects—which may usefully be seen as containers of histories. Bell argues that visual repatriation is a 'step in the process of reinvesting host communities with a degree of agency and a voice in what we write about them' (ibid.). Through this process we learn to see beyond the contents of images to the wider sets of relationships in which they are enmeshed—the 'visual economies' of their production, distribution and use (cf. Edwards 2003: 84).

How might it be possible to connect visual repatriation conducted at the local level with the archives of holding institutions and their public role more generally? The creation of virtual photographic collections is one way of making local visual repatriation projects 'present' for a more general public.

'REFLECTING ON THE PAST' (PARO MANENE): VIRTUAL AND LOCALIZED VISUAL REPATRIATION

A third sense of visual repatriation involves both local and virtual forms of presenting a photographic collection. This dual approach can be seen in the 'Luo Visual History' project,[21] which is one of some fifteen different virtual collections presented on the Pitt Rivers Museum website.[22] The 'Luo Visual History' website comprises 350 historical Luo photographs from the Pitt Rivers collection, dating from 1902–1936. Most of the images were taken by anthropologist Edward Evans-Pritchard in the late 1930s while he was conducting fieldwork among the Luo of Kenya; a small number by anthropologist Charles Hobley date from earlier. The website is the result of collaboration between the Pitt Rivers Museum and members of the Luo community of

Nyanza Province, western Kenya, facilitated by the National Museums of Kenya. The 'Paro Manene' exhibition project resulted in four local exhibitions being installed at locations in Nyanza, in early 2007, where the original photographs had been taken. These local exhibitions led to further research with members of the communities and descendants of those photographed.[23]

In addition to the website, photographs and documentation have been deposited at the Kisumu Museum, the British Institute of East Africa and the Jaranogi Oginga Odinga Museum and Mausoleum in Bondo. The photographs reflect the two anthropologists' interest in Luo political organization and culture: there are many images of chiefs and other leading individuals as well as the material culture of authority, such as the *tong* or spears of clan leaders and founders (Morton and Oteyo 2008). This directed vision makes the photographs interesting for Luo historians as well as for the families and communities of those photographed. The identities of the leaders and elders, as well as other people whom Evans-Pritchard photographed, is emerging through fieldwork. Gilbert Oteyo has worked on the Pitt Rivers Museum's Luo collections since 2002, first cataloguing ornaments and later the photographs by Evans-Pritchard and Hobley. The idea of developing photographic exhibitions for the communities represented was hatched around this time. Oteyo and Morton were inspired by Corinne Kratz's (2002) account of exhibiting her Kenyan Okiek portraits in Nairobi and the USA. Kratz explores the political and representational issues as they unfolded in the different locations where the portraits were exhibited. Unfortunately, the Okiek community was unable to travel to Nairobi to see the exhibition while it was in Kenya.[24] The idea was for the 'Paro Manene' exhibition to move between several venues in Luo country so that elders and schoolchildren would both be able to see it.

The exhibitions were enthusiastically received, although three days for each venue proved to be too short. Most Luo visitors to the exhibition were interested in the historical information to be found in the photographs. People were able to 'look past' the problematic colonial and historical contexts in which the photographs clearly came into existence in their strong desire to 'reappropriate and reclaim the history within the image' (Morton and Oteyo 2008). As the authors note, the term 'visual repatriation' refers to a variety of practices that stem from the moral and intellectual imperative to open up Western archives to local communities—and to take the initiative in doing so. Returning copies of old photographs does not transfer any use or reproduction rights over imagery from Western institutions to local communities— however much consultation and collaboration is involved—so that the imbalance of power remains intact. Since historical photography is increasingly understood as being the cultural production of the community concerned as much as the artistic production of the photographer, terms such as 'recuperation' and 'visual homecomings' may more accurate (cf. Pinney 2003).

Relatives of the three Luo chiefs portrayed by Evans-Pritchard were revisited in 2007 and presented with framed prints of the portraits. These were emotional events for the families of the three men concerned, which generated complex recollections including the ensuing histories after Evans-Pritchard and the colonial administration had gone. 'Paro Manene' is the first 'ethnographic' exhibition to be devised and curated by an African researcher taking an archive home. Despite this privileged position relative to the community, Oteyo recognizes that—just like any other researcher—he imposes his own narratives and biases on the archive. While the authors do not favour visual repatriation as an exclusively indigenous-led process, they do recommend an opening up of curatorial agendas to include more capacity-building in Africa.

As source community members access colonial photographic archives they do so for radically new purposes. Michael Aird's (2003) and Jo-Ann Driessens's (2003) ways of exploring and (in some cases) using Australian Aboriginal photographic archives show how the colonial photographic archive can be mined in new ways (Pinney and Peterson 2003; cf. Edwards 2001). The ability of family members to look beyond the stereotypical ways in which their ancestors have been portrayed to discover and recognize family members is one of the ways in which the colonial visual archive is being reconfigured (see Pinney 2003). Telling these stories via websites such as that of the Pitt Rivers Museum, as well as in professional publications, contributes in a vital way to refashioning contemporary visual economies.

CONCLUSION

> Visual repatriation enables photographs to be engaged with in private space and social space in some way contiguous with that from which the photographic moment was extracted.
>
> (Edwards 2003: 92)

Visual repatriation has become a major way in which historical 'ethnographic' collections—of both artefacts and images—can be given back to source communities. Ethically engaged curatorship, exemplified in the Yup'ik elders' visit to Berlin guided by Ann Fienup-Riordan, shows how visual repatriation involves museum artefacts and photographic images, as well as ways of engaging with them beyond the 'visual'. The role of the host institution in creating space for the elders to 'go through' Jacobsen's collection, making time for this to happen, and ensuring the privacy required facilitated the process.

The historical photographic collections returned by Joshua Bell to the Purari Delta area of Papua New Guinea enabled local people to revisit a past that had been

absent for some fifty years, in both public and private settings. Revisiting the past involves different generations of source and research communities, as well as the holding institution(s), in new kinds of relationships with materials flowing in new directions. Unlike photo elicitation, which emerged in the classic power relations of colonial anthropology to 'trigger' memories and produce cultural information for the researcher, visual repatriation emphasizes shared approaches, acknowledging sensitivities and the 're-absorption of photographs into social spaces where the ethnographer cannot and should not go' (Edwards 2003: 87).

The two-stranded visual repatriation of Luo visual history, by means of a travelling exhibition to the communities where the photographs were taken in colonial times (curated by Gilbert Oteyo, himself a Luo) and by means of virtual collections available on the museum website, shows a balanced way for museums to engage with source communities and to energize their collections in the process (Edwards 2003: 89). This way forward facilitates both the private recuperation of images as a 'kind of particularization, the enclosing in a new space of domesticity and affection of images formerly lost in the public wilderness of the archive' (Pinney 2003: 4) and may even hold out a promise for the reform of those public wildernesses.

KEY CONCEPTS

Repatriation	Cultural property
Cultural biography of things	Visual repatriation
Human remains	Contact zones

EXERCISES

1. Check the websites of major museums (e.g. the British Museum) for the latest on repatriation claims on parts of their collection (e.g. Parthenon Marbles).
2. Check the world news for details of claims by heirs of those dispossessed of their collections by the Nazis during the 1930s and 1940s (e.g. the Goudstikker heirs). What effect have such cases had on other claims for the return of cultural property (e.g. by First Peoples)?
3. Examine one case where relations between a museum and descendants of the original owners of cultural property have been renegotiated through collection items.
4. How has collection research been renewed as a result of repatriation claims?
5. What is the role of photographs and film in the renegotiation of cultural property?

FURTHER READING

Jonaitis, A. (1999), *The Yuquot Whaler's Shrine*, Seattle and London: University of Washington Press.

Jüdisches Museum Berlin (2008), *Raub und Restitution. Kulturgut aus Jüdischem Besitz von 1933 bis heute*, Göttingen: Wallstein.

Turnbull, P. and Pickering, M. (eds) (2010), *The Long Way Home: The Meaning and Values of Repatriation*, Oxford and New York: Berghahn Books.

AFTERWORD: TEYLERS REVISITED

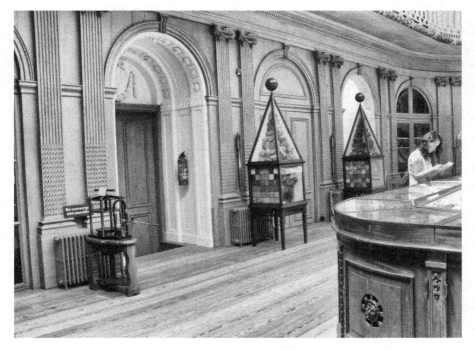

Figure A.1 Teylers Museum, the Oval Room, May 2011. (Photo: M.R. Bouquet)

The Oval Room is one of the most important cultural spaces in the world. The opening of the room in 1784 by and for citizens was of great cultural, political and social significance. As a microcosm of all the knowledge of art and science, the Oval Room embodies Enlightenment ideals as no other place. Almost nothing of the original architecture and installation has been changed since 1784. Partly because of this, the Dutch state recently nominated the museum for the UNESCO World Heritage List.

In his design for the Oval Room, architect Viervant had in mind a room made with 'the very best white oak.' Over the years, however, the Oval Room woodwork became steadily darker, whereby many details became invisible. Thanks to the restoration, the heart of the museum has regained its original light colour and the rich wood decorations are once again visible.[1]

Revisiting the Enlightenment museum seems a fitting way to end the story. It enables us to ask what has become of this public museum concept more than two centuries later—and to consider how this Enlightenment version of the institution is invoked and used by contemporary museums. When drawing together the threads of this book in 2011, I was confronted with some unanticipated changes to the visual system at Teylers Museum, analysed in Chapter 1. Revisiting the museum with students in May, we found that Teyler's portrait had been removed from its central position in the Oval Room to a corner of Paintings Gallery I and that the wood panelling of the Oval Room had become several shades lighter.

Restoration of the Oval Room in late 2010 and its official reopening in July 2011 coincided with the Dutch government's nomination of Teylers for the UNESCO World Heritage List. Restoration of the Oval Room, invoking Enlightenment values in the process, brings us face-to-face with the dynamics of heritage. Reference to Viervant's resolve to use 'the very best white oak' for the Oval Room holds out the promise of enjoying a view of the original, authentic Oval Room—as Viervant saw it. But what does removal of the traces left by the intervening centuries mean? Why is historically darkened wood considered less authentic than the results of a cleaning operation? If the repositioning of Teyler's portrait restores the original appearance of the Oval Room, what is lost by its removal? And what is gained by the bid for world heritage status? The personalized, idiosyncratic quality of the museum, acquired through time, has been exchanged for a cleaner look—perhaps intended as a more universal one.

The Teylers Museum website proudly presents the restoration process, pointing out that visitors will now be able to enjoy the room as architect Viervant intended.[2] But returning the room to its original glory is a controversial move. Which original state is that? The large central piece of furniture was a demonstration table

with storage space underneath when the Oval Room opened in the late eighteenth century. The display cases were added later, transforming a space of demonstration into an instrument of exhibition. While scientific demonstrations continued in the Oval Room and elsewhere in the museum, this early change illuminates the problem of fixing original states.[3] The wood panelling did indeed become darker with the years, and perhaps details did become obscure. Yet taking away this patina, it could be argued, is a denial of history: the darkening of the wood faithfully reflected the passage of time at Teylers and was an integral part of the museum. The facelift creates something new, adding value by claiming to have re-established direct contact with the eighteenth century—according to the logic of heritage (cf. Kirschenblatt-Gimblett 1998). The Oval Room is said to be a microcosm of all knowledge of art and science, thereby embodying Enlightenment ideals in an unparalleled way.[4] This appeal to Enlightenment ideals has to be placed in the broader political context of Europe in the 2010s, where Enlightenment values are also being called on for nationalist purposes.[5]

In reshaping its rather quirky identity as a museum, adding new lustre through material restoration on-site and expanding its virtual dimension (for example Teylers Universe), Teylers Museum is repositioning itself as world heritage. The added value of world heritage status—symbolized by the claim that the visitor stands eye-to-eye with the Enlightenment vision of its architect—is achieved at a cost. The desire to go back to Viervant, to see what Viervant intended, erases the additions of the intervening period: the darkened wood panelling and the portrait of the donor gave the Oval Room a sense of history.[6] Teylers seems poised to move from being one of Europe's best-kept secrets to joining the league of internationally recognized cultural heritage.

Before the main threads of the book are drawn together and areas for future research are identified, a brief remark on the severe financial crises that Europe and much of the world entered during the writing of this book is in order. The crisis of confidence and trust in financial markets is also a reminder of the complex nature of cultural value and its sustainability. Economic cutbacks in the cultural sector in some countries mean reduced state support for a large number of institutions including museums. This nervous situation raises many critical questions for museums: has a ceiling on their growth been reached in the government-supported model characteristic for many parts of Europe? Has a saturation point been reached with cultural heritage and museums, or has the value of these resources yet to be fully realized? Will public museums increasingly depend on corporate sponsors and private patrons? Is the circulation of both collection pieces and/or the public (as international tourists) a sustainable model for heritage production and consumption in the future—considering the global environmental effects of mass mobility? How

can we rethink the visibility and accessibility of collections in a more sustainable and equitable way?

While this book does not pretend to have the answers to these questions, its wide-ranging overview does bring a series of pertinent issues to the fore. The development of public museums, including the different stakes of donors, governments and the public in them, has depended on ongoing processes of recreating their visual and material culture. As we have seen, architectural extensions, *dépendances* and mega-renovations have played and are playing a major role in reinventing the museum. National (and corporate) museums use architecture (at home and overseas) as a demonstration of benevolent power—exercising an irresistible attraction over the public. For some national museums, this also involves the retention of certain masterpieces on-site, in the name of universal values—such as free access for the whole of mankind—while others circulate through different locations. The underlying view of centres and peripheries of the world cultural system betrays a provincialism in need of revision. The retention of some collection items which entered museums in earlier centuries, in the name of enlightened citizenship, colonial power and national identity, is now being questioned. Returning objects can produce interesting and satisfying stories—as well as new objects and relationships—as the return of the G'psgolox Pole from Stockholm to the Haisla amply demonstrates. Such moves befit great museums with a sense of history. Imagine the cultural value of a replica of the Parthenon Marbles in the British Museum if this were combined with the story of a once imperial nation, acknowledging the privilege of having kept these inalienable possessions for so long and, through their restitution, demonstrating confidence and trust in the provision made by the Acropolis Museum. The benefit of this move, in terms of public education, would be remarkable: a visible act of return would leave a trace in the public space of the museum (perhaps a void, perhaps a replica) of incalculable cultural value. Who knows: reinvigorating mutual relations of confidence and trust amongst the partners involved might serve wider economic and political ends.

Looking back at the questions raised in the Introduction, it is time to review and connect the points that have emerged from the foregoing chapters. The book began by examining different forms of visual presentation in the oldest public museum in the Netherlands. The digital representation of museums and their collections through the creation of websites constitutes a crucial complexification of visual culture. The new system of representation connects intriguingly with the older (and renovated) displays at the museum: picturing individual objects, decontextualized from sometimes overpowering historical displays, creates a new museum effect. Virtual isolation of the object allows the viewer to see it, or rather an image of it, in ways that might not be possible in the museum itself. The intervention of this image may thus affect

whether and how the object is seen on-site. Museums do not, of course, show their entire collections in this way: processes of selection (and rejection) play as vital a role in the images displayed by the museum (and information provided) as they do for the material objects displayed in the architectural space of the museum. Museums, and the website designers working for them, create new public faces for chosen aspects of their collection, premises and cultural enterprise more generally. Virtual knowledge and visibility extend the premises of the museum beyond its physical buildings, yet they perpetuate or even create new frontstage/backstage distinctions. Museums have been variously compared with department stores, cathedrals, theatres, secular ritual sites and donor memorials—all of which involve dramatic and performative dimensions; on the other side are the backstage areas where preparations take place. The interweaving of these virtual and physical dimensions in constituting institutional identities and museum effects is a promising area for future research.

The extension of museums into virtual reality (including the design and building of websites) complements the institution's physical extension (whether overseas or on-site) and renovation. Museum architecture is one of the clearest examples of how visual technologies are employed in the creation of new museums and in the mega-renovation of existing ones. Museum buildings occupy a central place (both physically and metaphorically) in creating the public identities that define their institutions. The projected images, or renderings, of (planned) new museum buildings, designed by one of the coterie of starchitects, help to create the museum's fame, reputation and power of attraction. Some nineteenth-century buildings were explicitly designed to materialize national identity through their material form. The visual and material power of national museum buildings was such that, even when local populations strongly objected to their costs and the symbolism (as with Cuypers's Rijksmuseum), these new public spaces nevertheless exercised a compelling power of attraction. Contemporary museum architects create powerful visual renderings and animations of their designs, as well as conventional models, both for the initial competitions and in subsequent negotiations with their clients. Jean Nouvel's renderings for the new Louvre Abu Dhabi, and Cruz y Ortiz's animations for the mega-renovation of the Rijksmuseum, (have) play(ed) significant roles in the controversial processes of stretching those national museums. Since Europe is no longer the metropolitan centre of the museum world, the strategies adopted by its national museums to reposition themselves, not least through their buildings, are sensitive registers of changes in public culture. Renewed attempts at creating distinctive national museums throughout the world reiterate the value of visible cultural difference—particularly in the commercial sense of providing recognizable destinations for international tourism. National museums as destinations of this sort steer a course between providing international public facilities while presenting

a credible vision of national difference—through their site (or sites), architecture, collections, exhibitions, and so forth. The fact that some of these very features share standardized forms of international design is a central paradox, illuminating the fundamental museum role of *creating* a distinctive national identity—whether through the masterpiece(s) of a collection, the history of a building or the creation of new areas of visibility and new ways of experiencing them. The future of national museums, whether through a multiplication of their sites or renovation of the original premises—deserves further exploration, as does the interim museum produced by these operations.

Ethnographic and national museums were in many respects interdependent. In representing other cultures, ethnographic museums helped to strengthen the sense of identity that national museums fostered. National museums assembled the nation's possessions—either home-produced or brought in from afar. In some cases, ethnographic collections developed within the national museum, sometimes splitting off later to form new specialized, disciplinary museums. Sometimes ethnographic museums were founded as separate institutions: as university museums, but also as colonial museums in Europe and in imperial territories. Ethnographic museums still wrestle with the legacy of the hierarchical knowledge and power relations that were built into them during the colonial period.

Ethnographic collections have great potential value in postcolonial multicultural societies: as resources for various communities (source and local), they can form a basis for collaborative research and exhibition and for the telling of new stories. The return of some ethnographic collection pieces, ranging from human remains to sacred objects to photographic records, as well as more respectful ways of sharing, has become a significant aspect of contemporary ethnographic museum practice. Studying the social networks and exchanges constituting ethnographic collections has clarified their historical development. New partnerships with museums in different parts of the world offer fresh ways of working with historical collections. Contemporary artists' involvement with ethnographic collections is also breathing new life into them and creating new perspectives and dynamics. Investigation of the multiple ways in which ethnographic museums and collections are reinventing themselves is a major research area of continuing importance.

Ethnographic research on the social relations of collecting, exhibition-making and public use of all kinds of museum has expanded understandings of their visual and material culture. As new areas of ethnographic exploration which have developed since the mid-1980s, these ethnographies articulate the negotiated and composite qualities of collections, exhibitions and guided tours. Long-term participant observation brings out both human agency (exercised through objects) and agency that appears to derive from the intrinsic materiality of certain objects: their particular

aesthetics, size and weight can affect plans and impact on the result. Tracing the social lives of museum objects from their site of production to their current situation allows (some of) those effects to be studied as they move between different contexts. In addition to the study of what happens when objects move through different social contexts of collection, storage and display, the movement of different public groups into the space of display also produces diverse interactions and meanings depending on the social positioning of visitors (for example in terms of age, gender, class, nationality, ethnicity and life experience). The claims made on or through collection items, the space of display and the narratives told there underline both the uncertainties of authorship and the power of display. The tangible contribution of an ethnographic approach to museum studies is its distinctive way of exploring the social and material worlds of collection, exhibition-making and the public use of the institution, which complements research by scholars from other fields.

Museums produce a specific form of culture: displays materialize relations of power (political and professional) and are the outcome of negotiation, at different historical junctures. Questioning the dynamics that underlie this form of visual culture unsettles the self-evident quality of a display case. Analysis of the practices of objectification, modernism and renovation in museums from the nineteenth century to the present shows that new domains of visibility are being created out of previously hidden areas or activities. These new areas of visibility may consist of behind-the-scenes activities on-site, but they are also about the inclusion of indigenous or minority groups into national displays from which they were previously excluded; and, more generally, about consultation. Collaborative practices of various kinds, including exhibition-making, have profoundly altered museums worldwide. While European museums may have been slower in picking up on these practices—because of the perceived distance in time and space from their colonies—by now such collaboration is seen as standard practice. Such moves are of course crucial to the transformatory logic of culture. Display helps to creates value through careful selection and presentation of new objects, by drawing attention to their previously unappreciated qualities and by telling stories that help to place them in a new light. The transformation of unconscious habitus into consciously designated Culture subtends a wide range of newly identified candidates for display.

Repatriation of collection pieces, in the broad sense discussed in the final chapter, is one of the options open to museums for reinventing themselves. Entering into negotiations with those making claims on cultural property held by museums can produce new and fascinating objects and stories—as we have seen. Against the background of this promising direction taken in collection use and visibility, the new Enlightenment museum seems set on a very different course. We should ask ourselves whether projects for restoring Enlightenment visions and values by contemporary

museums illuminate or obscure the intervening histories, enhance or diminish their educational value and open up or shut down the potential for reinvigorating social relations.

This book has shown that studying museums, collections, exhibitions and the public cannot be accomplished without taking into account the role of policies, capital, globalization and shifting balances of power. If we return to the first case, Teylers Museum would not exist without the foundation that created it, through their interpretation of the benefactor's will. And promotion of the same museum as a candidate for world heritage status would not happen without national government support. National museums once attempted to create tangible places of national identity; today, they have to accommodate millions of global citizens—whether as staging posts for tourists or as accessible and meaningful places in present-day postcolonial and multicultural societies. The display and circulation of objects have always served political and ideological ends: decisions to create overseas *dépendances* or to undergo mega-renovations are clear attempts at repositioning national museums to fit global circumstances. The metamorphoses undergone by ethnographic museums from colonial times to the postcolonial present underline the various options for articulating difference and identity—which range from taking account of history to gravitating towards art. The value of ethnographic approaches to museums and heritage consists in the insight they afford into the microlevel of practice and agency where the value, meaning and use of visual and material culture are worked out. This approach can be used to explore the activities of collecting, exhibiting and guiding the public, as well as repatriation processes and negotiations. Changing practices of object display include collaborative ventures with source communities and the incorporation of previously invisible or back areas and activities. The profound changes that have taken place in the creation and uses of heritage—from service to national and imperial ends to global issues of sustainability and local identities—shows the entanglement of this high-profile form of visual and material culture in social relations and invisible power relations. It also reminds us of the power of display itself: museums have a measure of choice in what they display and how they display it. The political and ideological context of visual display, including the restoration or renovation of museums as public spaces, reflects and also shapes global changes.

El Lissitzky's *New Man*, one of the Prouns created by the Van Abbe Museum in 2007, was an exercise in making a previously unrealized design materialize. The resulting creation, positioned against a window on the outside world, is an inspiring vision for the future: it combines the new and the old fearlessly in ways that are compelling without being confining. The museum as a public resource base can be a place where vision and understanding are renewed and extended, a place that is attuned to the world outside its walls.

NOTES

Introduction

1. The exhibition was entitled 'Lissitzky + Victory over the Sun', curated by John Milner (September 2009–March 2012). During this period, the Van Abbe Museum website offered various supplements to the exhibition, including texts, films and a game: http://vanabbemuseum.nl/en/browse-all/?tx_vabdisplay_pi1%5Bptype%5D=19&tx_vabdisplay_pi1%5Bproject%5D=501 (accessed 9 April 2012).

1: Museums in the Twenty-first Century

1. The website of Teylers Museum, Haarlem, was redone in 2009. The current site, http://www.teylersmuseum.eu/, designed by Studio Berry Slok, contrasts with the previous one, to which I refer. The information is 'the same', but the effect is radically different (apart from the 'Summary', the contents of which have been rearranged in the new site).
2. See Miller's 'The Fame of Trinis: Websites as Traps' (2001) dealing with the way Jamaican personal websites lure the viewer in. The museum website also has the potential of working as a 'trap', as the viewer is drawn into the site through the sensation in the 'moving-slice' headline images, which, when they 'stop', gently propel the eye into the written text below, which is often accompanied by attractive images that directly connect with the text. The written Dutch presentation of the collections is accompanied by images of a drawing, a painting, a fossil, an illustrated natural history book, a scientific instrument and a coin ('De collecties van Teylers Museum', Teylers Museum website, http://www.teylersmuseum.eu/index.php?item=64&flact=1&lang=nl, accessed 9 April 2012). The English text is much less developed in this respect, with only one accompanying image—of the great electricity machine.
3. The former website can no longer be accessed; the author of the 'Summary' was anonymous.

4. One of the things that make this short movie thrilling is the musical accompaniment, so that in fact the film is not silent. The music is called 'Dogs of Politics', by Wendy Boot, and is described as 'classical violin groove, polyrhythmic piece, minimal music' (allmusic.eu). The movie can be seen by visiting the 'Natuurkundige instrumenten' subpage (http://www.teylersmuseum.eu/index.php?item=65&ci=1&kw=video&lang=nl, accessed 9 April 2012) and clicking on the words 'deze video bekijken' (watch this video).

5. Although the new website is much more attuned to letting the visitor 'experience' the historical qualities of the museum, this experience is strictly controlled through the process of selection (and exclusion) and direction.

6. Visiting the museum first, and then the website, is another option.

7. On the other side of the Spaarne, just across from Teylers Museum, is the building of the Hollandsche Maatschappij der Wetenschappen.

8. The 2009 website has a section on Teyler's house, where it announces that in the future the house will be opened to the public; at the moment it is accessible only on the annual Open Monument Day. Teyler's library, drawings and numismatic and natural history collections were placed at the disposal of the two learned societies, which were to develop them for the general good. Thus, these personal collections made the transition from the invisible world of Teyler's private house into the public museum where the visitor stands. More important than the collections was the fortune bequeathed to five trustees, making various philanthropic bequests and establishing two societies, which met in Teyler's house. On Teyler's death, the foundation decided to use his fortune to build a public museum. Further interpretation of Teyler's will by the foundation, when Van Marum became its director, led to the establishment of an important scientific collection, used for both public demonstrations and experiments. During the nineteenth century, a contemporary Dutch art collection was acquired. Hence, the museum really starts with the neoclassical Oval Room, which opened to the public in 1784, where scientific demonstrations were held, artworks could be viewed, and books and scientific instruments were stored. While Teyler's portrait is prominently visible in the museum, the driving force behind it—Van Marum—is discreetly absent.

9. Although the objects on display in the museum are not for sale, there is now a well-stocked museum shop with the standard assortment of books, souvenirs, postcards and suchlike.

10. Teylers Museum's mission statement is exemplary in this respect:

> The first and oldest museum in the Netherlands aims to stimulate people's curiosity to visit its treasure chambers of art and science. The presentation of these

objects of art and science and the use made of these monumental premises aim to transmit knowledge and provide insight on their constantly changing meaning for society. The museum aims, in accordance with the ideals of the founder, to serve society by encouraging people to discover the world for themselves and to enjoy art and science.

(‘Missie’ can be found, in Dutch only, on the Teylers Museum website: http://www.teylersmuseum.eu/index.php?item=114&lang=nl, accessed 9 April 2012; the English translation is mine.)

11. See the Afterword for further reflections on this point.

2: Stretching the National Museum

1. The political framework includes two world wars (1914–1918, 1939–1945), the economic crisis of the 1930s, decolonization and the rise of the welfare state after the Second World War. Modern means of mass transportation and the growth of leisure and tourism, along with the development of media such as film, television and information technology, provide the cultural coordinates for these changes.
2. See Conlin (2006) on the rather different case of the British National Gallery.
3. Huis ten Bosch included *stadhouder* Frederik Henry's seventeenth-century mausoleum: the Oranjezaal.
4. After his coronation in 1813, Willem I established a Royal Cabinet of Curiosities and a Royal Picture Gallery in the Mauritshuis, The Hague (1816). Bergvelt raises the interesting question of why the collections in The Hague and Amsterdam were not united in 1816. Did Willem I somehow see the two collections in the Mauritshuis as his own private property, or as somehow belonging to The Hague and therefore not to be combined with the Amsterdam Royal Museum? In any case, Willem I gave no priority to establishing central, national cultural institutions (Bergvelt 1998: 90). Although the potential for royal interference in museums was great during the period of ‘absolute monarchy’ (1815–1848), until the Constitution of 1848 for the most part it was not so.
5. Between 1813 and 1870, the national collection was in The Hague, at Huis ten Bosch and the Mauritshuis; in Amsterdam, at the Trippenhuis and Dam Palace; and in Haarlem, at the Pavilion Welgelegen.
6. In his influential article, ‘Holland at Its Narrowest’ (‘Holland op z'n smalst’) in *De Gids* (1873), De Stuers made the case for art as government business.
7. The new museum concept was not welcomed by everyone: some critics (from among the largely Protestant-dominated political elite) saw in De Stuers's and Cuypers's plans a ‘Catholic conspiracy’.

8. The collection also included Quellinus's models for the Amsterdam City Hall.
9. The treasures looted from Benin City when the British Royal Marines sacked the city in 1897, which were removed to the British Museum, are a famous case (see Eyo 1994; and Chapter 7).
10. This discussion is based on contributions to the website *La Tribune de l'Art*, on the page 'Dossier Louvre Abu Dhabi' (http://www.latribunedelart.com/Debats/ Debats_2007/Page_Debat_Abu_Dhabi.htm, accessed 9 April 2012).
11. This is exactly opposite to the nineteenth-century movement whereby internationally renowned objects were declared national heritage—such as the Venus de Milo in the Louvre or the Elgin Marbles in the British Museum—inspired by the internationally oriented conviction that in this way they were being returned to the world. I am grateful to Maarten Prak for this observation.
12. In the novel *De Wandelaar* by Adriaan van Dis, the middle-class Dutch narrator finds himself drawn into an 'other world' of illegal migrants in Paris. On one occasion he attempts to visit a museum, accompanied by the stray dog he adopted after it jumped from a burning apartment complex housing illegal immigrants. He is duly turned away, realizing as he goes that had his dog been classified as a 'blind dog', he would have gained unproblematic entry (2007: 132, 134).
13. Compare with Henning (2006: 52).

3: A History of Ethnographic Museums

This chapter is based on a previous publication in Dutch, see Bouquet 2005.

1. All references to Siebold are taken from his request to King Willem I written in 1837, 'Kort begrip en ontwikkeling van de doelmatigheid en van het nut van een ethnographisch museum in Nederland', published as an appendix to *Overzicht van de Geschiedenis van het Rijksmuseum voor Volkenkunde, 1837–1937* (Leiden: A. W. Sijthoffs, 1937), pp. 63–69.
2. Edme François Jomard (1777–1862) was among those who sensed the emergence of a new sort of object in the nineteenth century; although at first it was not known how to designate such material, it clearly differed from classical, art and natural history objects (Dias 1991: 98). Jomard was a member of the scientific mission that had accompanied the French occupational force to Egypt in 1798. After returning to Paris, he worked at the Bibliothèque Nationale in Paris, editing the renowned *Description de l'Egypte* (1809–1824) and becoming curator of the geography department. Jomard stressed the documentary side of such objects—their use in reconstructing history—and devised a classificatory system within which they could be integrated.

3. The contribution made by scientific expeditions to ethnographic museum collections is a subject in itself. Scientific research was highly prestigious—producing another form of competition among nation states in their respective empires. For more on ethnographic expeditions to Melanesia in the 1870s–1930s, see O'Hanlon and Welsch 2000. On Haddon's famous 1898 Cambridge Torres Strait Expedition, see Herle and Rouse 1998.

4. The list includes the Palais du Trocadéro, which opened as the Musée d'ethnographie du Trocadéro in 1878, housing objects collected in the colonies for display at the Universal Expositions of 1867 and 1878; the Museum für Natur-, Völker- und Handelskunde in Bremen, opened after the Handels- und Kolonial Ausstellung of 1890 in that city; and the Deutsches Kolonialmuseum in Berlin, the basis of which was formed by ethnographic objects from the Deutsche Kolonial Ausstellung of 1896. Likewise, the great Colonial Exhibition at Tervuren Brussels, in 1897, was followed up with a decision to build a permanent museum the following year.

5. These included Boucher de Perthes in Abbeville, France, in 1847; and William Pengelly, Hugh Falconer and Joseph Prestwich in Brixham Cave in 1858. See Van Keuren 1984.

6. On the ideological component of evolutionary theory on display, see Bennett 1995; Van Keuren 1984; Coombes 1988.

7. It is interesting to compare the situation at the French Musée d'ethnographie, which opened in 1878, with the Pitt Rivers Museum in Oxford (1883) as well as Leiden (1937). E. T. Hamy, who became the first director of the Musée d'ethnographie at the Trocadéro, saw ethnographic objects as a form of evidence, a kind of document, to explain the past and present of both extinct and 'savage' peoples (Dias 1991: 99). The history of each object could be traced from its simplest to its most complex forms. Objects made sense as evidence of a stage in evolution rather than documenting a cultural type. Yet when it came to actually arranging the collections in the Palais du Trocadéro, Hamy opted for a geographical model, much as Siebold had proposed. Hamy further believed that unlike art objects, which do not require supplementary ornamentation, ethnographic objects made sense only within a system of classification and a specific framework. Hamy therefore installed panoplies and scenes of everyday life at the Trocadéro. These were partly decorative (as they were in the National Museum of Ethnology when it opened in Leiden in 1937) but also served to recontextualize objects and place them in meaningful combinations. Human needs were biologically determined and environmentally conditioned, according to Hamy (Dias 1991: 160). Cultural manifestations were reduced to what could be observed in the material world, so that a picturesque frame was

considered indispensable to ensuring that objects of secondary interest or with only ornamental value 'made sense'. For further accounts of the use of figures and panoplies in ethnographic museums, see Bouquet 1996 on the Oslo University Ethnographic Museum and Bouquet 2000a.

8. See, for example, the work by contemporary African artists included in the Sainsbury Gallery of the Department of Africa, Oceania and the Americas at the British Museum.

4: The Ethnography of Museums

1. Contemporary museum scholarship is characteristically multidisciplinary, with approaches from history, art history, history of science, media and cultural studies, sociology, science and organizational studies, as well as anthropology. These studies bring various perspectives on such matters as institutional history, collection formation, exhibition styles, conservation dilemmas, citizenship and 'the public', mediation and globalization, among the many issues characteristic of the museum as a cultural site. While opening up the possibility of conversations across established academic boundaries, evinced in a number of recent anthologies, these interdisciplinary developments also underline certain disciplinary specificities.

2. If the collection is already in the museum, then it will require tracking 'backwards', as the discussion of 'Melanesian Artefacts' in 1980s Lisbon indicated, to multiple places of origin.

3. The British Museum's Department of Ethnography was located at the Museum of Mankind in Burlington Gardens from 1970 to 1997, when it returned as the Department of Africa, Oceania and the Americas, opening to the public in several stages starting in 1999, at the heart of the newly refurbished British Museum.

4. As with collecting, some anthropologists have combined the roles of exhibition-maker and ethnographer; see, for example, Porto 1999; Wastiau 2000.

5. As with collecting and exhibition-making, it is also possible to conduct ethnography *as* a guide: Natasha Silva's (2005) account of guided tours at Artis Zoo is an example of this.

6. In his new role he was welcomed back to the Wahgi in 1990 as the kind of white person they had hoped they were getting first time around: not an indigent student but someone with resources to buy material culture. 'The main stresses were over controlling access to the resource that was us' (personal communication, Michael O'Hanlon).

7. Subsequent ethnographic research, such as Suzanne Küchler's work on the late-nineteenth-century collection of *malanggan* funerary sculptures from colonized populations of New Ireland by European collectors, interprets the sale of these sacrificial remains to collectors as opening up the road to the ancestors (Küchler

2002: 64). The tens of thousands of *malanggan* in museum collections bear witness to an active form of riddance on the part of local populations, resulting in an 'extraordinary theatre of memory that we have enshrined in our museums' (ibid.: 190) with these 'hollow remains of sacrifice' (ibid.: 8). *Malanggan* are among the ethnographica 'discovered' by the members of the Parisian artistic avant-garde in the early twentieth century, which, reclassified as 'primitive art' and later 'world art', began to find their way into museums of modern art and more recently into national museums, such as the Louvre, as 'masterpieces'.

8. See, for example, Hildelies Balk (2006) on Helene Kröller Müller, H. P. Bremmer, the collected artists (Vincent van Gogh, Bart van der Leck, John Rädecker, Floris Verster and Charley Toorop) and the paintings.

9. The introduction of entrance charges at museums can be seen as part of the new Tory emphasis on individual self-sufficiency and institutional accountability, in the context of a financial crisis and the 'funding gap'. Charging visitors to enter a public institution implied that museums now had to compete for their visitors' attention—and money—alongside other providers.

10. Macdonald makes an interesting comparison between museums and universities.

11. Situated work in this direction by anthropologists includes that of Jeanne Cannizzo (2001); Greg Hilty, David Reason and Anthony Shelton (1995); Boris Wastiau (2000); Nuno Porto (2000); and Mary Bouquet (1996).

12. For Palestinian visitors, the settler museum is a colonial instrument.

13. Although beyond the scope of this chapter, it is important to point out that Israeli master narratives of heritage have been countered by the creation of Palestinian heritage. This shows heritage being used as a resource for defining a 'just' future and as a metaphor to express grievances (Butler 2006: 475; De Cesari 2010).

5: Practices of Object Display

1. The notice above the glass case at the entrance reads:

Donations.

The British Museum has been free to the world since 1753. Please make a donation towards the future and enjoy your visit today. Thank you.

↓ £3, $5, €5 ↓

While entry to the British Museum's permanent exhibits is free, tickets for temporary exhibitions cost anything up to £12 for an adult. Membership costs £35

(by direct debit) per year ('Membership', British Museum website, http://www.britishmuseum.org/membership.aspx, accessed June 2011).

While currency has thus become a museum piece in a virtual world economy, real money displayed in this way indexes and symbolizes the transformation of economic value into cultural capital in the best tradition of the British Museum. As the website announces, 'The British Museum is free to all visitors. It is a Museum of the World, for the World.' Its scope is local, national and global:

> The British Museum's collection of seven million objects representing the rich history of human cultures mirrors the city of London's global variety. In no other museum can the visitor see so clearly the history of what it is to be human.
>
> The British Museum is a national museum for the whole of the UK, lending objects and sharing expertise across the country to make a reality of universal cultural entitlement.
>
> The British Museum's collection is worldwide in origin and is intended for use by the citizens of the world.
>
> The Museum collaborates on exhibitions, skills-sharing, and research with many international partners. These partnerships bring new insights into the collection, and help create new understandings of our changing world. ('Membership', British Museum website, http://www.britishmuseum.org/default.aspx, accessed June 2011)

2. Key texts in these debates include Karp and Lavine 1991; Bennett 1995; Macdonald and Fyfe 1996; Lidchi 1997; and Karp et al. 2006. As Lidchi explains, semiotic approaches draw on the work of Roland Barthes (e.g. *Writing Degree Zero*, 1967); discursive approaches are inspired by Michel Foucault (e.g. *The Order of Things*, 1970); practice-based approaches are based on Pierre Bourdieu (e.g. *Outline of a Theory of Practice*, 1977; *The Field of Cultural Production*, 1993). See also Duncan (1995) on the museum as a ritual site and Noordegraaf (2004) on museum presentations as 'scripts'.

3. This section is based on Gosden and Larson 2007. The Pitt Rivers Museum Relational Museum Project (October 2002–March 2006) digitized catalogue cards and archival sources, permitting statistical analyses of the collection. This afforded new understandings of its composition, as well as the chain of relationships extending out from the museum all over the world ('The Relational Museum', Pitt Rivers Museum website, http://www.prm.ox.ac.uk/Relational-Museum.html, accessed 9 April 2012). See also Coombes's (1994) and Lidchi's (1997) accounts of the Pitt Rivers Museum.

4. See Daniel Miller's (1987) abstraction of Hegel's concept of objectification in an attempt at resolving the subject-object dichotomy. He uses Hegel's idea concerning the public form of the progressive knowledge necessary for the process of objectification. Miller contends that the external public form of objectification need not arise through 'a language-based, potentially explicit and reflexive process of thought' (ibid.: 31). He continues that 'the creation of cultural form always acts as a transformation in the environment through which the society as subject becomes itself' (ibid.: 32).

5. Boas was involved in an early debate about museum classification practices at the American Museum. He challenged the practice of distributing Northwest Coast materials all over the museum, where they were integrated into exhibits about universal inventions such as fire-making, pottery-making, basketry, and so forth, with specimens grouped to show the 'putative evolution of a technological type' (Jacknis 1985: 78). Otis T. Mason (1838–1908) was head curator at the U.S. National Museum from 1884, where he introduced a classificatory system based on the development of inventions and drawing inspiration from natural history. While Mason defended his arrangement in terms of audiences—musicians, potters, soldiers, artists—who wanted to see juxtaposition, Boas proposed instead arranging sets of artefacts to represent ethnic groups, subsets to show tribal specificities (ibid.: 80).

6. Cf. Rebecca Parker Breinen's (2006: ch. 3) discussion of the seventeenth-century ethnographic portrait: she discusses Albert Eckhout's paintings of ethnic types in Brazil. She also suggests the influence of these portraits on subsequent representational modes: the eighteenth-century *casta* paintings, and nineteenth-century photographic portraits.

7. Compare with Gosden and Larson's discussion (2007: 41) on how Pitt Rivers, when presenting a Nigerian amulet at the Ethnological Society meeting, was not only presenting an object but also presenting himself as a man of far-flung and useful connections, who had in-depth knowledge of the material culture of the world.

8. At $200 per figure, the expense of the projected twenty-eight groups comprising some ninety-eight figures was pricey, and the process very slow (see Jacknis 1985: 97–98). Boas saw the purpose of museums as being first and foremost about entertainment, then instruction, and, lastly, research. He proposed to make a distinction between exhibits and study collections.

9. Typically, 'a family or several members of a tribe, dressed in their native costume and engaged in some characteristic work or art illustrative of their life and particular art or industry' (Jacknis 1985: 100).

10. Boas's resignation from the American Museum of Natural History in 1905 to take up an appointment at Columbia University partly reflects the limits of this

form of objectification, as well as his disillusion with these experiments at popularizing anthropology.

11. For example Haagse School, Barbizon and Pont Aven artists helped to make Dutch and Breton landscapes and their inhabitants famous, as well as visible.

12. Prior to the opening of Skansen, Hazelius's Scandinavian ethnographic collection had been on display at the Nordic Museum, Stockholm, where, since 1873, the public had been able to look into stage-like dioramas similar to those later developed in America.

13. It is remarkable that Dutch folk culture played this role in a society characterized for centuries by its predominantly urban character. Public displays of folk culture at exhibitions, in museum presentations, in performances and processions and on commemorative occasions were very popular in the Netherlands right up to the Second World War.

14. *Contact zone* is a term borrowed by Clifford from Mary Louise Pratt to conceptualize 'the space of colonial encounters, the space in which peoples geographically and historically separated come into contact with each other and establish ongoing relations, usually involving conditions of coercion, radical inequality, and intractable conflict' (Pratt 1992: 6–7, cited by Clifford 1997: 192). Clifford refined the notion as 'an attempt to invoke the spatial and temporal copresence of subjects previously separated by geographic and historical disjunctures, and whose trajectories now intersect' (1997: 192). He emphasizes copresence, interaction and interlocking understandings and practices, often within radically asymmetrical relations of power.

15. Art historian Gerard Brom described the reconstructed rooms at the Amsterdam Historical Exhibition as a 'real romantic illusion' (cited by De Jong 2001: 72). Cuypers was to develop this concept further at the Rijksmuseum, where he installed a mediaeval chapel, a Shipping Room and an Old Dutch Room.

16. First they went into storage. Then, in 1916, 200 life-size mannequins were shipped up the Rhine from Amsterdam to Arnhem. The folk collections and figures at the Rijksmuseum had fallen into such a state of disrepair that there had been complaints by villagers from Urk who felt ashamed by the dilapidated appearance of their costumes on public display in the national museum.

17. See Clifford's discussion of James Fenton's poem 'The Pitt Rivers Museum, Oxford', where, for example, 'descriptive labels seem to increase the wonder' (Fenton 1984: 81–84, cited by Clifford 1988: 216).

18. Lévi-Strauss, elaborating on his remarks about the American Museum of Natural History's Northwest Coast Gallery, continued, 'Surely it will not be long before we see the collections from this part of the world moved from ethnographic to fine arts museums to take their place amidst the antiquities of Egypt

or Persia and the works of medieval Europe' (1983: 3). His were prophetic words for the Louvre and the British Museum, which, respectively, included world masterpieces in the Pavillon des Sessions (Kerchache 2001) and reincorporated Africa, Oceania and the Americas (Sloan 2003: part V). See also Price 1989.

19. Picasso, Braque and Matisse were among the avant-garde artists who made such collections; collectors included Mr and Mrs Daniel Henry Kahnweiler, Paris, 1912–1913; and Mrs Pierre Loeb, Paris, 1929 (see Rubin 1984). Meecham and Sheldon argue, 'The received history of primitivism . . . was that it was a license for artists to throw off the shackles of European convention and to lose their Western inhibitions . . . Collapsing contemporary ideas of the "primitive" with notions of the "natural", the primitive came to be seen as a corollary to bohemia' (2000: 127–128). They cite Williams's observation that primitivism was a modernist strategy for breaking with the past (or side-stepping it altogether) based on the primitive as being 'innately creative, the unformed and untamed realm of the prerational and the unconscious' (R. Williams 1989: 58). See also Morphy 1998: 26.

20. The exploration of space by architects and designers took place across a range of forms, from chairs and lights, to exhibitions, to houses and public buildings. Rietveld's work, together with that of De Stijl, is emblematic of these developments. (See Dettingmeijer et al. 2010.)

21. The exhibition 'Lissitzky + De Overwinning van de Zon' at the Van Abbe Museum, Eindhoven, the Netherlands (2009–2010), reconstructed some of Lissitzky's Proun ('the interchange station between painting and architecture') designs for the first time (see Milner 2009: 16).

22. This section is largely based on Chapter 2 of Staniszewski's *The Power of Display* (1998): 'Aestheticised Installations for Modernism: Ethnographic Art and Objects of Everyday Life'. See also Leigh 2008.

23. He was clearly inspired by the Bauhaus, enthusing after his visit there in 1927 that this was 'a fabulous institution where all the modern visual arts—paintings, graphic arts, architecture, the crafts, typography, theatre, cinema, photography, industrial design for mass production—were all studied and taught together in a large modern building' (Staniszewski 1998: 74). With the rise of Nazism and Hitler's accession to power in 1933, many leading artists, architects and designers were forced to leave Europe for America. These included Alex Dorner, director of the Landesmuseum, Hannover. The atmosphere rooms were dismantled and modern artworks confiscated.

24. Barr's installations were sparse and isolated the individual artwork in a one-to-one relation with the viewer. Although there was a good deal of experimentation

during the 1930s and 1940s, the aestheticized, autonomous, apparently 'neutral' exhibition method that developed in the long term created an ideological apparatus for the reception of modernism in the United States (Staniszewski 1998). This kind of installation became standard in later-twentieth-century museum practice.

25. See, for example, Rassool on the District Six Museum in South Africa, in Karp et al. 2006.

26. *Culture* here refers to publicly valued and visible forms. Sansi argues that culture *is* by definition objectified—and that cultures are always a construction, transient and relative historical formations. When objectified, culture can be discussed, used and appropriated by social actors. Culture is seen as an ensemble of objects, spaces and people deemed to be bearers of a common and irredeemable collective essence.

27. Two examples of major museum buildings discussed by Jo Coenen (2010) are the Museu de Arte Moderna (MAM) Rio de Janeiro (Affonso Reidy, 1950s) and the Guggenheim, Bilbao (Frank Gehry, 1997). Blockbuster exhibits started, according to Kratz and Karp (2006: 12), in the 1970s with 'Treasures of Tutankhamun'. As for blockbuster renovations, in addition to the Louvre and the British Museum, the Rijksmuseum, Amsterdam, which closed its doors at the end of 2003 and is scheduled to reopen in 2013, provides an apt example (see Coenen 2010: 59–61).

28. Renowned examples of these various kinds of museum architecture include, in the category of entirely new, Daniel Libeskind's Jewish Museum, Berlin (opened 2001), and Frank Gehry's Guggenheim Bilbao (opened 1997); and, in the category of major renovation, Sir Norman Foster's recreation of the British Museum Great Court and David Chipperfield's extension to the Folkwang Museum, Essen (2010).

29. Coenen is interested in the way architects deal with (or reject) existing structures in exercising their profession: some opt for continuity (such as R. Moneo's carefully designed town hall for an historic square in Murcia); others completely reject the past (Super Dutch architects, such as MVRDV, fall into this category); dialogue with existing structures characterizes the work of yet others (Henning Larsen's Paleis van Justitie, Leeuwarden, or Sir Norman Foster's work for the Place de la Carré, Nimes). Agreeing or coinciding with surrounding buildings—the principle of congruence—inspires contemporary reconstructions of (partly) destroyed buildings using evocation rather than literal replication (Zeinstra's Oude Schans in Amsterdam); fusion is the somewhat chaotic mixing of styles, old and new, to produce a unique new creation (Villa Hadrianus, Rome; Piazza San Domenico Maggiore, Naples).

Museums may end up with several buildings dating from different periods and with several layers of exhibitions. For example the latest addition to the Natural History Museum complex in London's South Kensington (which began with the Victorian Waterhouse building) is the C. F. Møller Darwin Centre (2009).

30. Hirst installed a diamond-set skull, entitled *For the Love of God*, at the Rijksmuseum, 2009, together with his personal choice of Dutch seventeenth-century paintings. Cf. Peter Greenaway's *Nightwatching* at the Rijksmuseum, 2006.

31. Visible storage was introduced by the Museum of Anthropology when it opened its new building in 1976. Visible storage uses display cases and drawer units in a gallery setting where people can view different objects from the museum's collections. Through the display of a variety of objects of a similar type instead of just a few 'ideal' specimens, visitors are encouraged to compare for themselves the differences and similarities across different cultures. The Museum of Anthropology's visible storage now houses more than double its intended capacity due to the growth of the collections. Visible storage is criticized for appearing to store objects in warehouse conditions without adequate regard for conservation or cultural meaning.

Regarding visible storage, the museum's website states:

> Because it is a storage area with a high density of objects only minimal documentary information can be included. However, through endeavours such as this website, individual objects in Visible Storage can be highlighted in greater detail. ('Visible Storage', Museum of Anthropology website, http://www.moa. ubc.ca/Exhibitions/Online/Student/302/SA_Visible_Storage.html, accessed November 2010)

> The Museum's extensive open storage system is currently being completely redesigned and re-imagined as the 'Multiversity Galleries.' When these galleries are officially launched in early January 2010 as part of the Museum's $55.5 million Renewal Project, approximately 15,000 objects from the collections will be made visually accessible to the public. Arranged according to cultural origin and use, and informed by years of consultation with originating peoples, the objects in the Multiversity Galleries will invite individual and collective exploration of materials and technologies from societies all over the world. To add to the sense of discovery, many objects will be stored in cabinets with drawers that slide open to reveal their contents. Information on the objects will be found on computer terminals nearby. (Museum of Anthropology website, http://www. moa.ubc.ca/, accessed November 2010)

32. More generally, photographic images of museum objects now circulate beyond the walls of the museum by means of various media. Far from this decreasing the

object's aura, as Walter Benjamin thought, a transmedial reinforcement process appears to be taking place. Visible storage may be part of this more general interest in the museum as repository.

33. Renegotiation of the conditions of access and visibility to these objects in national institutions, together with the rise of the indigenous museum and cultural centre, has had an impact that reverberates throughout the museum world.

34. See the film *Restauration of Dali's Girl* (M. v.d. Lippe, 2010) on Boijmans Art Tube: http://arttube.boijmans.nl/en/video/salvador-dalis-girl-skipping-rope/ (accessed June 2011).

35. There are similar cases elsewhere. For three months in 2009, restorers and conservators at the Kroller Muller Museum worked on researching and conserving some 150 artworks—mainly sculptures—as part of an exhibit on restoration work and its dilemmas. Being made party to the issues—'to clean or not to clean' was the title—positions the audience very differently in relation to decisions made about artworks. See '"To clean or not to clean"—schoonmaken van kunstwerken op zaal', Kroller Muller Museum, Otterloo, 10 March–10 May 2009: http://www.kmm.nl/research-project-archive/2 (accessed 9 April 2012).

36. The Rijksmuseum renovation (by the architects Cruz y Ortiz), and the public debate it generated, is discussed in some detail by Coenen (2010).

37. 'Science at the Darwin Centre', Natural History Museum: http://www.nhm.ac.uk/visit-us/darwin-centre-visitors/science-darwin-centre-visitors/index.html (accessed 9 April 2012).

38. This human aspect is reinforced by the museum's Oral History Programme, which involves museum employees talking about what it is like to work at the museum.

39. Clifford compares the situation with that encountered by O'Hanlon in making a collection from the Wahgi for the British Museum, also in the 1980s; see Chapter 4.

40. We speak of a Van Gogh or a Warhol as if the artists are somehow in the artworks. Compare with Gell's (1998: 21) work on distributed personhood—social agency attributed to things.

41. See Morphy 2007, Driessens 2003 and Aird 2003 on historical photographs and archives in Australia. Gil Cardinal's film *Totem: Return and Renewal* (2007), on the return of the G'psgolox Pole from Sweden to the Northwest Coast, emphasizes the cutting and removing of the steel yoke and wires which held the pole up on display in the Swedish National Ethnographic Museum. The pole was shipped back to Vancouver from Stockholm, making a short stopover at the Museum of Anthropology in the interests of allowing its story to be told with full public ceremony. See also Chapter 6 on repatriation issues.

42. Film footage of the encounter between Ephraim Bani and his wife and the Haddon collection in the Cambridge stores (1995) can be seen in the film *Cracks in the Mask* (Frances Calvert, 1997). See Herle 2003.

43. 'African Worlds', described by Anthony Shelton as an 'idea-driven but object centred' exhibition at the Horniman Museum, was an attempt to bring in local black communities in South London to counter the inevitable objectification inherent to the deliberate modernism of the installation. Using the criteria of use, manufacture and meaning that have dominated ethnographic displays for much of the twentieth century, contemporary African voices breathed new life into the objects, thus challenging stereotypes about Africa (Shelton 2003: 189): they were added to the case labels, inventory labels and thematic text in the booklet. See the description of 'African Worlds' on the museum's website (http://www.horniman.ac.uk/index.php).

6: Object and Image Repatriation

1. See Moira Simpson's account (1996). Legislation such as the Archaeological and Aboriginal Relics Preservation Act, passed in Australia in 1972, sparked debate about research and possible repatriation of Aboriginal skeletal remains. The Aboriginal Arts Board, formed in 1973, argued in this context for the construction of keeping places, staff training and consultation (Simpson 1996). These initiatives on human remains were part of a wider discussion about the place and value of Aboriginal culture in dominant white Australian culture (see, for example, M. Anderson and Reeves 1994; Morphy 1998: ch. 9, 'Settler Australia').

 The New Zealand *Ngai Tahu Whanui*—tribal authority policy on human remains and heritage issues—aimed to reinvest authority and control over heritage issues and human remains with the tribe itself. It was recognized that the continuation of scholarly work could benefit the tribe by enhancing knowledge of the ancestors, if conducted with sensitivity and accountability. It called for the designation of museum space for collection management, and research reflected the transfer of authority over these activities in certain museums (Simpson 1996). Maori pride in their collections overseas is evident from the travelling exhibition 'Te Maori', which was put together in consultation with tribal elders in the late 1970s and visited a series of museums across the United States in 1984 (see Newton 1994).

 Pressure for change in US law had a profound effect on American museum practice; it also created a new sympathy among professionals that included openness to change. The passage of the Native American Graves Protection and Repatriation Act (1990), or NAGPRA, placed ownership and control over

human remains with the Native American population (Simpson 1996: 228). This legislation also required all federally funded museums to inventory skeletal remains and associated grave goods within five years. During the 1980s, the Smithsonian programme had documented skeletal remains of forty-five individuals at the Army Medical Museum and had contacted 225 tribes, although with little response. The National Museum of the American Indian, established in 1989 on the Washington Mall, was devoted to the history of Native Americans, including the human remains from the Smithsonian Institution. Native American remains had been collected during the nineteenth century from battlefields and grave sites by US army medical personnel. The repatriation of this material to appropriate tribal authorities was a priority for the National Museum of the American Indian. In 1992, twenty-nine Indian skeletons from 1890s battlefields were returned to the Sisseron Dakota Sioux upon formal request (Simpson 1996). Sacred objects and cultural goods were also inventoried under the terms of NAGPRA, establishing that only 2 per cent of museum collections fell under the terms of the law.

2. The Scotland Museum and Art Gallery was the first to respond positively to *Ngai Tahu*, allowing the return of Maori skeletal material for reburial. In July 2006, Aberdeen University's Marishal Museum announced that it would be repatriating some of its Maori collection—not as objects but as ancestors. The nine tattooed heads of Maori tribesmen will be returned to New Zealand, having been reclassified as human remains (BBC World News 2006).

3. See, for example, the *NRC Handelsblad* (2009) and BBC World News (2009).

4. No formal request for repatriation of the Yuquot Whalers' shrine has ever been made (Peter Whiteley, curator of North American ethnology in the Division of Anthropology at the American Museum of Natural History, personal communication).

5. See, for example, Abrams 1994 on the eleven Iroquois Wampum belts from Canada repatriated by the Museum of the American Indian; negotiations began in 1977, and the belts were repatriated at Onondaga longhouse on the Six Nations Reserve, Ontario, Canada, in 1988. A further three belts were returned to the Six Nations Reserve by the Canadian government in 1991. Abrams notes that the Canadian government was 'cooperative' in repatriation questions since they were also dealing with these issues in their own museums. Notably, the potlatch confiscation by the Canadian government and subsequent repatriation to Northwest Coast tribes made the Canadians sensitive to relations with the Six Nations Iroquois (Abrams 1994: 378). See Eyo 1994, in the same volume, on the repatriation of African cultural heritage. For Australian Aboriginal keeping

places in relation to government policy on repatriation of Aboriginal material from overseas, see Simpson 1996: 120 ff.

6. See the discussion by Aldona Jonaitis (with Richard Inglis) of Franz Boas's 'salvage ethnography':

> Boas and Drucker, adherents of the paradigm of salvage ethnography, attempt to portray cultures as they existed prior to contact, even though the Mowachaht had experienced over a century of acculturation. (Jonaitis 1999: 47)

> Little mention is made that Yuquot had experienced a century of interactions with non-Natives and that the Mowachaht were actively engaged in international trade. Boas and Hunt may have wished, or even believed, that they had found a culture untouched by interaction with the larger world, but this was simply not the case. Although motivated by an ethnographic salvaging informed by the disappearance of numerous cultural elements, in their quest for a unique ethnographic artefact of great value both of them chose to ignore some realities of Mowachaht history. (ibid.: 71)

7. See the Pitt Rivers Museum website's page on its totem pole: 'The Haida Totem Pole', http://www.prm.ox.ac.uk/totem.html (accessed 9 April 2012).

8. Ruth B. Phillips has made an eloquent case for this combination of old and new collection research techniques (2005). The 1992 Canadian Task Force Report on Museums and First Nations produced guidelines for the return of human remains, illegally obtained objects, sacred objects and objects of cultural patrimony—all of which required conventional research to be able to demonstrate the claims being made.

9. The Reciprocal Research Network of the Museum of Anthropology, University of British Columbia, is exemplary of the collaborative approach to research. See 'Overview' on the museum's site: http://www.moa.ubc.ca/RRN/about_over view.html (accessed 9 April 2012).

10. There is also a kinship connection. Boas is principally known for his ethnography of the Kwakwaka'wakw people, in which he was assisted by George Hunt. Dan Cranmer sponsored the 1921 potlatch as part of his marriage settlement. Cranmer would later become Boas's assistant after Hunt's death in 1933. Cranmer's second wife was a granddaughter of Hunt.

11. Cranmer 'gave away $10,000 worth of goods including canoes, gas boats, pool tables, bedsteads, bureaux, oak trunks, gas lights, gramophones, violins, guitars, washtubs, sewing machines, clothing, blankets, sacks of flour and cash' (Simpson 1996: 154). The ceremonial potlatch regalia included copper shields, dancing

masks and costumes, headdresses, rattles, whistles, headdresses, and boxes. See also Jacknis 1996; Saunders 1997.

12. Some of the best pieces were sold to George Heye for his Museum of the American Indian in New York; other pieces found their way to other museums, including the British Museum (Jacknis 1996). Nine pieces were returned by the National Museum of the American Indian in 1984.

13. See the documentary film *Totem. The Return of the G'psgolox Pole* (Gil Cardinal, 2003). For an account of the return of the G'psgolox Pole to the Haisla people, see Jacobson n.d.

14. Leif Pagrotsky, minister for education, research and culture, said in a speech at the totem pole ceremony held at the Museum of Ethnography in Stockholm on 14 March 2006:

> I would like to take this opportunity to describe how the totem pole came to be here in Stockholm. Cultures beyond our own borders have long fired our imagination and awoken our curiosity. Back in the 1920s, eager to learn more about the world and other cultures, Sweden was particularly interested in getting hold of an Indian totem pole. Olof Hanson, the Swedish consul of the day in Prince Rupert, is said to have negotiated the purchase of the Kitlope pole from the Haisla Nation. (http://www.turtleisland.org, accessed 2008)

15. The benefits of the long process of retrieving the G'psgolox Pole were explicitly expressed by Chief Amos, who remarked on the way it promoted understanding of and relationships with many different people in both Canada and Sweden: 'The pole is part of an ongoing journey which connects First Nations peoples with their past while building hope and relationships for the future' (cited by Cherry 2006).

16. A framed print of one of George Hunt's 1904 photographs of the shrine was presented by the American Museum of Natural History to Mowachaht representatives in New York in 1990. This public, ceremonial use of an historical photograph as a way of formalizing the new relationship between the institution and the source community is one instance of 'visual repatriation', where the emphasis is on the return of shared knowledge (cf. Jonaitis 1999). The agency of local photographers is a very clear part of the increasingly acknowledged forms of local agency. Hunt was very keen to acquire a camera for use in his research with Franz Boas (Jacknis 1992). Hunt's photography was part of his long-term project of recording Kwakiutl culture: 'Acutely aware of the changes he was witnessing, he was engaged in a kind of remembrance of things past' (ibid.: 150).

17. What happened was that, upon their re-encounter with the collection, as part of the museum's consultation process, elders began to tell stories and sing songs,

the objects triggering memories of an ongoing struggle—a kind of 'uneven reciprocity' (Clifford 1999: 439), in which the museum was called to its responsibilities. In effectively appropriating the occasion for their own purposes, the elders showed that the objects could never be entirely possessed by the museum: '[t]hey were sites of a historical negotiation, occasion for an ongoing contact' (ibid.).

18. On their return from Berlin, elders were honoured in various ways. 'Togiak threw a village-wide potluck dinner for Annie Blue . . . after which she showed the pictures she had taken with her pocket camera and described her experiences'. She was later awarded the Alaska Federation of Natives' Elder of the Year Award (Fienup-Riordan 2003: 39).

19. Compare with Alison Dundon's (2007) account of Gogodala longhouse revival. Although a very different case, it is instructive to see what happened when, in 1972, the anthropologist Anthony Crawford brought more than 100 photographs 'of Gogodala objects captured by adventurers and administrators some 50 or 60 years before' (Dundon 2007: 153). Crawford's aim was to stimulate the production of elaborately designed and carved artworks as part of a 'cultural revival': Crawford tried to convince people that their Christian present could be reconciled with their past, more particularly the period before expatriate missionaries and early Gogodala Christians transformed living arrangements and traditional practices associated with them in the 1950s. While Crawford's return of photographs does not correspond with visual repatriation in contemporary senses of the term, the photographs seem to have provoked similar discussions to those analysed in detail by Bell.

20. There is an extensive literature on Melanesian ideas about 'skin' as a metaphor for social relations; see, for example, Küchler 2002 on *malanggan* as containers for the social relations of a deceased person. Since the person is thought to be composed of their many kin and affinal obligations, these need to be 'contained' after the person's death and stopped by means of concluding transactions among those groups. Malanggan funerary carvings are 'skins' in this respect. Photographs can be seen as 'containing' social relations in a similar fashion.

21. 'Luo Visual History', Pitt Rivers Museum: http://photos.prm.ox.ac.uk/luo/page/home/ (accessed 9 April 2012).

22. See 'Virtual Collections', Pitt Rivers Museum: http://www.prm.ox.ac.uk/vcollections.html (accessed 9 April 2012).

23. See the Paro Manene project link on the 'Luo Visual History' page of the Pitt Rivers Museum website (http://photos.prm.ox.ac.uk/luo/page/exhibition/,

accessed 9 April 2012). Morton and Oteyo's article can be accessed here: http://photos.prm.ox.ac.uk/luo/page/exhibition-paro-manene-project/ (accessed 9 April 2012).

24. Kratz's (2002) account makes it clear that her photographs were viewed and commented on in album form beforehand, with these comments incorporated into the exhibit.

Afterword: Teylers Revisited

1. See 'Ovale Zaal heropend', Teylers Museum website: http://www.teylersmuseum.eu/index.php?item=119&page=47&lang=nl (accessed August 2011; translation mine).
2. Ibid.
3. Cf. Noordegraaf 2004: 10. Reinstallation of the renovated central piece of furniture in the Oval Room is visible on a YouTube film uploaded by Teylers; the original surface can clearly be seen before the glass cases are put back and filled with specimens: http://www.youtube.com/watch?v=msY9A4wwwXY (accessed May 2011).
4. The speech by Mrs Androulla Vassiliou of the European Commission for Culture made reference to both the Enlightenment and Teylers Museum's nomination for the UNESCO World Heritage List. The speech is reproduced, under the subheading 'Speech Androulla Vassiliou', as part of the article 'Ovale Zaal heropend' (see note 1).
5. See, for example, the Dutch policy document on integration, 2011 (Beleidsnota | 16-06-2011 | BZK Integratienota Integratie, Binding, Burgerschap: http://www.rijksoverheid.nl/documenten-en-publicaties/kamerstukken/2010/12/06/uitgangspunten-cultuurbeleid.html). Accessed July 2011.
6. On the other hand, YouTube films of the restoration of the Oval Room make visible the process of reassembling (but not dismantling) the central showcase of the Oval Room—the wood of which has *not* been cleaned: http://www.youtube.com/watch?v=msY9A4wwwXY (accessed May 2011).

BIBLIOGRAPHY

Abrams, G.H.J. (1994), 'The Case for Wampum: Repatriation from the Museum of the American Indian to the Six Nations Confederacy, Brantford, Ontario, Canada', in F.E.S. Kaplan (ed), *Museums and the Making of 'Ourselves'. The Role of Objects in National Identity*, London: Leicester University Press, pp. 351–384.

Abungu, G. (2004), 'The Declaration: A Contested Issue', *ICOM News*, 1, p. 5.

Aird, M. (2003), 'Growing Up with Aborigines', in C. Pinney and N. Peterson (eds), *Photography's Other Histories*, Durham, NC: Duke University Press, pp. 23–39.

Alpers, S. (1991), 'The Museum as a Way of Seeing', in I. Karp and S. D. Lavine (eds), *Exhibiting Cultures. The Poetics and Politics of Museum Display*, Washington, DC: Smithsonian Institution Press, pp. 25–32.

Ames, M. (1992), *Cannibal Tours and Glass Boxes*, Vancouver: University of British Columbia Press.

Anderson, B. (1983), *Imagined Communities. Reflections on the Origin and Spread of Nationalism*, London and New York: Verso.

Anderson, M. and Reeves, A. (1994), 'Contested Identities: Museums and the Nation in Australia', in F.E.S. Kaplan (ed), *Museums and the Making of 'Ourselves'. The Role of Objects in National Identity*, London: Leicester University Press, pp. 79–124.

Appadurai, A. (ed) (1986), *The Social Life of Things. Commodities in Cultural Perspective*, Cambridge: CUP.

Audenaerde, D.F.E.T. Van den (1994), *Koninklijk Museum voor Midden-Afrika, Tervuren*, Brussels: Musea Nostra (Gemeentekrediet).

Avé, J. B. (1980), 'Ethnographical Museums in a Changing World', in W. R. van Gulik, H. S. Van Straaten and G. D. van der Wengen (eds), *From Field-case to Show-case. Research, Acquisition and Presentation in the Rijksmuseum voor Volkenkunde (National Museum of Ethnology), Leiden*, Amsterdam: J. C. Gieben, pp. 11–28.

Balk, H. (2006), 'A Finger in Every Pie: H.P. Bremmer and His Influence on the Dutch Art World in the First Half of the Twentieth Century', *Simiolus. Netherlands Quarterly for the History of Art*, 32 (2/3), pp. 182–217.

Banks, M. (2001), *Visual Methods in Social Research*, London: Sage.

Banks, M. (2007), *Using Visual Data in Qualitative Research*, Los Angeles: Sage.

Banks, M. and Morphy, H. (eds) (1997), *Rethinking Visual Anthropology*, New Haven, CT: Yale University Press.

Barthes, R. (1967), *Writing Degree Zero*, London: Jonathan Cape.

Basu, P. (2007), 'The Labyrinthine Aesthetic in Museum Design', in S. Macdonald and P. Basu (eds), *Exhibition Experiments*, London: Blackwell, pp. 47–70.

Bazin, G. (1967), *The Museum Age*, tr. J. van Nuis Cahill, New York: Universe Books.

BBC World News (2006), 'Maori Artefacts Will Be Returned', 6 July, http://news.bbc.co.uk/2/hi/uk_news/scotland/5189490.stm.

BBC World News (2009), 'Dutch Return Head of Ghana King', 23 July, http://news.bbc.co.uk/2/hi/africa/8165497.stm.

Bell, J. A. (2003), 'Looking to See. Reflections on Visual Repatriation in the Purari Delta, Gulf Province, Papua New Guinea', in L. Peers and A. K. Brown (eds), *Museums and Source Communities: A Routledge Reader*, London: Routledge, pp. 111–122.

Bennett, T. (1995), *The Birth of the Museum. History, Theory, Politics*, London and New York: Routledge.

Bennett, T. (2006), 'Exhibition, Difference, and the Logic of Culture', in I. Karp, C. Kratz, L. Szwaja and T. Ybarra-Frausto (eds), *Museum Frictions. Public Culture/Global Transformations*, Durham, NC: Duke University Press, pp. 46–69.

Bergvelt, E. (1998), *Pantheon der Gouden Eeuw. Van Nationale Konst-Gallerij tot Rijksmuseum van Schilderijen (1798–1896)*, Zwolle: Waanders Uitgevers.

Berkel, K. van (2005), 'Institutionele verzamelingen in de tijd van de wetenschappelijke revolutie (1600–1750)', in E. Bergvelt, D. J. Meijers and M. Rijnders (eds), *Kabinetten, galerijen en musea. Het verzamelen en presenteren van naturalia en kunst van 1500 tot heden*, Zwolle: Waanders; Heerlen: Open Universiteit Nederland, pp. 129–152.

Bertz, I. (2008), 'Lovis Corinth: "Bildnis Walther Silberstein" [. . .] dieses "Juden"-Portrait aus Darmstadt', in I. Bertz and M. Dormann (eds), *Raub und Restitution. Kulturgut aus jüdischem Besitz von 1933 bis heute*, Berlin: Stiftung Jüdisches Museum Berlin/Jüdisches Museum Frankfurt-am-Main/Wallstein, pp. 266–272.

Bikvanderpol (2006), *NG-1991-4-25 Fly Me to the Moon*, New York: Sternberg.

Bjerregaard, P. (2009), *Inside the Museum Machine. Mind and Agency in Contemporary Ethnographic Exhibitions*, PhD diss., University of Aarhus.

Bloembergen, M. (2002), *De Koloniale Vertoning: Nederland en Indië op de Wereldtentoonstellingen (1880–1931)*, Amsterdam: Wereldbibliotheek.

Boswell, D. and Evans, J. (eds) (2004), *Representing the Nation: A Reader*, London and New York: Routledge.

Bouquet, M. (1996), *Sans og Samling . . . hos Universitetets Etnografiske Museum/Bringing It All Back Home . . . to the Oslo University Ethnographic Museum*, Oslo: Scandinavian University Press.

Bouquet, M. (2000a), 'Figures of Relations: Reconnecting Kinship Studies and Museum Collections', in J. Carsten (ed), *Cultures of Relatedness. New Approaches to the Study of Kinship*, Cambridge: CUP, pp. 167–190.

Bouquet, M. (2000b), 'Thinking and Doing Otherwise: Anthropological Theory in Exhibitionary Practice', *Ethnos*, 65 (2), pp. 217–236.

Bouquet, M. (ed) (2001), *Academic Anthropology and the Museum. Back to the Future*, Oxford and New York: Berghahn Books.

Bouquet, M. (2005), 'Het negentiende-eeuwse openbare etnografische museum,' in E. Bergvelt, D. J. Meijers and M. Ijnders (eds), *Kabinetten, galerijen en Musea. Het verzamelen en presenteren van naturalia en Kunst van 1500 tot heden*, Open Universiteit Nederland, Zwolle: Waanders Uitgevers, pp. 203–223.

Bouquet, M. (2008), 'The Dropping,' in N. Zonnenberg (ed), *Drop Sculpture (Atlas)*, Amsterdam: Rijksmuseum Publishing, pp. 3–6.

Bouquet, M. and Freitas Branco, J. (1988), *Melanesian Artefacts/Postmodernist Reflections*, Lisbon: IICT/Museu de Etnologia.

Bouquet, M. and Porto, N. (eds) (2005), *Science, Magic and Religion. The Ritual Processes of Museum Magic*, Oxford and New York: Berghahn Books.

Bourdieu, P. (1977), *Outline of a Theory of Practice*, Cambridge: CUP.

Bourdieu, P. (1993), *The Field of Cultural Production. Essays on Art and Literature*, Cambridge: Polity.

Bourgeois, P. (2003), *In Search of Respect. Selling Crack in El Barrio*, Cambridge: CUP.

Brakel, K. van, Scalliet, M.-O., Duuren, D. van and ten Kate, J. (eds) (1998), *Indië Omlijst. Vier eeuwen schilderkunst in Nederlands-Indië*, Amsterdam: KIT Press.

Buchli, V. (ed) (2002), *The Material Culture Reader*, Oxford and New York: Berg.

Butler, B. (2006), 'Heritage and the Present Past', in C. Tilley, W. Keane, S. Küchler, M. Rowlands and S. Spyer (eds), *Handbook of Material Culture*, London: Sage, pp. 463–479.

Cannizzo, J. (2001), 'Inside Out. Cultural Production in the Museum and the Academy', in M. Bouquet (ed), *Academic Anthropology and the Museum. Back to the Future*, Oxford and New York: Berghahn Books, pp. 162–176.

Chapman, W. (1985), 'Arranging Ethnology: A.H.L.F. Pitt Rivers and the Typological Tradition', in G. W. Stocking (ed), *Objects and Others: Essays on Museums and Material Culture*, Madison: University of Wisconsin Press, pp. 15–48.

Cherry, K. (2006), 'G'psgolox Pole Comes Home', *Northword* (summer), http://www.ecotrust.org/nativeprograms/gpsgolox_totem_pole.html.

Clavir, M. (2002), *Preserving What Is Valued. Museums, Conservation, and First Nations*, Vancouver: University of British Columbia Press.

Clifford, J. (1988), *The Predicament of Culture. Twentieth-century Ethnography, Literature, and Art*, Cambridge, Mass.: Harvard University Press.

Clifford, J. (1991), 'Four Northwest Coast Museums: Travel Reflections', in I. Karp and S. D. Lavine (eds), *Exhibiting Cultures. The Poetics and Politics of Museum Display*, Washington, DC: Smithsonian Institution Press, pp. 212–254.

Clifford, J. (1995), 'Paradise', *Visual Anthropology Review*, 11 (1), pp. 92–117.

Clifford, J. (1997), *Routes: Travel and Translation in the Late Twentieth Century*, Cambridge, Mass.: Harvard University Press.

Clifford, J. (1999), 'Museums as Contact Zones', in D. Boswell and J. Evans (eds), *Representing the Nation: A Reader. Histories, Heritage and Museums*, London and New York: Routledge, pp. 435–457.

Clifford, J. and Marcus, G. (eds) (1986), *Writing Culture. The Poetics and Politics of Ethnography*, Berkeley: University of California Press.

Coenen, J. (2010), *Noties*, Nijmegen: SUN.

Conlin, J. (2006), 'Art for the People', *History Today*, 56 (11), pp. 29–36.

Connolly, B. and Anderson, R. (1987), *First Contact. New Guinea's Highlanders Encounter the Outside World*, New York: Viking Penguin.

Coombes, A. (1988), 'Museums and the Formation of National and Cultural Identities', *Oxford Art Journal*, 11 (2), pp. 57–68.

Coombes, A. (1994), *Reinventing Africa: Museums, Material Culture and Popular Imagination in Late Victorian and Edwardian England*, London: Yale University Press.

Coombes, A. (1996), 'Ethnography, Popular Culture, and Institutional Power: Narratives of Benin Culture in the British Museum', in G. Wright (ed), *The Formation of National Collections of Art and Archaeology*, Washington, DC: Distributed by Yale University Press for the National Gallery of Art, pp. 143–157.

Crane, S. A. (ed) (2000), *Museums and Memory*, Stanford, CA: Stanford University Press.

Dam-Mikkelsen, B. and Lundbæk, T. (1980), *Etnografiske genstande i det kongelijke danske Kunstkamer/Ethnographic Objects in the Royal Danish Kunstkamer, 1600–1800*, Copenhagen: Nationalmuseet.

Dawson, A. (2003), 'Collectors and Commemoration: Portrait Sculpture and Paintings in the British Museum', in K. Sloan (ed), *Enlightenment: Discovering the World in the Eighteenth Century*, Washington, DC: Smithsonian Institution/British Museum, pp. 26–37.

De Cesari, C. (2010), 'Creative Heritage: Palestinian Heritage NGOs and Defiant Arts of Government', *American Anthropologist*, 112 (4), pp. 625–637.

Dettingmeijer, R., Thoor, M.-T. and Van Zijl, I. (eds) (2010), *Rietveld's Universe*, Rotterdam: NAi Publishers.

Dias, N. (1991), *Le musée ethnographique du Trocadéro, (1878–1908), Anthropologie et Muséologie en France*, Paris: Éditions du CNRS.

Dis, A. van (2007), *De Wandelaar*, Amsterdam: Uitgeverij Augustus.

Douglas, M. and Isherwood, B. (1978), *The World of Goods. Towards an Anthropology of Consumption*, London: Allen Lane.

Driessens, J.-A. (2003), 'Relating to Photographs', in C. Pinney and N. Peterson (eds), *Photography's Other Histories*, Durham, NC: Duke University Press, pp. 17–22.

Duncan, C. (1995), *Civilizing Rituals. Inside Public Art Museums*, London and New York: Routledge.

Duncan, C. and Wallach, A. (2004) [1980], 'The Universal Survey Museum', in B. M. Carbonell (ed), *Museum Studies. An Anthology of Contexts*, Oxford: Blackwell, pp. 51–70.

Dundon, A. (2007), 'Moving the Centre: Christianity, the Longhouse and the Gogodala Cultural Centre', in N. Stanley (ed), *The Future of Indigenous Museums. Perspectives from the Southwest Pacific*, Oxford and New York: Berghahn Books, pp. 151–169.

Duuren, D. van (1990), *125 Jaar Verzamelen. Tropenmuseum, Koninklijk Institute voor de Tropen*, Amsterdam: Tropenmuseum.

Duuren, D. van, Kate, M. ten, Pereira, M., Vink, S. and Legêne, S. (2007), 'Physical Anthropology Reconsidered. Human Remains at the Tropenmuseum', special issue, *Bulletin of the Royal Tropical Institute*, 375.

Edwards, E. (2001), *Raw Histories: Photographs, Anthropology and Museums*, Oxford and New York: Berg.

Edwards, E. (2003), 'Introduction to Talking Visual Histories', in L. Peers and A. K. Brown (eds), *Museums and Source Communities: A Routledge Reader*, London: Routledge, pp. 83–99.

Edwards, E. and Hart, J. (eds) (2004), *Photographs Objects Histories. On the Materiality of Images*, London and New York: Routledge.

Edwards, E., Gosden, C. and Phillips, R. B. (2006), 'Introduction', in E. Edwards, C. Gosden and R. B. Phillips (eds), *Sensible Objects. Colonialism, Museums, and Material Culture*, Oxford and New York: Berg, pp. 1–31.

Edwards, E. (ed) (1992), *Anthropology and Photography, 1860–1920*, New Haven, CT: Yale University Press.

Effert, R. (2003), *Volkenkundig Verzamelen: Het Koninklijk Kabinet van Zeldzaamheden en het Rijks Ethnographisch Museum, 1816–1883*, PhD diss., University of Leiden.

El-Haj, N. (1998), 'Translating Truths: Nationalism, the Practice of Archaeology, and the Remaking of Past and Present in Contemporary Jerusalem', *American Ethnologist*, 25 (2), pp. 166–188.

Elsner, J. (1994), 'The House and Museum of Sir John Soane', in J. Elsner and R. Cardinal (eds), *The Cultures of Collecting*, London: Reaktion Books, pp. 155–176.

Elsner, J. and Cardinal, R. (eds) (1994), *The Cultures of Collecting*, London: Reaktion.

Elzinga, G. (n.d.), 'Het Hindeloopen van Hendrik Lap', http://www.hindeloopen.com/hendriklap.html.

Eyo, E. (1994), 'Repatriation of Cultural Heritage: The African Experience', in F.E.S. Kaplan (ed), *Museums and the Making of 'Ourselves'. The Role of Objects in National Identity*, London: Leicester University Press, pp. 330–350.

Fabian, J. (1983), *Time and the Other. How Anthropology Makes Its Object*, New York: Columbia University Press.

Feldman, J. D. (2006), 'Museums and the Lost Body Problem', in E. Edwards, C. Gosden and R. B. Phillips (eds) (2006), *Sensible Objects. Colonialism, Museums, and Material Culture*, Oxford and New York: Berg, pp. 245–269.

Fenton, J. (1984), *Children in Exile: Poems 1968–1984*, New York: Random House.

Fienup-Riordan, A. (2003), 'Yup'ik Elders in Museums. Fieldwork Turned upon Its Head', in L. Peers and A. K. Brown (eds), *Museums and Source Communities: A Routledge Reader*, London: Routledge, pp. 28–41.

Foucault, M. (1970) [1966], *The Order of Things*, London: Tavistock.

Franits, W. (2004), *Dutch Seventeenth-century Genre Painting: Its Stylistic and Thematic Evolution*, New Haven, CT: Yale University Press.

Fraser, A. (2006), '"Isn't This a Wonderful Place?" (A Tour of a Tour of the Guggenheim Bilbao)', in I. Karp, C. Kratz, L. Szwaja and T. Ybarra-Frausto (eds), *Museum Frictions. Public Culture/Global Transformations*, Durham, NC: Duke University Press, pp. 135–160.

Gell, A. (1992), 'The Technology of Enchantment and the Enchantment of Technology', in J. Coote and A. Shelton (eds), *Anthropology, Art and Aesthetics*, Oxford: Clarendon, pp. 40–63.

Gell, A. (1998), *Art and Agency. An Anthropological Theory*, Oxford: Oxford University Press.

Gewald, J.-B. (2001), 'El Negro, El Niño, Witchcraft and the Absence of Rain in Botswana', *African Affairs*, 100, pp. 555–580.

Glass, A. (2006), 'On the Circulation of Ethnographic Knowledge', *Material World Blog*, 22 October, http://blogs.nyu.edu/projects/materialworld/2006/10/on_the_circulation_of_ethnogra.html.

Goldwater, R. (1986) [1938], *Primitivism in Modern Art*, Cambridge, Mass., and London: Belknap Press.

Gombrich, E. H. (1989) [1950], *The Story of Art*, London: Phaidon.

Gosden, C. and Knowles, C. (2001), *Collecting Colonialism. Material Culture and Colonial Change*, Oxford: Berg.

Gosden, C. and Larson, F. (2007), *Knowing Things: Exploring the Collections at the Pitt Rivers Museum, 1884–1945*, Oxford: OUP.

Gould, S. J. and Purcell, R. W. (1992), *Finders, Keepers. Eight Collectors*, New York and London: W. W. Norton.

Grasskamp, W. (1994), '"Degenerate Art" and Documenta I: Modernism Ostracized and Disarmed', in D. J. Sherman and I. Roghoff (eds), *Museum Culture. Histories, Discourses, Spectacles*, London: Routledge, pp. 163–194.

Greenaway, P. (2006), *Nightwatching. A View of Rembrandt's The Night Watch*, Rotterdam: Veenman.

Grimshaw, A. (2001), *The Ethnographer's Eye. Ways of Seeing in Modern Anthropology*, Cambridge: CUP.

Hall, M. (2006), 'The Reappearance of the Authentic', in I. Karp, C. Kratz, L. Szwaja and T. Ybarra-Frausto (eds), *Museum Frictions. Public Culture/Global Transformations*, Durham, NC: Duke University Press, pp. 70–101.

Hall, S. (2008) [1999], 'Whose Heritage? Un-settling 'The Heritage', Re-imagining the Post-nation', in G. Fairclough, R. Harrison, J. H. Jameson Jr and J. Schofield (eds), *The Heritage Reader*, London: Routledge, pp. 219–228.

Ham, G. van der (2000), *200 jaar Rijksmuseum*, Zwolle: Uitgeverij Waanders; Amsterdam: Rijksmuseum.

Handler, R. and Gable, E. (1997), *The New History in an Old Museum. Creating the Past at Colonial Williamsburg*, Durham, NC: Duke University Press.

Harvey, P. (1996), *Hybrids of Modernity. Anthropology, the Nation State and the Universal Exhibition*, London and New York: Routledge.

Henare, A., Holbraad, M. and Wastell, S. (eds) (2007), *Thinking through Things. Theorising Artefacts Ethnographically*, London: Routledge.

Henning, M. (2006), *Museums, Media and Cultural Theory*, Maidenhead: OUP.

Herle, A. (1998), 'The Life-histories of Objects: Collections of the Cambridge Anthropological Expedition to the Torres Strait', in A. Herle and S. Rouse (eds), *Cambridge and the Torres Strait. Centenary Essays on the 1898 Anthropological Expedition*, Cambridge: CUP, pp. 77–105.

Herle, A. (2003), 'Objects, Agency and Museums. Continuing Dialogues between the Torres Strait and Cambridge', in L. Peers and A. K. Brown (eds), *Museums and Source Communities. A Routledge Reader*, London and New York: Routledge, pp. 194–207.

Herle, A. and Philp, J. (1998), *Torres Strait Islanders. An Exhibition Marking the Centenary of the 1898 Cambridge Anthropological Expedition*, Cambridge: Cambridge Museum of Archaeology and Anthropology.

Herle, A. and Rouse, S. (eds) (1998), *Cambridge and the Torres Strait. Centenary Essays on the 1898 Anthropological Expedition*, Cambridge: CUP.

Hilty, G., Reason, D. and Shelton, A. (1995), *Hold. Acquisition, Representation, Perception. Work by Shirley Chubb*, Brighton: Green Centre for Non-Western Art and Culture at the Royal Pavilion, Art Gallery and Museum, Brighton.

International Council of Museums (ICOM) News (2004), 'Declaration of the Importance and Value of Universal Museums' (drafted 2002), reprinted in its entirety in *ICOM News*, 1, p. 4.

Jacknis, I. (1985), 'Franz Boas and Exhibits. On the Limitations of the Museum Method of Anthropology', in G. W. Stocking (ed), *Objects and Others. Essays on Museums and Material Culture*, Madison: University of Wisconsin Press, pp. 75–111.

Jacknis, I. (1992), 'George Hunt, Kwakiutl Photographer', in E. Edwards (ed), *Anthropology and Photography, 1860–1920*, New Haven, CT: Yale University Press in association with the Royal Anthropological Institute, pp. 143–151.

Jacknis, I. (1996), 'Repatriation as Social Drama: The Kwakiutl Indians of British Columbia, 1922–1980', *American Indian Quarterly*, 20 (2), pp. 274–287.

Jacobson, C. (n.d.), 'Field Notes. Welcome Home. G'psgolox Pole Returns Home to Kitimaat Village after 80 Years', *Ecotrust*, http://www.ecotrust.org/nativeprograms/gpsgolox_totem_pole.html.

Janse, G. J. (2011), *A Room to Hold the World. The Oval Room at Teyler's Museum*. Amsterdam: Nieuw Amsterdam Uitgevers/Haarlem: Teylers Museum.

Jonaitis, A. (1999), *The Yuquot Whalers' Shrine*, Seattle and London: University of Washington Press.

Jong, A. de (2001), *De Dirigenten van de Herinnering. Musealisering en nationalisering van de volkscultuur in Nederland, 1815–1940*, Nijmegen and Arnhem: SUN/NOM.

Jong, A. de (2010), 'New Initiatives in the Netherlands Open Air Museum: How an Early Open Air Museum Keeps Up with the Times', *Acta Ethnographica Hungarica*, 55 (2), pp. 329–347.

Kaplan, F.E.S. (ed) (1994), *Museums and the Making of 'Ourselves'. The Role of Objects in National Identity*, London: Leicester University Press.

Kaplan, F.E.S. (2006), 'Making and Remaking National Identities', in S. Macdonald (ed), *A Companion to Museum Studies*, Oxford: Blackwell, pp. 152–169.

Karp, I., Kratz, C., Szwaja, L. and Ybarra-Frausto, T. (eds) (2006), *Museum Frictions. Public Culture/Global Transformations*, Durham, NC: Duke University Press.

Karp, I. and Lavine, S. D. (eds) (1991), *Exhibiting Cultures. The Poetics and Politics of Museum Display*, Washington, DC: Smithsonian Institution Press.

Katriel, T. (1997), *Performing the Past. A Study of Israeli Settlement Museums*, London: Lawrence Erlbaum.

Katriel, T. (2001), '"From Shore to Shore": The Holocaust, Clandestine Immigration, and Israeli Heritage Museums', in B. Zelizer (ed), *Visual Culture and the Holocaust*, New Brunswick, NJ: Rutgers University Press, pp. 198–211.

Kerchache, J. with Bouloré, V. (eds) (2001), *Sculptures Africa, Asia, Oceania, Americas*, Paris: Réunion des Musées Nationaux.

Keuren, D. K. van (1984), 'Museums and Ideology: Augustus Pitt-Rivers, Anthropological Museums, and Social Change in Later Victorian England', *Victorian Studies*, 28, pp. 171–189.

Keuren, D. K. van (1989), 'Cabinets and Culture: Victorian Anthropology and the Museum Context', *Journal of the History of Behavioural Sciences*, 12, pp. 26–39.

Kiesler, F. (1965), 'Second Manifesto of Correalism', *Art International*, March 9, No. 2, pp. 16–19.

King, J. (2003), 'Romancing the Americas: Public Expeditions and Private Research c. 1778–1827', in K. Sloan (ed), *Enlightenment: Discovering the World in the Eighteenth Century*. Washington, DC: Smithsonian Institution/British Museum.

Kirschenblatt-Gimblett, B. (1998), *Destination Culture. Tourism, Museums, and Heritage*, Berkeley: University of California Press.

Kirschenblatt-Gimblett, B. (2006), 'World Heritage and Cultural Economics', in I. Karp, C. Kratz, L. Szwaja and T. Ybarra-Frausto (eds), *Museum Frictions. Public Culture/Global Transformations*, Durham, NC: Duke University Press, pp. 161–202.

Kopytoff, I. (1986), 'The Cultural Biography of Things: Commoditization as Process', in A. Appadurai (ed), *The Social Life of Things. Commodities in Cultural Perspective*, Cambridge: CUP, pp. 64–91.

Kottak, K. (2004), *Anthropology: The Exploration of Human Diversity*, New York: McGraw Hill.

Kratz, C. (2002), *The Ones That Are Wanted. Communication and the Politics of Representation in a Photographic Exhibition*, Berkeley: University of California Press.

Kratz, C. and Karp, I. (2006), 'Introduction. Museum Frictions: Public Cultures/Global Transformations', in I. Karp, C. Kratz, L. Szwaja and T. Ybarra-Frausto (eds), *Museum Frictions. Public Culture/Global Transformations*, Durham, NC: Duke University Press, pp. 1–31.

Kreamer, C. M. (2006), 'Shared Heritage, Contested Terrain: Cultural Negotiation and Ghana's Cape Coast Castle Museum Exhibition: "Crossroads of People, Crossroads of Trade"', in I. Karp, C. Kratz, L. Szwaja and T. Ybarra-Frausto (eds), *Museum Frictions. Public Cultures/Global Transformations*, Durham, NC: Duke University Press, pp. 435–468.

Küchler, S. (1999), 'Binding in the Pacific: Between Loops and Knots', *Oceania*, 69 (3), pp. 145–156.

Küchler, S. (2002), *Malanggan. Art, Memory and Sacrifice*, Oxford and New York: Berg.

Kurzführer (2010), *"Das schönste Museum der Welt". Museum Folkwang bis 1933*, Essen: Museum Folkwang.

Lane Fox [Pitt Rivers], A. H. (1868), 'Primitive Warfare. Part II', *Journal of the Royal United Services Institute*, 12, 399–439.

Launet, E. (2007), 'Un Louvre pour l'île du bonheur', *Libération*, reproduced on website of *La Tribune de l'Art Louvre*, http://www.latribunedelart.com/Debats/Debats_2007/Page_Debat_Abu_Dhabi.htm.

Legêne, S. (1998), *De bagage van Blomhoff en Van Breughel. Japan, Java, Tripoli en Suriname in de negentiende eeuwse Nederlandse cultuur van het imperialisme*, Amsterdam: KIT Publications.

Legêne, S. (1999), 'Past and Future behind a Colonial Façade: The Tropenmuseum in Amsterdam', *Archiv für Völkerkunde*, 50, pp. 265–274.

Legêne, S. and Postel-Coster, E. (2000), 'Isn't It All Culture?', in J. A. Nekkers and P.A.M. Malcontent (eds), *Fifty Years of Dutch Development Cooperation, 1949–1999*, The Hague: Sdu Uitgevers, pp. 271–288.

Leigh, N. (2008), *Building the Image of Modern Art. The Rhetoric of Two Museums and the Representation and Canonization of Modern Art (1935–1975). The Stedelijk Museum in Amsterdam and the Museum of Modern Art in New York*, Leiden: Proefschrift.

Levere, T. H. (1973), 'Teyler's Museum', in G.L'E Turner and T. H. Levere (eds), *Van Marum's Scientific Instruments in Teyler's Museum*, vol 4 of *Martinus van Marum. Life and Work*, Leiden: Hollandsche Maatschappij der Wetenschappen/Noordhoff International, pp. 39–102.

Lévi-Strauss, C. (1983) [1975], *The Way of Masks*, tr. S. Modelski, London: Jonathan Cape.

Lewis, O. (1966), 'The Culture of Poverty', *Scientific American*, 215, pp. 19–25.

Lidchi, H. (1997), 'The Poetics and Politics of Exhibiting Other Cultures', in S. Hall (ed), *Representation. Cultural Representations and Signifying Practices*, London: Sage/Open University, pp. 151–222.

Lundbaek, T. (2001), 'On the Origin of the Ethnographic Collection', *Folk, Journal of the Danish Ethnographic Society*, 43, pp. 41–71.

Macdonald, S. (1996), 'Theorizing Museums: An Introduction', in S. Macdonald and G. Fyfe (eds), *Theorizing Museums. Representing Identity and Diversity in a Changing World*, Oxford: Blackwell/The Sociological Review, pp. 1–18.

Macdonald, S. (2002), *Behind the Scenes at the Science Museum*, Oxford and New York: Berg.

Macdonald, S. (2003), 'Museums, National, Postnational and Transnational Identities', *Museums and Society*, 1 (1), pp. 1–16.

Macdonald, S. and Basu, P. (eds) (2007), *Exhibition Experiments*, Oxford: Blackwell.

Macdonald, S. and Fyfe, G. (eds) (1996), *Theorizing Museums. Representing Identity and Diversity in a Changing World*, Oxford: Blackwell/Sociological Review.

Macdonald, S. (ed) (1998), *The Politics of Display. Museums, Science, Culture*, London: Routledge.

MacGregor, N. (2007), 'Behind the Scenes at the British Museum', *Financial Times*, 14 September.

Malinowski, B. (1983) [1922], *Argonauts of the Western Pacific. An Account of Native Enterprise and Adventure in the Archipelagoes of Melanesian New Guinea*, London: Routledge and Kegan Paul.

Malraux, A. (1965), *Museum without Walls*, tr. Stuart Gilbert and Francis Price, London: Secker & Warburg.

Marstine, J. (ed) (2006), *New Museum Theory and Practice: An Introduction*, Oxford: Blackwell.

Meecham, P. and Sheldon, J. (2000), *Modern Art: A Critical Introduction*, London and New York: Routledge.

Meijers, D. J. and Roemer, B. van der (2003), 'Ein "gezeichnetes Museum" und seine Funktion—damals und heute', in B. Buberl and M. Dückershoff (eds), *Palast des Wissens. Die Kunst- und Wunderkammer Zar Peters des Grossen*, Band 2, Munich: Hirmer, pp. 168–182.

Messias Carbonell, B. (ed) (2007), *Museum Studies. An Anthology of Contexts*, London: Routledge.

Miller, D. (1987), *Material Culture and Mass Consumption*, Oxford: Basil Blackwell.

Miller, D. (2001), 'The Fame of Trinis: Websites as Traps', in C. Pinney and N. Thomas (eds), *Beyond Aesthetics. Art and the Technologies of Enchantment*, Oxford and New York: Berg, pp. 137–155.

Milner, J. (2009), *El Lissitzky. Design*, Woodbridge: Antique Collectors Club.

Mitchell, W.J.T. (1996), 'What Do Pictures Really Want?' *October*, 77, pp. 71–82.

Moerland, R. (2007), '"Louvre een touristisch uithandboard." Discussie in Frankrijk over vestigen van musea in Midden-Oosten' ('"The Louvre as a Tourist Attraction." Discussion in France about Establishing Museums in the Middle East'), *NRC Handelsblad*, 27–28 January, p. 9.

Morphy, H. (1998), *Aboriginal Art*, London: Phaidon.

Morphy, H. (2006), 'Sites of Persuasion: Yingapungpu at the National Museum of Australia', in I. Karp, C. Kratz, L. Szwaja and T. Ybarra-Frausto (eds), *Museum Frictions. Public Cultures/Global Transformations*, Durham, NC: Duke University Press, pp. 469–499.

Morphy, H. (2007), *Becoming Art. Exploring Cross-cultural Categories*, Oxford and New York: Berg.

Morris, W. (2001), *Proving Difference Creating Distance. Visual Authorizations of a Colonial Project. A Consideration of Belgian Sculptural Representations of Africans in the Royal Museum of Central Africa, Tervuren*, Masters thesis, University of South Africa.

Morton, C. and Oteyo, G. (2009), 'Paro Manene: Exhibiting Photographic Histories in Western Kenya', *Journal of Museum Ethnography*, 22, pp. 155–164.

Myers, F. (2006), 'The Complicity of Cultural Production: The Contingencies of Performance in Globalizing Museum Practices', in I. Karp, C. Kratz, L. Szwaja and T. Ybarra-Frausto (eds), *Museum Frictions. Public Cultures/Global Transformations*, Durham, NC: Duke University Press, pp. 504–535.

Newton, D. (1994), 'Old Wine in New Bottles, and the Reverse', in F.E.S. Kaplan (ed), *Museums and the Making of 'Ourselves'. The Role of Objects in National Identity*, London: Leicester University Press, pp. 269–290.

Noordegraaf, J. (2004), *Strategies of Display. Museum Presentation in Nineteenth- and Twentieth-century Visual Culture*, Rotterdam: Museum Boijmans van Beuningen/Nai Publishers.

Nora, P. (1989), 'Between Memory and History: *Les Lieux de Mémoire*', *Representations*, 26, pp. 7–24.

NRC Handelsblad (2009), 'Hoofd koning Badu Bonsu aangekomen in Ghana', *NRC.nl*, 25 July, http://www.nrc.nl/buitenland/article2310609.ece/Hoofd_koning_Badu_Bonsu_aangekomen_in_Ghana.

O'Hanlon, M. (1993), *Paradise. Portraying the New Guinea Highlands*, London: British Museum Press.

O'Hanlon, M. and Welsch, R. L. (eds) (2000), *Hunting the Gatherers. Ethnographic Collectors, Agents and Agency in Melanesia, 1870s–1930s*, New York and Oxford: Berghahn.

Olby, R., Cantor, G., Christie, J. and Hodge, M. (eds) (1990), *Companion to the History of Modern Sciences*, London and New York: Routledge, pp. 712–727.

Overzicht van de Geschiedenis van het Rijksmuseum voor Volkenkunde, 1837–1937 (1937), Leiden: A. W. Sijthoffs.

Parker Breinen, R. (2006), *Visions of a Savage Paradise. Albert Eckhout Court Painter in Colonial Dutch Brazil*, Amsterdam: Amsterdam University Press.

Parsons, N. (2000), 'El Negro/El Negro of Banyoles: Bushman from Bechuanaland, or Bechuana from Bushmanland?', paper presented at the University of Botswana, History and Archaeology Research seminar.

Peers, L. (2004), 'Repatriation—a Gain for Science?' *Anthropology Today*, 20 (6), pp. 3–4.

Peers, L. and Brown, A. K. (eds) (2003), *Museums and Source Communities: A Routledge Reader*, London: Routledge.

Phillips, R. B. (2003), 'Introduction to Community Collaborations in Exhibitions. Towards a Dialogic Paradigm', in L. Peers and A. K. Brown (eds), *Museums and Source Communities. A Routledge Reader*, London and New York: Routledge, pp. 155–170.

Phillips, R. B. (2005), 'Re-placing Objects: Historical Practices for the Second Museum Age', *Canadian Historical Review*, 86 (1), pp. 83–110.

Pink, S. (2006), 'Visualising Ethnography: Transforming the Anthropological Vision', in P. Hamilton (ed), *Visual Research Methods*, London: Sage, pp. 285–304.

Pinney, C. (2002a), 'Photographic Portraiture in Central India in the 1980s and 1990s', in V. Buchli (ed), *The Material Culture Reader*, Oxford and New York: Berg, pp. 87–103.

Pinney, C. (2002b), 'Visual Culture', in V. Buchli (ed), *The Material Culture Reader*, Oxford and New York: Berg, pp. 81–86.

Pinney, C. (2003), 'Introduction. "HOW THE OTHER HALF . . . "', in C. Pinney and N. Peterson (eds), *Photography's Other Histories*, Durham, NC: Duke University Press, pp. 1–14.

Pinney, C. and Peterson, N. (eds) (2003), *Photography's Other Histories*, Durham, NC: Duke University Press.

Pomian, K. (1990) [1987], *Collectors and Curiosities. Paris and Venice, 1500–1800*, Cambridge: Polity.

Porto, N. (1999), *Angola a Preto e Branco. Fotografia e Ciência no Museu do Dundo, 1940–1970*, Coimbra: Museu Antropológico da Universidade de Coimbra.

Porto, N. (2000), *Modos de Objectificação da Dominaçãocolonial. O caso do Museu do Dundo, 1940–1970*, PhD diss., University of Coimbra.

Poulot, D. (1991), 'Le Louvre imaginaire: Essai sur le statut du muse en France, des Lumières à la République', *Historical Reflections/Réflections Historiques*, 17 (2), pp. 171–204.

Pratt, M. L. (1992), *Imperial Eyes: Travel Writing and Transculturation*, London: Routledge.

Price, S. (1989), *Primitive Art in Civilized Places*, Chicago: University of Chicago Press.

Prösler, M. (1996), 'Museums and Globalization', in S. Macdonald and G. Fyfe (eds), *Theorizing Museums. Representing Identity and Diversity in a Changing World*, Oxford: Blackwell/ The Sociological Review, pp. 21–44.

Qureshi, S. (2004), 'Displaying Sara Baartman, "The Hottentot Venus"', *History of Science*, 42, pp. 233–257.

Rigney, A. (2005), 'Plenitude, Scarcity and the Circulation of Cultural Memory', *Journal of European Studies*, 35 (1), pp. 11–28.

Rose, G. (2007) [2001], *Visual Methodologies. An Introduction to the Interpretation of Visual Materials*, Los Angeles: Sage.

Rowlands, M. (2002a), 'Heritage and Cultural Property', in V. Buchli (ed), *The Material Culture Reader*, Oxford and New York: Berg, pp. 105–114.

Rowlands, M. (2002b), 'The Power of Origins: Questions of Cultural Rights', in V. Buchli (ed), *The Material Culture Reader*, Oxford and New York: Berg, pp. 115–133

Rozental, S. (2007), 'Using Film to Move a Totem Pole', paper given at the Centre for Anthropology Seminar, British Museum, http://blogs.nyu.edu/projects/materialworld/2007/05/using_film_to_move_a_totem_pol.html.

Rubin, W. (ed) (1984), *"Primitivism" in Modern Art: Affinity of the Tribal and the Modern*, New York: Museum of Modern Art.

Rudwick, M. (1976), 'The Emergence of a Visual Language for Geological Science, 1760–1840', *History of Science*, 14, pp. 149–195.

Rykner, D. (2007), *Le Spleen d'Apollon. Musées, fric et mondialisation*, Paris: Editions Nicolas Chadun.

Sandberg, M. B. (2003), *Living Pictures, Missing Persons. Mannequins, Museums, and Modernity*, Princeton, NJ, and Oxford: Princeton University Press.

Sansi, R. (2007), *Fetishes and Monuments. Afro-Brazilian Art and Culture in the 20th Century*, Oxford and New York: Berghahn Books.

Saunders, B. (1997), 'Contested *Ethnie* in Two Kwakwaka'wakw Museums', in J. MacClancy (ed), *Contesting Art. Art, Politics and Identity in the Modern World*, Oxford and New York: Berg, pp. 85–130.

Saunders, B. (2005), 'Congo Vision', in M. Bouquet and N. Porto (eds), *Science, Magic and Religion. The Ritual Processes of Museum Magic*, Oxford and New York: Berghahn Books, pp. 75–94.

Scalliet, M.-O. (1998), 'Natuurtonelen en taferelen van Oost-Indië', in K. van Brakel, M.-O. Scalliet, D. van Duuren and J. ten Kate (eds), *Indië Omlijst. Vier Eeuwen Schilderkunst in Nederlands-Indië*, Amsterdam: KIT Publications, pp. 39–89.

Schneider, H. D. (1998), *De Ontdekking van de Egyptische kunst, 1798–1830*, The Hague: Museum het Paleis; Leiden: Rijksmuseum van Oudheden; Gent: Snoeck-Ducaju & Zoon.

Shelton, A. (2003), 'Curating African Worlds', in L. Peers and A. K. Brown (eds), *Museums and Source Communities. A Routledge Reader*, London and New York: Routledge, pp. 181–193.

Sherman, D. J. and Rogoff, I. (eds) (1994), *Museum Culture. Histories, Discourses, Spectacles*, London and New York: Routledge.

Siebold, P. F. von (1937) [1837], 'Kort begrip en ontwikkeling van de doelmatigheid en van het nut van een ethnographisch museum in Nederland', in *Overzicht van de Geschiedenis van het Rijksmuseum voor Volkenkunde, 1837–1937*, Leiden: A. W. Sijthoffs, pp. 63–69.

Silva, N. (2005), 'Paradise in the Making at Artis Zoo', in M. Bouquet and N. Porto (eds), *Science, Magic and Religion. The Ritual Processes of Museum* Magic, Oxford and New York: Berghahn Books, pp. 119–140.

Simpson, M. (1996), *Making Representations. Museums in the Post-colonial Era*, New York and London: Routledge.

Sliggers, B. (2002), 'Van individu tot instituut. De opkomst van institutionele verzamelingen', in B. Sliggers and M. H. Besselink (eds), *Het Verdwenen Museum. Natuurhistorische verzamelingen, 1750–1850*, Blaricum and Haarlem: V+K Publishing/Teylers Museum, pp. 7–18.

Sliggers, B. (2006), 'Een biografische schets van Pieter Teyler. Niets bij zijn leven, alles na zijn dood', in B. Sliggers, J. Vogel, P. Beliën, A. D. de Jonge, P. Visser and E. Ketalaar (eds), *De Idealen van Pieter Teyler. Een Erfenis uit de Verlichting*, Haarlem: Gottmer Uitgevers Groep/Teylers Museum, pp. 7–18.

Sloan, K. (2003), '"Aimed at Universality and Belonging to the Nation": The Enlightenment and the British Museum', in K. Sloan (ed), *Enlightenment: Discovering the World in the Eighteenth Century*, Washington, DC: Smithsonian Institution/British Museum, pp. 12–25.

Spencer, F. (1992), 'Some Notes on the Attempt to Apply Photography to Anthropometry during the Second Half of the Nineteenth-century', in E. Edwards (ed), *Anthropology and Photography, 1860–1920*, New Haven, CT: Yale University Press in association with the Royal Anthropological Institute, pp. 99–107.

Staniszewski, M. A. (1998), *The Power of Display*, Cambridge, Mass.: MIT Press.

Stanley, N. (ed) (2007), *The Future of Indigenous Museums. Perspectives from the Southwest Pacific*, New York and Oxford: Berghahn Books.

Stocking, G. (ed) (1985), *Objects and Others: Essays on Museums and Material Culture*, Madison: University of Wisconsin Press.

Stocking, G. (1996), *After Tylor. British Social Anthropology 1888–1951*, London: Athlone.

Storrie, C. (2007), *The Delirious Museum. A Journey from the Louvre to Las Vegas*, London and New York: I. B. Tauris.

Stuers, V. de (1873), 'Holland op z'n smalst' [Holland at its narrowest]. *De Gids*, 37, pp. 320–403.

Taylor, L. (1998), 'Introduction', in D. MacDougall, *Transcultural Cinema*, Princeton, NJ: Princeton University Press, pp. 3–21.

Theunissen, B. (1989), *Eugène Dubois and the Ape-man from Java. The History of the First 'Missing Link' and Its Discoverer*, Dordrecht: Kluwer Academic.

Thomas, N. (1991), *Entangled Objects. Exchange, Material Culture, and Colonialism in the Pacific*, Cambridge, Mass.: Harvard University Press.

Thomas, N. (2010), 'The Museum as Method', *Museum Anthropology*, 33 (1), pp. 6–10.

Thomsen, T. (1937), 'The Study of Man. Denmark Organized the World's First Ethnographical Museum', *American-Scandinavian Review*, pp. 309–318.

Tilley, C., Keane, W., Küchler, S., Rowlands, M. and Spyer, P. (eds) (2006), *Handbook of Material Culture*, London: Sage.

Turner, V. (1977), 'Variations on the Theme of Liminality', in S. F. Moore and B. Myerhoff (eds), *Secular Ritual*, Amsterdam: Van Gorcum, pp. 36–52.

Tylor, E. B. (1871), *Primitive Culture: Researches into the Development of Mythology, Philosophy, Religion, Language, Art, and Custom*, 2 vols, London: John Murray.

Vaessen, J. (1996), 'Over Context', in *Jaarboek 1996 Nederlands Openluchtmuseum*, Nijmegen: SUN/NOM, pp. 11–29.

Vergo, P. (1989), *The New Museology*, London and New York: Routledge.

Vermeulen, H. (1996), 'Enlightenment Anthropology', in A. Barnard and J. Spencer (eds), *Encyclopaedia of Social and Cultural Anthropology*, London and New York: Routledge, pp. 183–185.

Vogel, S. (1991), 'Always True to the Object, in Our Fashion', in I. Karp and S. D. Lavine (eds), *Exhibiting Cultures: The Poetics and Politics of Museum Display*, Washington, DC: Smithsonian Institution Press, pp. 191–204.

Wastiau, B. (2000), *ExItCongoMuseum. Een essay over het 'sociale leven' van de meesterwerken uit het museum van Terveuren*, Tervuren: Koninklijk Museum voor Midden Afrika.

Weiner, A. (1992), *Inalienable Possessions: The Paradox of Giving-while-Keeping*, Berkeley: University of California Press.

Whyte, W. (1988), *The Social Life of Small Urban Spaces* [film], New York: Municipal Art Society of New York.

Williams, R. (1989), *The Politics of Modernism*, London: Verso.

Williams, R. J. (2004), *The Anxious City. English Urbanism in the Late 20th Century*, London and New York: Routledge.

Wolff Purcell, R. and Gould, S. J. (1986), *Illuminations. A Bestiary*, New York: W. W. Norton.

Woudsma, C. (1990), *The Royal Tropical Institute. An Amsterdam Landmark*, Amsterdam: KIT.

Wright, G. (1998), 'National Culture under Colonial Auspices: The École Française d'Extrême-Orient', in G. Wright (ed), *The Formation of National Collections of Art and Archaeology*, Washington, DC: Distributed by Yale University Press for the National Gallery of Art, pp. 127–141.

Zonnenberg, N. (ed) (2008), *Catalogue. Drop Sculpture (Atlas)*, Amsterdam: Rijksmuseum.

INDEX

Webster, Gloria Cranmer, 168
white cube, 145
Whiteley, Peter, 204n4
Whyte, William, 7
Williams, F. E., 174
Williams, Raymond, 199n19
Willem I, King, 63, 72, 191n4, 192n1
 see also Royal Cabinet of Curiosities
works of art, 38, 39, 40, 52, 87, 90
 ethnographic objects as, 82
world exhibitions, 9, 47, 66, 72, 74, 90, 128
 colonized peoples on display at, 128
 Paris 1878, 130
world heritage, 53, 90, 182, 183, 187

see also value, adding
Worm, Ole, 68, 69, 70

Yifat Museum, 110–13
Yimar headmask, photograph of, 97
Yingapungapu sand sculpture, 147
Yolngu, 146–7
Yup'ik collection, 172–3, 177
Yuquot Whalers' Shrine, 162, 163, 164–9, 171,
 204n4
 media, 160
 visual representation, 165

Zionist pioneering settlement, 110
 Israeli master narrative of, 99, 113, 195n13

CPSIA information can be obtained
at www.ICGtesting.com
Printed in the USA
LVHW081721080719
623454LV00004B/9/P